C O N T E N T S

19.99
707

A D V A N C E D

ART & DESIGN

WHITE & WHITE

Philip Allan Updates
Market Place
Deddington
Oxfordshire
OX15 0SE

Orders

Bookpoint Ltd, 130 Milton Park, Abingdon, Oxfordshire, OX14 4SB

tel: 01235 827720

fax: 01235 400454

e-mail: uk.orders@bookpoint.co.uk

Lines are open 9.00 a.m.–5.00 p.m., Monday to Saturday, with a 24-hour message answering service. You can also order through the Philip Allan Updates website: www.philipallan.co.uk

Printed in Great Britain by CPI Bath.

Philip Allan Updates' policy is to use papers that are natural, renewable and recyclable products and made from wood grown in sustainable forests. The logging and manufacturing processes are expected to conform to the environmental regulations of the country of origin.

P00690

INTRODUCTION

HOW TO USE THIS BOOK

This is a handbook for critical and contextual studies at AS and A2; its purpose is to help you use those studies to make art. You might consult this book at the start of a project if you have a theme or an artist you're interested in and want to know what to do next. Or, if you are already working on a project (usually called a unit in this book) and need further inspiration, or are stuck on a technical question, you could — just as if you were making something new and complex — look up the information in the relevant chapter. The basic ordering of this book follows the chronological development of a unit, but you can just as easily dip in and out and use it as a reference book. While there is a clear format for you to follow, the emphasis throughout is on making your own art and feeling proud that it could only have been made by you.

'But, I'm not doing painting'

There are many different disciplines (sometimes called endorsements) in the Art and Design specification currently covered by three exam boards in the UK. A discipline in this context means a type of art making. This book does not distinguish between different types of art; rather it lays out a process of thinking about art that applies to any type of work you want to make. A wide range of art is analysed to assist you. Always remember that an art work in any discipline can be helpful to you, whatever the medium or process you have chosen to work with.

HOW THIS BOOK IS ORGANISED

Chapter 1 takes you through the key terms and structures you will need for success at this level. Chapters 2, 3 and 4 tackle the 'Genres' (see pages 5–7 for advice on what this specialist term means). Each of these chapters also takes on two of the 'formal elements' (see pages 7–11), as well as analysing art made by a wide range of artists. These main chapters are organised to reflect the way in which a unit develops, working from first thoughts through studying other artists, observation work and development of ideas to final outcomes.

Chapter 5 looks at how to approach a given exam theme. It uses many types of art and suggests routes for you to take to enable you to make successful final pieces during the actual exam days. Chapter 6 contains specific advice on such key topics as how to write about art or how to use colour. Chapter 7 talks you through ways of successfully visiting art galleries.

There is a list of key words and their definitions in Appendix 1 to help extend your knowledge of the crucial specialist terms that you need to know. Appendix 2 gives fuller details of works of art referred to in the text — their size, materials and, crucially, where you might find them. There is a bibliography and lists of internet sites in Appendix 3.

ACKNOWLEDGEMENT

We would like to express our gratitude to Ken Baynes for his helpful comments during the preparation of this book.

ROUTE PLANNING

'KEY STEPS IN YOUR JOURNEY'

THIS CHAPTER FOCUSES ON...

- the connections between 'art making' (what the artist does; his or her role) and 'art criticism' (what others say about what the artist does; the critics' role)
- how these two roles come together in AS/A2 Art and Design and the role you can play in any work you want to make
- the underlying structures and approaches that critics use, and in particular the 'Genres' or types of art picked out by critics in the past
- the underlying structures and approaches that artists use, and in particular the formal elements or visual qualities of works of art
- the steps you can take to make successful art of your own that fits the examination criteria

BY THE END OF THIS CHAPTER YOU WILL BE ABLE TO...

- understand the different roles of artist and critic and see how the two interact
- play the roles of artist and critic in your own work
- understand what the formal elements are and how other artists use them
- understand how to use the formal elements in your own art
- identify the 'Genres' and how they have evolved in contemporary art
- make a focused study of the work of other artists that will prompt you to produce work of your own
- feel confident that you can follow the steps needed to build up a unit of examined work which satisfies all the assessment criteria

Key words for this chapter	
art study	the formal elements
creativity and understanding	the 'Genres'
critic	modulation
	sketchbook

CREATIVITY AND UNDERSTANDING

Art is an unusual subject to study: you have to be both a maker of art and a critic of it. You need to develop your skill and creativity as an artist and your understanding of art. To do well at AS/A2, it helps if you are aware of the way in which artists talk, not only to each other, but to themselves. The easiest way to eavesdrop on this conversation is to look at the context in which art is made (see the 'Art study' section on page 4, where this is discussed in more detail).

Every new piece of art has its roots in art that came before it. Sometimes artists continue with a tradition, sometimes they react against it. Over the past 150 years or so, art that has reacted against the past has been valued more highly. In making art, every artist is working within a shared context of ideas and images, while at the same time trying to make something new and personal.

What the critic says

'If you see there is such a thing as art then you must also see that art is made up of its own history: art already has something in itself. To want to conserve this thing, to look at it, to understand what it is and how it works and to respect it and be curious about it is already to resist lies and shallowness. Art has knowledge and skills, and to come to know them is to be implicitly against a culture that is against knowledge (today's mass culture which aims to produce a lot of consuming morons).'

Mathew Collings, 'Modern Painters', March 2005

CRITICAL SELF-AWARENESS

When you make your own art, you will need to show why you have done what you have done, to reveal your intentions. How does your art fit into the shared context of ideas and images? You may want to write and talk about the art you are making and studying, but it is equally important that you explore and analyse it through the use of art media: collage, drawing, modelling, painting etc. You are not simply finding out about art for its own sake, but using it as a source of example and inspiration for your own work.

Who influenced whom?

Generally, artists do not set out to explain what has influenced them or what they thought about when making their art. The work is expected to speak for itself, the background experience being contained within the art. Critics do set out to explain why artists do what they do — that is their role. Each critic describes how they think a particular artist has been influenced, and the influence of that artist on others. Critics do not create new art; their medium is words. Those words set up a conversation around a work which critics hope will explain and interpret the meaning of the art, and the value of that art in relation to others.

UNIT STRUCTURE

Most Art and Design work at AS/A2, and all work in this textbook, is based around the notion of a project or 'unit' of work. Each unit has a similar structure, but the content and outcome of each unit will be different. The length of time devoted to each will also vary. The unit is a way of organising the journey of your artistic development.

EACH UNIT MUST CONTAIN:

1 **Research** This consists of what, in this book, will be termed 'first drawings', usually made as part of the art study in a sketchbook. Many of these drawings will be made from direct observation or will be drawings that analyse the work of other artists.

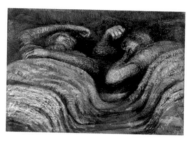

HENRY MOORE
Shelter Drawings,
1941

Work journal or sketchbook?

The traditional name for the bundle of notes, drawings and thoughts made by an artist is a 'sketchbook'. It tends to refer to a particular object or book. 'Work journal' or 'supporting studies' is the name currently given by some exam boards to *all* the work that you do in preparing to make a final piece. The 'work journal' or 'supporting studies' will therefore include your sketchbook(s), which is probably where most of your art will live, and larger drawings, practice pieces and the critical record of things you have seen and things you have done. In this book we tend to use the term 'sketchbook', as it is the more familiar, to cover all the work that you do in preparation for a 'final piece'. See 'How to use a sketchbook' on page 242 for greater detail.

2 **Art study** This means a study of the work of other artists, or a single artist, whose art relates to the theme or topic you are working on. The artist(s) may have worked on similar imagery, tackled similar themes or used relevant techniques, processes or materials. You may want to focus on a single artist, or on many. However, it cannot be stressed enough: art study is never a biographical essay.

You need to show how the art you've studied supports your own analysis of the ideas and themes you are working on. Demonstrate your creativity and under-standing through exploration and analysis of art media (artistic means: drawings, sketches, working notes and annotated collections of related images) and histori-cal and contextual information (critical means: critical comments, interpretations, artist's comments (if any)).

3 **Development** This is the point at which you embark on your personal journey. The 'development' step of a unit is the one in which you build on your research and art study and move towards your 'final piece'. You need to show the

examiners the details of your trip, the decisions you have taken and how you have gathered understanding along the way. This section will include what we call 'second drawings': further visual research made from direct observation and from close analysis of art works, and more experimental work in developing your own ideas and images.

During the development step, you will be expected to evaluate your progress, not in terms of good and bad, but in terms of noting investigations that were useful for further work as well as those that didn't lead anywhere.

4 **Final piece** This consists of a completed piece of art, in whatever medium suits your ideas and intentions.

All chapters and sections in this book are designed to fit into this unit structure and to suggest routes from research through art study into development and on to the final piece.

What the critic says

'It was not all work. We socialised generally late at night and when we did we talked about art — incessantly — and with utter seriousness...Talking about art was our primary recreation... Why did avant-garde artists need to congregate and to establish a community? Primarily to avoid loneliness after long hours in the studio, to socialise with kindred spirits; or to receive the assurance of fellow avant-garde artists that their moves into the unknown were not insane. But was there more? What if de Kooning had not met Gorky or Pollock? What if still, Rothko, Gottlieb, Newman, and Reinhardt had not become friends? Would Abstract Expressionism have come into being, or how would it have been different? I wonder.'

Irving Sandler, *A Sweeper-Up After Artists*, Thames and Hudson, 2004

THE ART STUDY

The reason for studying art by others is to understand how and *why* artists think and act, and to learn and to be inspired by their example. Try to imagine how artists would talk to each other and how they would discuss their own work. Or, imagine an artist talking to him or herself while at work. A good way to look at an art study is to see it as an attempt to reconstruct this sort of artistic conversation.

HOW MIGHT SUCH A CONVERSATION BE STRUCTURED?

Why was the work made? Did it follow on from something the artist had made before, or come from a new stimulus or influence? Did the art you are studying react against tradition and seem revolutionary and important at the time? Or, as often happened, was it ignored, only to be rediscovered and revalued much later? Who were the other key artists of the time and what were they doing? What were the key themes? Think about the art's social/political context and what was happening in the wider world. Did those events resonate in the art?

How was the art made? Are the techniques familiar? How did the chosen medium affect the art? Was the medium essential to the work?

What is the work actually like? It is vital to analyse the reality, what is sometimes called 'the presence' of the work. Try to see the work you are studying, if at all possible. What is its composition? How does the artist use the formal elements of line, tone, colour, form, pattern and texture? What is the story in the work? What is the scale of the work and does that scale matter? What is the impact of standing in front of this piece of art?

HOW TO REACT WHEN CONFRONTED BY ART

The following advice is designed to make you focus carefully and move from glancing at something to visual analysis.

1 Make a list of *everything* that you can see in the art.
2 What looks familiar to you in this painting? Can you make connections to other works of art? Does it echo other images from advertising, film, television or photography? The world is full of images — are any of them relevant to the art you are looking at?
3 Make a drawing of it. It should be an image that you can use for your art study, not a laborious imitation and yet something more than a scribble. Allow a good half hour, but not much longer.

In order to understand any object, we need to think both as a critic *and* as an artist. The first two questions provoked words, the critic's medium. To think visually, always make a drawing.

REMEMBER

After completing an art study, you do not need to follow the work studied exactly. Art studies should inspire you to follow a direction of thought. See also 'How to annotate a work' in chapter 6.

THE 'GENRES'

Examiners cannot expect you to have a complete knowledge of art history at AS/A2. What they are looking for is evidence that you are familiar with a range of works relevant to the themes you are tackling. That evidence should include analysis of a number of art works from different periods, suitable practices and ideas and some sense of the context in which artists worked. In other words, are you capable of explaining, as a critic, why these artists did what they did? As an artist, how has that knowledge helped your own art?

Humans have been making art since their earliest beginnings, probably since we came down from the trees and left the forests, and you will soon realise that there

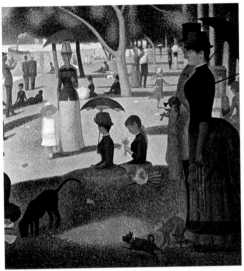

GEORGES SEURAT *La Grande Jatte*, 1884 (detail)

are many different ways of categorising all that work. Art historians tend to refer to 'schools' and 'periods', for example, organising art by date and chronology.

One method that is helpful in understanding the vast multiplicity of images is to think of art in terms of subject matter, linking art works together by what they are about. In the eighteenth and nineteenth centuries, critics placed types of work in what might be called 'like-minded' groups. These groupings were known as the 'Genres' and are still recognisable today. Originally, the list represented a hierarchy: the further removed from everyday experiences the art produced, the more uplifting and valuable it was thought to be. We probably take a different view today, but the list of names is still useful. It is important to realise, however, that these days many works fall into more than one category.

What the curator says: organising collections

In the past, museums have usually displayed art by date, beginning their tours with the earliest artists in the collection and ending with the most recent. It's interesting to note, however, that in 2000 when Tate Modern came to organise and display its collection of art made since 1900, the curators returned to the idea of displaying art by subject rather than chronologically. They used the following categories: History, Memory, Society; Nude, Action, Body; Landscape, Matter, Environment; Still Life, Object/s, Real Life.

The Museum of Modern Art in New York reopened in 2005 and has continued to display its collection chronologically. Tate Modern might return to a similar method in the future. Which do you think is the best method to present a collection, and why?

The Genres were:

- history painting
- landscape
- portraiture
- 'genre scenes'
- still life

The Genres are far from dead and it will be helpful to you to understand their original meanings.

THE GENRES HIERARCHY

history painting Originally this referred to representations of stories from classical myths or the Bible, or stirring images from history, all designed to make the viewer think of higher things; it was also known as the Grand Manner. An example would be David's *The Oath of the Horatii*, 1784, which shows three brothers raising their swords to swear allegiance and offer their life to their country, a story with great relevance to the later revolutionary French state. History paintings were large, public statements. The subjects they depict tell you what mattered to the patrons (those who paid for the art) as well as to the artists.

portraiture How and why individuals are portrayed in art varies according to the culture from which they come. This Genre also includes self-portraits. Much of the late twentieth century's interest in identity might fit here, for instance Gilbert and George's *Death Hope Life Fear*, 1984.

still life This Genre depicts inanimate objects, such as fruit, flowers, dead animals or everyday items. The insignificance of the objects portrayed placed still life low in the hierarchy of Genres, and yet it is now one of the most common subjects for art. A still life could be part of a larger painting or a subject in its own right, often with allegorical or hidden meanings.

There are many variations on the basic type of still life: flower painting, fruit and vegetable paintings, vanitas (symbolic paintings about death) and game (dead animals and birds). Also included are works that take in the clutter of the artist's studio, sometimes containing what is to become the artist's lunch, for example Cotan's *Quince, Cabbage, Melon and Cucumber*, 1600, showing fruit and vegetables hung in a curved arrangement in a stone box-like space, apparently an early form of larder. Most of the analytic Cubist works by Picasso and Braque are still-life paintings. Still life involves identifiable everyday objects and hence provides scope for analysing the culture that creates them, for example Jasper Johns' *Painted Bronze*, which depicts two ordinary beer cans (see pages 50–58 for further details).

landscape This is not as straightforward a definition as you might think. Nowadays, this type of art covers everything from Constable's *Hay Wain* (1821) to Land Art, for example Richard Long's *Slate Circle*, 1979. It could also take in any depiction of deep pictorial space, such as de Koonings' *Door to the River*, 1960.

'genre scenes' Confusingly, the last form of the Genres is called 'genre', written with a small 'g'. This refers to scenes or pictures from everyday life and the representation of ordinary people. Typical subjects might include peasants being amusing, such as Jan Steen's household scene *The Effects of Intemperance*, 1663, which shows drunken women and the results of their behaviour, or scenes of domestic contentment, as in Vermeer's *A Woman standing at a Virginal*, 1670. In genre scenes the subject is not elevated to the ideal, as occurs in history painting at the other end of the Genres hierarchy.

THE FORMAL ELEMENTS

Chapters 2, 3 and 4 of this textbook each take a pair of formal elements and examine them in depth. The formal elements are the basic building blocks of art, and you must have a good grasp of what they are and how to use them to do well at this level. At certain points, their basic definitions will overlap. In such cases, there is a cross-referencing system to alert you to other possibilities that you might want to investigate.

LINE

Reducing the fully coloured, tonal, three-dimensional world to a series of lines (linear drawing) demands choice and thought. It is for this reason that line has often been seen as the superior form of drawing.

There is more to line drawing than simply tracing an outline. A series of closely placed lines, for example, can describe tone, while the angle of the line on the page will investigate three-dimensional form. Look at van Gogh's drawing of *Postman Joseph Roulin*, 1888, made with a reed pen (see pages 25–26 on how to use a reed pen). Note how the forms of the cheekbones and nose are made by curving groups of cross-hatched lines. Compare this treatment of skin with the hairy mass of beard and the different length and type of lines he uses.

There are many factors that affect the quality of a line. A drawn line reflects the speed at which it was made, for example. The rapidity shows in the texture of the mark and the thickness and intensity of the line. How does one know how quickly

What the critic says: artists define the line

The German–Swiss artist Paul Klee talked of drawing as taking a line for a walk. The English artist, print maker and poet William Blake — who wrote the once-radical words that are now used for the establishment hymn, 'Jerusalem' — called drawing the wiry line of truth. The English painter William Hogarth put a 'line of beauty and grace' on to the palette in front of him, celebrating the importance of drawing in the making of art, in his self-portrait *The Painter and his Pug*, 1745.

Task

Line drawing

Take a piece of silver foil and crush it slightly. With a sharp, hard pencil, draw on paper as much of the foil as you can in half an hour, using lines less than a centimetre long. Such an exercise makes the eye concentrate, strengthens hand-to-eye coordination and shows the effect of using pure line.

to draw? The qualities of the subject should determine the speed of the line that analyses it. A large smooth object, a landscape or a static figure could be responded to with slow, soft-drawn strokes.

A line drawing should show precisely, and only, what is needed. Line drawings are the most immediate and direct of drawings. A small, spiky object will need short sharp marks from a sharp hard pencil. A soft, spongy subject demands slow curving lines with a soft pencil.

TONE

Tone is the description of light, and is sometimes referred to as 'shading'. Tonal drawings are often made with a soft pencil or charcoal. Tonal values are the gradual moves of tone from light to dark that you can see on any object under light. Simplified, these can be divided into the lightest areas (highlights), the darkest areas (shadows) and the values in between (midtones).

In representing tonal values, you are attempting to describe the degrees of light falling on an object or scene, rather than a range of perceived colours. Remember that tone is separate from local colour (the different colours of that same object under light — see page 10). Traditionally, the way to view this play of light is to half close your eyes.

Tonal research has a wide range of uses. Showing how strong light falls upon a large shape is a good way of analysing form, and a raking light (light at an acute angle) is a useful way to pick up different textures.

Tone is often used to create feeling. Soft, delicate light will have a different emotional impact to the intense darks of deep shadow and contrasting bright highlights.

FORM

Form refers to three dimensions and means the volume of an object — the space that the object occupies. The term defines a property, as well as a process of making art (sculpture), and you can use the other formal elements to describe it.

When working in three dimensions, you can analyse one form by building another. Try using your knowledge of the fundamental processes of making form (carving, moulding and assemblage) to understand how the forms have been arrived at. In two dimensions you can, for example, use tone to show how the bulk of an object turns away from you. In colour studies the red part of a drawing will appear closer to the eye and perhaps linger. The thickness of a line will show the size of the edge of an object. Remember too the role that contour lines can play in mapping out form.

TEXTURE

Surface qualities can have a significant effect on how we perceive an object. Think of Meret Oppenheim's *Breakfast in Fur*, 1936, a disconcerting Surrealist artwork in which a cup and saucer have been covered with fur. The basic forms of the cup and saucer are unchanged and the colour is not unusual; it is the inappropriate texture that makes this work so powerful. Again, you can use a range of formal elements to describe the quality of texture. Tone is particularly useful, and various media can help in the description. The edge of a charcoal stick lightly rubbed along heavy paper can describe the soft sheen of human skin, whereas tight white marks from the sharpest of pencils can represent the bristles of a brush. Work in three dimensions can investigate this element with great success.

Task

Tonal drawing

In making a tonal drawing of a red flower, you would be interested in the range of tonal values, examining the intensity of darkness at the centre of the flower against the shine of the highlight on the petal, rather than studying variations from cadmium red to magenta. To represent the tonal values, remember that you don't have to use black, white, grey etc. Any restricted palette will do, as long as the range and proportion of tonal values you paint or draw are the same as those on your subject. It also helps a great deal if your subject is under direct light — use a lamp so that you can see highlights and shadows more clearly.

COLOUR

Technically, colour is the sensation produced on the eye by rays of light, a sensation altered by the source of light and the object illuminated by it. The visible spectrum, white light, is made up of seven main rays (the colours of the rainbow, ranging from violet, with the highest frequency and shortest wavelength, to red, with the lowest frequency and longest wavelength). These give the familiar properties ascribed to 'warm' and 'cold' colours — red appears to be in front of the picture plane and blue appears to recede behind it, creating the illusion of depth and the appearance of pictorial space.

Colour is a huge and exciting area in art and the 'modulation of colour' is an important skill. The phrase 'the modulation of colour' describes the passage from one colour to another. Artists achieve this either through blending so that the change is hardly visible, or by careful arrangement of like colours next to each other. Through modulation you can show how a form changes shape. The more abrupt the change

What the scientist says: colour terms

The apparent colour of an object in front of you — the red of a flower, for example — is described as local colour. Local colour is the actual or 'true' colour of an object or area as seen under plain daylight before that local colour is affected by reflected light, overshadowing, distance from the eye, etc.

Another technical term for colour is hue. Hue is what we really mean by colour, the dominant wavelength of light that corresponds to a named colour, i.e. the part that produces the 'colourness' of a colour, for example the redness of red.

from one colour to the next, the sharper the change from one illusory dimension to another. Look, for example, at Delacroix's *Death of Sardanapulus*, 1827, especially the woman and the man stabbing her in the left foreground. Delacroix makes these fleshy forms appear rounded by changing from creamy white through darkening reds to darkest tones at the forms' edges. The darker the tone, the sharper the edge of the form as it goes into pictorial space. In some areas, the turn is gentle (e.g. across the shoulders), in others, it is sharper (e.g. the folds of the man's knee).

COLOUR AND SYMBOLISM

Unlike the other formal elements, colour has obvious symbolic roles within art. In Christian art, the Virgin Mary's robe is nearly always blue. Yellow has a range of symbolic properties in different cultures. In many, it is the colour of the sun and therefore associated with heat and fire, and also with wealth through its similarity with gold. For the Chinese, yellow means the centre or the earth. For Australian

Aborigines, yellow ochre symbolises death. Modernist artists have stressed the role of colour as fundamentally important to the process of making art. 'Colour expresses something by itself,' van Gogh said. Colour has a place in nearly all art and design work and therefore you should have, and be able to demonstrate, a working knowledge of different colour systems, both local and symbolic. The sketchbook is a good place to do this.

PATTERN

Pattern can be defined as the regular and repeated arrangement of forms. The term tends to be applied largely to craft works, but it is a quality that applies equally to all art works. A Mondrian painting is as much a pattern as the Gees Bend quilts made in Alabama (see page 225) or a contemporary central Asian felt carpet. All three are similar patterns on surfaces divided into geometric areas of strong colour, but patterns designed for different purposes.

What the examiner says: colour

Many students fail to take advantage of what colour can do and tend just to plonk unmixed colour straight from the tube on to their work. You should experiment with ranges of colour. For example, look at greys: blue grey, pink grey, cold grey, warm grey etc. The range of colour in a work is called the 'palette', named after the flat board on which artists mix their colours. Each artist has a characteristic palette, and recreating that range in your sketchbook would be an excellent way of demonstrating your analysis of this fundamental formal element.

FOLLOW UP: PATTERN

A comparison of the composition of patterns in art would be an interesting way to explore the properties of this formal element. Although most patterns use flat areas of colour, there is nothing to prevent you from experimenting with repeated sections of modulated colour or patterns based on recurring textures. Try overlaying different lace patterns, or work paint through net curtains or lace doilies. These can be used as stencils for printing too.

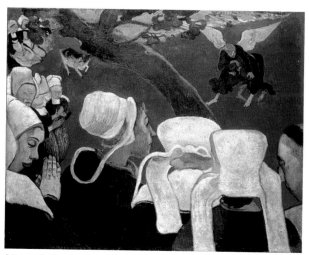

PAUL GAUGUIN *Vision after the Sermon (Jacob and the Angel)*, 1888

CHAPTER SUMMARY

This chapter has…

- introduced you to the roles of the art critic and the artist
- stressed the importance of connecting 'art making' and 'art criticism' for success at AS/A2
- analysed the importance of critical self-awareness in making your own art
- introduced you to the unit structure (research, art study, development, final piece), the format that will guide all your work at AS/A2 and ensure that it meets assessment objectives
- introduced you to the Genres (history painting, portraiture, landscape, still life, 'genre scenes'), the traditional method for organising types of art (but one that is still relevant today)
- analysed the formal elements (line, tone, form, texture, colour, pattern) and their role in making art

What the examiner says: 'intentions'

One of the crucial terms in the assessment objectives is the word 'intention'. Your recording and observation work is expected to be 'appropriate to intentions'. Your 'response' should realise 'intentions'.

For an examiner to understand what you intended to do and whether you have done it, you need to make your intentions clear and easy to find in your sketchbook. Although the logical place to find statements about your intentions would be at the beginning and end of the unit, it will help your case further if you refer to your intentions throughout the development of a unit. Ideas change, mature and progress. Demonstrate how and why, and as a result of what new stimulus. Use brief, easily identified diagrams, sketches, annotated images or notes to make your developing intentions evident throughout your work.

COURSEWORK WATCH

It's likely that, at the start of any unit, you'll be unclear as to what direction your art is going to take. This is a good thing, since it shows that you are genuinely responding to a theme. Leave a few pages blank at the start of your sketchbook so that you can return to them at the end of the unit to explain and analyse what happened and why (see the 'What the examiner says' box above). Annotating your research and development in hindsight shows all-important critical self-awareness.

Don't forget to refer to these analyses in your evaluation at the end of the unit.

CHAPTER TWO

LIFE AND STILL LIFE: LINE AND TONE

'PEOPLE AND THINGS'

THIS CHAPTER FOCUSES ON...

- the still life genre (concentrated observation of a collection of objects) and the role that line and tone can play in art
- six works in depth, to investigate making a 'still life' (although none of these images is a pure still life)
- using analysis to point you towards work of your own that takes still life as a starting point, but could end with art in any medium and at any scale that suits you

THIS CHAPTER INTRODUCES THE FOLLOWING TECHNIQUES...

- observation drawing from primary and secondary sources, working with pen, pencil, paint, charcoal and ink wash
- the use of tone and line to build form
- moving from two- to three-dimensional work when considering a still life

BY THE END OF THIS CHAPTER YOU WILL BE ABLE TO...

- put together an art study
- analyse works of art that represent the inanimate world through careful visual analysis — the still-life Genre
- understand the relationship between people and objects and ways of exploring this relationship in art
- understand key areas and ideas in the history of art, in particular the English Enlightenment, early French and British Modernism, and US Pop art
- understand the role of gender in looking at, and making, art
- arrange your own subjects for still life, and work through a wide range of mark-making techniques, emphasising the role of line and tone and exploring the drama of light

Key words for this chapter

abstract/abstraction

chiaroscuro

figurative

impasto

installation

narrative

palette

pastiche

picture plane

Pop art

Post-impressionism

squaring off

Surrealism

vanitas

■ understand more about what is involved when making a three-dimensional (sculptural) response to a theme, and know how you might move from one medium to another

INTRODUCTION

This chapter begins by exploring the idea of still life as a subject for art, taking a broader view than the traditional arrangement of fruit and vegetables. The focus is not simply on objects but also on the relationship between people and objects. Even where people are absent, a still life implies a human presence. The artist was there to observe the objects and pass on his/her insight to the viewer. Viewers bring their own ideas to the work; the image may be 'read' in many ways. The ways in which an art work is understood by individuals — artist and viewers alike — is decided by their personal and cultural experiences and attitudes.

The term 'still life' implies that the artist has chosen what he or she is analysing.

What the artist says

'It is my misfortune — and probably my delight — to use things as my passion tells me. What a miserable fate for a painter who adores blondes to have to stop putting them into a picture because they don't go with a basket of fruit! How awful for a painter who loathes apples to have to use them all the time because they go so well with the cloth. I put all the things I like into my pictures. The things...so much the worse for them; they just have to put up with it.'

Pablo Picasso, 1935

The objects you choose to stare at intensely must have some intriguing qualities. These could be purely visual — for example, the smooth curves of worn stone contrasted with the sharp edges of broken glass and the soft ruffles of old clothes. What is important is that these qualities slow down your eye as you study them, as well as the eye of the viewer looking at all your hard work.

As is often the case with still life, the chosen objects may have other meanings. They may be prized possessions, or professional or technical equipment, or they may have a symbolic or metaphorical meaning. For example, the Spanish artist Joan Miró's still-life painting of a boot, *Still Life with Old Shoe,* 1937, is an electric image, containing extremely vivid colours that almost hurt the eye with their intensity. His palette makes more sense when you realise that this painting was made just at the start of the Spanish Civil War. Although not a simple illustration of human violence, the image of a fork plunged into a cake is frightening and thought provoking.

SUMMARY

The common thread in still life is the careful, concentrated 'looking' at a collection of smallish objects. Although a whole group of things could probably be taken in and understood in a single glance, a well-chosen grouping may take you several weeks to analyse visually and could be the starting point for a long sequence of work.

FOLLOW UP

One closely observed subject is the painting of footwear which, like many still-life works, often has intentions beyond the description of appearances and can have deeper meanings. Van Gogh frequently painted boots during his short life — for example, *A Pair of Boots*, 1887, depicts heavy working-men's boots, images made to show that he was one of the people and that his art was not exclusive.

What the artist says: light

'Light is not something that can be reproduced, it must be represented by something else, by colours...the more colour is harmonious, the more drawing is precise. When colour is at its richest, form is at its fullest.'

Paul Cézanne, 1905

What the artist says: light

'I certainly agree that abundance and variety of colours contribute greatly to the charm and beauty of a picture. But I would have artists be convinced that the supreme skill and art in painting consists in knowing how to use black and white. And every effort and diligence is to be employed in learning the correct use of these two pigments, because it is light and shade that make objects appear in relief. And so black and white give solidity to painted things.'

Leon Battista Alberti, *Treatise on Painting*, 1436

Footwear could be a productive subject for a range of still-life investigations. Vary the technique according to your different perceptions of the role of the boot or shoe you are studying and compare your work with others. (Try looking at Courbet's *The Stonebreakers*, 1849–50, for example.)

JOAN MIRÓ *Still Life with Old Shoe*, 1937

What the critic says

Traditionally, a still-life painting or drawing involves the close observation and interpretation of inanimate objects. Still life as a descriptive term for a type of art originated in seventeenth-century Holland, the Dutch 'stilleven' meaning non-moving object or immobile nature. The painstaking depiction of domestic equipment, fruit and flowers is probably what first comes to mind when we think of still life, but the idea of making art out of small collections of things goes right back to the Ancient Greeks. In the twentieth century, products — especially those made for mass consumption, such as soup cans or wine bottles — came to occupy a special place in art. In the early part of the century,

Cubists painted signs, bottles and newspapers; later, Pop artists created 'still-life' art works in which products became icons. This was both a comment on growing consumerism and the new values it was creating, and a celebration of the graphic world of advertising, fashion, fast food, neon and packaging. Popular or mass culture has always influenced art strongly, and vice versa. Many images made for adverts echo art works. This is not surprising since most graphic designers and advertising directors have been through art school. 'Still life' in its widest sense provides a window to contemporary lifestyles and the contemporary world of mass consumption.

LINE

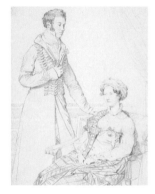

JEAN-AUGUSTE-DOMINIQUE INGRES *Sir John Hay and his Sister*, 1816 (detail)

Making a line-based study and analysing the fall of light through tone are two fundamental forms of visual research. Your work for both AS and A2 should show that you can use these techniques. In general, you could say that tonal drawing is atmospheric and line drawing is analytic. Shading the curve of light around a form tends to make generalisations about an object, whereas a line is a specific mark that is either right or wrong. It may also be expressive or powerful. A line drawing is versatile and can be used to suggest movement or scale. Above all, line is used to analyse form — think of the contour lines on maps.

Don't forget that using an equally weighted line to draw the outline of an object tends to make an apparent hole in the page. To describe the object's form, try varying the weight (thickness) of the line and draw *across* the form, not just around the edges.

What the critic says

Line drawing involves choice — choosing which areas to include and which to leave out. The artist is deciding how to reduce a world described by gradations of light into areas surrounded and acted upon by lines of varying thickness and speed. It is sensible to ask why artists would want to do such a thing and why critics and artists have valued this skill so highly in the past.

One of the great 'linear' artists was Jean-Auguste-Dominique Ingres. Look, for example, at his line drawing of *Sir John Hay and his Sister*, 1816. Descriptions of Ingres' drawings often use terms like 'purity, accuracy and precision'. It is terms such as these that

describe the key characteristics of this formal element. Although a line drawing may be made for its own sake, many line drawings are made as part of a process, with artists using line for its immediacy in sketches and working notes. In many cultures, line has been used as the main element in finished works. In the art of China and Japan, the outline of the shape became the structure of the image, with colours and textures being added inside the boundary line. Medieval manuscripts and early stained glass windows worked in exactly the same way, as do many of today's animated films and comic books.

FOLLOW UP

Try making a drawing of a simple object, a crumpled piece of a paper perhaps. Where the light on a crease is brightest, the drawn line should be as fine as possible; where the creases curve into shadow, thicken the line. Work across the surface of your drawing paper, putting down lines only where they correspond to creases on your subject and ignoring areas where there are no creases. What you will end up with is an almost abstract image, the idea of a crumpled piece of paper. It is important to realise that line drawing is a form of abstraction driven by the thoughts and decisions you make.

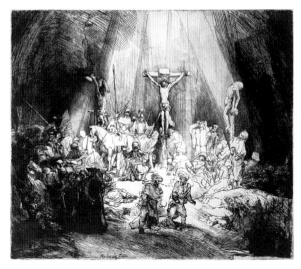

REMBRANDT *The Three Crosses, 4th Version,* 1653

What the examiner says: Rembrandt and light

In any investigation of light and tone, an examiner would hope at least that you have had a look at Rembrandt. While he did not tackle still life, his paintings of light forms against dark backgrounds have been highly influential. The powerful three-dimensional quality of Rembrandt's shapes are described by the change from dark to light, finished by thick white highlight. A painting like *The Blinding of Samson*, 1636, has dramatic composition. A rectangle of light stretching from the upper left to bottom right is full of writhing figures and deep shadows. Only the brightest areas are clear — the shining metal on the central assassin's helmet and the source of light streaming in from the left. In such a painting, the light itself is part of the narrative, as the light is extinguished from the young biblical hero Samson, who is blinded forever. If you get the chance, it is worth looking at Rembrandt's etchings as well, especially *The Three Crosses*, 1653, a view of Christ's crucifixion that involves three theatrical spotlights from above and rows of dark figures in the foreground. Etching as a technique depends entirely on revealing areas of light. Most educational institutions don't have access to this sophisticated technique because of the strong acids used in making the print, but leap at the opportunity to make etchings if you are ever given it.

TONE

Tone can be used to model a surface by showing the change in density of light that falls on it, while the depth of shading can help to show the mass of an object. Varying the density of tone to show mass can be useful in still-life work, especially when you want to show the solidity and comparative weights of the things you have chosen to look at. In a drawing about light (often called shading), you are considering the larger areas of the subject and trying to create a recognisable version of the three-dimensional reality you perceive in front of you. This will involve simplifying the subject, usually into areas of highlight, midtones and darkest areas. You will be ignoring detail in favour of an overall impression.

FOLLOW UP

Tone, like line, can be highly expressive. Softly modulated light might suggest a calm, peaceful atmosphere as, for example, in a Vermeer painting. Experiment with different media and techniques to vary the impact of your subject. Sharply edged areas of deep black and harshly formed areas of ragged tone would suggest an alternative reading to a still life rendered in soft grey ranges of modulated pencil.

Try to recreate the drama of an etching by using pens of various thicknesses and washes of ink. Indian ink is an excellent medium for tonal work. Undiluted, it produces a deep glossy black on any flat surface, although paper is probably the best surface to use. Try analysing the different effects of pen and brush using pure ink. Indian ink is waterproof when dry (unlike Chinese ink) so that if you use it heavily diluted as a wash, you can brush one layer of pale grey on top of another to build up the appearance of layers of differentiated tone.

What the critic says: representing light

Representing light has always been a crucial process in art. Apart from Rembrandt, another well known artist who uses light to represent objects and their relationship to people is Vermeer. In *The Kitchen Maid*, 1656, for example, he uses the same approach in modelling the maid's features and forearms as in the still life of jugs, basket and bread. Vermeer's observation of objects and people is equal and intense. It tells us about the kitchen maid's function within a household, implying either that she has no more importance than these functional objects or that all things on the earth are of equal importance, depending on your point of view. Which point of view do you hold and has the depiction of tone helped in that decision?

2.1 'PEOPLE AS THINGS'

INTRODUCTION

Section features

Works:
- Harold Gilman *Mrs Mounter at the Breakfast Table*, 1917
- Paul Cézanne *The Card Players*, 1893–96

Genre: still life

Formal elements: line and tone

Unit element: first drawings

We now start to look closely at specific works — paintings. How were they made? Can this analysis help your own art?

YOUR WORK IN THIS UNIT

At this point in the unit system, you are making what we have called first drawings — your initial attempts to understand the theme and how and why other artists have tackled it. In these early stages, you will probably be concentrating on collecting information, deciding the route you are going to take and making your first steps on the journey towards art of your own. Your own diagrams, sketches, maps and drawings will be more valuable than large chunks of copied text.

THEMATIC OVERVIEW

The essence of still life is the close analysis of objects — usually small and often domestic — that are normally overlooked. In the still-life Genre, it is the artist's task to draw our attention to the qualities of the ordinary and to focus our thoughts on the real and the actual. Both the featured paintings, Gilman's *Mrs Mounter* and Cézanne's *The Card Players*, show people. It is their relationship to the objects painted and the way that those objects are painted that focuses the viewer on the themes behind the paintings.

Notice that Gilman has paid the same amount of attention to the teapot as he has to Mrs Mounter and that Cézanne's card players are so static that they might as well be the apples he is so well known for painting. Indeed, one of the people Cézanne painted remembers the artist shouting at him to stop moving and behave more like an apple.

What the critic says

As we have seen, still life is one of the Genres of art. It is hard to come up with a precise definition but the French term for still life, *nature morte* (things that don't move), describes it well.

Still life has long been a subject for art. It can be found in ancient classical sites, such as the Roman wall paintings at Pompeii, and continues through to the present day in one form or another. The high points in still-life painting are probably the Netherlands in the seventeenth century and the early Modernist artists, especially Cézanne and the subsequent Cubist movement that Cézanne partly inspired. Most artists work with still life, either as a personal exercise or as an object to sell. It might be worth asking yourself what a contemporary still life should contain.

What the examiner says: 'review and refine'

As with any artist starting a new piece of work, your exact direction will be vague. However, it is important that before a unit is submitted for examination you make clear your approach to the theme. Can any reader of your sketchbook easily discover *why* you are pursuing this route? Leave some space at the start of your sketchbook so that once you know what you are doing, or once the final piece has been completed, you can return to the beginning and explain what happened.

The key term for this process is 'review and refine'. There's no need to pretend that you are starting out for the first time, just analyse each significant step as part of the journey of the work. There are many possible methods you might choose, but avoid writing essays. A sentence every few pages will do; and diagrams or storyboards could also map out the route easily. Remember that the intention is to analyse, not merely describe. Make the relationship with the art studied obvious and keep answering the question, 'Why did I do this?'

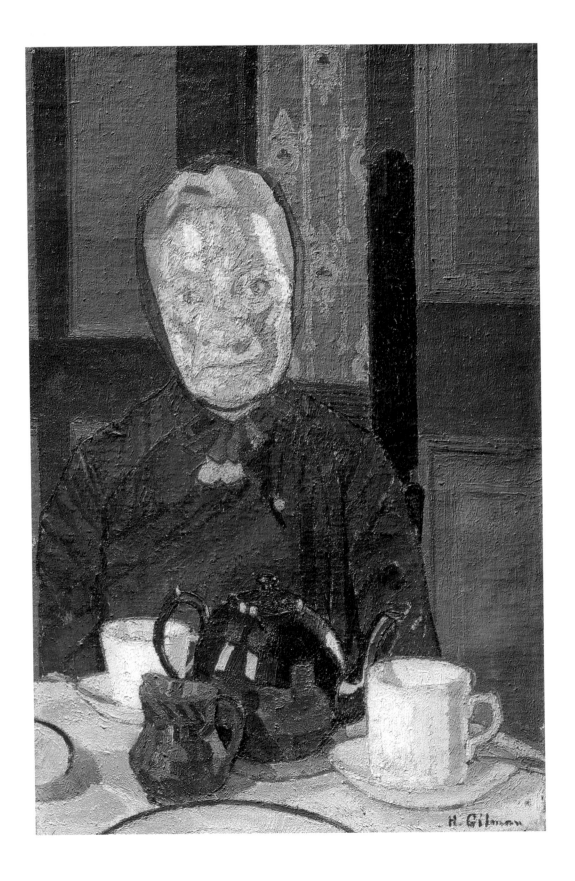

H. Gilman

Harold Gilman

Mrs Mounter at the Breakfast Table, 1917

TECHNIQUES

Are the techniques used by Gilman and Cézanne relevant to your art study? Think about the notion of art as a conversation. In paintings and drawings, mark making is the language that artists use.

Detail

To make this point clearer, compare the Harold Gilman painting to an earlier still-life example, e.g. Harmen Steenwyck's *Still Life: An Allegory of the Vanities of Human Life*, 1640, a 'vanitas' image. Ask yourself the following questions:

- Can you see the brushstrokes in the earlier work?
- Are we made aware of how the artist painted it?
- Can we see the artist's thoughts about the textures of the objects in the way they are painted?

What the art historian says

The story of art is marked by the move from representing an object to recreating the experience of the artist. The positioning of the artist at the centre of the work, with his or her experience becoming the subject, is characteristic of Modernism, a type of art that dominated Western culture from the middle of the nineteenth century onward.

- It is difficult to find the artist in a beautifully made but sealed vanitas painting, but can we 'see' Gilman's hand in the thickness of the paint?

Look at the way the brush changes direction to show the flow of the tablecloth around the brown jug. Note how the cloth contrasts with the solid shapes of the squat jug and the upright cylinder of the white cup. These evident marks are part of the discussion Gilman is having with himself about the visual qualities he can perceive in front of him, and part of the 'conversation' he is continuing with other art that he knew well.

FOLLOW UP

Gilman worked from careful drawings which he 'squared off', and you can often see grid lines on the surface of his paintings. He would make second versions of a work by squaring off the first and copying the design across to a new one.

Squaring off was a common artistic technique used to move a small drawing up to a larger painting. Gilman learned the method from another English artist, Walter Sickert. Clearly both artists were keen on pictorial composition.

There are other ways to use the squaring-off process. You might choose to keep the grid on your work and treat each defined area differently. Perhaps some squares could contain references to Gilman, others to previous works of your own. Use the full range of techniques you have tried in investigating the theme, all the while demonstrating that the experience of the artist is at the core of the art work you make.

COMPOSITION

Mrs Mounter was Gilman's landlady and he made several other paintings and drawings of her, including a very careful drawing for this particular painting (now in the Ashmolean Museum, Oxford). As part of the art-study process, you should have made a drawing of the whole work. Think now about the planes that make up the

What the critic says: pyramidal composition

The basic form of Mrs Mounter creates a flattened pyramid. This triangular composition is familiar throughout the history of art. Three good examples are:

1 Gwen John's *Dorelia in a Black Dress*, 1903–04, in which Dorelia is a narrow, elongated triangular shape, suiting the sitter's character.

2 Frieda Kahlo's *Broken Column*, 1944, showing the pain caused by her horrific accident.

3 Leonardo da Vinci's investigations, starting with the *Virgin of the Rocks*, 1508, and moving on to the *Virgin and Child with St Anne*, 1508–10, as the pyramid becomes more complex.

Pyramidal composition makes a painting appear calm. It is a strong, secure form, giving a feeling of solidity. In this work, however, Mrs Mounter, although essentially pyramidal, is just off centre, and that stability seems dislocated and not quite right.

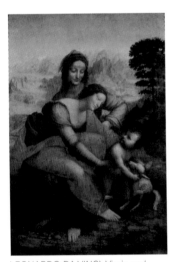

LEONARDO DA VINCI *Virgin and Child with St Anne*, 1508–10

composition. To help explain the painting visually, you could make a line drawing of the key planes and arrangements of the composition.

Behind Mrs Mounter are two doors and between them we can see the bright blue wallpaper of another room. The effect of the dominant horizontals of the door and the bright wallpaper is to make the internal space of the picture, or 'pictorial space' as it is known, appear shallow and to push Mrs Mounter and the table towards the viewer.

This composition also emphasises the physical position of the artist. Look at the flat plane of the table. It is placed in such a way that it would be possible for us to imagine the table continuing through the actual surface of the painting or 'picture plane' (see 'Key terms' on page 273) and extending into our space; we might be sitting at the same table. If you look carefully at the reflections on the teapot, you can see the table extending in reverse and by implication including the artist/viewer.

FOLLOW UP

Think about constructing your own compositions using a horizontal table, the open space of a doorway and a chair. What sort of large patterns (similar to the wallpaper in Gilman's painting) can you find to mark the vertical planes that frame the door? How will those patterns match the shapes made by the chair? Remember that you don't have to find an existing scene — you might be able to construct one of your own using suitable props and rolls of paper.

CONTEXT
OTHER ARTISTS

For each unit, you have to make one or more art studies. All artists go through this process in one way or another, although practising artists don't have to produce evidence of their art studies before their work is exhibited in the White Cube Gallery. To get a good grade at examination, you will have to produce that evidence.

WHO INFLUENCED WHOM?

Compare Mrs Mounter with a Cézanne portrait, for example *Woman with a Coffee Pot*, 1895. Gilman probably saw this painting when he visited Paris in 1910 or 1911, and there are certainly similarities.

SIMILARITIES

- Like Mrs Mounter, Cézanne's woman forms a pyramid, although a slender version with a smaller base.
- Like Mrs Mounter, Cézanne's woman is to the left of centre and behind her are door panels that flatten the pictorial space.
- Beside Cézanne's woman is a white mug and a cafetière of coffee.

DIFFERENCES

- The key difference is colour. Cézanne uses close, muted tones, a range of blues, browns and greens. These hold the stronger whites and reds in place so that no single colour stands out. Gilman's colours, especially the oranges of the headscarf and on Mrs Mounter's face, are bright in comparison.
- Gilman uses his composition to focus on the figure, as though the viewer has zoomed in on the subject.

These similarities and differences are important and should be pointed out if you compare the two works as part of your art study.

Task
Making an art study
In analysing this work, look at the artists who affected Gilman. Make these comparisons visually. Place drawings, coloured photocopies or painted versions of the works to be compared next to each other. Annotate the images showing where they share similarities and differences (see 'How to annotate images' in chapter 7). Include versions of your own attempts to solve the same artistic problems.

POST-IMPRESSIONISM

Mrs Mounter at the Breakfast Table is a Post-impressionist painting (a period in the history of art dating from about 1880 until about 1905), which means that Gilman was particularly influenced by a combination of the art of van Gogh, Cézanne and Gauguin. You can see this in the high-key colour that Gilman uses and the broad planes and crisp outlines.

The direct frontal confrontation between artist and sitter, as shown in this painting, is a compositional device Gilman learned from Cézanne and van Gogh. The viewer is placed in a direct relationship with Mrs Mounter, as though seeing her through the eyes of the artist.

FOLLOW UP: PORTRAITS

Traditionally, in a portrait the sitter is seen slightly turned away from the viewer, for example in Holbein's *George Gisze, A German Merchant in London*, 1532, in which

Who influenced whom?

It is possible that Mrs Mounter's orange headscarf is a direct quote from Gauguin's *Christ in the Garden of Olives*, 1889, in which Christ has orange hair. Gauguin's painting was one of many that had been shown at the hugely influential 'Manet and the Post-impressionists' exhibition in London in 1910. Gilman's painting, like the work of many other British artists, changed dramatically after this show. Gauguin was the first of the three major Post-impressionists to be admired by Gilman, but he gradually shifted his admiration to van Gogh.

What the examiner says

Gilman's range of borrowings and quotes from other artists is common, especially in work from this period, and there is no reason why you should not use the same process. Make sure that you steer clear of a wholesale pastiche, which in this context would mean just copying someone else without trying to make a visual argument.

Mr Gisze is facing slightly to our right but still looking at us. Around him are all the details of his job, painted in enormous detail. When drawing faces, you will probably have noticed that trying to make an image of a face that is exactly parallel to yours is not easy. The nose is especially difficult. You will find that artists often tilt the face they are representing so that it points away from them. This makes the task easier and is something you could try yourself.

There are other factors at work as well. Compare the position of Mrs Mounter with another portrait in which the sitter is viewed slightly from one side, for example Goya's *Dona Isabel de Porcel*, 1805. Dona Isabel is a glamorous woman, looking to our left (her right), surrounded by gorgeous ruffles of black lace. In her sleek European finery, Dona Isabel is the exact opposite of the solid Mrs Mounter in her dowdy London landlady's clothing. Finding a strongly contrasting, but thematically similar, image like this is often a good way of explaining what you mean.

CONTEXT
SOCIAL/POLITICAL

Avoid biography in your art studies — only use information about the artist that is relevant. Gilman, for example, did not have a happy life. He injured his hip at school, and took up art during his recovery. His marriage was unhappy: the parents of his American wife disapproved of his art, his son died young, his wife took their other three children home and he never saw them again. Gilman's artist friends were wealthy, whereas he was always poor and died in the influenza epidemic of 1919.

Is his story relevant to our art studies? It might explain why a middle-aged married man was living in cheap rooms with a landlady, but does it relate to the theme, technique, colours and composition of this painting? Are we studying *Mrs Mounter* as biographers illustrating his life? No, we are artists analysing his treatment of still life for our own work.

Who influenced whom?

Gilman's story has is one obvious relevance. His personal troubles meant that he identified with the idea of the struggling painter, such as van Gogh. Gilman borrowed van Gogh's compositions, and Gilman's thick impasto and strong colour also mark his influence. Gilman kept postcards of van Gogh's work and he used van Gogh's drawing style for his own reed pen and ink work. The drawings for *Mrs Mounter* are full of characteristic, van Gogh-like marks.

FOLLOW UP: REED PENS

Try one of van Gogh's techniques yourself.

- Take a thin piece of bamboo cane or a reed, about the length of a pen. Whittle one end with a chisel or a sharp knife (e.g. a Stanley knife). Take great care and always cut away from yourself.
- What you need is a short, flexible flap of material at the end of the stick, about 2 mm thick, 10 mm long and 3 or 4 mm wide.
- Dip this pen into ink to draw, studying your still-life subjects as you do so.
- The new pen can't hold much ink, so the strokes must be short and quick. The more you press on the nib, the fatter the line and the thicker the ink.
- Vary the thickness and shape of the nib for different effects. Making a vertical cut in the nib will make it hold more ink. Compare your results with Gilman's and van Gogh's drawings.
- Investigate other potential drawing materials, such as twigs, straws and the wrong ends of paintbrushes.

- In your sketchbook, you will build up descriptive marks based around still life and the work of others. Use these researches to turn into images of your own.
- Translate strokes of one thickness or direction into one colour, and another direction or shape of nib into another colour or texture of paint.

DIRECT COMPARISONS

There are two van Gogh portraits that might help with this art study. Try comparing *Mrs Mounter* with van Gogh's painting of *Postman Roulin*, 1888, in particular the frontal directness of the sitter and the use of flat planes of colour to model form. Or look at *La Berceuse*, 1889, which is similar to Gilman's painting in that it shows another melancholy woman, with bright wallpaper behind her. Examine also van Gogh's use of line to show the edge of form. For example, compare his treatment of the woman's arm and shoulder with Gilman's work on Mrs Mounter's shoulder, arm and the handle of the teacup. What is the role of thick impasto and high-keyed

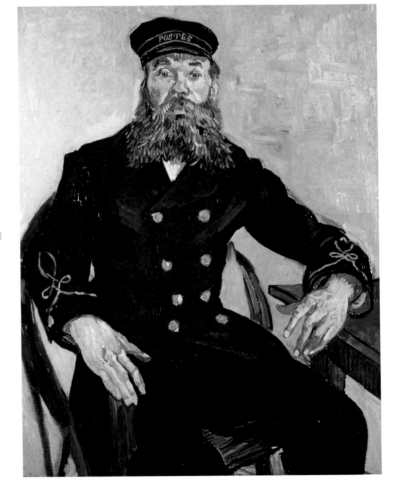

VINCENT VAN GOGH
Postman Roulin, 1888

colour in both works? How does each artist use line, tone and colour to create form? Can you make your own versions of similar subjects to add to your art study?

SOME RESULTS OF YOUR ANALYSIS...

You would expect the bright collection of colours Gilman used to produce a cheerful painting, but the combination of the off-centre pyramid, the shallow pictorial space, the dark form of the teapot dominating the foreground, and the balancing of those bright tones against each other make a downbeat image. Is it stretching our analysis too far to ask if the plate in front of Mrs Mounter is in fact empty? In 1916/17, when this melancholy painting was made, there would have been many empty places at tables across the country as the First World War continued to claim lives.

As a postscript to the rather miserable image of the artist, it should be mentioned that at the end of 1917 Gilman married again and moved to a new house, and was apparently happy until he died of flu in 1919.

What the examiner says

When looking at artists' use of line, there is an area you need to be careful about: 'the turning edge' (see 'How to show the turning edge' in chapter 7 for greater detail). Examiners sometimes use a student's treatment of the turning edge as a diagnostic tool — a way of diagnosing or finding out about confidence or fluency in visual research. In this particular art study, it would be sensible to show that you are aware of the process by, for example, making a study of an actual cup handle and comparing it to Gilman's version.

WHERE TO GO NEXT...

As already stated, you must be careful about using biography in art studies, and yet there is an air of sadness about this painting. Might it be that Gilman's personal troubles created the mood? His father died and his divorce came through from America in 1917. Could the war going on around him have created a sense of loneliness? Or might the mood be the by-product of the careful arrangement of the forms and colours the artist used? Your art study should be an analysis of the emotional impact of the techniques employed by the artist, but it could then go on to consider what creates emotion in art. For the role of colour in art, see chapter 4, but perhaps also think about the composition. Set up and draw a collection of objects such as a teapot and teacups.

Think about how Gilman focused on Cézanne's composition and ask yourself these questions:

- Does drawing your still-life composition from close up have a marked effect?
- Is it different to the results gained from six feet away?

- What happens when you draw the objects arranged on the floor with you above them? Does the scale of represented objects matter?
- Can you ascribe states of mind to these different viewpoints?
- Which state of mind is most relevant to your next steps on this theme?

Afternoon tea seems a peculiarly British subject. Gilman seems to have consciously made a British version of the French scene of a woman with a cafetière, which Cézanne painted in the work *Woman with a Coffee Pot*. If you were to make an equivalent art work today, which objects would you include?

FORM

The creation of form through contrasting colours is central to *Mrs Mounter*. Try this task to analyse the process further:

Step 1: Place a selection of objects on a white tablecloth, for example a red balloon, a yellow teacup and a blue bowl.

What the examiner says: ellipses

Before you start to draw cups and pots, which you can think of as circles in space moving away from you, make sure that you can represent these objects convincingly (see 'How to draw an ellipse' on page 237). Nothing alerts an examiner more than a weakly drawn ellipse.

Step 2: Look carefully at the relationship between each object and the white cloth.

Step 3: Now shine a series of coloured lights on them. Apart from red, yellow and blue, try yellow, pink and purple. If you can't find coloured bulbs or coloured gels to stick in front of lights, try photocopiable acetates and waterproof inks. Which light brings out the form of which object?

Step 4: Take the pairing of colours and make tonal drawings of the objects, using the nominal colour of the object as the darkest tone and the colour of the light as the highlight. The mix of the two can act as the midtone.

Step 5: Undertake a series of tonal studies, using variations of contrasting colours to make form. Try also using drawn lines of contrasting colours to make form.

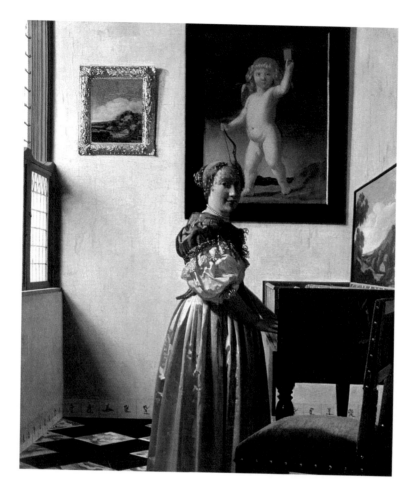

JAN VERMEER *A Young Woman
Standing at a Virginal*, 1670

INTERIORS

There are many paintings from the nineteenth and early twentieth centuries that show figures in interiors. Try looking at Vuillard's work, such as *Moira Sert and Felix Valloton*, 1899, in which the patterns and textures of thick paint mesh the two figures and the great vases of flowers together into one decorative surface. Then try experimenting with different textures of paint to represent different densities of tone, separating areas of paint by line in the manner of van Gogh or Vuillard. Look back to the work of an earlier, well-known painter of figures in interiors, Vermeer, such as *A Young Woman Standing at a Virginal*, 1670. Notice that in this painting there are several paintings hung on the wall behind the young woman. You could perhaps include some of your own past art in this way. It might help you to comment on the process of carefully looking at small objects in a still-life manner.

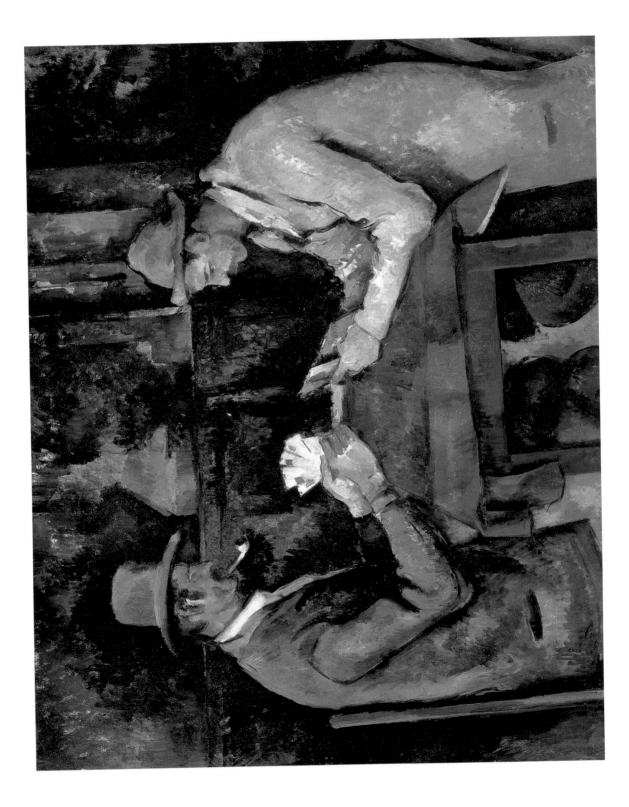

Paul Cézanne

The Card Players, 1893–96

THEMATIC OVERVIEW

Detail

This is the last of a series of works around this subject that Cézanne painted in the 1890s, and in which he gradually reduced the number of figures from five at the start to the two shown in this painting. The process of reduction is common in art and one that you might want to use in your own work.

There is no story being shown here. You can tell this by the way the subjects are treated. Cézanne does not seem to be interested in these two men as individual characters in a story. We are not shown their faces in close-up as a clue to their inner thoughts, a traditional way in which artists lead us into a narrative. Cézanne is interested in these figures as objects, as things he can examine with

The recipe thief

Other artists contemporary to Cézanne were interested in the same formal problems. Gauguin wrote to Cézanne's friend and teacher Pissarro: 'If he [Cézanne] should find the recipe for giving full expression to all his feelings in one single procedure, I beg you try to make him talk during his sleep by giving him one of those mysterious homeopathic drugs and come to Paris immediately and tell us all about it.' Gauguin bought many of Cézanne's paintings in search of this recipe, and Cézanne always accused Gauguin of being a thief and refused to talk to him. Is Cézanne following a formula? Or does *The Card Players* show evidence of careful and continuous work in front of nature?

great care. This is the still-life method we were looking at in *Mrs Mounter*. For example, how does one part of the jacket relate to another? What is the relationship of turning forms to the background? Should the background be a dead area? Can the colours used in the background activate the forms in the foreground? Look at the role of contrasting colours in creating form on page 28 of the preceding section. These are the sorts of visual questions that Cézanne seems to be asking himself.

FOLLOW UP

Notice that Cézanne used different methods and techniques. He tried many types of mark making, various ranges of colours and different forms of composition to research the objects in front of him and how they related to each other. This is much the same sort of process that you can follow in the work that you submit for assessment.

TECHNIQUES

In *The Card Players*, the figures are treated like apples or other still-life subjects. Look at the range of tones, and note that overall the tone is subdued. Some of the paint is thinly brushed on, while, at certain points, especially around the faces, the paint is crisper and more carefully applied. Think of the properties of warm and cool colours (see page 10 for further information on colour) and observe how the warm, red end of the spectrum appears to come towards the viewer and the cold, blue end seems to go backwards. Look at the back wall and the patch of brilliant red. You would expect that red to jut forward awkwardly into pictorial space, yet it is held in check by the surrounding blues. The function of the red patch is to liven up the colours around it, in what would otherwise be an area of inert colour.

Notice the same properties of colour in the vivid orange of the table and cloth that pushes the table end forward, or how the patches of red on the jacket of the

What the biographer says

'But Cézanne considered technique subordinate to sensitivity. He once remarked: "Technique grows in contact with nature. It develops through circumstances. It consists in seeking to express what one feels, in organising sensation into personal aesthetics". And he told Renoir: "It took me forty years to find out that painting is not sculpture." To this Renoir commented:

"That means that at first he thought he must force his effects of modelling with black and white and load his canvas with paint, in order to equal, if he could, the effects of sculpture. Later his study brought him to see that the work of a painter is to use colour that, even when it is laid on very thinly, it gives the full result."'

John Rewald, *Paul Cézanne*, 1986

left-hand figure pull his shoulder toward us. The blue on the hats and collars marks the turn of the bodies.

Cézanne is using colour to create form — a revolutionary process. Since the Renaissance, most artists created form simply by using light or dark areas of paint, but Cézanne adapts the warm and cold properties of colour instead. He also works his paint differently. Look carefully and you will see that Cézanne uses thinned areas of paint or marks, so that he is almost drawing with paint.

FOLLOW UP

You might try analysing the remarks of Cézanne quoted above by comparing the 'black and white' methods he uses to create form in his early work with the methods he uses later in *The Card Players*.

COMPOSITION
'CONSTANCY'

It is Cézanne's intense concentration on the tones, as well as the process of observing them, that creates oddities. For example, there are certain points where the shapes shown differ from what you might expect: the verticals of the table lean to the left and the left figure has excessively long knees and a tall, thin body. These are not wild exaggerations for the sake of distortion; they occur because Cézanne focuses on colour, tone and form rather than a literal representation of the subject. Cézanne has done away with what is called 'constancy', because it alters what the artist thinks is the true or initial impression of the object.

Look at the bottle on the table. As with many paintings, this still life-type object acts as a centre, or fulcrum, around which the rest of the composition pivots. The bright, white vertical highlight on the bottle links the various white areas of the painting together: the cards of the man on the left, his pipe and collar, and the collar and hat

What the critic says

Constancy is the perceptual faculty which normally ensures that objects do not appear to swell or to shrink alarmingly as they approach or recede from the spectator. This constancy will correct our perception of an object when it is bigger or smaller than we expect.

brim of the man opposite him. The strong verticality of the bottle echoes the vertical forms of the door behind the two men and the two table legs in front of them and the chair back to the left. Note how the still-life-type object in this painting unifies colour and form. When you come to set up your own subjects, think carefully about the role of each object and make notes in your sketchbook explaining your thinking.

FOLLOW UP

When you are making your own closely observed visual analyses, bear in mind the type of distortion you might want to use to emphasise the processes of perception. Once you have finished your drawing, try making a brief diagrammatic copy of it in your sketchbook to compare your discoveries with those of the artist(s) you have been studying.

CONTEXT
OTHER ARTISTS/PLAYING CARDS

It makes sense to compare Cézanne's painting with that of other artists who came before and after him whose work shares certain similarities, such as the eighteenth-century French artist Jean-Baptiste Chardin. Chardin was well known for his still lifes and for his careful paintings of figures, seen in *Young Draughtsman Sharpening his Pencil*, 1737, and *The House of Cards*, 1737, in which he uses the same sort of close focus that we can see in Cézanne's *Card Players*.

Look at the shape that the arms make in Chardin's two paintings. In both works the position of the arms, in particular those of the young draughtsman, appears similar to the positions in which Cézanne places his card players. You might make a series of annotations in your sketchbook pointing this out. Note how Chardin uses tone to create form, and how the card player's arm has darkness behind it to create the sense that this limb extends forward into space. Now compare Cézanne's

Who influenced whom?

'Theodore Reff has persuasively argued that Cézanne has somewhere in mind the image of Chardin's *House of Cards*, hanging then as now in the Louvre...There is something about both artists' sense of pace — the gentle nearly mute way in which the figures go about their slow and patient business — that suggests they understood the idleness of games and the attention that a hand of cards can bring'.

Joseph R. Rischel, *Cézanne*, Philadelphia Museum of Art, 1996

JEAN-BAPTISTE-SIMÉON CHARDIN
Young Draughtsman Sharpening his Pencil, 1737

treatment of the same area of the figure. Note how he uses colour as well as tone to create the appearance of the push and pull of form on the picture plane. Use your own arm studies to point out these differences.

FOLLOW UP

Use these discoveries to spur you on to make studies of your own. Positions of the arm would be a logical place to start. It may prove difficult to get someone to sit for you with their arm on a table for any length of time, in which case you can set up a mirror and use your own arm.

CONTEXT
SOCIAL/POLITICAL

Cézanne's father owned a bank and deeply disapproved of what his son was doing. We have already warned you to treat biography with caution, so why is this piece of information relevant? The money that Cézanne received from his family meant that he did not depend on sales for his living. He could paint what he wanted and wasn't restricted to painting one particular subject just because he knew it would sell. He could therefore concentrate for years, if necessary, on trying to get a painting right, as he did with *The Card Players*. There are many versions and supporting drawings — exactly the same sort of process that you as an art student would be expected to carry out in producing a major work of your own.

After early disappointments in Paris, Cézanne hid himself away in Provence on his family's estate, only occasionally going to Paris to see other artists. It was not until

Who influenced whom?

Cézanne was profoundly influential on the artists who followed him, and Picasso and Braque in particular. Try looking at some of the more obscure forms in the Analytic Cubist phase of these two artists, such as Picasso's *The Accordionist*, 1911. Although the figure in this painting is face-on rather than in profile, somewhere, in its basic pyramidal form, are shapes that relate to the same sorts of turning shapes of arm and face that we saw in Cézanne's *The Card Players*.

relatively old age that his work was recognised as important and many artists came to visit him. Again, why is this significant? Cézanne's paintings are not narrative based, unlike the paintings of his Parisian friends. Cézanne painted objects to show their form, not their role in a wider social and political world. Of the Impressionist artists, Monet and Renoir intentionally chose images of urban leisure and entertainment, while Pissarro focused on rural industry and the growth of factories. Although it is possible when we look at Cézanne's work to see wider implications in his treatment of Provençal peasants, essentially these men are painted as objects, one form relating to another.

FOLLOW UP

Take what appears to be a relevant section of Picasso's *The Accordionist* painting (mentioned above) and compare it to *The Card Players* and to your own drawings of an arm. Ask yourself these questions:

1 In what ways does the Cubist approach differ to Cézanne's?

2 In particular, how does each artist use tone to represent form? Look carefully at the way Picasso angles the light on each plane.

3 Which seems to be the most suitable method for your own studies of still-life forms?

WHERE TO GO NEXT...

THE CUBIST APPROACH

Does the Cubist approach solve the problems of representing three dimensions on a two-dimensional surface? Which of the approaches we have looked at so far is worth exploiting further and why?

FIGURE COMPOSITION: 1 (WITH MODELS)

Cézanne's figures have a great weight about them. Try thinking about the process of restricted figure composition and some of the artists who have used it, perhaps the pre-Renaissance Italian fresco painter Giotto.

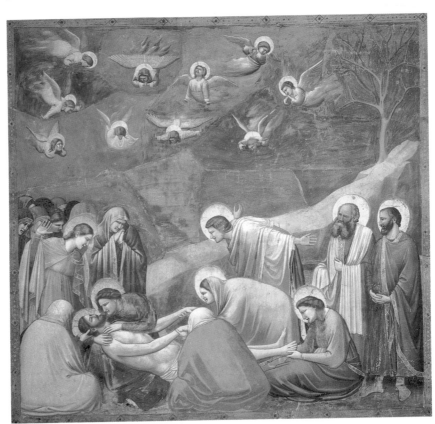

GIOTTO *The Lamentation of Christ*, 1305

Step 1: Look at Giotto's *The Lamentation of Christ*, 1305, which shows heavy, solid figures, completely still but caught at significant moments. The earthbound nature of Giotto's figures, created by deep areas of tone against strong highlights on the robes of the figures, and the broad gestures made by their arms, give each figure a definite sense of space around them.

Step 2: If possible, the best route forward would be to arrange figures, or mannequins, into the positions you can see in the Giotto and to try to include the positions of Cézanne's two card players as part of the tableau.

Step 3: Light the set-up strongly with white light from the upper left as though light was coming from outside the picture frame. Make large tonal studies, balancing areas of tone against descriptive line. Look at the types of drawing media described in chapter 1 and decide which would be the most suitable before moving on to consider the role of colour in suggesting form, as used by Cézanne.

FIGURE COMPOSITION: 1 (WITHOUT MODELS)

Step 1: If, as is likely, you do not have large numbers of models or mannequins, there are other routes you can follow. Given that Giotto appears to mould solid form with light, you could analyse the Giotto images as a relief exercise.

Step 2: Find a large board, as big as possible, and make a series of armatures on it (see page 266), roughly corresponding to the masses of the figures that you can see in the fresco. The armatures must be fixed in such a way that the board can be placed vertically.

Step 3: Find as many unwanted old sheets, cloths, curtains etc. as you can. Stand the board upright and drape the cloths on the shapes in such a way as to correspond approximately to the drapes in the fresco.

Step 4: Light the board and drapes from a single direction, ideally from above. You now have a source to work from. Painting the whole set-up white will help you to analyse the fall of light. Cheap white emulsion painted roughly over it all will unify the various surfaces and give a good subject. Start with quick tonal studies, building up into substantial studies.

Step 5: When you are more confident, you could perhaps progress to Cézanne's methods of building form with colour.

Step 6: Or, you could use your studies to paint on to the cloths themselves, building up a large relief painting based on the theme of light creating weight.

SECTION SUMMARY

This section has:

- used the still-life process of closely observing objects to examine two careful paintings of figures, paying particular attention to line and tone
- looked at the early stages in building up a unit of work (first drawings)
- analysed the role of composition in creating meaning
- introduced you to the notion of constancy in analysing and reproducing your own visual perception of the world around you

FOLLOW UP

You could experiment with using a range of tones within one colour yourself. Cézanne's palette had a range of yellows, reds, greens and blues on it. His range of yellows, for example, was as follows:

- brilliant yellow
- Naples yellow
- chrome yellow
- yellow ochre

What the biographer says: Cézanne and modelling form with colour

John Rewald in his book on Cézanne (see Bibliography) recalls another artist watching Cézanne at work: 'Emile Bernard noted how Cézanne painted a still life: "He started with the shadow and with a brush stroke, then covered it with another, larger one, then a third, until all the spots of tones, forming a kind of screen, modelled the object in colour." To give him an idea of his approach, Cézanne advised Bernard to "…begin lightly and with almost neutral tones. Then one must proceed stealthily climbing the scale and tightening the chromatics." In order to accomplish this, Cézanne instead of mixing a lot of colours, had ready on his palette an entire scale of tone gradations.'

Try setting up a similar range, from the bright pure tone of brilliant yellow to the darker, more complex tone of yellow ochre. Use the tones to describe forms under direct light.

2.2 'THINGS THEMSELVES'

INTRODUCTION

The middle section of this chapter looks at the complex ideas behind more recent art. The featured works relate to issues key to twentieth-century art. Both are figurative; the objects are recognisable, but the artists' intentions are different. Louise Bourgeois' collections are often seen as a long personal narrative, whereas Johns' recognisable consumer items are part of the long story of the art object itself.

We also use these works to ask questions about gender in art:

1 Does the gender of the artist affect the art she/he makes or how we view it?

2 Can you as an artist make your own art to further that analysis?

YOUR WORK IN THIS UNIT

In this section, you are at the stage of the unit that we call 'second drawings'. You have made initial research about your theme, and have some idea about the direction your art might be taking. Second drawings are a good time to consider where you have got to, and to start undertaking intense visual analysis for the route ahead.

THERMATIC OVERVIEW

In this section we introduce you to archetypes, the stock characters that people our culture. In Bourgeois' case, these archetypes interact with her personal history, but Johns' life story is unimportant in our analysis of his art.

We also look at 'objects in art'. The early twentieth-century French artist Marcel Duchamp made the act of choosing an object an art work in itself.

Section features

Works:
- Louise Bourgeois *Cell (Eyes and Mirrors)*, 1989–93
- Jasper Johns *Painted Bronze*, 1960

Genre: still life

Formal elements: line and tone

Unit element: second drawings

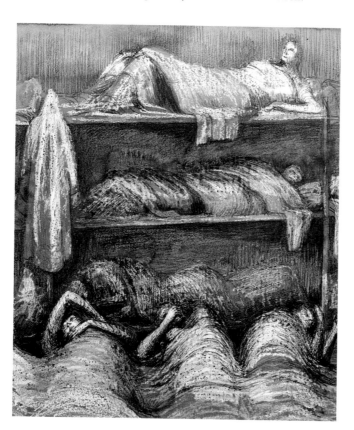

HENRY MOORE *Shelter Drawing*, 1941

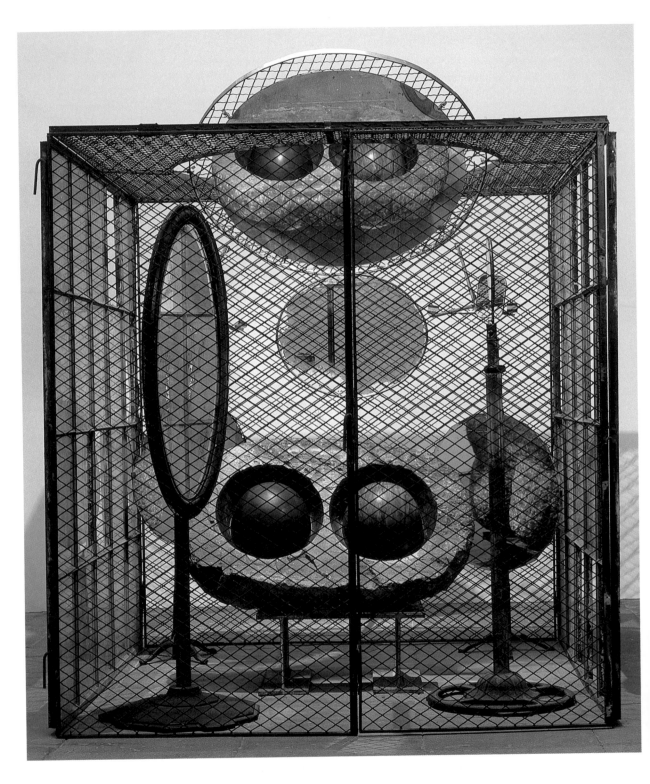

Louise Bourgeois

Cell (Eyes and Mirrors), 1989–93

TECHNIQUES

Some of this sculpture is carved in marble. Like bronze (see page 51), marble has important associations that go back to classical statuary. Does Bourgeois claim those associations?

Bourgeois' work is part installation, part figurative and part abstract sculpture, employing some traditional sculptural techniques. For example, you can see smooth marble spheres, rough carved surfaces, cuts made by saw rather than chisel, and raw or untreated stone. Stone techniques are part of the work itself, an idea you might like to consider using in your own art.

FORMAL CONTRADICTION

There is a formal contradiction between the perfect marble spheres, the roughness of the cut or raw stone and the flat circles of the old mirrors. What does 'formal contradiction' mean? Formal refers to the arrangement and types of form in the work. Contradiction means that those shapes do not agree with one another, for example spheres against circles. Techniques contradict in the same way, such as the use of perfect carving as opposed to cutting.

FOLLOW UP

- Reduce each form to a line drawing to find the formal relationship of each part. Rearrange a similar selection of circles and spheres. How do your new compositions compare to the original? Do they intensify or dilute it? Why?
- Since Duchamp, the way in which art work is displayed in a gallery has become as important as the objects themselves. How can that knowledge affect the art that you make?

DRAWINGS

Bourgeois' ideas for her sculptures start with drawings, although these are not standard observation drawings. Her line drawings are of strange shapes, forms in tension and under pressure, and claustrophobic rooms. These are recognisably sculptor's drawings in that they show properties of weight, texture and hardness, softness and positioning of forms, and they use line and bunches of lines to indicate tone and edge.

Henry Moore's *Shelter Drawings* (see page 39) are useful sculptor's drawings to consult. They were made in the London Underground during the Blitz. What

interested Moore were the overall forms of each figure and how those forms interact. These are not detailed drawings, but large shapes described by rapidly drawn lines acting as contours to describe turning forms.

FOLLOW UP: MOORE'S TECHNIQUE

Moore worked with wax crayons and ink, an effective method that you might try yourself.

Step 1: You will need some white, red and grey or black wax crayons, or possibly oil pastels, and some thinned Indian ink. The ink should be diluted with water so that it acts as layers of grey wash.

Step 2: Make your drawings of relevant forms using crayons to draw the lines. Work from large pebbles or bunched cloth if you have no sleeping people to work from.

Step 3: Wash layers of black ink over the drawings as you work and you will find that, because of the resistant properties of wax, the lines appear to stand proud of the

What the critic says

Light, i.e. tone, is an important element in sculpture. The way three-dimensional works are positioned, and the way light falls upon them, can significantly affect how we perceive them. How a sculpture is lit makes us aware of its mass and the materials from which it is made. The mirrors in *Cell* reflect light back on to the viewer. The arrangement is, like all elements of *Cell*, enclosed within wire mesh. Across each object the mesh casts grid-like shadows, which resemble a series of contour lines. We see their form as we try to 'see' their meaning. The deep cuts around the dark spheres make strong circular shadows, like eyes at the centre of the work which draw our own eyes to them. Again, this emphasises looking as a key element of the work.

described surface, particularly the white. In other words, you have a line-based drawing that creates form through tone, although it could well appear almost abstract.

Don't forget to document this process in your sketchbook, making it clear that the idea comes from Moore. Show through annotation what your intentions were and will be next. Don't describe only what you are doing — explain why are you doing it too.

COMPOSITION

This is one of many such cells that Bourgeois made in the 1990s, each one being a form of enclosed space. In this particular work, the old glass from industrial windows, combined with the diagonal metal grid on the other two side walls, emphasises a feeling of claustrophobia. The front of the cage is made up of sections

that can open, but are not opened for us the viewer. This arrangement makes a space that the viewer could potentially walk into, although the area is so full that little could be done with the vaguely industrial contents. It could be said to be a mental space.

So what is this work about? The rounded marble forms seem vaguely reminiscent of the sort of human shapes Picasso was making in the late 1920s and 1930s, which are called biomorphs.

Many of Bourgeois' works seem to feature these rounded, possibly female forms. The title of this work gives some sort of clue, suggesting that the rounded forms could also be seen as eyes, particularly given the three mirrors, making this a work about seeing and being seen. Pain also appears to be an important source for Bourgeois, especially the pain contained within families. One personal source of pain and upset in her life, often referred to by critics, is the fact that her father kept her governess as his mistress.

What the critic says

Unlike, for example, the Johns' bronzes (see below) or Cézanne's *Card Players* (see page 31), Bourgeois' art is auto-biographical, originating in her own experiences and often concerned with her relationship with her father. However, her art is not directly figurative. It deals in archetypes, an archetype being the basic model from which others are copied. Some well-known character types are described as archetypal in that their behaviour is always typical and has followed the same basic patterns since stories began. These characters turn up in Bourgeois' art: the unfaithful husband, the distant and cruel but charming father, the dying mother, the clever daughter competing for the father's attention with his young mistress. These are all archetypal characters as well as actual characters in Bourgeois' personal history.

CONTEXT
OTHER ARTISTS

Bourgeois' work, like that of many female artists, does not easily fit into the usual art historical descriptions, possibly because such descriptions were designed to describe men's art. What do you think?

Bourgeois' art seems faintly Surrealist in that her arrangements are always unsettling and could refer to a troubled subconscious. Yet she denies any connection with Surrealism, and certainly knew and loathed most of the main Surrealist artists. Apart from the visual similarity, there is little connection to that sort of art, so we could say that this is not a dream image. The art critic Lucy Lippard has called it Eccentric Abstraction, and that term seems to fit as well as any.

FOLLOW UP

After reading Leger's statement in the panel below, ask yourself whether or not Bourgeois' sensitivity functions unhampered.

Although her work, even her many drawings and earlier paintings, looks nothing like Leger's, there is a formal similarity in her use of tubular and other geometric forms.

Step 1: Try comparing a painting of Léger's, e.g. *Contrasts of Form*, 1913, with *Cell (Eyes and Mirrors)* to make this connection clearer.

Step 2: Léger's painting features a basic range of colours: red, blue, yellow and green. Bourgeois' sculpture is 'self coloured', the original colour of rock, steel etc., which in this work gives an overriding grey colour. Compare colour in both works.

Step 3: If colour is muted, as it is in *Cell*, or restricted, as it is in *Contrasts of Form*, the viewer concentrates on tone, or the proposed effects of light. Make a tonal drawing of an arrangement of rounded forms, varying that arrangement so shadows are concentrated in different areas.

Who influenced whom?

Louise Bourgeois was taught, among others, by the painter Fernand Leger. Leger was one of the early believers in the 'machine aesthetic', a term invented to describe art that optimistically uses the visual language of machinery, employing hard edges, bright flat colours, straight lines and lots of cog- and wheel-like shapes. Leger said 'modern man is living in a new order geometrically directed...victims of period marked by criticism, scepticism and intelligence, people are bent on understanding instead of letting their sensitivity function unhampered.'

Step 4: Angle the light so that the darker areas intensify the effect of gravity. Does deeper shadow closer to the ground emphasise the weight of the things you are looking at? If the lighting is reversed, does light close to the ground make lighter forms and a seemingly trivial artwork? How can you use light to make the arrangement look organised and geometric? How can you alter the light to make the arrangement look unhampered and not in any way carefully organised?

CONTEXT
MIRRORS IN ART

Mirrors turn up in art a great deal, and help to make the viewer look closely into the subject of the work. The three best known examples are probably van Eyck's *The Arnolfini Marriage*, 1434, Velásquez' *Las Meninas*, 1656, and Manet's *A Bar at the Folies-Bergère*, 1881. All three paintings reflect someone outside the picture. There are more instances you might find.

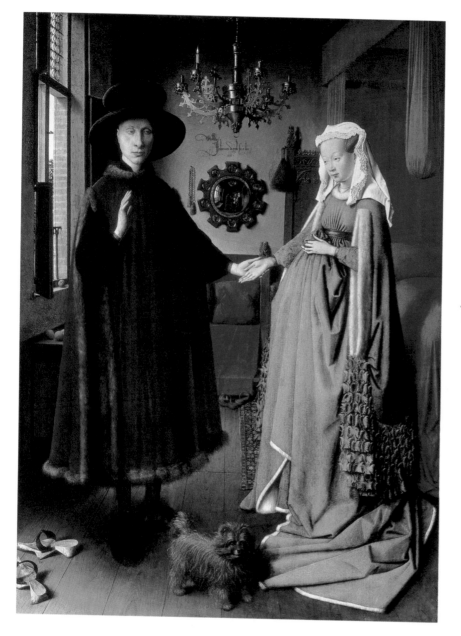

JAN VAN EYCK
The Arnolfini Marriage, 1434

VAN EYCK: *THE ARNOLFINI MARRIAGE*

In van Eyck's painting, it is the priest in blue who is outside the picture, probably sanctifying the engagement of the couple in the painting. You can see his reflection in the small mirror on the wall behind the couple. The priest is in exactly the same position as the viewer; in other words, by looking at this event we are giving it our blessing.

VELÁSQUEZ: *LAS MENINAS*

The same theme is developed further by Velásquez. In *Las Meninas*, the mirror is in the same position as it is in the earlier Dutch painting, at the back of the room, but this time the reflection shows the king and queen. The royal portrait is being painted by Velásquez, whom we can see looming out of the darkness behind a huge canvas on the left. As a result of this development, the viewer in the mirror has moved up from a priest to a royal. The act of looking has become even more important. Interestingly, at the time this was painted *The Arnolfini Marriage* was in the royal collection, so Velásquez would have known it well.

MANET: *A BAR AT THE FOLIES-BERGÈRE*

The Manet painting reflects the huge cultural changes made by urbanisation in the nineteenth century, the whole background of the painting being a mirror. Standing in front of this reflective background is a barmaid. We see her back in the right-hand side of the mirror and she is talking to a man in a top hat, a customer. Surely that man must be us standing directly in front of her? Yet the angle of the reflection is wrong, deliberately so. The view cannot be a direct reflection of us, as in the earlier paintings. Life in the new cities is more complex, so perhaps we are seeing a dream. Or perhaps we are witnessing alienation, the way in which none of us can directly relate to one another in the modern world? Or is this a representation of a series of different events in time, a bit like a combination of snapshots?

What the critic says

Identity and its social construction is an important part of women's art. Explore the work of the Black American artist Carrie Mae Weems, who examines race, racism and the continuing effect of the history of slavery on Black Americans. For example, *From Here I Saw What Happened and I Cried* (1995–96) is a series of photographs of images from the past overlaid with texts that describe the experience of Africans torn from their original homes.

What the critic says

John Berger's *Ways of Seeing* (see Bibliography) was written for a television series some time ago. It is still relevant and worth reading on the social, political and cultural processes of perception. Berger writes: 'Men act and women appear. Men look at women. Women watch themselves being looked at. This determines not only most relations between men and women but also the relation of women to themselves. The surveyor of woman in herself is male: the surveyed female. Thus she turns herself into an object.'

FOLLOW UP

After analysing these three well-known images of mirrors, there are questions you could ask yourself:

- Is this the complex meaning that underlies the mirrors that feature in Bourgeois' art?
- Are these earlier uses of mirrors relevant, and if so how?
- What other references do Bourgeois' mirrors suggest?
- How can you start to use mirrors in your own art?

CONTEXT
SOCIAL/CULTURAL/THE 'GAZE'

Bourgeois has also made many studies of eyes. Eyes, like mirrors, have a clear place in the history of art, and they draw us on to think about how we look at each other. In the context of analysing *Cell*, we need to think further about looking and the role of gender.

THE 'GAZE'

Later twentieth-century theorists developed the idea of how the sexes look at each other and the world into the concept of the 'gaze'. Feminist interpretations of the theory of the 'gaze' were that all looking is gendered. That is, the way we 'see' each other depends on social and cultural behaviour, in particular the conscious and unconscious domination of women by men. What happens in society also happens in art. Therefore, all art by men always treats its female subjects in certain identifiable ways, there being a visual language of dominance in all male art and behaviour. Men observe and women are the observed, and, as such, they are permanently subjects of that action. The way women perceive and act, therefore, should produce different forms of art.

The role of the mirrors in *Cell (Eyes and Mirrors)* reflects the 'gaze' theory, but only to a certain extent; the mirrors reflect you the viewer in the act of viewing, but the two carved eyes are polished black marble, seemingly blind. As Bourgeois has said: 'Each Cell deals with the pleasure of the voyeur, the thrill of looking and being looked at.'

Her works could be a search for identity:

- as an individual woman with a specific history, for example her relationship with her father
- as a mother (of three boys)
- as a female artist trying to make her way in a largely male world (see also Neshat on pages 184–193)

WHERE TO GO NEXT...

WOMEN AND CLOTH

Although *Cell* is full of determinedly hard textures — marble, metal and steel — many of Bourgeois' other works use the softer texture of textiles. Her parents ran an upmarket textile and tapestry repair business and, as a young girl, she spent time working in their workshop. That familiarity with materials can be seen in many of her works, e.g. *Untitled 2000*, a tower of white and blue fabric shapes stacked on top of one another, ranging from the smallest at ground level to the largest at about half a metre high. *Cell 1* shows another enclosed space, containing among other things a metal bed base on which embroidered blankets have been placed. They contain phrases like 'Art is the guarantee of sanity, Pain is the ransom of formalism' or 'I need my memories they are my documents'; Bourgeois has been using writing in her work like this for some time. Try comparing her approach to Tracey Emin and her blankets, e.g. *Something I've Always*

What the examiner says

If you can, please avoid the temptation, as a result of analysing this work, to sit down with a small mirror and make a drawing of your eye. Small drawings of eyes that are not well executed are a standard 'school art' subject. Louise Bourgeois' art is formally and intellectually complex. Try to use your study of her work to analyse rather than copy archetypes.

If you must draw eyes, remember that they bulge out toward you. Don't forget to include the perpendicular edge of the lower eyelid. Notice that the 'white' of the eye is not that white and that it is wet and shiny. Be aware that the pupil not only includes reflections (not dissimilar to the mirror in *The Arnolfini Marriage*), but it also contains a wide range of closely toned colours.

Been Afraid Of, 2002, or Emin's installations, e.g. *Bed*, 1998. What is the difference between the two women's approaches to textiles? If you were to make work that combined textiles and installation, which of these artists would you follow and why?

MEN AND CLOTH

Is Bourgeois' art, and the textile-based art referred to above, entirely gendered art? In other words, can it only be made by women? Is it an approach that men could tackle? There are male artists who use cloth, but there is a difference between art that stems from textiles and tactile approaches and art that just uses cloth as any other material. For example, Robert Morris's sculptures feature industrially-produced felt draped across galleries, such as *Untitled*, 1967–68, often arranged by the curator rather than the artist. Morris said that he was interested in sculpture without fixed form and that he had chosen cloth because it is not rigid and its form is different

each time you throw it on the gallery floor. This is art that uses cloth like any other found material, unlike textile art that conspires with the history of cloth.

Step 1: Compare a male and a female artist's approach to similar materials to make your point. You could, for example, take a length of canvas and photograph it in various positions to explore the boundaries of your art room. Paste these semi-documentary images into your sketchbook, with analysis of your reasoning.

Step 2: Alongside this conceptual cloth work, make drawings and notes for an embroidery that stresses the nature of the material. Perhaps test fine threads for the warp and rougher yarn for the weft. Paste swatches of the cloth into your sketchbook with notes and ideas about the processes to follow.

Step 3: From this gendered presentation of cloth, you could work up to a sculptural installation, making a feminine space within which cloth treated in a 'female' manner was ordered and arranged by male conceptual rules.

WOMEN IN ART

There are other women artists whose work is of interest, for example Jenny Saville, whose large fleshy paintings of herself and other women raise many questions about how women have been represented in the past. Try looking at her painting *Propped*, 1992, which shows her naked looking down into a mirror. The mirror has a text from the French feminist writer Luce Irigary written on it, so we see the image of a woman (Saville) through the writing. Given the role of mirrors discussed in this section, this method is perhaps something you could explore further.

THE CELL

The word cell can refer to a place of imprisonment as well a room for a monk to retreat to for isolation and meditation; in both cases, the occupant is removed from the outside world. This sort of state could well have some resonance with those forced to study intensely for AS and A2. Ask yourself these questions:

- How should that isolated study, whether real or imagined, be represented?
- What form would the physical space take?
- What would be its boundaries?
- What would be the content of this new cell?

Notice also that there is a third type of cell, the building block of all life, the biological cell. How would the knowledge that what you are building by working toward exams — your own building blocks toward your future life — affect the possible creation of your own 'cell'?

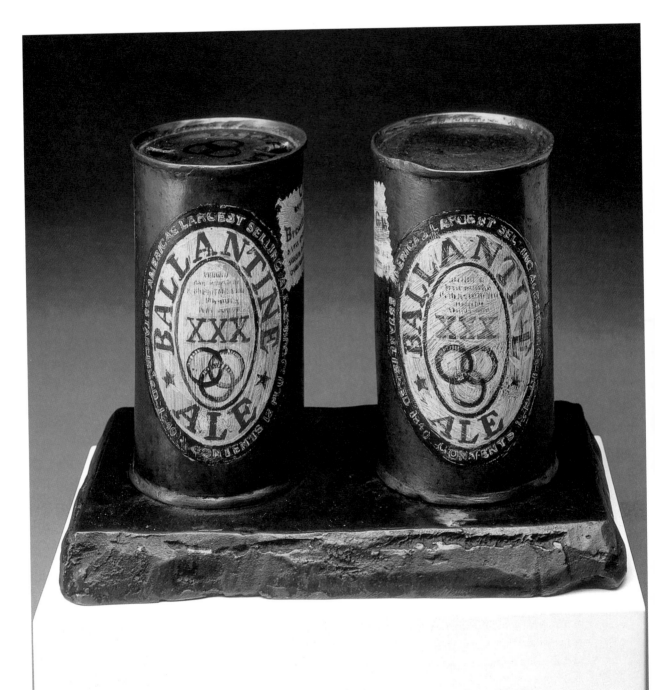

Jasper Johns

Painted Bronze, 1960

THEMATIC OVERVIEW

The essence of still life as a Genre is the intense observation of objects that are usually, but not always, small — 'looking at the overlooked', as the writer Norman Bryson put it (see bibliography). *Painted Bronze* is a knowing work: Johns was keenly aware of the art that came before him and the relationship between his art and that context is a major part of his subject.

Detail

All the artists we have looked at so far have been responding to the work of others, usually to specific artists, such as Gilman's response to van Gogh. Johns is different in that he is responding to entire categories, like still life, or to broad movements in art such as Dada and Abstract Expressionism, and to larger questions — in particular, what is the role of the object in art?

What the critic says

Bronze is an alloy of copper and therefore harder, but it is easier to melt and cast than copper and longer lasting. It is a 'Fine Art' medium, involving skill and expense. This in itself sets up expectations in the viewer, who is aware of looking at work in a tradition that started in Ancient Greece before moving through the Renaissance to a high point in the nineteenth century.

A sculpture cast in bronze is by definition a high-class object; beer cans are by definition not high-class objects. Jasper Johns uses bronze as a knowing reflection of the role of this material in the past, and that is the central point of this sculpture.

TECHNIQUES

The two beer cans are cast from actual Ballantine Ale cans, which are also a bronze colour. They are close to the real thing, making the viewer ask questions about realism/illusionism in art, such as 'how real can you get?' The two cans or cylinders are painted by the artist to give them a slightly handmade look. You can't quite read the small-print writing, and the artist's thumbprint is on the base of one. One of the beer cans has been opened, so it is presumably less full than the other. It also appears to be slightly smaller and has the Ballantine symbol painted on the lid. The patination, or surface quality, and the handmade appearance reinforces the beer cans' 'artness'.

COMPOSITION

Formally speaking, we are looking at two cylinders and a rectangular block. These are fundamental geometric forms and present the sort of formal contradiction seen

in Bourgeois' work (see above). However, the two cylinders differ considerably from Bourgeois' abstractions in that they have immediate and obvious representational references. They are painted to look like beer cans and they are mounted on a plinth.

It's useful to point out that Johns' sculptures are small, the same size as the objects they are cast from. Many small sculptures seem as though they were made to be picked up and weighed in the hand, to be deliberately tactile.

What the critic says: the plinth

The plinth or stand on which art is displayed is important in three-dimensional work. Remember that all art refers to art that came before it. The origin of the plinth is the stylobate or steps around a Greek temple, which raised the building into sacred space, symbolically lifting it away from the ordinary world of the mortal and into the immortal. A plinth, however small, performs the same symbolic act, lifting whatever is placed upon it into the world of art.

The way art work is presented matters a great deal. The next time you go into a gallery or museum (see chapter 7), look carefully at how the institution has arranged the works so as to make the viewers react to them. You will probably also see some Minimalist work (see Donald Judd in chapter 3) which is placed directly on the floor. How do you react to the different methods of displaying art work? How would you perceive this work if it was without a plinth and shown on the floor, or on a table surrounded by junk? How should your own art be displayed?

FOLLOW UP

You could experiment with a series of small sculptures, some moulded out of clay, some carved from wax, soap, chalk, cast blocks of plaster or stone. The criteria for each work would be the combination of weight in the hand and the way in which each object nestles into the fingers and allows the thumb to curve over it. How does the shape of each work, presumably determined also by the quality of the materials used, catch the light? How can you work with the materials to emphasise that tone, by working on the texture, for example?

CONTEXT
BEER CANS AND ARCHETYPES

Bourgeois' sculpture *Cell (Eyes and Mirrors)* (see above) demands an understanding of archetypes. Are these two cans archetypes? Do they stand for all beer cans and the history of young men's often depressingly destructive relationship with alcohol? Or are they two specific objects treated in a more familiar manner than the still life studied earlier in this chapter?

POP ART AND OBJECTS

Pop artists reacted to the artists before them, in particular Abstract Expressionists. Johns' use of paint and craft probably puts him before Pop, but his interest in consumer objects links him closely to later Pop art. Johns' art has always been about art — what Johns called 'things the mind already knows', such as in van Gogh's chairs and boots or Cézanne's apples. A key concern was the notion of high and low art. Cans of beer had not been the traditional subject of high art (although bottles turn up in Manet's *A Bar at the Folies-Bergères*, 1881). Pop artists, especially those after Johns such as Andy Warhol, celebrated (and in some cases criticised) all things modern. Their art exploited images of consumerist society, mostly advertising, one famous example being Warhol's *Campbell's Soup Can*, 1962. Pop art took the visual characteristics of the modern world, turning them into high art.

MARCEL DUCHAMP
Fountain, 1917

What the artist says

Johns told a story about this work: 'I heard a story about Willem de Kooning [a key Abstract Expressionist artist]. He was annoyed with my dealer, Leo Castelli, for some reason, and said something like, "That son-of-a-bitch; you could give him two beer cans and he could sell them." I heard this and thought "What a sculpture — two beer cans". It seemed to me to fit in perfectly with what I was doing, so I did them and Leo sold them.'

What the critic says

Is this a double portrait, for example like *The Arnolfini Marriage*, 1434, by van Eyck, in which a couple stand looking at the painter? The man dominates because of his dark clothes, upright stance and raised right hand, a contrast to the woman in lighter green, whose bunched dress makes her body curve backwards submissively. See also Gainsborough's *Mr and Mrs Robert Andrews*, 1748–49, in which the man stands and the woman sits.

FOLLOW UP: DOUBLE PORTRAITS

You might find examples of art that depend on the formal relationship between two objects, putting these examples into your sketchbook. The questions to ask yourself are as follows:

- How does the artist express that relationship?
- Is it a relationship of equals?
- What are the roles of scale, colour and stance?
- Do these findings relate back to your original couple, the two nearly identical cans?

OBJECTS IN ART

Johns was also aware of the French artist Marcel Duchamp, who lived in New York from 1915 to 1923 and moved permanently to America in 1942. Duchamp's ready-mades had been a vital step in the history of twentieth-century art. They are relevant to *Painted Bronze* because ready-mades were another way of taking real objects and making them into art, or of challenging traditional art categories.

What the critic says

The ready-mades were little-changed, industrially produced objects that had been declared 'art works' by an artist (Marcel Duchamp). It is the combination of that act of choice and their exhibition in a gallery that makes a previously ordinary object become a work of art: a ready-made. The first ready-made was probably the 'assisted ready-made' of the *Bicycle Wheel*, 1913, mounted on a kitchen stool. The most famous ready-made was possibly *Fountain*, 1917 (original lost, copies in the Museum of Modern Art, New York and the Tate Modern, London), signed with a made-up name, R. Mutt, and submitted to an art competition in the USA. *Fountain* was an ordinary gentleman's urinal. By taking this mass-produced object and merely adding a title, Duchamp produced a 'ready-made' sculpture.

The ready-mades were a way of pointing out the intellectual basis for art and of moving attention away from the physical process of making art (Duchamp said, 'I wanted to put painting once more at the service of the mind'). They also posed questions about the fundamental nature of art and the way it was exhibited (see the information on the plinth above).

The influence of Duchamp's ready-mades was considerable. The introduction of the witty shock to the viewer, critic and art authorities, and the insistence that the intellectual and philosophical side of art need not be accompanied by a lovingly crafted object, had a profound effect on the subsequent history of art. There is a direct connection between the ready-mades and contemporary conceptional art. In the context of Johns' beer cans, notice also the social status of *Fountain* as a 'thing'. You can't get a more low-class object than a gentleman's urinal — or can you?

CONTEXT
SOCIAL/CULTURAL

Painted Bronze was made in 1960 in New York at the end of the dominance of one form of art making — Abstract Expressionism (see page 75). This was also a time when mass media, and print advertising in particular, was becoming a new and powerful form of visual language.

The 1960s was, famously, a period in which social and cultural behaviour changed radically and Pop art made after Johns was connected to, and partly instrumental in, these changes.

TITIAN *Bacchus and Ariadne*, 1522–23

What the art historian says

In the past, representing metal was an important function of the artist, especially one of the most expensive metals, gold. The Florentine writer on art, Alberti, did much to establish the way we see artists today and the way artists actually made their art (he described linear perspective, for example). He wrote that 'there is more admiration and praise for the painter who imitates the rays of gold in colours'. In other words, artists should show off their ability by painting gold objects using pigments, setting them on a surface made from gold leaf to demonstrate their ability. Look at Titian's *Bacchus and Ariadne*, 1522–23, in which the artist shows off his ability to paint a golden urn on a yellow cloth, and then shows off even more by painting his signature onto the curving surface.

Some work with gold and other metals

It is unlikely that you will be able to cast two beer cans in solid gold and use them as a subject for your still life, but you could perhaps play with the notion of gold and base metals that comes out of this sort of research. Place a gold ring on a piece of lead and put both objects under strong light. Note how each surface absorbs and reflects that light. What materials can you use to show those qualities? You could set highly reflective objects on a mirror or silver foil, or sit gold jewellery on gold leaf or stainless steel on a yellow plate.

FOLLOW UP: REMAKING *PAINTED BRONZE*

How would you remake *Painted Bronze* to turn it into an optimistic, celebratory image? Think about how you can use line and tone in that reworking. For example, soft lighting has a different effect to harsh front light on objects; strong light from behind differs again, creating dominant silhouettes. The visual effect of a gentle pink line is more positive and easier on the eye than, for example, thick aggressively-ly made black strokes. These beer cans are 'old', in that they have been used and are clearly hand painted; Warhol's soup cans, which were made later, are brand

new and untouched. What difference does that make? Develop further the idea of Johns as a pre-Pop artist. Is *Painted Bronze* a sculpture that celebrates advertising in the same way that Warhol's Campbell soup cans images did later?

The art critic Lucy Lippard in her book *Pop Art* (1991) wrote that: 'One of the many reasons Johns is not and never was a Pop artist is that his subjects are not brand new. Their painterly surface rids them of the newly minted mass-produced aura typical of Pop. The patina of Johns' objects is neither sentimental nor picturesquely evocative, like that of some arsenic and old lace Assemblagists, but it does connote use. Use in turn connotes the past, and the past, even the immediate past evokes memories. Pop objects deliberately forego the uniqueness acquired by time. They are not yet worn or left over. Every Campbell's soup can looks like every other Campbell's soup can since it has had no time to acquire character.'

FOLLOW UP

To further analyse Lippard's comments, you could invent various methods to study the effects of evident 'use' on an object.

Step 1: Try taking two new cans, one to act as an untouched and unused 'Pop' can and the other to be treated as roughly as you wish.

Step 2: After working on the used can, look at it carefully. You will find marks, creases and evidence of use. These are as much forms of 'mark making' as any drawn lines and could become a 'visual language' to contrast with the bland smoothness of the new can.

Step 3: Think of 'patination', the weathering and wearing down of a surface, and compare — perhaps in close-up — the used surface with the pristine can.

Step 4: Experiment with different media. The back-lit qualities of a digital image are probably applicable to the unused version. Heavy texture that catches the light might work well for the used can.

WHERE TO GO NEXT...

Try comparing *Painted Bronze* with the work of more recent artists who use modern materials, such as Tony Cragg, who described his work as about 'man's relationship to his environment and the objects, materials and images in that environment. The relationships between the objects, materials and images...' Cragg's concerns are similar to those voiced by Johns some 40 years before.

Britain Seen from the North, 1981, is an important work of Cragg's. Like most of his art, it uses found pieces of plastic, taking smaller objects and arranging them to make a larger whole and linking them by colour rather than by shape.

TONY CRAGG *Britain Seen from the North*, 1981

What the examiner says: objects alone

After analysing *Painted Bronze*, the next step might be to present objects themselves as art. Many artists have done that. Remember, however, that you are being assessed and that the single presentation of two beer cans as your final piece might not always show off *all* your abilities.

After analysing this work, you might be tempted to take a beer can, empty or not, and make a small tonal drawing of it.

Please ensure that you develop the idea further. Try to analyse the visual language of illusionism. How 'real' can you make the image look? Whose reality are you remaking? Is this reality the same as yours? Would it look the same to a teetotaller as to a beer manufacturer? How would it appear to an examiner coming across yet another painting of a crumpled beer can?

Cragg describes the subject of his works as 'Celluloid wildlife, video landscapes, photographic wars, polaroid families, offset politics. Quick change on all channels. Always a choice of second hand images…Reality can hardly keep up with marketing image'. *Britain Seen from the North* shows the shape of a figure staring at a map of Britain, or rather the shape of Britain filled in with pieces of plastic, with the north of the country facing the viewing figure. Notice that, as the title suggests, we are made to rethink our traditional view of Britain, which is centred in the southeast. At the time this art work was made, Britain was suffering serious civil unrest and mass unemployment. Nothing was certain any more.

You could take Cragg's list of subjects as a way of looking back into the role of collage in art, a way of thinking about the use of found materials as a means of representing a fragmented society, and as a way of combining collage and still life. Remember that collage can include images made by you as well. As you make exploratory drawings, developing the direction of your work, consider which of the formal elements fit your subject. Try a combination of line and tone first.

This will establish the forms needed to make your own visual language convincing, before you get stuck into careful colour studies. If you are inspired by Pop art, think about the imagery you use and its relationship to your own period. Ask yourself the following questions:

- What are the visual characteristics of the mass media around you now?
- What, for example, are the features of computer screens that you can use in your work?
- What about pixilation and digitised images?

Remember that you are not merely copying the world around you; your task is to analyse it visually. Make sure that *all* your analysis is recorded in your sketchbook in a suitable visual style.

Painted Bronze uses traditional skills such as careful painting to make the cylinders appear as 'real' as possible. Johns further emphasised hand skills by deliberately putting a thumbprint on the base of the sculpture.

Step 1: You could take an object and repaint the packaging onto it (cardboard boxes and paper packaging are easier to paint on than metal or plastic).

Step 2: Go further and paint the packaging on to another product.

Step 3: Choose which products you are going to juxtapose carefully. Use your repainted objects as the basis for a still-life image that also plays with the concept of trompe l'oeil.

SECTION SUMMARY

This section has:

- analysed two sculptures, one dependent on a personal approach to making art, the other tied into the history of art
- introduced you to the importance of archetypes in making art
- asked you to consider the difference between abstraction and figuration in sculpture and whether a three-dimensional object can ever be truly abstract
- considered sculptural methods and the visual language of different techniques
- looked at feminist interpretations of art from the past and how the process of perception might be considered gendered
- looked at how the presentation of a work of art is essential to the meaning of the work
- looked at the treatment of objects in twentieth-century art, and the importance of Duchamp's ready-mades for later art
- looked at how you might use objects for your own art

2.3 'THINGS: SIGNS OF THE TIMES'

INTRODUCTION

The final section of this chapter looks at two dramatically contrasting works. The first dates from the point in the late 1700s that saw the start of the Industrial Revolution and the intellectual revolution known as 'the Enlightenment'. The second work is from the latter half of the twentieth century, when consumerism was taking off. Both images use easily recognisable objects. How the artists represent those objects leads to a series of meanings and possible work of your own.

YOUR WORK IN THIS UNIT

At this point in the unit system, you will be thinking about what is called 'the resolution of your ideas'. In other words, a final piece in which you resolve some of the problems you have set yourself during the rest of the unit. These two works use different methods of composition to produce powerful imagery. Despite the fact that the works are paintings, there is nothing to prevent you experimenting with such methods in any media you choose. Always try to work in a medium that challenges you, but at this stage it is as well to be certain that you are confident in your chosen materials. Practise in your sketchbook before you start.

THEMATIC OVERVIEW

Both these works are large and what links them is their relationship to the still-life process. Both depend on the same approach to the careful examination of objects; the scientific objects are the key to Wright's painting and the new glossy qualities that Rosenquist displays tell us about his interest in modern consumer products. Both images have messages firmly rooted in their context, and we can discover this by analysing the techniques and the composition of the objects as well as by looking at exactly what those objects are.

FOLLOW UP

Even just the contrast, the visual difference, between the two images can be a rich source of ideas, both critical and artistic. For example, the way both artists treat light could lead to further examination of this subject throughout art. Rosenquist arranges his objects in such a way as to direct us to two of twentieth-century art's key processes, collage and montage, both of which are still crucial today. Both images contain political messages. How do these same issues affect us now?

Section features

Works:
- Joseph Wright of Derby *An Experiment on a Bird in the Air Pump*, 1768
- James Rosenquist *F1-11*, 1965

Genre: still life

Formal elements: line and tone

Unit element: final piece

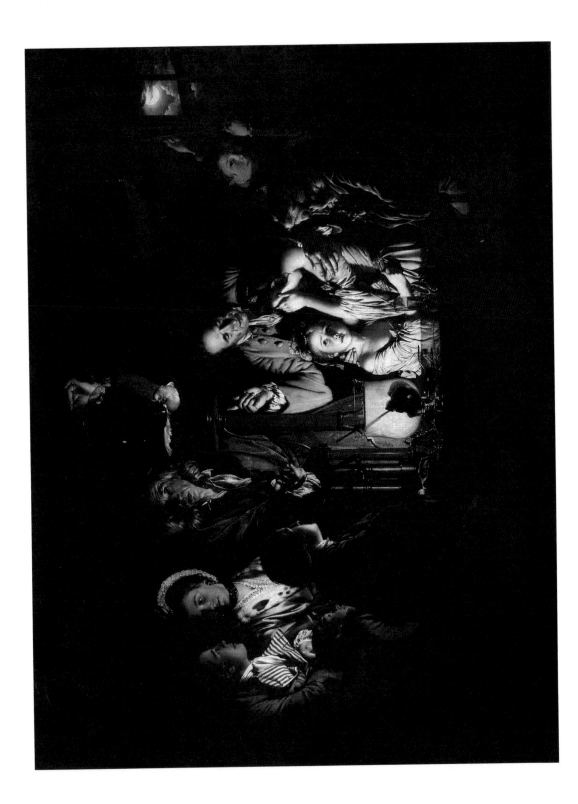

Joseph Wright of Derby

An Experiment on a Bird in the Air Pump, 1768

THEMATIC OVERVIEW

Wright's painting is known as a conversation piece, in which a group of people, usually a family, gather around a central subject or object, in this case a scientific experiment. It is also a dramatic narrative image about light and human progress. In this unit, we have looked at the ways artists have used light. Wright takes light not only to represent form, but also to symbolise the scientific present and future.

Detail

What the art historian says

The painting of light and dark to create form is called chiaroscuro, a technique long known in art and one that can be seen in the work of Leonardo da Vinci, such as *Virgin of the Rocks*, 1508, and that of Caravaggio (see page 64). Wright's version of chiaroscuro is called 'tenebrism', a term describing paintings that are mostly dark with figures and objects picked out in the light.

TECHNIQUES

This is a painting in oil (see also the information on Philip Guston, page 85), a medium that can be used in many ways. The effect of light is one of the classic subjects for oil paint. In *Air pump*, Wright has used oil paint mimetically (mimesis means trying to imitate, or mimicry), attempting to recreate the exact forms of different shapes and materials under light. Notice how Wright moves carefully from bright white through a range of tones to deep darkness at the edge of the painting.

FOLLOW UP

Take sections of the painting to analyse how it uses light.

Step 1: Look at the profile of the man on the right staring at the skull. The lamp light shines on his forehead and nose, alternating with darkness down the side of the nose. There is another bright stripe down the cheek and mouth and dark stripes down the side of the face, with light on the curls of the hair shading into darkness at the back of his head.

Step 2: Contrast this striping of light with the silhouette of the skull pickled in liquid in the centre of the painting, and the soft, full darkness gently shading into the brightest area of light in the rest of the painting.

Step 3: Compare this area with the full highlight on the shoulder and arm of the little girl to the left of the skull.

Step 4: After this analysis, set up a series of your own tableaux, reflecting Wright's 'tenebrist' techniques. You need not use people, just try to set up objects under light that show similar conditions.

Step 5: Once you have made a series of visual analyses (see pages 230–32 for different drawing materials), try texture and low relief to indicate the effects of light. Remember: the stronger the source, the higher the relief.

COMPOSITION

A group of middle-class people watch a scientific demonstration in a domestic setting. In the centre is part of a human skull in a jar, a memento mori or reminder of death, a direct reference to vanitas painting (see pages 279–80). Behind the skull is a candle, the main source of light. Outside the room, the moon is a secondary light source. The moon also refers to those scientists who met on the Monday closest to the full moon and were called the Lunar society. Many influential scientists, industrialists, engineers and artists belonged to this group, sometimes described as 'the high command of the Industrial Revolution'. They often watched experiments like this one.

In the centre a scientist or natural philosopher (as scientists were then known) has pumped the air from the flask to create a vacuum. The bird is dying from lack of oxygen. The man's left hand is held over the valve, ready like the God he resembles, to restore air and life to the dying bird. The older man, in the bottom right, stares at the skull, meditating on death. Top right a boy holds the cage ready to catch the bird when, or if, it is released alive from the flask.

What the critic says

Wright's bird is a rare white cockatoo, probably more expensive than the equipment that is killing it. Although a bird in art was often an image for courtship and love, here it might be seen as a symbol of the Holy Ghost. Look, for example, at Piero della Francesca's *Baptism of Christ*, painted in the 1450s, in which a dove hovers above Christ as the Holy Ghost enters his body. Both Wright's and della Francesca's birds are in similar positions. Is Wright drawing our attention again to life and death? His bird doesn't seem to refer to romantic love. Investigating the role of birds in art in a well-documented form in your sketchbook could lead to your own work around that theme.

PIERO DELLA FRANCESCA
Baptism of Christ, 1450s

LIGHT AND VERTICALITY

Wright's painting is dominated by verticals, stressed by the pillar of the pump standing near the centre, which is echoed by the standing figures radiating outwards from it. The light makes a large oval shape, running from the moon at the right to the man with the stripy lapels to the left. (Note that della Francesca's painting is evenly lit, in contrast to Wright's image.)

FOLLOW UP

To analyse the composition of this work:

Step 1: Draw a line to mark each clear demarcation between light and dark.

Step 2: Continue to make a line-based diagram of the verticals and the light-filled area.

Step 3: You should finish with a map of the composition of form as shown by light. This could be the starting point for a composition of your own.

CONTEXT
OTHER ARTISTS

FRENCH CANDLELIGHT

Many artists have painted candle-lit or lamp-lit scenes. The seventeenth-century French artist Georges de la Tour was famous for his tenebrism (see page 61). In *Saint Joseph the Carpenter*, 1640, he shows candlelight glowing through the fingers of a small child shielding the flame. De la Tour does not celebrate scientific discovery in the way that Wright does, but to paint light shining through fingers demands an almost scientific level of observation.

ITALIAN LAMP LIGHT

Caravaggio's painting of light has a different effect. His life story reads like a film script. He famously killed a man in Rome over a tennis match, attacked a judge in

Who influenced whom?

In discussing apparently similar works, do not assume that one influenced the other. You might think, for example, that de la Tour influenced Wright since the dates fit neatly and the techniques seem so close. There is no evidence of this, however. De la Tour was practically unknown in England in the eighteenth century and not really rediscovered until the twentieth century.

Naples, was knifed in a brothel and died chasing a boat that had taken all his belongings. His paintings are equally dramatic.

Caravaggio's first version of *Supper at Emmaus*, 1601 (see page 189), is a powerful moment of revelation in which the strong light from the left creates deep shadows and strong highlights. Although the source is unseen, the light/chiaroscuro in this painting creates great dramas, solid figures and almost sculptural cloth. Comparing Wright's painting with Caravaggio's, you notice that the Italian uses 'shadow as narrative'. This refers to the way the shadow cast by the innkeeper on the left makes a dark halo above the head of the central man (despite his haircut, it is a man), telling us that the man is Christ. The other key shadow, under the still-life bowl of fruit, is a compositional rather than narrative device — remember the importance of still-life arrangements within painting. The shadow tells us this bowl is about to fall, and the illusion of darkness creates the suspense that it might fall through the picture plane into the viewer's lap. The overall effect is to heighten the surprise that is at the centre of the work.

FOLLOW UP

You could set up your own combinations of objects.

Step 1: Put together a powerful light source and deep shadow. Like Caravaggio, try using the illusion of an internal picture plane so that shadows appear to be bursting through.

Step 2: Use a central light that, rather than appearing outside the pictorial space, seems to come from within the work itself.

Step 3: Remember the role of texture in making light appear stronger than mere colour.

CONTEXT
SOCIAL/POLITICAL: THE ENLIGHTENMENT

Joseph Wright was painting during the 'Age of Enlightenment', a modernising period which natural philosophers and the new men of industry believed would bring light into the dark age of superstition (hence the period's name) and remove political tyranny. Science and the 'light' of pure reason were to be the tools used in the Enlightenment. In this context, the light in the centre of this painting does not just create an exciting image — it is celebrating intellectual and political change.

FOLLOW UP: VANITAS

If you were to update the vanitas theme, what would you include? You need something more than luxury goods representing wealth — your choice of objects must symbolise time passing quickly. Try to be inventive with your choice of memento mori, and find something other than a skull. The key to the theme is the passing of time: that which rots away, that which takes great effort to own but will ultimately wither. How can you represent this perception of values in your art?

What the critic says: vanitas

The *Air Pump* is not only a historical record of the period in which it was made, it is also about time in a more local sense — if the scientist gets his timing wrong the bird will die. Other still-life paintings, known as vanitas paintings, take time as their subject, e.g. Harmen Steenwyck's *Still Life: an Allegory of the Vanities of Human Life*, 1640. Vanitas works represent symbols of time passing, for example the skull in the centre of Wright's painting, an hourglass, a bubble or burned-down candles. The name comes from the biblical phrase 'vanity of vanities, all is vanity', meaning that owning objects in this world is pointless if life is so short and the afterlife so long. For a vanitas painting to work, the objects have to be painted with great skill. The illusion of their actual presence needs to be as strong as possible in order for them to serve as visual sermons, reminding you to be good each day.

WHERE TO GO NEXT....

LIGHT, PORTRAITURE AND *THE CORINTHIAN MAID*

Light often turns up in art as a cultural or political metaphor. You should search out examples and put those images alongside your analysis of the *Air Pump* in your sketchbook. For example, light appears in *The Corinthian Maid*, a myth about the founding of art painted by Wright in 1782–85. The classical story he represented runs as follows. A young girl wanted to keep the image of her lover for ever as he was before he left for the war. She made the first portrait by tracing his shadow on the wall, creating an image to serve as a constant reminder. Not only does this story make light central to all art, it also, importantly, marks the beginning of art as a female achievement. Silhouettes were a fashionable form of portraiture in the eighteenth-century and might be another way in which you can further analyse the visual characteristics of objects and people. The easiest way to produce a silhouette is to stand in front of a strong light (an overhead projector works well) and project your shadow on to paper pinned to a wall or to a board on an easel.

VISUAL LANGUAGES OF MODERNITY/DELAUNAY

Wright's painting is a self-conscious image of modernity, a subject often tackled by artists. You could use their 'visual' languages as a way of tackling this topic. The Cubist-influenced French artist Robert Delaunay, for example, made many paintings of the Eiffel Tower during and after it had been built. This hi-tech architecture was the most modern structure of its age and Delaunay tried to find a visual style to match. His method is to twist and distort a vivid tower in a semi-Cubist style as the surrounding air and buildings swirl around it. He developed this style further into almost pure abstraction.

What the art historian says: light in art

Light in art can just describe form, or it can be narrative. It can depict daylight, or night and the light of moon, stars or lamps, as they are part of a larger story. Light in art can mean knowledge (Enlightenment), or it can be spiritual and an indication of the divine presence; 'Allah is the Light of the Heavens and of the Earth', as written in the Koran. Light can be implied in its opposite; Lucifer carried the light before becoming Satan, a fallen angel and the Prince of Darkness. Light was at the beginning of the universe and will be the last element left at the end.

Step 1: Find subjects that strike you as equally indicative of the modern world and take the same journey as Delaunay.

Step 2: To give this process further depth, contrast modernity with art that looks backwards, such as the pastoral nostalgia of Constable's *Hay Wain*, 1821.

Step 3: Compare the soft falling of light of Constable's work with the hard edges of Delaunay's red tower. How does each artist paint light and tone?

Step 4: Does each artist's method reflect their attitude to the subject?

Step 5: Take a section from each painting to make this difference clear.

Step 6: Find subjects that represent your own modernity: new buildings, cars, technology, graphics, urban views, suburban scenes etc.

Step 7: Remake the chosen section of each painting, using first the modern and then the nostalgic visual languages.

Step 8: Repeat the process with new subjects and new art.

PAINTERS OF LIGHT: IMPRESSIONISM

The classic painters of light were the Impressionists, a group of artists based around Paris in the middle to late nineteenth century. Monet explained that he painted not objects or views, but the envelope of light that surrounds them. If you analyse any of his 1877 paintings of the Gare Saint-Lazare, you will find that they are perfect images of modernity and well worth using for the process detailed above. Notice that Monet's use of thick paint (impasto) and his observation of the combination of steam and shadow obscures all sense of edges and form, so that everything is light and air.

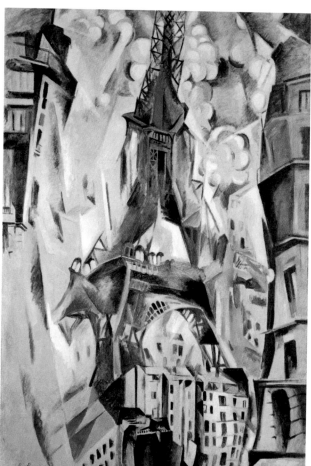

ROBERT DELAUNAY
Eiffel Tower, 1911

Step 1: Rather than the sharp, edge light of Caravaggio or the slightly darker tenebrism of Wright, try using the bright, soft tonal transitions and impasto of Monet to represent the envelope of light around your subject.

Step 2: You might even try to repaint *Air Pump* in a classic Impressionist manner.

Step 3: If you find Monet's paintings from of the 1870s interesting, you should also have a look at his late water lily paintings.

LIGHT ON THE BODY

Studying Caravaggio and de la Tour could be the cue for you to make your own careful observations of the effect of different forms of light on the body, building up to a rigorous display of images you have made on that theme. Remember that such an objective analysis will demand a quasi-scientific presentation at the end — for example, grids of drawings or a well-documented sequence of images.

PONTORMO

Many paintings depict time, sometimes showing several episodes within one frame, for example Pontormo's *Joseph with Jacob in Egypt*, 1515. In this smallish painting, the stages of the story move from bottom left to top right. Action in comic books or graphic novels also moves in stages but, unlike the Pontormo painting, each narrative step has a frame around it. We don't see each step in Wright's painting either, but we are made aware of what came before and what might happen in the future.

You could take this further:

Step 1: Select groups or objects from *Air Pump* to show what might happen next. What, for example, are the stages that led up to the bird dying, or not, in the flask?

Step 2: What sort of knowledge will each of the participants take away from this experiment, and how might you represent it?

Step 3: Pay particular attention to how the light sources will change according to each step in time.

Step 4: Repeat this process with other objects or people that have more relevance for you.

'COLOURS OF THE PAST, PRESENT AND FUTURE'

The *Air Pump* is a painting that situates itself clearly in an almost exact moment in time. We can see that the clothes fit the period, and the subject reflects what we know of the social and cultural history of the time. In other words, this image appears as we might expect the middle-class past to look.

When we see documentaries and 'faction' on television and film, the director, art director and stylist will have spent hours working out how they want the past to 'look'. This recreation of the 'look' of the past is itself a statement of our own ideas and attitudes about the present. Your next task could be to think about how you, as director, art director and stylist, think the past should appear. Ask yourself the following questions:

Step 1: What should be the tonal range of any representation of a particular moment in the past?

Step 2: What colour was the past? What palette would you use?

What the art historian says: Joseph Wright

'Joseph Wright was the first professional painter directly to express the spirit of the Industrial Revolution...He was also a natural philosopher himself, preoccupied with the problem of light, which was the subject of his ceaseless experiment. The cold light of the moon mingled with dim candlelight; the glow of phosphorus in a chemical laboratory; dark trees silhouetted against blazing furnaces and a star-lit sky; the glare of molten glass or red-hot iron in gloomy workshops; the flaming pottery ovens at Etruria. By studying effects such as these Wright achieved that distinct and personal style that marks his position in the history of art.'

Francis D. Klingender, *Art and the Industrial Revolution*, 1968

TYPES OF LIGHT

If nothing else, Wright's painting could lead you on to studies of the effects of various lights sources.

Step 1: Choose a suitable scene. Since this chapter looks at still life, a collection of objects would be suitable, and you should bear in mind the underlying vanitas theme.

Step 2: Make tonal studies of the collection under ordinary incandescent electric light, fluorescent light, a single torch, candlelight (remember to take sensible health and safety precautions) and moonlight, if you can.

Step 3: Think about which medium is the most suitable. Look back to chapter 1 and the range of drawing media.

Step 4: Make comparisons between your results and the relevant sections in the Wright painting.

Step 5: Move on to make a large, suitably lit art work of your own. Remember that it does not have to be a painting. This study could lead on to most types of art work.

James Rosenquist

F1-11, 1965

THEMATIC OVERVIEW

This painting is huge: one of the largest paintings made in the twentieth century. It is so big that it needs a room of its own. *F1-11* uses the collage method, first developed in the early part of the century by the Cubists. The images grouped together owe their 'look' to magazines and film, so their visual language is based on a heightened illusionism.

TECHNIQUES

Rosenquist trained as a billboard painter and, partly because of the scale and partly because of the effect he is after, the majority of *F1-11* is made using an airbrush. The paint is delivered to the surface by a compressed-air spray gun, a bit

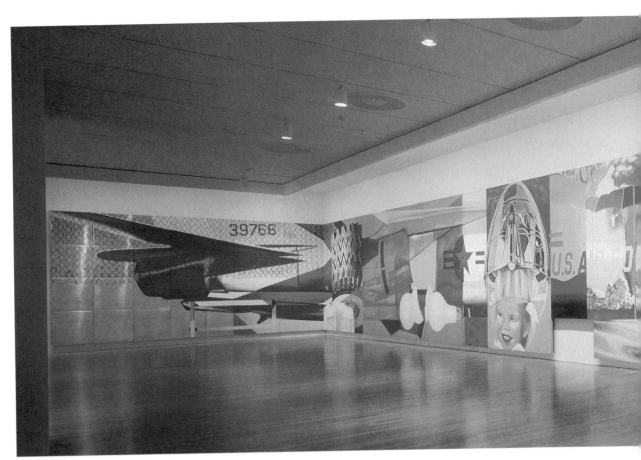

like a large, powered aerosol spray can. This allows the artist to make perfectly flat surfaces and to create huge areas of gentle gradation from one tone to another.

It is unlikely that you will have access to an airbrush to work on such a scale, and the closest you might find, car spray, is too toxic to use in most institutions without a spray booth. The key areas of interest in this work, therefore, are the process of building up images, the possible meanings of those images when combined and the palette used.

USE OF IMAGES

Like all of Rosenquist's paintings dating from after 1960, *F1-11* is made from layers and fragments of images. These fragments seem to come from film, television, posters and magazines. There are different viewpoints and changes of scale within the composition. Some forms are enlarged, some are roughly life-size, some diminished. Rosenquist wanted the fragments to be 'read', identified or understood at different speeds.

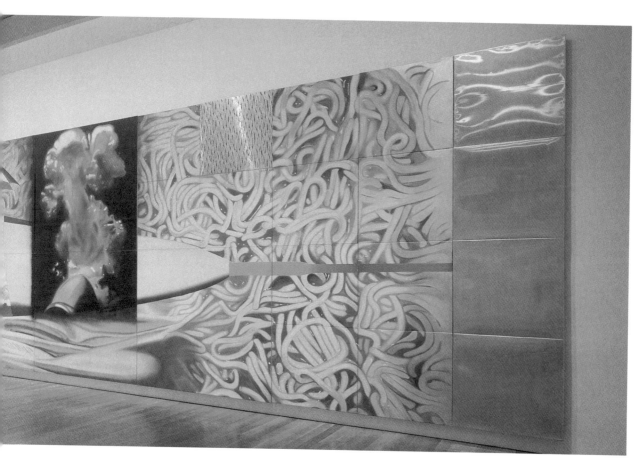

When making your studies and turning them into images, think about the scale of each area. Do we 'read' larger forms in one way and smaller shapes in another? This reading process depends on a combination of the eye stopping to look at small marks and tending to scan larger forms with less detail. Ask yourself the following questions. How do we perceive images elsewhere, such as when we watch television or read a magazine? How much attention do we pay to the images we see? How does that compare to the slow process of visual analysis involved in still-life work? How can you use information and communication technology to help you understand these processes?

FOLLOW UP

Try thinking about what coloured ground to work on. You don't have to use the brilliant white of paper or primed board.

Step 1: Make a grisaille study (see the panel opposite), perhaps of metallic objects. First put down a grey wash as your midtone.

Step 2: Work darker grey tones into that middle colour.

Step 3: Add lighter grey and white highlights at the end of the study.

Step 4: Your ground does not have to be rectangular. *F1-11* consists of irregular canvas panels with aluminium sheets stuck on to them. Rosenquist often painted on aluminium sheets. You can see the ground underneath the plane's tail, and again at the far right-hand side.

Step 5: Paint will take to most surfaces. Try experimenting with different grounds and different shapes to reflect your subject.

COMPOSITION

Look at the selection of objects that Rosenquist uses in this work. If you read from left to right, they are:

- the tail of the F1-11 fighter bomber plane that names the painting; beneath all the images runs the shape of the newly built aircraft
- a wallpaper-type repeated pattern of flowers; the pattern was applied with a wall-paper roller
- a runner's hurdle
- a round cake pinned with flags showing which vitamins the cake contains (e.g. vitamin A, niacin) and other contents too (i.e. food energy, protein and iron)
- a section of a Firestone tyre whose shape echoes that of the cake; apparently this is a snow tyre
- a series of abstract shapes that to some extent relate to the aircraft and its wings as they stick out of the picture plane; their shapes correspond to where the bomb bay doors would be on the F1-11

- Three semi-spherical objects: one is clearly a light bulb, the other two are possibly light bulbs seen on end. One of these is broken and its egg-like form might relate to the cake — or they may have other symbolic associations. For instance, they could be viewed as falling from the bomb bay doors.
- a star insignia
- A young girl under a hairdryer, at a totally different scale from the other images and much brighter in tone. She has ribbons in her hair, which presumably conflict with the drying process. The hairdryer resembles either a metal aircraft nose cone or a military helmet.
- To the girl's upper right is an orange arrow, below which is a parallel stripe in the complimentary colour to orange: blue.
- Running across the centre of the aircraft's fuselage are the words 'U.S. AIR FORCE'.
- In front of the lettering is a beach umbrella and behind it an image of the characteristic mushroom cloud of a nuclear explosion in a similar shape to the beach umbrella. The cloud appears to be on a flat plane (slightly like an attached piece of paper or poster — notice the small section of drop shadow on the bottom left).

What the critic says: the restricted palette

Rosenquist's earlier paintings were in grisaille, a palette restricted to a series of grey tones. You should be aware of the important differences between grisaille and monochrome. Monochrome is made in any one colour, such as Degas' *Woman Combing her Hair*, 1896, which is painted in strong reds to reflect the red hair that is being brushed. Grisaille is restricted to grey, appearing in Rosenquist's painting at the bottom of the spaghetti section, under the nose cone of the aircraft. Restricting the palette is a useful technique. Set up a group of objects of similar colour, for example oranges, satsumas and Penguin books with orange spines, surrounded by orange cloth. Make your visual analyses entirely in the orange/red range of the spectrum.

- Spaghetti appears behind the aircraft nose cone, filling most of the right-hand of the painting. It is tinned spaghetti in tomato sauce, rather than freshly cooked pasta.
- Parallel to the umbrella/cloud is a blue image of what looks like an underwater explosion, or huge bubbles pushing up through water.
- Below this is a diver's helmet. As Rosenquist said: 'that's an underwater swimmer wearing a helmet with an air bubble above his head, an exhaust bubble that's related to the breath of the atomic bomb. His "gulp" of breath is like the "gulp" of the explosion. It's an unnatural force, man made.'
- The nose cone finishes just short of the right-hand edge, where it meets four panels of aluminium.
- Below the cone and to the right of it, the colour changes to grisaille.
- Above the grisaille is a small section of a wallpaper-type repeated pattern, although different to the pattern on the left.
- Below is a folded-up cloth.

JAMES ROSENQUIST
F1-11, 1965 (detail)

CONTEXT
OTHER ARTISTS/POPULAR CULTURE

F1-11 is a classic piece of US Pop art. Like most art, it was a response to its cultural environment. The history of art since the middle of the nineteenth century — a period associated with 'modern art' or 'Modernism' — is full of artists who include images in their work, images that previously had nothing to do with art. From Impressionists painting cafés and haystacks, to Cubists making collages with old newspapers, to Marcel Duchamp putting a urinal in an art gallery, the list is long. The process continues today.

FOLLOW UP

Consider the following. While sitting in a British art room, you make a painting of a packet of crisps, contrasting the shining of light on the packet and the absorption of light by the crisps with the contrast of textures between packet and fried potato slice — that is, you concentrate on the object's aesthetic identity. Would this image,

What the examiner says

Pop artists carried on the 'Modernist' theme by including advertising images in their art. Investigate this process by examining the world around you to establish key contemporary visual features. Rather than merely copying a Coke bottle and assuming you are 'doing' Pop art, you need to show that you understand the fundamental assumptions behind any Pop image. You can make that demonstration by collecting images of the contemporary world, but the important area to concentrate on is the processes by which these images are made. As established above, Rosenquist used the different methods by which we scan the new visual languages of the contemporary world as the basis for his work; you will need to do the same.

associated with footballers through advertising and poor nutrition through government description, have the same resonance as Rosenquist's images of cakes and tinned spaghetti? Or do we live in an entirely globalised world? Does globalisation have any impact on your reading of this painting?

CONTEXT
SOCIAL/POLITICAL: THE VIETNAM WAR

What was happening between 1964 and 1965? The US president John F. Kennedy was assassinated in 1963. The USA was heavily involved in the war in Vietnam and began a bombing campaign in 1965, although the F1-11 wasn't introduced into active service until 1968. Since this painting was first exhibited, many critics have seen *F1-11* as attacking US involvement in foreign wars. They have linked the munitions industry of the Vietnam War with the affluent society of the 1960s, implying that one was feeding the other. The US art critic John Russell said the painting showed how 'some little girls could live high of the hog because some

other little girls where going to be burned alive'. He was referring to one of the most shocking images of the Vietnam war: Nick Ut's 1972 photo of a naked young girl (the 9-year-old Phan Thi Kim Phuc) running down a road toward the camera, burning alive, having been covered with the napalm used by US troops.

Although Rosenquist's paintings come out of his own experience, they are not auto-biographical. Unlike the works of the earlier Abstract Expressionists, *F1-11* does not try to analyse the identity of the artist.

What the critic says

Pop art was also a reaction to the self-referential quality of Abstract Expressionism, in that Pop art can only exist in reference to something else. The spaghetti of *F1-11*, for example, can be seen as a reference to Jackson Pollock's dripped technique, such as *Summertime: No. 9A*, 1948, which shows thin swirls and coils of dripped paint. You could continue that theme and technique of painting and find a visual equivalent for it in a foodstuff, such as impasto paint and mashed potato or washes of colour and thin soup.

What the art historian says

There has always been a connection in American life between owning goods and democratic freedom. In a televised debate with the Soviet premier in 1959, the US vice president Richard Nixon declared that the distinction between capitalism and communism was that US capitalists were free to buy what they wanted. They could have any washing machine they chose and this was freedom, an idea that would have startled the founding fathers of the American constitution. Certainly, images of consumer durables, hairdryers and processed food have a greater meaning in a US context than they do in a British one.

WHERE TO GO NEXT...

MULTIPLICITY

Think about 'multiplicity' — the combining of large numbers of images in one composite work.

Step 1: Usually we make a still life by jumbling objects together in a way that makes them look attractive. Try relating the objects in a more organised manner. Look at the work of artists like Michael Craig Martin, Lisa Milroy or R. B. Kitaj first.

Step 2: Make a large collection of small objects.

Step 3: Relate your collection by 'organised proximity' — put objects next to each other in a semi-scientific rather than 'aesthetic' way, perhaps using a grid-like forma-tion like Milroy's *Shoes*, 1985 (see page 88), which shows the same pair of black shoes arranged in a block, three pairs across and four pairs down. Alternatively, consider a series of line drawings in which the lines meet and often overlap, as is

the case in the graphic work of Craig Martin. Try contrasting 'organised proximity' with 'aesthetic' arrangements to make a final image.

Step 4: What do different ways of organising these images tell the viewer about contemporary ideas regarding possessions?

LIGHT BULBS IN ART

F1-11 features a light bulb, which has possible symbolic associations. There are several similar and well known uses of light bulbs in art, and it might be fruitful to search them out.

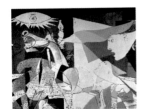

PABLO PICASSO
Guernica, 1937 (detail)

The most memorable must be Picasso's *Guernica*, painted in 1937 (see page 86 for the full image). This huge painting was made in response to the bombing of a Spanish town on market day. German planes, supporting the Spanish Fascists, bombed Republican supporters, killing 1,654 people and wounding another 889. In this monochrome painting, a woman holds out an oil lamp, but above her is a light bulb in a jagged shape. It is both an explosion of manmade light and an artificial sun.

Francis Bacon often painted light bulbs to create a sense of loneliness. This can be seen in *Triptych May–June 1973*, three paintings about the suicide of his partner. In the centre panel, a man is isolated by the dark paint around him. His shadow leaks like blood across the floor; above him a single light bulb hangs on two cords. You could take the symbolic aspects of this light source as your starting point. What role could this small source of light take in the early twenty-first century? Will your treatment of the light bulb be relatively optimistic like Rosenquist's, will it make a powerful statement about man's inhumanity to man in the style of Picasso, or will it reflect human isolation as in the image created by Francis Bacon? Or will you make a completely different interpretation based on your own experience?

SCALE

What the artist says

'...painting is the ability to put layers of feeling in a picture plane and then have those feelings seep out as slowly as possible, and those feelings, a lot of them have to do with where you are from.'

Rosenquist

We have made associations between *F1-11* and Abstract Expressionism, not just, for example, in Rosenquist's creation of an all-over composition similar to Jackson Pollock's *Blue Poles, Number 11*, 1952, but also in the size of their art. Think about the role of scale of Rosenquist's work. His paintings are extremely big; *F1-11* is a series of panels (there are 51 of them) and is 305 by 2,621 cm overall. The head of the average adult reaches up to the top of the girl's head under the hairdryer. He called it a 'wrap around room painting'.

Rosenquist comes from North Dakota, a huge empty US state. He claims an environmental sense of scale as an influence; he remembers, for example, seeing his only neighbour 10 miles away turn out his bedroom light at night. Rosenquist started out as a sign painter at a time when enormous advertising images were still painted by hand, for example the vast pictures of movie stars on Times Square billboards.

Step 1: To think about scale in your work, imagine a Rosenquist image up close.

Step 2: Can you tell what these huge areas of paint refer to? At close distance are they just abstract?

Step 3: Enlarging recognisable images until they are almost abstract is a method with many possible applications. Take your own images derived from observation and expand their scale to an extent where they become abstract colour fields, a good basis for screen prints or textile works.

COLLAGE OR MONTAGE?

Most art forms refer to art that came before them. Compare Rosenquist with Synthetic Cubism (from about 1912 to 1914), the movement that made collage an art form. Rosenquist's work looks like collage but it has a different name: 'montage'. Montage was initially developed in film editing. In collage (e.g. Picasso's *Glass and Bottle of Suze*, 1912), the objects lie parallel to the picture plane. In montage, the artist uses different depths of pictorial space.

In *F1-11*, look at the combination of mid-distance umbrella, far-off mushroom cloud, relatively close-up underwater explosion and very close-up spaghetti. We are, as it were, being bounced around in space.

Synthetic Cubist collage operates in two dimensions: to or from the picture plane in a parallel motion. Notice that Picasso's work includes an identifiable product — Suze (a bitter French drink based on gentian).

Task
Experiment with these two accumulation processes
Step 1: Take a range of consumer products — perhaps the crisp packets mentioned above, as well as other packaging. **Step 2**: Try the montage and collage approaches, with the aim of leading up to separate sketches for a final piece. **Step 3**: Which method seems the most appropriate in the contemporary world? Why? **Step 4**: Make sure that each step is carefully documented in your sketchbook.

SECTION SUMMARY

This section has:

- considered the role of light in art, from practical ways of representing this crucial quality through to symbolic connotations
- analysed time as an important subject, showing how a sequence of events can be implicit in one still image and how the speed in which a viewer 'reads' an image can be an important element in the composition of a work
- noted that art can be made from groups of similar or different objects, materials and images
- noted the difference between collage and montage
- discussed political meanings of the representation of objects, noting the role context plays in how art is seen at the time it is made and subsequently

CHAPTER SUMMARY
LOOKING BACK

This chapter has:

- looked at the still-life genre and the connections between people and objects, demonstrating that selecting, arranging and representing objects tells a larger story
- looked at the history of still life, how artists have used it in the past and the methods and ideas you might use now; 'still life' can refer to the careful representation of small things, but remember that you should use it as part of a larger work in order to produce complex, relevant meanings
- considered the two formal elements of line and tone, their practical use and some of the meanings and symbolic associations other artists have generated through these qualities
- showed you that by analysing the composition of art works, you can understand the intentions of the artist and communicate your own intentions

Who influenced whom?

Twentieth-century art borrowed from, and was influenced by, mass culture: film, television, advertising graphics etc. Art has in turn influenced the mass media, fashion and design. This could be a fascinating area to look into and might be the career you are aiming for, but at this stage approach the research cautiously. It is unusual for artists to borrow heavily from one specific image; rather, their work tends to be a summing up or a concentration on one particular aspect, method or process. It is difficult to track down and date particular images from the history of advertising, making it more difficult to say who influenced whom.

COURSEWORK WATCH

Chapter 2 'Life and still life' stressed, by example, the importance of careful visual analysis of the work of others, showing how that analysis can lead to work of your own. Remember that the importance of art studies lies not in making a pastiche of others' work, but in presenting in-depth analysis visually, and thereby developing your own visual language as a result. Notice also that the art you are encouraged to make is not restricted to two dimensions. Several sculptural works have been analysed in this chapter, as well as many other directions and media, including photography and graphics.

CHAPTER THREE

FORM AND TEXTURE: HISTORY/FIGURE

'SHAPING UP'

THIS CHAPTER FOCUSES ON...

- a classic example of history painting (David's *Death of Marat*, 1793), so that you feel comfortable with the definition of this type of art
- a wide range of art works that use figures, from painting (Philip Guston's *Painting, Smoking, Eating*, 1973) to a sculpture that uses a large number of figures (*The Chapman Family Collection*, 2002, by the Chapman brothers)
- introducing you to some of the social and cultural themes that underpin contemporary art (Chris Ofili's *No Woman, No Cry*, 1998)
- history/figure as a broad definition that includes abstraction (Donald Judd's *Stack*, 1980) and Hinduism (*Shiva Nataraja, c.* AD 1100); we use analysis to point you towards works of your own that take 'history/figure' as a starting point, but could end with art works in any medium and at any scale that suits you

THIS CHAPTER INTRODUCES THE FOLLOWING TECHNIQUES...

- the application of thick paint (impasto) and working ranges of colour, particularly in the representation of flesh
- the application of thin layers of paint in semi-transparent layers to build up form
- working with modulated tones to mimic form
- working with collage to build up a decorative two-dimensional surface

BY THE END OF THIS CHAPTER YOU WILL BE ABLE TO...

- use, or refer to the actions of, figures in your work with confidence
- use line (e.g. contour) and area to create form
- employ an extended range of methods for self-portraiture, including figuration and abstraction
- identify the role of texture in creating form and visual interest in a work

Key words for this chapter

figurative

Grand Manner

lost wax method

modulation/modulated

modelling

picture plane

raking

scumble

stipple

tones

- use texture with confidence yourself
- work with an extended understanding of the possibilities of collage

FIGURE PAINTING

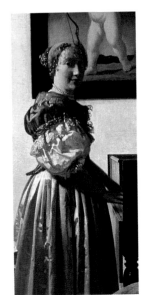

JAN VERMEER *A Young Woman Standing at a Virginal*, 1670 (detail)

In the past, the representation of the figure, or its actions, was considered one of the highest forms of art, and those representations with a moral message ('history painting') the highest art form of all. Since Impressionism, traditional history painting has fallen out of favour, but the large art work with an overpowering message has remained with us.

The earliest images made by humans show the figure as having always been central to artists' work, although in some instances it may not be present, only implied through the behaviour and themes shown.

Regularly working from the figure — even asking clothed friends to sit for half an hour — is a classic part of art education and highly recommended. Look for local education bodies that run life-drawing classes.

FOLLOW UP

Even if you don't have access to a life model, history/figure painting could still be a suitable route for you. Implying the role of a person by 'attributes', for example, could be a direction to follow. Using objects to suggest someone's behaviour or history is a familiar process in art.

What the artist says: figures in art

The Futurists were a group of Italian artists from the early twentieth century whose aim was to stir up the art world. They wanted to bring the modern world, such as the exciting speed of the newly invented motor car, into their art. *Futurist Painting: Technical Manifesto* stated that:

'To paint a human figure you must not paint it; you must render the whole of its surrounding atmosphere...

How often have we not seen upon the cheek of the person with whom we are talking the horse which passes at the end of the street.

We fight against the nude in painting, as nauseous and as tedious as adultery in literature. We wish to explain this last point. Nothing is immoral in our eyes; it is the monotony of the nude against which we fight. We are told that the subject is nothing and that everything lies in the manner of treating it. But this truism, unimpeachable and absolute fifty years ago, is no longer so today with regard to the nude, since artists obsessed with the desire to expose the bodies of their mistresses have transformed the Salons into arrays of unwholesome flesh.'

Umberto Boccioni, *Futurist Painting: Technical Manifesto*, 1910

FOLLOW UP

Read Cennini's descriptions in the panel opposite, then try them out. Do they work now? There are many other systems for measuring and representing human proportions. See if you can find, and test, other methods. Which system is the most helpful? Keep a full record in your sketchbook, with suitable diagrams. Look at

expressive figure drawings. How has the artist distorted familiar proportions? How can you use such distortions in your own work to create different meanings?

What the critic says: figure and proportion in the past

Cennino Cennini wrote *The Craftsman's Handbook* in early fifteenth-century Florence. It is mainly a long list of how to mix up colours and how to do unspeakable things to animals to make glues and materials to paint on and with. Yet, despite the time difference, Cennini's description of human proportions is still useful today; notice, however, that attitudes toward gender have (we hope) changed significantly:

'The proportions which a perfectly formed man's body should possess, Chapter LXX.

Take note that, before going any farther, I will give you the exact proportions of a man. Those of a woman I will disregard, for she does not have any set proportion. First as I have said above, the face is divided into three parts, namely: the forehead, one; the nose another; and from the nose to the chin another. From the side of the nose through the whole length of the eye one of these measures. From the end of the eye up to the ear, one of these measures. From one ear to the other, a face lengthwise, one face. From the chin under the jaw to the base of the throat, one of the three measures. The throat, one measure long. From the pit of the throat to the top of the shoulder, one face and so for the other shoulder. From the shoulder to the elbow, one face. From the elbow to the joint of the hand, one face and one of the three measures. The whole hand, lengthwise, one face. From the pit of the throat to that of the chest, or stomach, one face. From the stomach to the navel, one face. From the navel to the thigh joint, one face. From the thigh to the knee, two faces. From the knee to the heel of the leg, two faces. From the heel to the sole of the foot, one of the three measures. The foot, one face long.

A man is as long as his arms crosswise. The arms, including the hands, reach to the middle of the thigh. The whole man is eight faces and two of the three measures in length. A man has one breast rib less than a woman, on the left side. A man has [original words missing here] bones in all. The handsome man must be swarthy, and the woman fair etc. I will not tell you about the irrational animals, because you will never discover any system of proportion in them. Copy them and draw as much as you can from nature, and you will achieve a good style in this respect.'

Cenino Cennini, *The Craftsman's Handbook* (*Il Libro dell'Arte*), 1437, translated by Daniel V. Thompson Junior, 1933

FORM

Artists have found various methods to represent form. Traditionally, tone has been used to create the modelling of form. For example, look at how Giotto created monumentality through the weighted form of his figures. In the Scrovegni Chapel in Padua, Italy, his *Massacre of the Innocents*, 1304, shows a sturdy figure pulling a child away from its mother. The shapes of those figures and their emotions are

shown to us by the folds of cloth that cover them, and the representations of the folds are made using three types of tone.

For a more recent analysis of the same subject, look at Frank Auerbach's paintings. These have so much paint on them, 10–20 cm thick in some cases, that not only do they represent the texture of the people that he portrays, physically they become the emotional landscape of the subject.

FOLLOW UP

Using light to describe and create dramatic form is a familiar method. Artists such as Caravaggio, Rembrandt and Joseph Wright of Derby used bright, direct illumination or an indirect glow to show changes in shape and the way in which a textured surface can cause powerful shadows. Imagine the way in which a hairbrush might make shadows, as opposed to a flat pan scrubber. It is those highlights and areas of varying darkness that can tell us all about a form. Setting up a series of different

What the artist says: form

There are all sorts of forms to think about. Take the work of Rachel Whiteread, an artist whose work consists of casting spaces, the sort of invisible forms we tend to take for granted, such as *Ghost*, a huge plaster cast of the inside of an ordinary room. As she says: 'It's a room that's been put inside a room. When I made *Ghost*, I was interested in relocating a room, relocating a space from a small domestic house into a big public concrete anonymous space, which is what museums have done over the world for years and years.'

contrasting surfaces under lights is always interesting, and by careful tonal drawing you can describe the underlying form. How did the Spanish artist Cotan analyse close and direct light on fruit and vegetables to represent gentle changes in texture?

TEXTURE

The French Post-impressionist artists Vuillard and Matisse deliberately flattened forms, and both made the human figure just one element in a composition. Vuillard's painted surfaces are textured, involving the use of scumbled paint. That texture makes the viewer aware of the picture plane, and aware that what is on view is as much a decorated surface as a three-dimensional illusion. Traditionally, artists have used scale and tone, as well as colour, to create depth. Vuillard used colour and receding, flat planes of textured form to make up the composition. The progression of Matisse's paintings shows a move from carefully modulated tones to pure, flat colour cut into shapes that relate to figures and drawings of figures.

FOLLOW UP: TEXTURE

Texture need not be just descriptive, it can be admired for itself. Both Burri and Tapies make art that depends on the qualities of textured materials, especially sacking and sand. Burri's work *Wheat*, 1956, features some paint, but is essentially an arrangement of burlap sacks mounted on canvas. As with many other of his 'sack' works from this period, you could read a cross shape into the arrangement if you wanted to. Burri started painting in 1943 when he was a prisoner of war in Texas; he had worked in field hospitals during the war and those experiences transmitted into his art, particularly the intention to represent or display authenticity. Rough or strong texture can often be used to denote the 'real'.

Task
Texture and light
Texture is an often-ignored formal element. Have a go at making exaggerated versions of the textures that you see in front of you. What materials can you find to make the sort of sweeping, dramatically lit statement characteristic of the Grand Manner painting of Caravaggio, David or Artemisia Gentileschi? (See Appendix 1 for a definition of Grand Manner.) Pay particular attention to the strong contrast between highlight and deep shadow that you might find. Scale is equally important.

What the artist says: texture

Texture in art is tied up with the surface qualities of a work and therefore how it is made. The varying thicknesses of a brush stroke, for example, will catch the light in different ways. There are many technical terms used by artists and critics to describe these processes and the textures that result. In painting, for example, there is stippling, sgraffito, scumbling and tonking, as well as the overall term impasto, which is used to describe any degree of texture in paint. There is also a wide range of surface qualities you can produce with different tools, such as flat brushes, pointed brushes and palette knives.

3.1 'THE SHAPE I'M IN'

INTRODUCTION

This section looks at the importance of the figure in art and its relevance to you as an artist. It also looks at the role of form, texture and colour in art, in particular the importance of impasto as a key tool.

YOUR WORK IN THIS UNIT

The featured images have been presented as the first step in the process by which you make your own work: 'first drawings'. That is the place in a unit where you begin to study in depth how other artists have responded to the same sort of themes and techniques that interest you.

Section features

Works:
- Philip Guston *Painting, Smoking, Eating*, 1973
- Jacques-Louis David *Death of Marat*, 1793

Genre: history/figure

Formal elements:
form and texture

Unit element:
first drawings

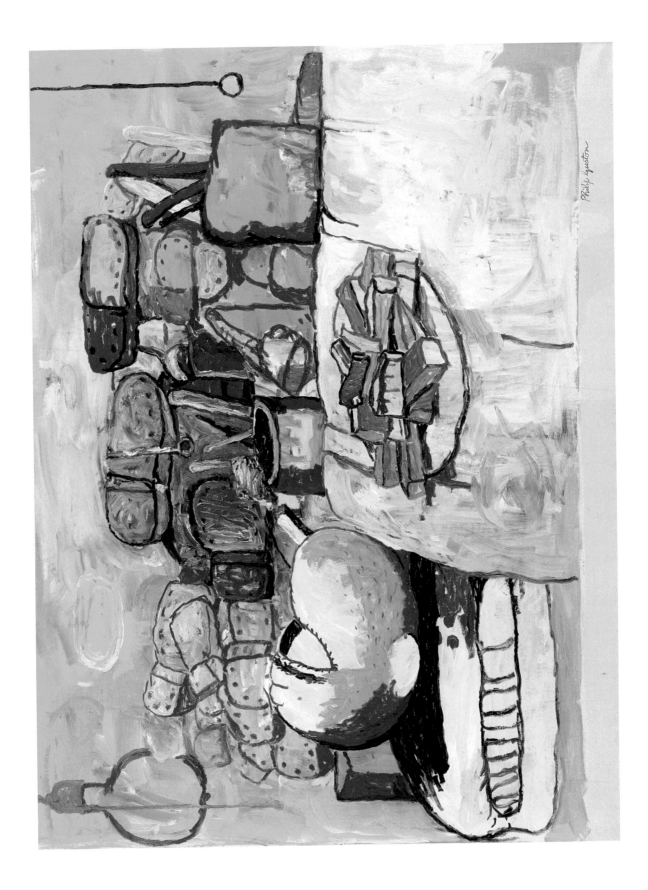

Philip Guston

Painting, Smoking, Eating, 1973

THEMATIC OVERVIEW

Representing the figure as a hero, or antihero, is a wide subject, full of possibilities for visual and thematic analysis. The self-portrait of the artist as hero is a common one — few artists miss the opportunity to present themselves well. Guston's painting, however, is a portrait of the artist as antihero.

Detail

TECHNIQUES

Guston's early works show urban violence, for example *Martial Memory*, 1941, in which a group of small boys are dressed up, with paper bags as helmets and holding planks of wood ready to play violent games. Hooded Klu Klux Klan-like figures also feature in his art, for example *Drawing for Conspirators*, 1930 (these

What the critic says

The progression of Guston's art is interesting. His development from recognisable imagery to abstraction and then back to semi-figuration again is unusual. How have your ideas about the development of an image changed? Remember that you don't need to be a painter to appreciate and get something out of Guston's development.

reappear again after 1970). Guston's style changed after a trip to Europe in 1948 and he moved into abstraction, an example of which is *The Bell*, 1952. This style, known as Abstract Impressionism, made Guston extremely successful. His paintings from this period tend to feature a series of shapes or marks in the centre of a canvas, often slightly grid-like in their arrangement and with the colours muted and surrounded by large areas of paler colours. Although entirely abstract, many critics saw references to earlier art, particularly Monet's late paintings of water lilies.

Guston moved from his old abstract methods by making a huge painting of his New York studio; 'a hundred foot long grimy loft', he called it, 'the useless light cords, the old easels, all the crap lying around'. He painted this scene for an 8- or 9-hour stretch in 'a desire for more solid forms'.

Guston showed his new figurative paintings in 1970 in New York and the art world reacted badly. Other Abstract Expressionist artists and critics could not believe that one of the heroes of Abstract Expressionism had changed his art so much. From

the 1950s, the relationship between abstraction (e.g. Jackson Pollock's *Blue Poles, Number 11*, 1952) and figuration or traditional painting had become so fraught that pro-abstract artists or critics were capable of calling a figurative artist a fascist or a communist and lining them up with Nazi or Soviet realists. De Kooning was critical of this narrow-mindedness, apparently asking Guston at a party: 'What do they think, we're all in the same baseball team?'

COMPOSITION

A range of ideas turn up with some frequency in Guston's paintings, things you could term his vocabulary; he called them 'dumb creatures'. They include piles of shoes, easels, one-handed clocks, low-hanging light bulbs, tools for painting, books, ladders and hooded figures. In *Painting, Smoking, Eating* we can see a light bulb and switch-like shape in the top left, and a kind of hanging light pull on the right. Some of these 'dumb creatures' had personal meanings for Guston. The light bulb, for example, could refer not only to the light in Picasso's *Guernica*, 1937, but also

What the artist says

Talking about his shift in style, Guston said: 'Our whole lives, since I can remember, are made up of the most extreme cruelties of holocausts. We are the witnesses of hell. So when the 1960s came along I was feeling split, schizophrenic. The war, what was happening to America, the brutality of the world. What kind of man am I, sitting at home, reading magazines, going into a frustrated fury about everything — and then going into my studio to adjust a red to a blue…I wanted to be complete again, as I was when I was a kid… Wanted to be whole between what I thought and what I felt.'

to Guston's memory of his first studio in the family home in Los Angeles, which consisted of a cupboard lit by a bare bulb, as well as to memories of his other studios since. Were you to create your own vocabulary of 'dumb creatures', what would it contain and how would you represent them?

PABLO PICASSO
Guernica, 1937

CONTEXT
OTHER ARTISTS

The flat-out man with a plate of food on his chest is not a noble image. In depicting himself in this way, Guston is denying himself the idealised role of the artist. Compare this work to previous images of artists, for example, Dürer's *Self Portrait at the Age of Twenty-Eight*, 1500, in which he shows himself as Christ to emphasise the creative power of the Renaissance artist. Also note the contrast with David's image of the dead revolutionary hero, *Death of Marat*, 1793 (see page 91), the other work featured in this section. What points of comparison can you make, for instance in the scale and treatment of the head, and the viewpoint of these other artists, both physical and intellectual?

The shapes behind the figure could be a pile of old shoes. Guston's father had been a blacksmith in Odessa, Russia, before emigrating to Canada and then America. He found little work and ended up as a rag and bone man walking the streets, before

What the critic says: food in art

On the bed you can see a plate of food, probably thickly cut chips with tomato sauce on them. There is a long history of a still life of food as part of a painting, for example, Manet's *Déjeuner sur l'Herbe*, 1863, which has a bottle of wine and a loaf of bread in the bottom left-hand corner. Do these French fries deliberately site themselves within the history of food in art in the conscious manner that Jasper Johns, for example, employed with his beer cans (see page 51)? How would Guston have to change the composition and treatment of paint in this work to make that connection?

the 10-year-old Guston found his father's body hanging in the family shed. It is possible that these piles of strange objects refer to his father and his collections of second-hand goods. Whatever they are for, these images do make a visual world that is slightly frightening and certainly difficult to understand; a doomed world, Guston called it.

Task

Food in art

Try investigating the theme of food in art in your sketchbook. Perhaps you could move from the apple in the Garden of Eden, via the Last Supper, through to Sarah Lucas's use of fried eggs and doner kebabs in *Two Fried Eggs and a Kebab*, 1992. Ask yourself the following questions. What has been the significance of food in art in the past? Has it been just another point of visual interest and of little intellectual relevance? Does the inclusion of food have an important part in the narrative of a work? How can you tell? Is the position of the food within the composition important? Do the techniques used matter? How does that knowledge help with understanding the role of the plate of something that is food-like in Guston's painting?

CONTEXT
SOCIAL/CULTURAL

The title of this painting refers to what you could call Guston's 'signature acts'. At the time of this work, he was smoking 60 unfiltered Camel cigarettes a day and, apparently, ate far too much. In fact, as you might work out from these 'signature acts' and his position in the painting, he was not physically well. Guston died 8 years later from a second heart attack, during supper with his doctor.

FOLLOW UP

Remember that your overall task is to find visual languages to express the sorts of questions asked, for example the 'Food in art' task described on page 87. To pursue investigations in your sketchbook, you could try analysing some strongly contrasting images with a view to finding visual languages that make different sorts of emotional impact.

What the critic says

Guston changed his style partly because he felt that abstraction had little relevance to the world around him. Sadly now, as then, we live in a time full of death, destruction and questionable behaviour by governments. It is entirely up to you whether you think art has a social or political function, or even whether as an artist you feel you should bear witness to what you see happening in the wider world. Clearly, Guston felt that his work should reflect more than just the activity of 'pure' painting. What do you think? Perhaps you feel that there is already enough 'bad news' and that your role should be to lighten things up a bit?

LISA MILROY *Shoes*, 1985

CONTRASTING IMAGES

1 What would be the characteristic closely toned colours and fluffy forms used in an image of cute puppies? Think of the sort of soft lighting and gently curving lines that might be used.

2 Now compare that technique to the sort of horrific images we are used to seeing in newspapers and on television. Note the use of harsh, strong light, sharp, direct lines, and the semi-scientific observing image.

3 Take a still-life subject, such as a pair of boots or food, and represent it using both systems you have analysed so far. Which appears to you to be the most successful and why?

Make sure that you annotate both images carefully, referring back to Guston and his decision to change his own methods.

WHERE TO GO NEXT...

BRUSHES

You don't have to expose your own 'signature acts', but why not show that art matters to you? Behind Guston's figure is a tin of brushes. The tools used by artists could be a route for you to explore. Jasper Johns and Jim Dine both made images of brushes, directly referring to the making of art. Johns' *Painted Bronze, Savarin*, 1960, is an old paint tin full of artists' brushes cast in bronze; Dine's *Four German Brushes*, 1973, is one out of many works he produced based on hand tools.

Don't directly copy these artists by making pictures of brushes. Try starting your visual research by considering what these tools do. If you were drawing a pencil, you'd probably use a pencil, but why not use a huge brush? Think about playing with the scale, function and characteristic gestures made by each artist's tool. How can you group these objects? Should they be arranged like preserved specimens across the page in rows? Try looking at some of Lisa Milroy's works, such as *Shoes*, 1985, as an example of this approach. Or, should the arrangement be random but aesthetically pleasing? Remember, as always, to make notes and diagrams in your sketchbook so that the journey of your ideas becomes clear to any examiner.

IMPASTO

Guston's use of thick paint is worth investigating. Compare his impasto to that of other artists. Examine again the Realist French artist Gustave Courbet's *The Stonebreakers*, 1849–50. This time compare Courbet's technique with Guston's and your own methods. As subject matter, collect your own 'vocabulary of dumb things' from your surroundings: taps and cups, shoes and bottles, bags and coats. Light your own 'dumb things' with a strong raking light so that you can work into deep shadows. If, like Guston, you are using oil paint, then add a little linseed oil to make thick paint workable. If you are using acrylics, there are brands of acrylic texturising mediums, but they are expensive. Try other mediums too.

PINK

Guston had a characteristic palette, and used a certain pink in particular. Think about the effect of this colour and how it becomes a visual glue uniting textures and unrelated objects. Make studies using a restricted palette or, more relevant to Guston, try experimenting with odd objects, unrelated colours and meaning. Use flesh tones for the physicality of human existence, yellow and greens for sunshine and growing plant life and ultramarines for a watery lifestyle. The overall effect should present a real contrast to the fleshy life that Guston is creating.

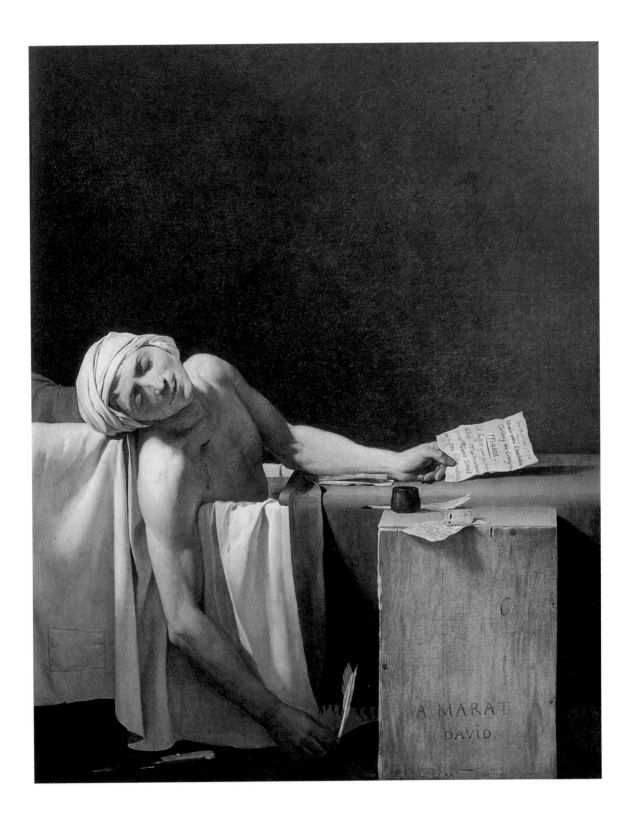

Jacques-Louis David

Death of Marat, 1793

THEMATIC OVERVIEW

This painting is a celebration of 'the sublime features of heroism and virtue', as David put it. It makes a martyr for the French Revolution: Jean-Paul Marat, murdered by the young aristocrat Charlotte Corday. The artist's intention to celebrate ideas while portraying a man has controlled his composition.

TECHNIQUES

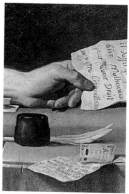

The oil painting method used affects how a final work is interpreted. Thick impasto in the style of Guston (see page 84) shows every artistic decision. In David's painting, the oil paint is in semi-transparent layers, building up illusory form. Tones are carefully modulated or blended into each other, with no edge between tones. Paint mimics three-dimensional shapes and makes flat canvas contain deep space.

Detail

What the art historian says

This canvas is the right size for an altarpiece, 165 by 128 cm. The altar is the raised table in a temple or church, a place for sacrificial offerings. In Christian churches, the altar is at the east end and the altarpiece is a picture, sculpture or decoration that sits behind it. In the *Death of Marat* the lack of obvious violence makes it an image for contemplation, for thought rather than action, an intention helped by the large empty area at the top of the canvas.

COMPOSITION

Why was the murdered man in the bath? Portraits of dead men in the bath are rare. Marat, however, had a serious skin complaint and soaked his skin in water with a vinegar-soaked turban on his head. He could not eat solid food, was covered in rashes and drank vast quantities of black coffee — not obvious hero material. The real murder was messy and far from grand, very unlike this painting, which is in the style known as the Grand Manner (see page 199).

Death of Marat is full of simple lines and large shapes, a composition of horizontals and verticals, broken only by the falling arm. Almost the whole top half of the painting is dark nothingness. Does the space above the dead republican hero signify the empty void or does it represent the possible afterlife of a hero? At his death, Marat was (supposedly) writing a note, giving money to a widow with five children whose husband had died for the revolution. Marat was worshipped by the Parisian poor and hated by the royalists. In his hand is a letter written by his murderer, a royalist.

Task

Cropping and meaning

Experiment by arranging large sections of empty space or by carrying out fierce cropping in a composition. Do these experiments affect how we read an image? Annotate your images to bring out your results, referring back to David as you do so.

COLOUR

The large dark area above the dead hero makes the viewer focus on the figure, as though he has been spotlit from top left. Try blocking off this dark area to see the effect. Before he became a revolutionary, Marat had been a physicist and had written a paper on the colours of the spectrum. Although this fact doesn't initially seem to have been used in the painting, perhaps the full range of the spectrum has been displayed somewhere, maybe in the flickering colours above the dead hero.

What the art historian says: deposition

The Deposition is the name given to Christian paintings of the Descent from the Cross, the scene after Christ's crucifixion when the dead body is taken down from the cross. Joseph of Arimathea arranged for the removal and burial of Christ's body and brought a linen sheet to wrap him in. Look, for example, at Rubens' *Descent from the Cross*, 1611–14, which has the tumbling Christ being lifted into a long white length of cloth that falls from the top right of the painting. There are two iconographic references to the Deposition in *Death of Marat*:

1 Notice the echo of Joseph of Arimathea's linen in the falling cloth behind Marat.

2 Deposition paintings often show Christ's right arm trailing down lifeless, almost to the ground.

These references are deliberate, although contemporary revolutionaries said that to compare Marat to Christ was to slander Marat.

CONTEXT
OTHER ARTISTS

We don't see the act of murder or the murderer, the artist's intention being to make us think of higher things. Look at the fallen hand that holds the quill pen. In Christian paintings, Christ's trailing arm is one of the characteristic signs of a Deposition composition (see above). David is quoting that sign, raising the importance of this martyr as high as he can, comparing him to the most famous Christian martyr of all: Christ.

The nudity of the figure makes us think of classical statues, and the notions of beauty and truth. After his death, Marat's body was laid out in the Pantheon, a building that until the revolution had been a church. His body was shown like the painting, naked from the waist up; next to it was placed the bath, the wooden crate, the quill and the inkpot. This method of showing Marat's possessions is exactly the same as that used to show the relics of a Christian saint. Housing such relics would have been an important function of the building when it was a church (see the section on relics on the next page).

Try making a direct comparison between *Death of Marat* and other examples of the celebration of virtue after death, such as the Rubens painting mentioned above. Look, in particular, at how the artists compose forms to put across their message and how the artist's control of texture aids that process.

WHERE TO GO NEXT...

PROPAGANDA

This is a painting with a strong political content. Colour has a prominent role in politics, for example the colour red. Look at El Lissitzky's *Beat the Whites with the Red Wedge*, 1919, in which the revolutionary artist uses abstract forms to make a powerful political message. A white shape is attacked and divided by a red one, telling the revolutionaries (the Reds) to fight back against the reactionaries (the Whites). This method is worth thinking about as one to adopt in your own work, although to become art, political events need to be changed into a visual language that makes metaphors.

Look also at the work of other artists who seek to illustrate events rather than create meanings, such as Howson's *Serb and Muslim*, 1994, which was made after time spent as an official war artist in Bosnia-Herzegovina.

EL LISSITZKY *Beat the Whites with the Red Wedge*, 1919

RELICS

Objects in art can have significant meanings, emphasised by the visual language artists use to depict them. Find random objects and investigate ways of representing them so that they appear to have the significance of the relics of a saint, a dead pop star, a wartime hero or a footballer.

HERO/ANTIHERO

David and Guston use paint techniques and composition to affect the manner in which viewers read their art. First, investigate the role of paint texture and meaning by making a comparison of the two works. Second, work with a figure and think carefully about your view of the subject. Locating the figure so that you are below it will make the subject appear more important than you, the artist or viewer. Looking down on the subject will have the opposite effect. If you do not have access to a model, try looking back to the entry on using a hairbrush as a model on page 82. Any object can stand in for your hero or antihero. Choose separate objects that reflect your intentions, and that have enough visual interest to keep your attention. Remember to note down your discoveries about texture.

SECTION SUMMARY

This section has:

- looked at two paintings that work from the figure, considering it as a horizontal form
- considered the importance of the figure in art and its relevance to you as an artist working now
- looked at ways of depicting the artist, notably images of the artist as hero and antihero, and how to make heroic and antiheroic images
- analysed the use of light and texture to build up form and the different meanings you can create, using these two crucial formal elements
- studied the emotional resonance of form, texture and colour in art
- looked at impasto and how different thicknesses of paint may be created and the sorts of meanings that could be attributed to them
- viewed the role of objects within a composition, including the role of 'dumb objects' in art such as shoes and light bulbs, and how you might use the things that surround you to create art that specifically refers to the actions and feelings of individuals

3.2 'FIGURING IT OUT'

INTRODUCTION

Section features

Works:
- Donald Judd *Untitled, Stack*, 1980
- Chris Ofili *No Woman, No Cry*, 1998

Genre: history/figure

Formal elements: form and texture

Unit element: second drawings

The middle section of this chapter moves on from analysing the single reclining figure as a recognisable hero or antihero to look in greater detail at the forms that can be seen in a standing figure and at shapes that might make you think of a standing figure. The two works in the previous section were reasonably straightforward paintings. In this section, a sculpture with a sleek manmade surface is compared to a two-dimensional image, one that makes the viewer acutely aware of the qualities of the flat surface by combining thin layers of resin, paint and newspaper to create a complex piece with many levels of references.

YOUR WORK IN THIS UNIT

This section assumes that you are at the stage in a unit we call 'second drawings'. In your journey so far you have begun to research the figure in art and the history/figure theme. You will be starting to get some sort of idea about the direction your art might be taking from the first drawings you have made. You might have been prompted perhaps by the heroic and anti-heroic images you have looked at and by your experiments with different techniques — for example the thickness of paint. The next step is to extend your analysis of the history/figure theme, widen the context of your own art and carry out further intensive visual analysis.

THEMATIC OVERVIEW

The two works studied in this section are quite different. The first is an abstract sculpture in a style often described as Minimalist. Minimalism (see glossary, page 271) was a visually simple, yet intellectually complex part of twentieth-century art history. We revisit it here with Judd's *Stack* to think about ways of composing groups of similar forms. This work emphasises the importance of considering the fundamental elements of space and form when looking at any sculpture.

Ofili's work is a total contrast; it depends largely on the notion of collage, the adding of different elements in layers to make up a new image. We analyse that process, in the context of Ofili's ideas and working methods, as a way of making your own multilayered art.

Ofili is usually grouped together with other young artists of the late twentieth century under the heading 'Brit art'. What perhaps marks him out from other members of that generation (Hirst, Emin etc.) is his deliberate references to themes outside art, the role of young black Britons in particular.

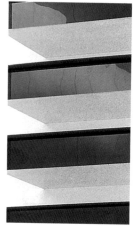

DONALD JUDD *Untitled, Stack*, 1980 (detail)

What the artist says: space and exhibiting

Judd believed that the way in which his work was shown was crucial. He felt, in particular, that all art works create the space around them. He saw this space as dynamic; 'art well exhibited makes space visible', he said. An important aspect of Judd's sculpture, therefore, is that it is an exhibition of how art occupies and defines space. Unlike traditional sculpture, his works are not displayed on a plinth. How work is displayed tells us a great deal about the intentions of the artist. How is your work seen, and how will it be displayed to an external examiner, to your parents and to your friends?

FOLLOW UP: COMPARE AND CONTRAST

In common with most of the sections in this book, 'Figuring it out' contrasts the art works. Comparing and contrasting art works is often a useful route to follow. You may well find direction for your own work in the clash, or sympathetic meeting, of different types of art. There must be some connections between the art you examine. There are subtle connections between the Judd and Ofili analysis here; can you spot them? These might be visual, for example the same use of colour, composition or texture. Or, you might choose to compare artists who use different materials or dimensions to analyse similar themes, for instance, sculptors and textile artists who use repeated forms. Linking works with other underlying qualities is another option, for example how a man and a woman consider the same subject. Make sure, as always, that your thoughts are carefully documented. Annotated examples of the work in your sketchbook would be a good starting point.

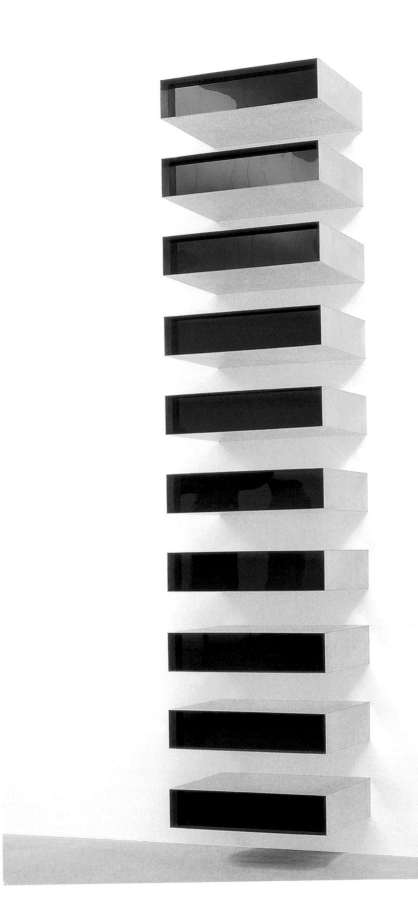

Donald Judd

Untitled, Stack, 1980

THEMATIC OVERVIEW

Ten identical rectangular shapes are fixed to the white wall of a gallery. The sides of the shapes are made from aluminium, the fronts from coloured Perspex. What does a viewer have to do in order to understand such an apparently simple art work? More importantly, how can such simple arrangement help your own figure-inspired art?

TECHNIQUES

Judd's *Stack* is made from ordinary industrial materials that, deliberately, make no reference to past art. It is therefore unlike any obviously painted surface which, when seen in a gallery context, will resonate with the whole previous history of art.

Why boxes?

Most of Judd's later work involves some sort of box, open on one side. A box is the simplest and clearest way of defining space. It *encloses* space in a way that is easily understood as well as projecting crisply into the room in which it is displayed (a box-like space placed within a box-like building). Judd also designed his own furniture, which looked much like the art he made: a bed stripped down to the basic essentials of a rectangular box raised off the floor and chairs consisting of wooden boxes with solid wooden tops.

Judd was a major figure in the art movement known as Minimalism. To help your understanding of this type of art, think of the Minimalist artist Frank Stella's description of his work as 'what you see is what you see', or, as Judd put it, 'the simple expression of complex thought'. Minimalism often features industrial materials and basic forms. Its sculpture is characterised by a reduction to the fundamental dimensions of sculpture (up/down/across) or to fundamental shapes (cube/sphere/plane). Although Judd himself hated the term Minimalism, it is a useful shorthand for the context within which he worked.

Judd's works emphasise space, an important element when considering sculpture. In modernist sculpture, space is separated and delivered to the viewer, almost chopped up into basic shapes, cubes, rectangles, spheres and so on. This means that this invisible concept becomes a visible element with a distinct quality of its own. After Minimalism, the way artists viewed space as a formal element in sculpture was changed radically.

COMPOSITION
HOW TO LOOK AT MINIMALIST WORK

Traditional art always refers to something else. When looking at a painted represen-tation of a person, for example, the viewer is aware that the painting is not the actual person, just an image that makes reference to that person. A minimalist work like Judd's is nothing but itself; it does not represent a subject. Minimalist artists describe each work as a new reality.

The clue to looking at Minimalist art is the care with which you do it, and, despite what the artists themselves say, you do need an awareness of the art that has come before. 'Art is something you look at,' Judd said. But this is not work to look at in a hurry. Minimalist art is precise and controlled but not detailed, so it needs a different type of looking. 'In looking you understand; it's more than you can describe. You look and think, and look and think, until it makes sense, becomes interesting,' Judd explained. Notice he believes that looking comes first, unlike

What the critic says: the artist's touch

The hand of the artist, often an important part of an art work, is certainly not evident here. Indeed, after 1964 Judd didn't make the work himself but employed others more skilled than himself. Does the lack of obvious craft and skill by the artist make this any less of an art work than a heavily textured painting, for example?

many critics who, according to Judd, approach art with preconceived notions of what they are looking at. 'But why can people not just accept what they see?' he asked. 'If anything that is exactly the gift of art: that maybe you see something you haven't seen before. That is exciting, don't you think? Instead when people see something new they get nervous because they prefer to see what they had hoped to see: that is, more of the same'. The artist Robert Smithson described Judd's works as 'hideouts for time'.

JUDD AND COLOUR

Modernist art separates and amplifies the formal elements (line, tone, colour, form, pattern and texture). Each element is made louder and stronger so that the tradition-al role of illusion in art (see page 99) is taken away and the viewer can see how the work was made.

Colour is a surprisingly important element in Minimalism. In Judd's work, the colour he uses has no association with anything else. The colour blue in this *Stack* does

not refer to a blue sky, or a deep ocean. Ask yourself some questions at this point. Is it possible to dissociate colour from meaning? Is it impossible to divorce colour from the illusion of representing pictorial space? Judd certainly thought so, claiming 'Two colours on the same surface almost always lie on different depths.' Notice how, in this work, no two colours are put next to each other, Judd's intention being to remove that illusionism. Is his intention realised? Try putting blocks of colour into your sketchbook and analysing their effect.

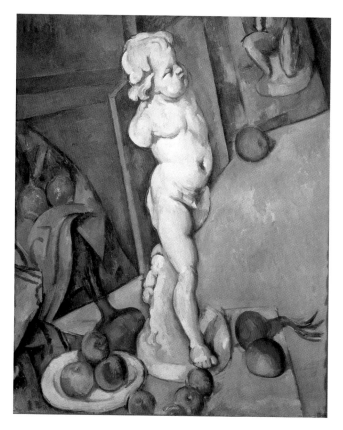

PAUL CÉZANNE *Still Life with Plaster Cupid*, 1895

What the critic says: illusionism

Illusionism is a tricky term but, as Judd said, 'illusion is the way things are, illusionism is the way things are not'. What does this mean for you as an artist? We know that, for example, an apple does not have an edge but is a continuous turning surface. However, look at Cézanne's painting of an apple in *Still Life with Plaster Cupid*, 1895, and you will see that the artist has painted the apple as though there is a crisp point at which the object turns away from us (see the section on Judd and colour on page 102). Cézanne shows a piece of pictorial illusionism. Why? Perhaps he does so mainly because illusionism is the most efficient way, when working in two dimensions, to analyse visually the experience of looking at three dimensions. As an artist you will spend a lot of time on this fundamental problem. Judd would no doubt make the point that this whole process is unnecessary. What do you think?

FOLLOW UP

Read the box on illusionism in art on page 99. Look also at a late Cézanne still life, such as *Still Life with Green Melon*, 1902–06, in which he paints many versions of the turning edge, showing how the eye adapts to looking closely at objects.

Put images of the two artists' differing approaches to edges in your sketchbook, comparing Cézanne's multiplicity of turning surfaces with Judd's precision. Then pursue the theme of edges in art, looking at as many other types as you can. To make sure that your own analysis moves beyond the descriptive into the analytic, you must use these images of different edges to lead on to representations of your own, perhaps in both two and three dimensions. See also 'Judd and perspective' on page 101.

CONTEXT
OTHER ARTISTS: THE 'GEOMETRIC' ROUTE

It is possible to see Minimalism as a continuation of Mondrian's early twentieth-century art. This hard-edged approach continued through the Bauhaus to the purely abstract paintings of the early 1960s that were full of sharp lines and edges (e.g. the work of Frank Stella). Geometric art is one term used to describe this type of art. This route has been used to explain Judd's art, although Judd himself thought Barnett Newman's huge abstract paintings of enormous plain surfaces and single vertical stripes a closer precedent, for example Newman's *Adam*, 1951–52.

HARMONY OR MULTIPLICITY?

In this stack, there are ten boxes. The combination of forms creates neither harmony nor disharmony, but multiplicity. If you look at the way artists have used repeated forms, then this distinction might have more meaning. Matisse, for example, made a series of sculptures of the nude back, *Woman in Back View 1–4*, 1916–17. These are four large reliefs, each showing a life-size female nude seen from behind. Her right arm hangs against her body, parallel to a long ponytail that hangs down the middle of her back. The forms in the four works move gradually toward abstraction. What starts in number 1 as almost a recognisable portrait becomes, by number 4, an arrangement of organic shapes. These shapes are slightly similar and clearly related to each other but are not arranged symmetrically; in other words, they can be seen as a harmony of forms.

FOLLOW UP

Step 1: Try comparing Judd's *Stack* with Matisse's *Woman in Back View*. Note that Judd's piling up of repetitive forms in *Stack* makes a vague reference to the way human vertebrae are stacked on top of each other. His ten boxes are arranged in such a way that there is a repetitive rhythm. Matisse's backs also feature shapes

arranged so as to make rhythmic patterns, but in a harmonic rather than multiple composition.

Draw out these shapes in your sketchbook to make these two fundamental compositional techniques clear.

Step 2: What would the opposite of a harmonic composition be called? A disharmony of shapes, perhaps? Such a disharmony could be any arrangement that does not appear to have an internal compositional logic. In other words, the forms just look as though they have tumbled there.

For an example of disharmony, look back at Guston's *Painting, Smoking, Eating*, 1973, and the arrangement of shoes behind the central figure. At the left-hand side of the painting, the shapes have become a tumbled mess, a disharmony. What does this tell us about the state of the figure represented?

Can you, as a result of the analysis of different arrangements of forms in art, make your own visual analyses of arranged forms, bringing out intentions and meanings inspired by the art you have looked at? Arrangements include harmonic and 'disharmonic' arrangements, perhaps in sculptures or paintings containing many figures, photographic still lives, or relief printing that contrasts flat arrangements of colour.

WHERE TO GO NEXT...

MINIMALISM

If you find this work interesting, search out some of Judd's other works, for example *Untitled*, 1969, a stack of ten boxes, this time in shiny copper with no insert (i.e. you cannot see into them). Would such a change of material and the lack of visible depth within the box make any difference to the way in which you appreciate the work?

Alternatively, look at Judd's larger boxes, such as *Untitled*, 1986, which is a complex arrangement of 30 large open-fronted plywood boxes, hung in three rows at equal intervals from each other. Each box has an internal division and a coloured rear wall. Each is divided differently from the others with a wide range of combinations for the artist to choose from. Such arrangements might make you return to your own life and look at different methods of arranging space — kitchen cabinets, bookshelves, compact disc towers etc. Can you examine those spaces in a Minimalist manner?

JUDD AND PERSPECTIVE

The way Judd's stacks are photographed often makes them look like an exercise in perspective. Try looking at other examples of this sort of process, such as in the Renaissance artist Paolo Uccello's 1450 drawing of a vase, or chalice, in which he

showed a series of curving shapes stacked on top of each other. Set up balanced, similar shapes in a room with a clear vanishing point, or within a large rectangular box, so that you can examine how forms are mathematically displayed, using linear perspective and crisply ruled lines on white paper. There are many objects you could use for this sort of exercise: stacks of books slightly skew to each other; matchboxes; compact disc cases; paint tins or mugs balanced on each other. However, do take care when drawing ellipses (see the guidance on 'How to draw ellipses' on pages 237–38).

JUDD AND COLOUR

Artists' colours were developed to mimic nature, either in interiors or in northern European landscapes. Think of oil paint and van Eyck, as in *The Arnolfini Marriage*, 1434, or the brightly lit surfaces of Tuscany, as in the Pollaiuolo brothers' *The Martyrdom of Saint Sebastian*, 1475. Does the range of materials used by Judd reflect twentieth-century life? Industrial paints, the sort Judd used, do not have the illusionistic depth of a van Eyck green or a Tuscan Pollaiuolo blue. Try comparing the flat colour inside each box of the Judd stack with a Renaissance sky. Which has the greater appearance of depth? Colour can also create the feeling of mass or weight in an object. Which appears lighter, red or blue?

PIET MONDRIAN
Composition A, 1920,
oil on canvas,
90 × 91 cm.
© 2006
Mondrian/Holtzman
Trust c/o HCR
International,
Warrenton, VA, USA

MODERN MATERIALS

Judd consciously uses modern materials. What are the equivalent materials and techniques you could be using now, many years after he made this particular stack? What are the qualities of colour and surface in the plexiglass that Judd uses, or any bright plastic surface you can find? There is an odd quality to plastic colour in the sense that it seems to be under the shiny surface and to have great depth, although the colour itself is difficult to place. Where does the colour actually reside in a piece of reflective plastic, for instance in the handle of a cheap stapler? Compare this inherent quality with a different material where the colour is part of the fabric and where there is no sense of disparity, perhaps the surface of a piece of cotton or wool.

Look at the combination in *Stack* of the blue plexiglass reflected in the polished galvanised steel. It would be interesting to construct a graph or chart of graduated colour, using applied colour (for example, acrylic paint), intrinsic colour (plastic perhaps) and colour that lives beneath the surface (as you might find in dyed cloth).

Another approach to colour and modern materials

This is the description of a work of art carried out by the artist Scott Burton on 28 April 1969 at Hunter College, New York. It was called *Four Changes*:

'A performer faces the audience, stage center, wearing a shirt and a pair of pants the same color, color A. He removes the shirt revealing under it an identical shirt of color B. He removes the pants, revealing under them an identical pair of color B. He removes the shirt, revealing an identical shirt of color A. He removes the shirt revealing an identical shirt of color B. He removes the pants, revealing an identical pair of color B.'

From *Six Years: the Dematerialization of the Art Object 1966–72*, ed. Lucy Lippard

Do you think Scott had made annotations in his sketchbook to explain the journey of his ideas?

Such a chart would not only be a useful guide for you as a maker of art, it would, if suitably annotated, be a useful form of visual analysis to put into your sketchbook.

JUDD AND OTHER ARTISTS

To think about the derivation of Judd's art, compare his boxes with a Mondrian painting, such as *Composition of Lines and Color III, 1937*. The Mondrian consists of a series of black horizontal and vertical lines on a white background, with a small rectangle in the bottom right corner painted in blue. Much like Judd's reduction of the elements, it is a careful arrangement of some basic two-dimensional elements, for instance, up/down, line/colour. Are there any other similarities? Can you imagine either work turned into a painting or a sculpture? What would each work look like as a result? Now compare these two works with the Barnett Newman mentioned above. Which seems to you to be a closer fit and why?

Chris Ofili

No Woman, No Cry, 1998

THEMATIC OVERVIEW

Detail

Ofili's art combines traditional images — in this case the painting of a single figure — with contemporary techniques and references. *No Woman, No Cry* shows a woman in profile, a traditional portrait format called a bust (see below). The artist uses collage and layers of complex pattern to build up his image. He also brings significant social context — the life of young black London and the death of a young black Londoner — into his multilayered imagery. These are all processes and ideas that can be useful and productive even if the exact circumstances do not apply to you.

What the critic says: the portrait format

The 'bust' is the name given to an image of the head and upper part of the body. The term was first used, probably by the ancient Egyptians, to refer to sculptural portraits. The format was followed by the Greeks but it is the Romans who are best known for their portrait busts. The composition was reinvented during the Renaissance (see page 111 for ideas on how to develop the profile format). Nowadays, the description 'bust' can refer to three- or two-dimensional portraits of head and shoulders. The two other portrait formats most often used are the full-length life-sized portrait and the three-quarter-length portrait, usually of a seated figure.

TECHNIQUES

Ofili builds up his paintings in layers, usually with dots of colour, cut-out images, glitter and areas of paint, generally bright oil and acrylic colour. Each layer is covered with clear polyester resin so that every part can be seen. As the layers build up, the patterns become more and more complicated.

FOLLOW UP

Clear resin is an interesting but dangerous substance, meaning that you are unlikely to be able to use it in most institutions. The two substitutes you could try are polyvinyl acetate (PVA) glue or water-based varnish. Both have their drawbacks, but can work well providing you accept that every medium has different qualities. Spend some time experimenting with them. As always, make sure that you keep annotated records of those experiments, explaining not only what you are doing but also why and how these tests relate to your approach to a theme.

DEATH MASKS

In the past, portraits were often painted after the sitter's death as a commemoration, with the artist working from a death mask cast from the deceased's face immediately after death had occurred. Do not attempt to take casts from the face of a living person. It is not only extremely uncomfortable for the person being cast, but such a process is potentially very dangerous.

FOLLOW UP

If you were to make a portrait of a close friend, which format would you choose? Would you use the same format for a powerful politician or a well-known footballer? What does each format tell the viewer about the subject?

What the artist says: comparing approaches to collage

Like Ofili, the Pop artist Rauschenberg also used collage. He compared the sense of his imagery to that of switching through television channels or flicking through a magazine: 'I was bombarded with television sets and magazines, by the excess of the world, I thought that an honest work should incorporate all those elements, which were and are a reality'. Try looking at some of Rauschenberg's work and comparing and contrasting it with Ofili's, such as Rauschenberg's illustrations of 'The Inferno', a section of Dante's vast pre-Renaissance poem, *The Divine Comedy*. Notice that neither artist makes a direct illustration to what concerns him. It is up to the viewer to make those connections.

COLLAGE

Essentially, an Ofili work consists of a layered collage. You should therefore look briefly at the history of collage as an art medium. By definition, a collage is the arrangement of already existing images, put together to make a new one. It can involve images made especially for the work, as well as found images, surfaces, printed elements etc. It was first developed as an art form by the Cubist artists Picasso and Braque in 1912–14, an example being Picasso's *Still Life with Chair Caning*, 1912; the artists' work from this period is often called Synthetic Cubism. Collage has two important strands that are still relevant today:

1 It was the first use of non-fine art materials in an art setting, a process that has developed ever since, from Dada through Pop art to Brit art and beyond.
2 Like the basic idea behind Cubism itself, a collage assumes that the world is complex and cannot be represented by a single image; many contrasting images and methods are needed.

FOLLOW UP: TRANSFERRING IMAGES

Ofili cuts out and sticks his sources straight on to his work. If you try this yourself, take care with edges. If edges stick up above a relatively flat work, the different surfaces catch and distract the eye. Rauschenberg used a different method, transfer printing, which involves soaking images cut from newspapers and magazines in a chemical solution. The soaked images were then placed on a clean surface and a pen rubbed over their reverse side, thereby transferring the image to the new surface. You can see the strokes of the pen on Rauschenberg's transferred collages. Unfortunately, the chemical solution he used was lighter fluid, a solvent banned for students because of its flammability and the risk of solvent abuse. There are other techniques you can use, including a material that irons images on to fabrics. This works reasonably well and there are other similar products on the market, none of them expensive. Ask in your local art/craft shop.

THE DOT

The dot is a key element in Ofili's work. Look closely at the surfaces of his pictures and you will see dots many layers deep. Notice that they are sometimes randomly placed to cover an area, while elsewhere they radiate from a point, e.g. on the arms and shoulders.

DOTS IN ART

Like collage, the dot has a resonant history in art, one worth investigating in your sketchbook, where you can build it up to a useful technique.

ROY LICHTENSTEIN
Whaam, 1963

NINETEENTH-CENTURY DOTS

The Neo-impressionist artists Georges Seurat and Paul Signac used small dots of pure primary colours close together. This created stronger, clearer versions of the resulting secondary colours in the eye of the viewer than if the colours had been mixed on the palette. Look at *La Grande Jatte* by Seurat, 1884–86 (for an in-depth discussion of this painting see pages 139–47).

TWENTIETH-CENTURY DOTS

The US Pop artist Roy Lichtenstein took his dots from comics, e.g. *Whaam*, 1963 (see page 107), painted in a range of single-colour dots. In this work, a small comic-strip image of a plane in combat has been enlarged to a painting 173 cm by 406 cm. Lichtenstein copied Ben Day dots, the cheap industrial printing process once used in magazines and newspapers. An image was printed with a pattern of dots, each dot of a different density in order to create a half-toned image. The method, which can be used for both colour and black and white images, reduces tone to areas of

Art as commentary

In one of the layers, Ofili has written: 'RIP Stephen Lawrence'. In the blue tears coming from the woman's eye are small photographs of Stephen Lawrence himself. Lawrence was a black teenager murdered by a racist gang in south London in 1993. This painting therefore commemorates the young man and his murder, and protests at a society in which racism can operate. The painting also celebrates Stephen Lawrence's family who worked hard for recognition of that racism and for justice for their son.

distinct contrast. Seen through a magnifying glass, Ben Day dots are abstract patterns that resolve into an image from a distance.

TWENTY-FIRST-CENTURY DOTS

Ofili's fellow Brit artist Damien Hirst has made spot paintings, for example *Argininosuccinic Acid*, 1995, which features brightly coloured circles of flat, bright gloss paint in grid formation on a large white canvas. The paintings' titles refer to pharmaceutical chemicals, their compositions to Minimalist art.

FOLLOW UP

What are the intentions behind these artists' use of dots? Why did they have those intentions? What are the differences between their methods? Can you use any of them in your work? Which is most appropriate?

OFILI'S DOTS

Ofili's dots are probably inspired by African pattern making (he had visited Africa on a scholarship). The British Museum in London has *Ear Plugs*, a work from Zululand and Natal, South Africa, which consists of small objects with bright geometric patterns made from contemporary materials such as Perspex, metal, rubber and vinyl. Look at three-dimensional dots or beads. Beadwork is a consistent feature of African art, each bead forming a dot within a larger pattern. Try incorporating beads and patterns into your own work, bearing in mind that each African beadwork pattern has tribal significance. Look at objects like the *Beaded Crown* from Nigeria, again in the British Museum, which shows the high standard of Yoruba beadwork from this region. See also information on the Nigerian-born British artist Yinka Shonibare on page 131.

COMPOSITION

The underlying layers of *No Woman, No Cry* are a basic criss-cross pattern covered by yellow pools of translucent paint. At the edges of the canvas are some of Ofili's characteristic swirling line drawings. On top of this is the image of a woman. Essentially, what you are looking at is a single figure portrait, not of an individual woman, but of an archetype (see page 43 for more information on archetypes in art).

FIGURE ON A GROUND

The single figure against a background is one of the most traditional forms of painting composition, especially if the figure is in profile. You should ask yourself the following questions:

- How much does the figure dominate the ground?
- What are the proportions of one to the other?
- What scale is the figure? Life size? Less or more?
- *No Woman, No Cry* is 244 cm by 183 cm, making the figure at least three times larger than life. What is the effect of these proportions?
- What do those proportions tell us about the artist's intentions?

PRESENTATION: THE DUNG

The most famous ingredient in the presentation of Ofili's work is elephant dung. At first, the dung simply provided a contrast to his painted surfaces: ugly dung against a beautifully decorated surface. Sometimes, the dried dung was used to prop up his paintings, as with this work, in which one piece of dung carries the

Detail of dung

words 'No Woman', and the other, 'No Cry'. In more recent works, the dung has become part of the paintings by being painted over or covered with map pins. Elephant dung is a new surface for painting, but by using it as a medium the artist is also playing with notions of black culture, history and stereotypes.

Notice that Ofili's work is rarely hung at eye level. His paintings stand on the floor and lean against the wall. Like the sculptural plinth (see page 52), hanging a painting on a white wall elevates the image into sacred 'art' space. Ignoring that process makes Ofili's art more approachable.

FOLLOW UP

In more recent paintings, Ofili has restricted his palette to the colours of Marcus Garvey's design for a pan-African flag, including only Rastafarian colours — red for blood, black for those who have died and green for the lost land of Africa. Which particular set of colours has symbolic resonance for you?

'Young, gifted and black'

No Woman, No Cry has many different meanings. It is an image of a young black woman, which is rare in the history of Western art, except in depicting servants. The questions to ask are why this is so, and to what extent does Ofili tackle this? His art tries to understand the role of images in art, as well as his own religious upbringing (a Manchester-born son of Nigerian parents, he was brought up a Catholic), and to explore how black people are typecast. As Ofili has said: 'It's about beauty, it's about caricature. And it's about just being confused. But at the same time it's about not being uncomfortable with that state of mind.'

THE LAST SUPPER

With the architect David Adjaye, Ofili created a chapel-like setting for a version of the Last Supper, representing the twelve disciples as monkeys, each displayed in a single colour, with Christ in gold leaf. The work was first shown in Venice, a city well known for its Madonnas and rich religious imagery. You can imagine how some critics reacted to seeing the disciples as apes in Rastafarian colours. The work is now in Tate Britain.

CONTEXT
OTHER ARTISTS/FAMOUS FEMALE PORTRAITS

Any image of a single woman inevitably invites comparison with other famous works, from Leonardo's *Mona Lisa*, 1503–06, to the most famous mother in Western art, the Virgin Mary. Ofili has made his own painting of this last subject. *The Holy Virgin Mary*, 1996, was shown in Charles Saatchi's 'Sensation' exhibition, which was

shown in New York between 1999 and 2000. Former New York mayor Rudolph Giuliani tried to have it banned.

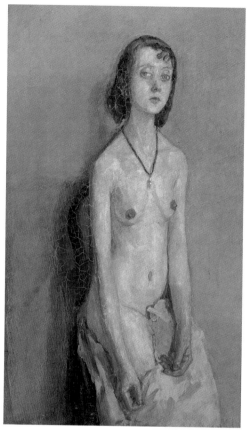

GWEN JOHN
Nude Girl,
1909

Task

Images of women

As a composition, how does *No Woman, No Cry* compare to past iconic images of women?

Step 1: Take, for example, three images:

- the earliest known image of a woman, the *Venus of Willendorf*, 24,000–22,000 BC, a small Neolithic sculpture
- Alesso Baldovinetti's *Portrait of Lady in Yellow*, 1465, of a woman in profile with a highly patterned dress
- Gwen John's small close-toned portrait *Nude Girl*, 1909

Compare and contrast these images, paying particular attention to relevant features, for example, pattern, texture, colour and how the artists do or do not create form.

Step 2: Use that information to work out what might be the intention behind each image.

Step 3: Build up your own image, using those key formal elements you believe to be relevant to representing the image of a woman in the twenty-first century as well as those suited to commemorating the brutal death of a young black man.

CONTEXT
SOCIAL/CULTURAL, THE PROFILE

Ofili's picture is of a woman in profile facing right, a composition used in many Renaissance images (see the reference to Alesso Baldovinetti above). The profile portrait comes from Roman coins and medals. Its use here links the portrayed to the classical past, making the sitter seem more important. At the other end of the scale is a different type of profile with which you might be familiar, the police 'mug shot'. In these photographs, the arrested person is shown facing left, right and forward, usually with some sort of measuring device.

FOLLOW UP

Ofili's art questions assumptions about the white, middle-class bias in art, a theme that comes through in many contemporary artists' work. Notice that he does this through visual language involving colour, presentation and composition, as well as through his

knowledge and understanding of the context and history of art. This is an approach you could fruitfully follow in your own art, as long as you remember that this is a visual medium and that *visual* research is vital for any examination success.

WHERE TO GO NEXT...

DUNG?

You probably won't have access to the dried excreta of one of the world's largest vegetarians, and it would be unwise to use the by-products of other animals. Besides, elephant dung clearly relates to Ofili's art and has, as it were, been patented by him. There are other objects with equal cultural resonance that could illustrate your own cultural standpoint. Toy guns, for example, might be effective in belittling the imagery associated with the rise of gun culture and the prominent role of weapons in rap music.

COLLAGE 1: MULTIPLICITY

Making art using lots of things, none of which easily fit together, is a key technique. Ofili's method of building up an image uses many of the processes seen in Rosenquist's *F1-11* (see pages 70–77). The result in Ofili's case is a density of layering.

You could experiment with constructing different types of collage-like composition:

1 In some of your collage analyses, the images might just touch.
2 In others, there could be a thick layering of images on top of each other.

COLLAGE 2: CREATING SPACE

Many British artists of the 1960s played around with collage. Both Richard Hamilton and Eduardo Paolozzi made careful images out of old photographs and adverts, for example Hamilton's *Just What is it That Makes Today's Homes So Different, So Appealing?*, 1956, or Paolozzi's *Real Gold*, 1950. How does this iconic British Pop art contrast with Ofili's equally British art?

1 In Ofili's approach, the construction of a convincing image from previous parts is not his main intention. Why are Paolozzi and Hamilton using illusionistic space and recognisable objects?
2 Ofili's intention, unlike the Pop artists, is the creation of an almost abstract, intensively busy surface in which not all elements are recognisable.
3 All three artists are involved with their own contemporary society, but remember that Ofili's painting also celebrates the Lawrence family and commemorates the death of Stephen Lawrence. Does this make a difference?

Sadly, there have been incidents similar to Lawrence's murder since. Are these issues relevant to your art?

COLLAGE 3: THE LAYERING PROCESS

Try combining Synthetic Cubism and Rauschenberg's collage technique to build an image.

1 Find images, perhaps scanned or downloaded and then printed, or from newspapers, magazines and flyers.

2 Paste these sources on top of each other onto A1 card. Use PVA glue thickly on the back of each image. Do not worry about exact composition; just build up the surface until it's at least three layers deep.

3 When this paste of images is almost dry, tear through the layers to make new images. Keep tearing and adding more layers until you have an exciting surface, or at least one section of the card, that looks interesting.

4 Now you have to make two decisions (art is all about difficult choices).

 ▪ Often an image made from different papers is difficult to 'read', with textures that distract the eye so that you cannot concentrate on the content. You can solve this by applying a thin wash of colour over the whole lot to make a unified surface.

What the examiner says

Ofili's painting borrows a song title but does not simply imitate it. There will be many songs with which you are familiar and which you might want to use in your art, but an image copied from a photograph of a band would fail most of the examination criteria. It is important that you fully understand the approach that Ofili has adopted. A series of visual analyses, creating a suitable artistic and cultural context from which to take your own visual language, will be the crucial first steps. Ofili's work is made of layers and there are meanings and references on many levels; it is more than an illustration to be taken in at a single glance.

 ▪ The second decision revolves around which area you should focus on. Make a viewfinder with four lengths of paper and place it over the best bit.

5 If you can, photograph or scan that section into Adobe Photoshop or a similar programme. Work through the filters or make a series of layers of your selected area, altering the image to enhance its visual qualities. Save and print the best results, then take them back into the studio as inspiration for your future work.

6 If you don't have digital access, think about scaling up the image to enhance the effect of layering and collage. Choose an area and expand it as many times as you can, at least up to A1.

7 Rework those new images using every method of paint and texture you can find.

Remember that your sketchbook must describe your developing understanding and display your growing visual language and craft skills. In this type of layering, you will be obliterating the layer beneath. This is part of the process, but be aware that your work will be examined. Keep a record of each layer, such as a photograph, a

dumped and printed computer screen or a diagram pasted into your sketchbook and annotated. Point out how each stage relates to critical and contextual studies research to gain suitable credit. You can't just stick in a few pages torn from a newspaper to get the grades your layered ideas might deserve.

SECTION SUMMARY

This section has:

- introduced you to two radically different works as a way of discovering approaches to making art, in particular arranging 'lots of things', either by stacking identical spaces or by collage
- covered key aspects of Minimalism, a period in the development of Modernism
- asked you to think about the importance of colour in representing form, illusion and illusionism
- discussed harmony and multiplicity as ways of describing the arrangement of forms
- introduced you to art that uses a combination of collage and portrait to make contemporary references, thereby introducing social context into art
- covered methods of using collage to make significant art
- discussed the dot as a suitable form to use in a work
- introduced you to the wide range of images of women in art

3.3 'THE POSE'

INTRODUCTION

Section features

Works:
- *Shiva Nataraja*, southern India, possibly Tanjore District, Tamil Nadu c. AD 1100
- Chapman brothers *Chapman Family Collection*, 2002

Genre: history/figure

Formal elements: form and texture

Unit element: final drawings

The last section of this chapter considers the wider context of a work of art, looking at non-European cultures and how the presentation of art affects meaning. Your work will be displayed in a particular context: assessment. Can you use that context as part of your subject?

YOUR WORK IN THIS UNIT

At this point in the unit system, you are bringing all your ideas together to make a 'final piece'. Remember, for your critical and contextual studies to make any sense, your understanding of the work of others should be evident throughout your sketchbook, not least in the final phase.

These two works produce powerful imagery. Both are sculptures, but there is nothing to prevent you working in any other medium you choose. Always try to work in a medium that challenges you, but be certain that you are confident in the use of your chosen materials.

THEMATIC OVERVIEW

This section looks at two radically different forms of figurative sculpture and places them in their cultural context. *Shiva Nataraja* is a Hindu piece. Hindu sculpture depends on particular stances, often of dancing figures. This section investigates these stances to find ways of making your own art and to widen your understanding of art involving figures in general. The Chapman brothers' work is different in that it depends on thinking about how and where works of art are displayed, and on Western cultural assumptions about art that comes from other cultures.

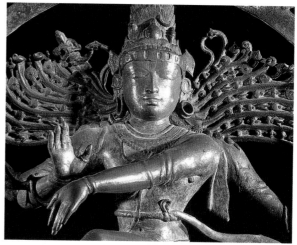

Shiva Nataraja (detail)

What the art historian says: outer forms

'Of great significance in India is the belief that outer forms can be assumed at will; divinity expressed as a transient form is a fundamental concept of both art and mythology. In sculpture this means that the same deity may be depicted in a number of different ways, often simultaneously.'

Dr George Michell, *In the Image of Man, the Indian Perception of the Universe through 2000 years of Painting and Sculpture*, Arts Council of Great Britain, 1982

FOLLOW UP

You should make annotated records of the experiments that lead to your 'final piece', the sketchbook being as good a place as any to keep them. These records should be more than a long list of sentences starting 'and then I did…' Answer these questions as you go:

- Why am I using these materials?
- How do the results relate to the theme I am tackling?
- How do the results relate to the work of other artists I have been looking at?
- What do I expect the next experiment to achieve?

Keep those records as visual as possible — annotated photos or diagrams are a good idea. Avoid unsubstantiated opinion. 'I really like it' is an opinion that doesn't tell an examiner anything. 'I really like it because…' is the start of an attempt to substantiate that opinion.

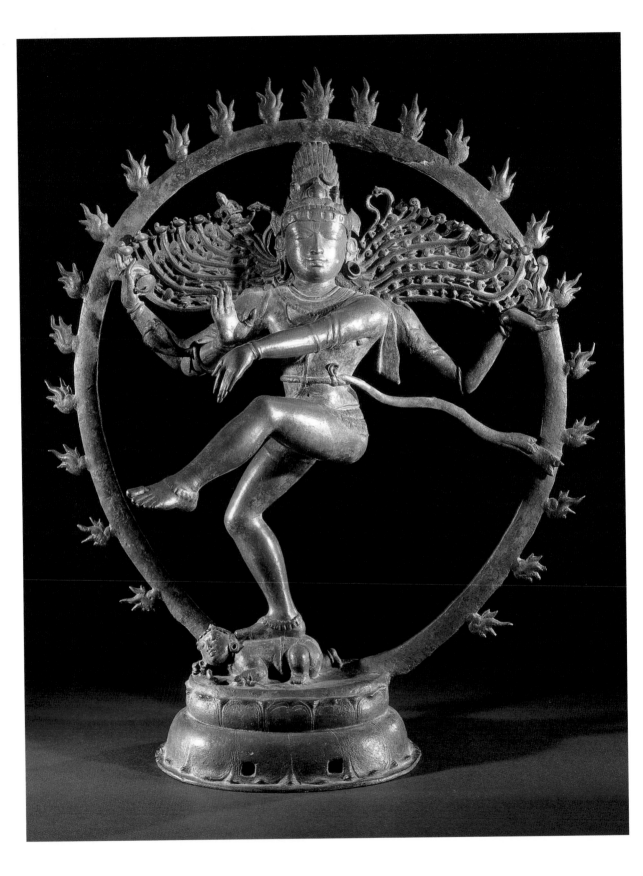

Shiva Nataraja, southern India, possibly Tanjore District, Tamil Nadu *c.* AD **1100**

THEMATIC OVERVIEW

Alongside the Western European sculptural tradition, there are equally long traditions of representing the human figure in other cultures. In Buddhist, Jain and Hindu sculpture, the sculpted figures are gods, goddesses and demons shown in visible form. These images illustrate the divine, based on the idea that the gods and truth (whatever that might be) lie behind our ordinary visible world.

Detail

The figure shown here was made to sit in splendour in a temple. *Shiva Nataraja* is one of many Chola Hindu bronzes made to be kept deep inside a temple, yet it is now isolated from the world in a case in the British Museum. The Chola period,

What the examiner says

As you enter the final phase of a unit of work, it is crucial that you continue to make connections between your own work and the work of others. Students often make these connections clear in their final evaluation (see 'How to evaluate your work' in chapter 6, page 236) and you should do the same yourself. It would also be sensible to make references to other artists throughout the construction of your 'final piece'. Try to make it a general rule that there is such a reference on every double page of your sketchbook.

between the ninth and thirteenth centuries in southern India, was a period of considerable wealth.

TECHNIQUES

Hinduism has a complex set of beliefs demonstrated in a vast series of stories; Shiva is one of the three central Hindu gods. In Hindu sculptures, gods and goddesses tend to have bland symmetrical faces, arched eyebrows, clear sharp noses and full lips. This creates an idealised image of a calm figure, one who might be involved in deep thought. Even if we are not Hindu, these sculptures are relevant to us as artists researching images of the human figure because of the way in which (as with any story) key aspects of the narrative affect how the central figure is shown. Showing many arms, for example, makes the figure look superhuman, the exact position of the arms and what the hands contain being crucial.

Shiva is shown in one of his many forms here, as the Nataraja or Lord of the Dance (Nata = dance, Raja = king). There are three elements to this sculpture that might be relevant to your analysis and your own art:

- He is inside a circle of flames, representing not only the whirling activity of the whole cosmos but also the circle of time that has no end.
- Shiva is a destroyer and a creator, the god who controls the start and finish of time cycles. He is a dancer, ending one life cycle and bringing in the next.
- The work demonstrates a different, circular concept of time to the Western linear system, which believes that time only goes forward.

COMPARE AND CONTRAST

When looking at an unfamiliar piece of art, it often helps to compare and contrast it with another work. This sculpture, for example, is made in bronze using the lost wax method. You could compare the lost wax method of moulding (see 'Key terms', page 271) to other sculptures, for example Marc Quinn's *Self*, 1991.

What the art historian says: individualism

We do not know who made this bronze. Hindu art does not value individual talent in the Western manner of following the development of a single person's artistic style. Ever since the High Renaissance (Michelangelo, Raphael, Leonardo), Western art has depended on the notion that what is on display is in some way the genuine outpourings of a uniquely talented individual. Does this sculpture's anonymity affect how you view it?

Self is a moulded frozen head made from blood; in theory, it is a perfectly made, three-dimensional self-portrait. Over a period of 5 months, Quinn had eight pints of blood taken from his own body; the average amount of blood in the human body is eight pints. This blood was poured into a mould Quinn had made of his own head and then frozen (the refrigeration unit serves to keep the sculpture frozen solid). Traditionally, a portrait head would be placed on a plinth (see page 52) and Quinn's presentation of *Self* makes some reference to that tradition. The moulded head sits on a white stack (resembling a plinth and housing the refrigeration unit) and within a glass case. This means that, although *Self* is a work that involves technology and modern artistic techniques, such as shock tactics, it is in fact a traditional presentation.

FOLLOW UP

After comparing and contrasting *Shiva Nataraja* and *Self*, what points of contact can you find between the two works? Ask yourself the following questions:

1 How are both works presented to the viewer?

2 How was each work made, and did that making affect the form, texture and composition of the final object?

3 How does each work approach its own cultural or artistic traditions? Shiva, as Bhairava, one of his manifestations, offered his own head as the ultimate gesture of surrendering the self. Self-decapitation has a long history as a Hindu image. How does this compare to Marc Quinn's *Self*?

4 Can you use any of this knowledge in making your own art, whether three or two dimensional?

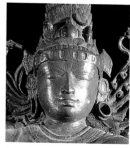
Detail

COMPOSITION
CONTRASTS

Shiva is often worshipped as a single standing pillar, known as a *linga* or *lingam*. This is a male symbol, sometimes displayed in temples next to a female symbol, the yoni. The union of opposites, male (*purusha*) and female (*yakshis*), is represented on earth by Shiva and his bride Parvati. Shiva is a god who brings together

What is an ascetic?

An ascetic denies himself or herself luxuries, food, shelter and possessions in the search for a higher spiritual life. Dancing is often part of this search, the ascetic dancing until he or she reaches a mystic state. Matted hair is associated with holiness and penitence, showing that the ascetic concentrates on more than mere appearance. Rastafarians in Jamaica adopted dreadlocks for the same reason. Asceticism is an important part of many faiths. In Christianity, Christ lived in the wilderness without food for 40 days and many Christians have copied him. Mary Magdalene is supposed to have lived alone in a cave in the French Alps after the crucifixion and images of her sometimes show long matted hair.

contrasts: day and night, life and death. This notion of contrast is clear throughout this work — the god is wearing male and female earrings.

The composition shows Shiva, as Supreme God and Lord of the Dance, in the Anandatandava position. Starting from the statue's top right, the viewer can see that:

- His hand holds a double-sided drum, a *damaru*. The beat of the drum starts the cycle of creation. The drum is made from the top part of two human skulls joined together with skin stretched over them. A stone or pellet attached by a string sounds the drum when it is spun.

- In his upper left hand, Shiva holds the opposite of creation, the flame of destruction. The god is shown overcoming the opposite sides of his nature, destroying one time cycle to create the next.

- His lower left hand points to his instep, where the worshipper might be safe, and to the dwarf of ignorance, Apasmara, on whom he treads with his right foot. By treading on one of his small followers, in this instance the personification of

ignorance, the sculpture reminds us that, beyond these clashing opposites, there is a higher unified reality.

- Shiva's lower right hand is posed with its palm toward us in a position called *abhayamudra*, which indicates that those who worship him should not be frightened of him.
- Within his wild flowing hair (*jatamukuta*), usually shown in a form of dreadlocks to symbolise that he is an ascetic, is the goddess of the river Ganges, who symbolises fertility.

FOLLOW UP: HAIR

Try finding contrasting representations of hair in art and advertising media. Then make your own visual researches of different hair types and arrangements under a series of contrasting titles: young/old, deep thought/frivolity, ascetic/rich.

CONTEXT
SOCIAL/CULTURAL

Indian figure sculptures have a series of distinct typical features. Some of their relevant characteristics are listed here:

- The underlying belief was that the more beautiful the figure, the more likely the gods would come down to earth and inhabit these earthly representations.
- The figures are usually standing, making meaningful gestures, particularly with the hands, which display divine beauty.
- The gods have broad shoulders, wide chests and slim waists, with the stomach slightly overhanging the belt.
- The goddesses have elaborate headdresses and jewellery, large round breasts, slim waists and wide hips.
- There is little attempt to show musculature or 'naturalistic' representation since these are images of perfect beauty.
- The stance of the figures is important. They appear to be holding their breath, because breath (*prana*) is the essence of life, and the control of breath is central to religious discipline.
- To further emphasise their superhuman nature, the standing figures bend at three points (the '*tribhanga*' pose): neck, shoulders and hips. The figures have many heads and/or arms, their multiple positions often being derived from dance, so as to make the poses even more graceful.
- Facial features are stereotyped, inward looking. Rarely do the gods leave their supernatural plane to directly engage the viewer. The faces are unnaturally calm, although some of the more bloodthirsty gods, such as Kali, have protruding eyes, long fangs and tongues dripping with blood.

Shiva and the chariot, part 1:

Remember that Shiva is both a creator and a destroyer. In the Mahabharata, in which many of the great Hindu myths are collected, the gods order a chariot for Shiva to destroy the triple cities, or worlds, of the universe — earth, sky and heaven. To make the chariot the gods bring together all the elements that had been dispersed at the first creation:

'The world-protectors, the rulers of the gods, water, the dead, and wealth, were made into the horses, and the snakes and others became bands to bind the manes of the horses. The day proceeding the new moon, the day after the full moon, the day of the new moon and the day of the full moon — these auspicious days they made the traces of the horses and the riders and the leather neck strap. Action, truth, asceticisms and profit were made the reins; mind was the base, and speech the chariot's path. Banners of various hues and patterns fluttered in the wind, and the chariot shone forth brilliantly, as it was girded with lightning and rainbows.'

Hindu Myths, translated by W. Doniger, 1975, page 132

FOLLOW UP: FACES

Try comparing the characteristic facial features of Indian sculptures with Western representations. Analyse those methods that represent thought, contemplation and spirituality. Try contrasting these quiet emotions with wilder expressions of feeling.

CONTEXT
OTHER IMAGES OF SHIVA

These are some of the other forms in which Shiva appears:

- In abstract form, as a single, plain standing pillar, called a *linga* or *lingam*, usually put inside the temple.
- Shiva can also be seen in several human forms, sometimes as Bhairava, a wild man in a landscape accompanied by his dog. Bhairava was known for the worst of crimes, that of cutting off one of the five heads of the god Brahma; the fifth head was stuck to Bhairava's palm as he wandered the earth.
- Shiva may also be seen as Dakshinamurti, the wise, peaceful teacher or guru. Dakshinamurti is shown as a young ascetic, often seated, with matted hair and sometimes with four arms. He is usually near a tree, which in Buddhist theology is where the guru sits to give out wisdom.
- Shiva is often shown with his consort, or female partner, Parvati. Sometimes images of Shiva physically combine him with Parvati, for example *Painting of Ardhanarishvara*, late eighteenth/early nineteenth centuries, in which we can see both male and female sides combined. Shiva makes up one half of the figure (on the right, or male side). The male side is largely white and the river Ganges flows from his dreadlocks. On the left (female) side, Parvati is mainly red in colour and carries a lasso. Together they sit on a lion skin and in front of them is a bull, another of Shiva's symbols.

■ In what are sometimes called 'holy family' images, Shiva, the male figure, is wrapped in snakes, while the female figure sits on a tiger skin holding an elephant-headed child (her son Ganesha). Their son the six-headed Skanda stands next to them with a peacock. Try comparing these holy family images, in which all Hindus know the meaning of each complex component, with Western images of Joseph, Mary and the infant Jesus.

FOLLOW UP

Shiva is a god of many contrasts, not least in his combination of male and female qualities. You could make a series of investigations yourself, based on the theme of combining male and female attributes in one coherent whole. Remember also to pay attention to the left and right sides of that whole.

WHERE TO GO NEXT...

POSES: EAST AND WEST

Looking at figures and their poses would be a logical route to pursue after this analysis. When setting up poses for figure drawing, compare the traditional contrapposto stance (derived from classical Greece) of the European figure tradition (i.e. one foot in front of the other, weight on one leg, head slightly turned) with the classical Indian '*tribhanga*' or three bends position. If you can, use a model.

POSES: HANDS AND GESTURES (*MUDRAS*)

It may be easier to concentrate on the language of hand gesture, known as '*mudras*'. This is a vast area both in Indian and other non-Western cultures. Examining the role of gesture in Western narrative paintings could be equally fruitful, for example the positions of the Madonna's hand as she makes a blessing in Leonardo's *Virgin of the Rocks*, 1508. It would be sensible to make drawings comparing hand movements from various cultures, but aim to move beyond those

Shiva and the chariot, part 2

'They made the body of the chariot out of the goddess Earth, garlanded with spacious cities, the supporter of all creatures, with her mountains, forests and islands. Mount Mandara was its axle; the great rivers were made its shanks; the regions of the sky and the intermediary directions were its cover. The dynasty of constellations became its shaft; the Krta Age became its yoke. The supreme snake Vasuki became the pole to which the yoke is fixed.'

Hindu Myths, translated by W. Doniger, 1975, page 131

PABLO PICASSO
The Three Dancers, 1925

first drawings to consider the results of those gestures. For example, what mark making materials could you hold in your hand as you make a particular gesture and on what medium could you work? Fine inks on cream paper for *abhayamudra*, perhaps, blue paint on canvas for the gestures of the Madonna, and so on.

DANCE: EAST AND WEST

There is a European tradition of gaining inspiration from dance (see the works of Degas), which could be compared with the long history of Indian sculpture and dancing gods. Are the positions the same? Could you draw Shiva in pastels in a Degas-like manner or a ballerina in the '*tribhanga*' position?.

Alternatively, analyse a Western artist like Picasso and his aggressive imagery of dancers. Look at *The Three Dancers*, 1925. This is a painting full of the knowledge of the suicide of Picasso's friend Cassegmas, who had been rejected by a dancer; the dancing figure on the left looks especially horrific.

Step 1: Try examining *The Three Dancers* by looking at the arrangement of limbs, the violent angles they make and the way in which Picasso has emphasised his theme through the use of paint and texture.

Step 2: Now compare Picasso's work with the limbs and circle of Shiva Nataraja. You might do this by making an outline diagram of one image and superimposing it onto the other.

Step 3: Take another copy of the superimposed diagram and block out parts of one diagram to emphasise Picasso's aggression and the wildness of the dance. On the other diagram, bring out the Chola sculptor's elegant combination of limbs and gesture.

Step 4: By making further drawings, bring out Shiva's characteristic combination of male and female as opposed to Picasso's violent clash of the sexes.

Step 5: Can you use these two new images as the basis for work of your own that continues this sort of analysis?

POSES: CONTEMPORARY IMAGES OF SHIVA

It is worth searching out popular Hindu prints of the various manifestations of Shiva. They use powerfully strong colours and a rather cloying range of images, but it is worth comparing them with Western figurative imagery.

Step 1: Analyse how these prints work and what systems the artists have used to represent form.

Step 2: What is the characteristic range of colours, the palette, that is used in these prints?

Step 3: Try applying that visual language to your own figurative images taken from direct observation of the figure or suitable symbols.

Step 4: If possible, find work of the Singh sisters, British Sikh twins. The sisters work in the Indian miniature tradition but take images of celebrities like Beckham or Madonna and paint them as though they were Hindu gods, with many arms and all the right attributes.

POSES: CLOTH

Shiva Nataraja has a long scarf flowing from his waist and a fold of cloth over his right shoulder. You could relate this depiction of cloth to three Western examples:

1 Folds of cloth in Byzantine art are schematic. Look at the mosaics of San Vitale in Ravenna, Italy, such as *Emperor Justinian with his Retinue* (sixth to seventh century AD). In this early Christian mosaic, the long folds of clothing hang in parallel vertical lines, making a rhythmic geometric pattern and giving little sense of the figures underneath.

BERNINI *The Ecstasy of St Theresa*, 1645–52

2 The ultimate sculpture featuring moving drapery is Bernini's Baroque work *The Ecstasy of St Theresa*, in which an angel in wet-look billowing drapes is holding an arrow that has pierced the heart of the saint. Theresa is surrounded by huge quivering folds of heavy marble cloth that lead the viewer's eye to her heart.

As part of your study of Shiva, make comparisons between images of cloth in art in your sketchbook, then analyse pieces of actual cloth to replicate the emotions and techniques you have seen in the art.

Chapman brothers

Chapman Family Collection, 2002

THEMATIC OVERVIEW

The intention behind the *Chapman Family Collection* is different to that of the work already covered in this book. The visual language is important, but ultimately it is only a small part of the art. What matters more is why the figures are there; you will need to examine how art works are acquired and displayed, particularly those from other cultures. The *Chapman Family Collection* asks questions such as:

'CFC78396086'

- How have curators displayed such work in the past? Does that display affect our understanding?
- How have artists used work from other cultures in the past and now?

What the critic says: contemporary artists and craft skills

The Arts and Crafts movement of the late nineteenth century believed that 'handcrafted' objects, made slowly and skilfully by hand, produced things that were morally and aesthetically superior to those made by machine. This in turn led to a belief in the moral superiority of the craft worker and of the person who bought that craft. The Chapman brothers appear to deny all of that; much of their work is genuinely unpleasant and offensive. They have said: 'When our sculptures work they achieve the position of reducing the viewer to a state of absolute moral panic...they're completely troublesome objects.'

- Is there a similarity between this use/display and the racism that often occurs between different cultures?
- Is this the same racism that underpinned slavery and the colonialism that took such art in the first place?
- Who benefits from the displays of work from other cultures? Is it the people who made them? Where did the work come from? How did it get there? Should that journey affect how we see the art?

These are big questions, but art, notably contemporary or 'modern art', looks at how we live, how we look at art and, significantly, asks the question: what is art for?

'CFC79309302'

TECHNIQUES

The Chapman brothers make all their own work. The 33 figures in the *Chapman Family Collection* are hand carved from wood, a traditional skill, and the work is of a

high standard. These objects are pastiches, made from a variety of sources or deliberately made in a familiar style so that the elements of that style might be highlighted.

COMPOSITION

'CFC76311561' is part of a larger assortment of carved wooden figures; the presentation of these figures in dimly lit glass cases is part of the work. Their exhibition is designed deliberately to remind the viewer of the sort of display you would find in a museum, rather than the white cube of the art gallery. In particular, it recalls the sort of museum that shows anthropological exhibits.

If you look more closely at the sculptures, you will see that they all have references to McDonald's, either to the linked golden arches motif or to Ronald McDonald. Why? Notice also that the long number, 'CFC76311561', which looks like a scholarly reference number, is in fact the phone number of a London branch of McDonald's .

What the examiner says

To find contemporary artists using high-quality skills themselves is unusual. A lot of contemporary art is made by skilled workers other than the artist. The role of the artist is often to work on ideas rather than materials. Do not get seduced by this practice yourself since it is not one you can use in your examination. It has to be your own unaided work that is examined.

INFLUENCES
OTHER ARTISTS

The Chapman brothers have always made some sort of reference to the history of art. In another work, *Insult to Injury*, 2003, they took an edition of famous prints by the Spanish artist Francisco de Goya and 'improved' them. The changes included drawing puppy heads and clown faces on the original prints, which are a horrific and violent series of images of what men do to each other in war.

MODERNISM AND AFRICAN ART

Apart from McDonald's, the other important reference in the *Chapman Family Collection* is to the role of 'primitive' art in the development of Modernist art, especially Cubism. African art had been seen in Paris from the 1890s, not only in the museums but also in local shops. Such objects would have been brought back from the French colonies, mostly those in central Africa. The best-known European use

of African art appears in *Les Demoiselles d'Avignon*, painted in Paris by Picasso in 1907. If you look at this crucial painting, you will see that two of the faces display 'African-ness', probably absorbed from carvings that Picasso had been looking at. The simplification and use of powerful line evident in African and Oriental art was something that Matisse probably first investigated by looking at sculptures from the Congo. It was these sculptures that Matisse subsequently showed to Picasso.

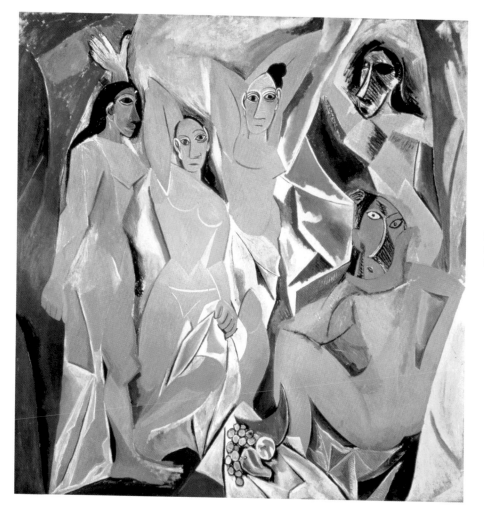

PABLO PICASSO
Les Demoiselles d'Avignon, 1907

FOLLOW UP

We are increasingly dominated by mass consumer culture, a culture that largely comes from the USA. Products like McDonald's and Coca-Cola are completely bound up with US identity. To make this cultural dominance clearer, think of an English product that creates a similar patriotic glow and identification with the home country. Is there one? If so, how would you represent it in an art work?

What is anthropology?

Anthropology is the study of humankind, the investigation of the behaviour and activities of other cultures. The *Chapman Family Collection* looks like it is from a museum that displays sculptures and objects from the past. Such objects would have been collected as examples of 'primitive' art, art made by peoples and cultures supposedly less sophisticated than the people who took the work and colonised those countries.

CONTEXT
SOCIAL/CULTURAL

THE OTHER

Why was non-European art so relevant to these early Modernist artists? During the later nineteenth century, European powers had been stripping Africa and dividing it up into colonies; slavery was only outlawed in 1863. Africa stood not only as a Europe's opposite, but also as an exciting concept for avant-garde artists looking for something other than illusionism to represent the quickly changing world around them.

Darwin published *On the Origin of the Species* in 1859 and *The Descent of Man* in 1871. In the post-Darwinian age, Africa — or the dark continent, as it was known — was also seen as representing Europe's childhood, a place without scientific rationalism and the laws of reason. Describing Africa as a continent that had, apparently, not evolved meant that artists and writers could imagine it to be the opposite to Europe and a place of uncontrolled sexuality.

The psychologist Sigmund Freud, an important influence on the later Surrealists, used this familiar image when he called women 'the dark continent'. African art was useful for late-nineteenth and early-twentieth century artists, not just for the excitement of the new shapes and ways of representing the figure that it showed them, but also because it represented something disturbing and completely apart from the usual European way of behaving: the 'other'.

PRIMITIVE?

It is here that we need to acknowledge the inappropriate use of the word 'primitive'. Much of the African art plundered by the colonial powers and displayed in European museums was, until relatively recently, labelled 'primitive'. This term depended on a series of false assumptions, mostly on the racist notion that the societies and people that produced this work were in many ways lower down the evolutionary scale and therefore less sophisticated. For artists, this might have meant that Africans were closer to the true emotions of humanity, but for others it meant that they were further away from 'civilisation'.

THE INFLUENCE OF AFRICAN ART

The interest in African art shown by the Cubists, Expressionists and Post-impressionists led to new treatments of the human form, for example the characteristic angular, almost detached planes of Cubism and Expressionism. This in turn led to the new use of space in art and the rejection of the conventional perspective that had characterised art since the Renaissance. It is this progression that the Chapman brothers are satirising by combining African art and McDonald's references. They are also bringing our attention to US cultural behaviour in the twenty-first century.

At this point, you could ask the following questions:

- Are the Chapman brothers making a successful combination of past themes?
- Do you think the points are worth making, or is this art made solely to annoy as many people as possible?

What the examiner says

Some aspects of the Chapman brothers' work are unsuitable for examination at AS/A2; there is a limit to the number of people you can successfully offend in order to get a higher grade. There are useful aspects, however; the Chapmans are not the only artists interested in the combination of craft, colonialism and pastiche.

WHERE TO GO NEXT...

SHONIBARE AND GAINSBOROUGH

Look at work by Yinka Shonibare, the Nigerian-born British artist. His trademark is bright African cotton fabric prints, such as *Mr and Mrs Andrews Without Their Heads*, 1998, a three-dimensional remake of a famous painting by the British artist Gainsborough. The original has been argued over by art critics for years, notably by John Berger in his key text *Ways of Seeing*. While critics disagree about Gainsborough's painting, they all think it indicates Britishness and the role of ownership. It is likely that some of Mr Andrews' income came through trade, which during this period relied to a large extent on slavery. By remaking this iconic image but dressing the couple in African print and displaying the mannequins without heads, Shonibare is asking many of the same questions as the Chapman brothers. He also inserts the notion of the personal identity of black Britons, not dissimilar to the ideas in Ofili's work (see pages 109–11). Analysing the work of

Shonibare and the Chapman brothers could lead to combining well-known art work with new patterns, objects and visual languages to make it relevant.

Step 1: Take an art work that you know well.

Step 2: Think about the issues that might apply to it. When was this work made? What are the social/cultural issues that surround it, particularly those to do with ownership?

Step 3: Now think about the issues that surround your own wider social and cultural identity and the visual forms that might bring those identity issues to mind.

Step 4: How will you start to combine them?

As always, remember to state your intentions and to document each step in your sketchbook.

What the examiner says: texture

You would be surprised at how many students ignore the role of texture, both in the form they are analysing and in the subsequent representations that they make. Even changing the thickness of a brush stroke can tell you something about how a form turns under light, or what the mass of a form might be. Always remember that all forms, however abstract, have some sort of weight and that texture can help describe what that might be.

SCULPTURE AND BRANDS

The *Chapman Family Collection* involves wood carving, a fine technique but one that involves considerable practice. What other technique could you use?

SECTION SUMMARY

This section has:

- analysed sculpture in such a way as to lead you into working in a wide variety of three-dimensional techniques
- looked at ways in which you might represent the figure in both two and three dimensions, working from one medium into another and back again in order to produce exciting results
- paid particular attention to the importance of non-Western cultures, showing how less familiar myths and stories can provide new visual languages while still allowing you to make art about personal themes
- introduced you to some of the complex issues involved in looking at art

CHAPTER SUMMARY

This chapter has:

- looked at the history painting Genre and explained how the figure has been treated in art
- considered how abstract art can imply the presence of a figure through the proportion or arrangement of its elements, such as Donald Judd's *Stack* and its similarity to vertebrae
- showed you different ways to arrange figures, and how the methods of making art that you might select to represent those figures can contain a range of meanings

- looked at the formal elements of form and texture, demonstrating how analysing and creating form is one of the fundamental skills of any artist
- looked at many of the ways in which artists have 'put lots in' their work, from the piling up of stuff in Guston's painting to the decorative collage methods of Ofili

FOLLOW UP

We live in a crowded, busy world in which images come at us constantly. If your art is to reflect your own culture and society, then experimenting with techniques for building up imagery would be a productive way to start.

FRAGMENTS: HOW ONE ARTIST USED THE PAST HISTORY OF ART

The artist Alison Lapper has the congenital disorder phocomelia, which means that she was born with no arms, with legs without knees and with her thigh bones ending at her feet. Marc Quinn has designed a 3.5 metre-high marble statue of her. *Alison Lapper Pregnant* was temporarily installed on the vacant plinth in Trafalgar Square, London, in 2005. At first, the statue appears as a celebration of physical difference. Quinn has said, however, that 'I'm very, very happy that it should help the cause of disabled rights. But that's not why I made it. It's not an agitprop piece. I always hope my work will be seen in a way that surprises me and to be honest this one has been.'

Like most art, this statue comes out of ideas about other art. Quinn had been walking around the British Museum looking at the Parthenon frieze. He said, 'the marbles are full of people with missing arms and legs, fragments that are regarded as beautiful because they are old. But I found myself thinking, "If someone like that actually came into the room, the public would pull away its children and leave. Men get their girlfriends to pose in front of the Venus de Milo as a kind of ideal of feminine beauty, it's as though they think her upper arms are missing on purpose, that she was made like that".' His own sculpture *is* made like that: 'Her torso is absolutely the same as the Venus de Milo's. The same set of the shoulders, the same balance of the vestigial arm on one side and no arm on the other'.

Parthenon sculpture, fifth century BC

As Alison Lapper put it, 'he (Quinn) said that old sculptures where the limbs had fallen off through the wear and tear of time have come to receive an unconditional acceptance of their beauty. He wanted to make equally beautiful sculptures of people who had been born naturally without limbs. What's the difference?'

COURSEWORK WATCH: 'HEADROOM' AND 'SNAGGING'

As you plan each unit, it is worth making sure that you have enough time to include new knowledge. Don't forget that you can always go back to coursework sketchbooks and add new information or redo work. For example, what you learn in one coursework unit might well be relevant to another and may help explain what you were trying to do in that instance. Alternatively, you might have learned a new technique that will serve to improve the quality of an earlier final piece. Unless you leave enough time, it's not possible to make such additions.

Project managers on large construction sites talk about building 'headroom' into their plans for a building. By that they mean allowing extra time at the end of a project. Headroom means that any delays can be fitted in, or that they can carry out 'snagging' — that is, checking that all problems or 'snags' have been sorted out. Make sure you build in headroom to allow for snagging.

CHAPTER FOUR

LAND: COLOUR AND PATTERN

'BEYOND THE BLUE HORIZON'

THIS CHAPTER FOCUSES ON...

- traditional landscapes. Can you use them to improve your own art? We widen the definition of 'land' to include views of the world, and our behaviour in it, as much as views of countryside
- colour in art, from the traditional uses of colour through to Divisionist attempts to mix colour in the eye, finally analysing some symbolic presentations of colour in art
- the function and methods of war art, asking if strong imagery is the best way to describe man's inhumanity to man
- the view that past art has often ignored art by women. After considering this theme you will begin to answer such questions as whether the gender of the artist matters

THIS CHAPTER INTRODUCES THE FOLLOWING TECHNIQUES...

- the analysis and combination of colours to enable you to use them effectively in your art
- the application of colour in block and thin layers to describe the effect of light on landscape
- the use of a variety of methods in front of a landscape that you can later work up into larger images
- the various methods employed by the photographer Shirin Neshat, including digital manipulation of imagery

BY THE END OF THIS CHAPTER YOU WILL BE ABLE TO...

- use a range of colour systems to describe landscape and the experience of being in the landscape

Key words for this chapter

additive colour

additive mixing

complementary colours

cropping

divisionism

en plein air

hue

intercolumniation

local colour

palette

repoussoir

secondary colours

subtractive mixing

- demonstrate an awareness of the different formal and symbolic ways of using colour in art
- understand the importance of context in making a work about land
- understand the context of those artists you are analysing and how you can use your own context as one of the elements in your art
- show an awareness of the role of gender in looking at and making art

INTRODUCTION

This chapter begins by considering traditional landscape paintings and the illusion of pictorial space or depth.

LEONARDO DA VINCI *Virgin of the Rocks*, 1508

LANDSCAPE AND DEPTH

In early Renaissance art, landscape served to fill part of the background of a painting, only occasionally becoming part of the subject itself, for example the Garden of Eden. As the history of art developed, landscape became an important subject in itself, one of the Genres, and artists established a range of methods to represent it. One of the crucial processes artists use is the representation of depth.

AERIAL PERSPECTIVE AND SFUMATO

Aerial perspective has been used throughout the history of landscape painting to create depth. Leonardo da Vinci, for instance, used sfumato, or smokiness, in his paintings. This is a blurriness that recreates the atmospheric effect of haze and loss of contrasts on the horizon. Sfumato is often combined with a range of blues to improve the illusion. Try these methods yourself.

> **Task**
>
> ### Discovering two methods of describing a landscape
>
> **Step 1**: Find a view that has potential.
>
> **Step 2**: Create a careful tonal study, making the background dark and unfocused.
>
> **Step 3**: Think of a story to fit into this view.
>
> **Step 4**: Redraw the view, removing all tone and making the important elements of the story the largest in the composition.
>
> **Step 5**: Compare the two images you have made to da Vinci and di Paolo.

Who influenced whom?

Jean Wainwright: Are there other artists who have influenced you or you feel that are powerful or provoke you?

Tracey Emin: Loads — like Bruce Nauman, Frida Kahlo, van Eyck, Vermeer and Jackson Pollock. There are a couple of Rothko's I wouldn't mind owning. It's a really mixed up, diverse taste, it's not what people would naturally think it was. I think all the artists I have mentioned are quite sexy.

Tracey Emin in conversation with Jean Wainwright, *The Art of Tracey Emin*, ed. M. Merck and C. Townsend, Thames and Hudson, 2002

FOLLOW UP

Sfumato

To understand how sfumato creates depth, compare Leonardo's *Virgin of the Rocks*, 1508, with an earlier landscape painting, such as Giovanni di Paolo's *St John the Baptist Retiring to the Desert*, 1454. Notice the clear focus and sharp rock edges in the earlier painting and how different it is to the Leonardo, where the blue rocks in the upper left become paler and less distinct. The figures in the di Paolo painting are too big for the cliffs around them, telling us that this image is about the *idea* of landscape, rather than the *fact* of landscape that makes up Leonardo's rock forms.

Colour in art

Clearly, colour is a crucial element of any art work. 'Colour expresses something by itself,' as van Gogh said, and the repetition of similar forms (i.e. pattern) is, like texture, an element in successful art that is often ignored.

Colour has a place in nearly all work in art and design, and therefore you should have, and be able to show, a working knowledge of colour systems. Your sketchbook is a good place to do this. Analysis of colours used by other artists must be part of the annotations you make and part of the analyses you carry out when creating your own art, such as colour studies when making a still life, flesh tones from figure studies and so on.

Colour also has symbolic roles within art. The Virgin Mary's robe is usually blue, for example. Most cultures give specific colours symbolic associations. In China red is a lucky colour, meaning happiness and joy, whereas for Christians the association of red with blood means that it often becomes a symbol for martyrdom and cruelty.

Pattern in art

The essence of pattern is repetition. This could show itself in the arrangement of folds of cloth; drapery is often a place to look for repeated forms. When analysing pattern look also at the larger forms in a composition such as how figures are arranged. Is there a recurring element in how the artist has placed these large shapes? Purely abstract art, especially Minimalist art, uses repeated forms. Study how these are composed and whether a disruption to that pattern will create a different meaning.

4.1 'AS FAR AS THE EYE CAN SEE'

INTRODUCTION

Section features

Works:
- Georges Seurat *Sunday Afternoon at La Grande Jatte*, 1884
- Joseph Mallord William Turner *Norham Castle, Sunrise*, 1845–50

Genre: landscape

Formal elements: colour and pattern

Unit element: first drawings

In this section we look at colour systems, in particular those that underlie the art of Seurat and Turner. We examine these two artists' different approaches to landscape and discuss how you might tackle a tricky subject like a big view.

YOUR WORK IN THIS UNIT

This chapter assumes that you are at the start of a unit and planning what route to take, the stage we call 'first drawings'. We will be looking at the theme 'land' and working out how the formal elements of colour and pattern might help you. These first steps analyse how Seurat and Turner used the unique properties of those elements and the contexts within which their art was made. Remember the importance of your own annotations, drawings and diagrams; these souvenirs of your journey will be far more important than chunks of copied text.

What the artists say: two views of the colour of shadows

The colour of shadows is a constant theme throughout Impressionist and Neo-impressionist art. Here are two views to set you thinking.

Leonardo da Vinci:

'Shadow is the diminution alike of light and of darkness, and stands between light and darkness. A shadow may be infinitely dark, and also of infinite degrees of the absence of darkness'.

From *The Notebooks of Leonardo da Vinci*, ed. I. Richter, OUP, 1998, page 131

Paul Signac (friend of Seurat and, like him, a Neo-impressionist painter):

'Shadow, faithful complement to its regulator, light, is purple, blue or blue green and these elements modify and cool down the darker parts of localised colour'.

From *Art in Theory: 1815–1900*, ed. C. Harrison, P. Wood and J. Gaiger, Blackwell Publishing, 1998, page 981

Do shadows tend to black as Leonardo thought, or colour as Signac and other nineteenth-century artists believed? Make experiments to find out. How have other artists approached this subject? Try contrasting Cézanne with Caravaggio.

THEMATIC OVERVIEW

Both featured works are defined by their use of colour. The Seurat painting depends on a careful, almost scientific use of colour, so the first part of this section concentrates on definitions of colour and how Impressionists and Neo-impressionists used it. Turner's colour appears spontaneous and less thought out, but he too had a system. That system is discussed here as well as how you might apply it to your own work.

SEURAT *Sunday Afternoon at La Grande Jatte*, 1884 (detail)

FOLLOW UP

For this section, you will need to understand the difference between additive and subtractive mixing of colour.

1 Look up these two concepts under 'Key terms' (pages 265–80). Experiment with the different techniques, making careful annotated notes in your sketchbook to demonstrate your understanding.

2 Make sure that an examiner will know that you are referring to Seurat's *La Grande Jatte*.

3 Be clear about why you are making this study. How does it refer to your own work?

Remember: analyse, don't just describe.

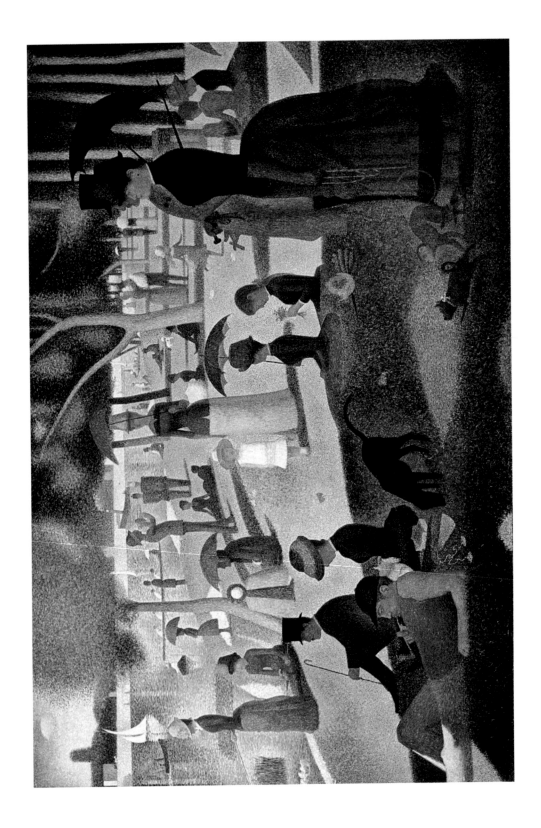

Georges Seurat

Sunday Afternoon at La Grande Jatte, 1884

THEMATIC OVERVIEW

Impressionism was an art movement based around Paris in the second half of the nineteenth century. The Impressionists tried to paint the modern life of the new city growing around them. Their paintings were made quickly, on the spot, in front of the subject. The Impressionists wanted paintings to look like what they could see, and to be brighter. The term they used was 'greater luminosity', and they adopted a range of techniques to find it.

By 1886 they were running out of steam, and at the last Impressionist exhibition that year a newcomer showed a novel style of painting. That newcomer was Georges Seurat, the painting was *La Grande Jatte* and the style became known as Neo-impressionism.

The subject of Seurat's painting is typically Impressionist: Parisians enjoying themselves on a Sunday afternoon on an island in the Seine. There is a mix of social classes, such as the working-class boatman (bottom left) lying near to a lady (see the fan that defines her) and a gentleman in a top hat. According to some critics, the women by the lake are fishing for men, and the monkey is a symbol of wild behaviour. There is more to this view than meets the eye.

Detail

TECHNIQUES

NEO-IMPRESSIONIST USE OF COLOUR

Seurat's semi-scientific theory, sometimes called divisionism, was that colours could be made stronger by 'optical' rather than actual mixing of colour. Think of making a painting of light on grass. Rather than mixing yellow and blue together on your palette ('actual mixing'), try putting yellow and blue patches next to each other on the canvas. From a distance, these patches mix to form a green hue. The intensity of the green is not diminished because, technically, no subtractive mixing has been used.

Task
Studying real and painted grass
Step 1: Divisionism can be more complex than this. Look carefully at the grass in the foreground of Seurat's painting.
Step 2: As different densities of sunlight fall upon the grass, local colours (green for grass) change. Orange can be mixed in between the yellow and blue and the local colour to show the extra layer of colour the eye perceives.
Step 3: Look at the shadows in the painting: blues, purples and greens with dots of yellow and orange to show dappled sunlight. Notice that these pure dabs of colour, if mixed at all, were only blended with white and the dab varied in size according to the scale of the picture and the position of the dab within it.
Step 4: Make a colour study of this section of the painted grass and compare it with your own detailed colour study of a lawn. Try both Seurat's divisionist techniques and more traditional colour-mixing methods.

HOW DID THE IMPRESSIONISTS USE COLOUR BEFORE SEURAT?

The Impressionist Monet used what was called the rainbow palette, a combination of contrasting complementary colours. Monet adopted this method because he believed the brown tones in earlier landscape art were not true to nature. What techniques did the Impressionists use to achieve 'greater luminosity'?

CONTRAST: COMPLEMENTARY COLOURS

Impressionists contrasted colours but did not follow the scientific rules of the Neo-impressionists. Look at Renoir's *Boating on the Seine, the Skiff*, 1879–80 (a skiff is a small boat); it shows an orange boat set against a blue river, each complementary colour straight from the tube. This is an example of the luminosity that his fellow Impressionists were searching for. It came from the pure new artificial pigments that were increasingly available, and from a knowledge of complementary colours: cobalt blue against chrome orange. As Monet said: 'Colour owes its brightness to force of contrast rather than to its inherent qualities...primary colours look brightest when they are brought into contrast with their complementaries'. What helped plein air painting (i.e. outside, in front of the subject) was the invention of the tin tube in 1841; previously, paint had been stored in pigs' bladders that dried out or split. As Renoir said: 'without paints in tubes, there would have been no Cézanne, no Monet, no Sisley, no Pissarro, nothing of what the journalists where later to call Impressionism.'

FOLLOW UP: FADING

The zinc yellow that Seurat used throughout *La Grande Jatte* has faded badly so that the green, yellow and orange have all darkened. The original bright yellow has become closer to yellow ochre, the bright emerald green has turned to olive and most of the oranges have become red/brown. You could take sections of the painting containing these faded areas and rework them to show the original colours.

CHIAROSCURO

Since the Renaissance, artists working in two dimensions have made forms look three dimensional by using a highlight against darkness. This method is called chiaroscuro, the contrast of dark tone, usually made with black, against a lighter one to make a turning form. Look at Joseph Wright of Derby's *An Experiment on a Bird in the Air Pump* (see page 60), and how the artist used bright tones next to darker areas to create the forms of gesturing hands.

Task

Colour wheels

You have probably already looked at colour wheels and complementary colours. Make it clear in your sketchbook that you understand the basic rules and can work with primary and secondary colours. The many different colour wheels are interesting in themselves, but don't spend hours copying a colour wheel. That would be description, not analysis. Instead, take a section of the painting and organise the patches of painting into the pure primaries and the subsequent secondaries that are optically produced in your eye. Apply this knowledge to your own landscapes and views.

HOW IMPRESSIONISTS AND NEO-IMPRESSIONISTS MADE FORM

Impressionists sought only to paint what they could see. If, as they insisted, there is no black in nature, how could they create the illusion of three-dimensional form? The answer lies in the key properties of colour: warm/cold colour and contrasting complementary colours.

WARM/COLD COLOURS

Warm colours, the red end of the spectrum, appear to come toward the viewer out of the picture plane. Cold colours, the blue end of the spectrum, appear to recede, moving away from the viewer behind the picture plane. Put red next to blue and you can start the illusion of form. Analyse the jockey's arm in *La Grande Jatte*. Now study your own arm, just using warm and cold colours, to show this key property.

Task
Colour and edges
Seurat painted complementary colours on the frames of a work, affecting the colours next to them in the actual painting. Attempt this yourself by experimenting with the edges of your colour work. Don't let images peter out into white paper. Try working out the complementary colour to the hue that stands at the edge of your image and paint that next to it.

COMPLEMENTARY COLOURS: SHADOWS

How did Impressionists and Neo-impressionists make shadows? In Renoir's *Dance at the Moulin de la Galette*, 1876, the darkness is not black but violet blue shadow. Why did Renoir choose this colour? Violet, or violet blue, is the complementary colour to yellow as it lies opposite it on the colour wheel. Why yellow? Yellow is the colour of sunlight and sunlight makes this shadow. Painting shadows using colour avoids using chiaroscuro/darkness to build form. 'I have finally discovered the true colour of the atmosphere. It's violet. Fresh air is violet,' Monet said. Do shadows have any particular colour? Experiment outside at different times of day. What is the effect of direct sunlight on cast shadow at midday, compared to late afternoon?

COMPOSITION

HORIZONTALS AND VERTICALS

Generally the figures in *La Grande Jatte* face toward the river, but how does the artist arrange his composition to prevent it appearing unbalanced? One way of arranging a complicated composition is to 'anchor' it with strong horizontal and vertical shapes. Does this happen here?

DOMINANT VERTICALS

- the man and woman on the right
- the trees behind them
- the woman with the orange umbrella

Why are they called complementary colours?

Complement means to make whole. Two colours are complementary if, when added together, they complete the spectrum. Theoretically, if you added pure violet pigment to pure yellow, it would make black. Most pigments, however, are not pure, so you are unlikely to achieve such an effect. The basic complementary pairs are: blue/orange, red/green, yellow/ violet.

- the man to her right with the trombone
- the funnel of the boat behind him
- the smaller figures by the shore
- the woman in a similar orange on the far left of the painting standing on the shore

All these upright shapes anchor the composition and stop it appearing skewed to the left.

DOMINANT HORIZONTAL SHAPES

There are three basic horizontal bands that further stabilise the composition:
- the darker shaded area approximately at the bottom third of the painting
- the sunlit band that takes up the majority of the surface
- the darker green of the leaves of the tree to fill in the top section

The horizontal elements are further reinforced by the mainly horizontal shadows receding into the distance. The effect of these horizontal and vertical features is to make a calm, ordered and almost static image. Seurat continues this theme by

Comparison with the *Bathers at Asnières*

The full title of *La Grande Jatte* specifically mentions Sunday, indicating that the people in this painting are likely to be families. There is a painting in the National Gallery, London, *Bathers at Asnières*, 1884, which is the companion to *Sunday Afternoon at La Grande Jatte*. The bathers are shop workers on their own day off, Monday; they are shown on the opposite bank of the Seine to the one on which we see the families enjoying their Sunday in *La Grande Jatte*.

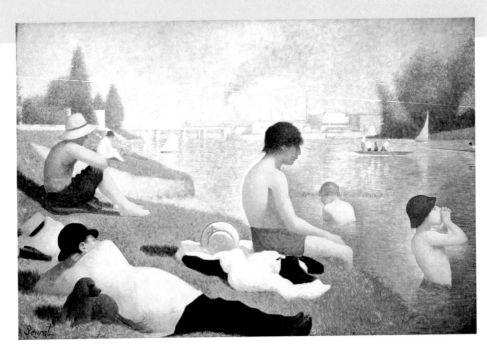

GEORGES SEURAT
Bathers at Asnières,
1884

making the pose of the figures equally solid and unmoving, the figures being shown either from the front, back or the side.

CONTEXT
OTHER ARTISTS/OLD AND NEW

The people in *La Grande Jatte* are self-consciously modern people and wear modern dress (their Sunday best in fact), but this ordered composition makes the figures appear timeless. They look as though they are organised in a frieze or flat arrangement of figures in a procession. They are not really involved in modern behaviour. No one is bathing, there are no large picnics on the grass, nor are there any of the restaurants, cafés or food and drink sellers, all of which apparently filled the Grand Jatte area at this period. Seurat said: 'The Pan-Athenaic frieze of Phidias was a procession, I want to make the moderns file past like the figures on that frieze, in their essential form, to place them in compositions arranged harmoniously by virtue of the directions of the colours and lines'.

What the artist says: not the best way to do your art

Renoir told a story about how Cézanne treated his work. Renoir had gone up to Estaque, a well-known place on the coast where Cézanne also used to paint. Looking at the view, Renoir found an old piece of paper lying on the ground. 'It was one of the finest of Cézanne's watercolours; he had thrown it away among the rocks after having slaved over it for twenty sittings.'

Don't do this yourself. Throw nothing away until you have carefully selected what to submit for examination.

WHERE TO GO NEXT...

COLOUR

The role of colour in traditional painting has been to:
- create the illusion of different depths on a two-dimensional painted surface
- represent the illusion of different types of surface (cloth, fur, skin etc.)
- create a recognisable combination of symbols (blue for the Virgin Mary, red for blood etc.)

To achieve this, painters paid careful attention to the uniformity of the surface of the painting. It had to be even and flat, since any raised areas would catch the light and break the illusion the artist had spent so long trying to create. The exception, of course, would be where the artist used a thick white to create the highlight, the last touch in an illusory painting such as Rembrandt's *A Woman Bathing*, 1654. Make sure that you have some in-depth analyses of artists' traditional methods in your sketchbook before you move on to Seurat's techniques.

SCIENTIFIC USE OF COLOUR

La Grande Jatte used the most recent methods, based on new scientific ideas about colour, to make an image about modern life.

- What are the equivalent subjects and techniques today?
- Is there a comparison you can make between the smallest unit that makes up digital images — the pixel — and the small brush stroke that Seurat uses?
- Take a subject — fashionable clothing, perhaps — and find three different techniques to represent it:

 1 an obviously pixellated image

 2 a Seurat-influenced painting, using small brush strokes and dabs of pure colour

 3 a carefully modulated image that shows no edge between colours
- Can you now combine all those methods in one image?

COLOUR AND EMOTION

Colour has also been used in art to create feeling. To find examples of this process you could compare Rubens and Rembrandt, although it is mainly in art made after Impressionism that the role of colour starts to develop. After Impressionism, colour was no longer restricted to representation and started to include the creation of emotion and mood in the viewer and to be a direct reflection of the emotions and moods of the artist.

- Look at Symbolism as well as Expressionism — even Mondrian's restricted yet symbolic use of colour.
- Set yourself a series of emotions to work with.
- Try using single colours or combinations of colours, first with traditional illusionist techniques and later with Modernist methods.
- Which works best for each emotion and why?

THE DOTS AND THE DABS

It is often thought, wrongly, that Seurat painted in dots. Look carefully at the surface of this painting and you will see that it is made up of a series of small strokes, dabs or touches of pure paint. Observing this could lead you on to an analysis of the role of the brush stroke in art, the actual texture of the paint or material used and, from there, to the effect of both colour and pattern on the viewer.

Step 1: Try comparing van Gogh's brush strokes, e.g. in *Vincent's Chair*, 1888, with De Kooning's huge brush strokes, for example in *Door to the River*, 1960.

Step 2: How would a bright yellow change its characteristics under the working method of each artist?

DE KOONING *Door to the River*, 1960

PARADISE

The Isle of the Grande Jatte is shown as an island in the sun, a symbolic idea that has often been used in art as an image of paradise and freedom, a love island. You could follow this theme further. Try looking at some of Matisse's paintings such as *Luxe, Calme et Volupté*, 1904, or Mark Rothko's large and abstract arrangements of two-dimensional forms and colours, such as *Untitled*, 1950. Many have seen Rothko's paintings as having something to do with spirituality and an otherworldly place. Rothko's art would make a spectacular stepping-off point for a series of textiles on combining colour and pattern along this theme.

Joseph Mallord William Turner

Norham Castle, Sunrise, 1845–50

THEMATIC OVERVIEW

Norham Castle is on the Scottish/English border. Turner had painted it before, and his first versions were clear and precise. As he got to know the scene, he developed his ideas about the landscape, in particular the role of light. This is almost an abstract painting, but made well before Modernists developed abstraction. Is it really just a quick sketch, or is there more to this image?

Detail

Who influenced whom?

Claude Lorrain was the great seventeenth-century painter of idealised landscapes. His images of glorious sunshine and Italianate afternoons were ones that other artists sought to outdo. Turner knew Claude's paintings well and demanded that his own paintings should hang next to Claude's after his own death. There are two framing elements on either side of Norham Castle: the two banks of the River Tweed. These act as the *repoussoir* (see Glossary) used in traditional landscape paintings. Compare this with Claude's *Seaport with the Embarkation of the Queen of Sheba*, 1648, an image which Turner knew well enough to copy.

TECHNIQUES

WHERE IS THE CASTLE IN THE PAINTING?

The thin glaze of blue on the horizon is the castle, the paint being so thin that you can see where it has dripped down the canvas. Turner has used a warmish ground, having painted a thin layer of colour over the whole canvas before he started. That warm, light ground mixes with the darker cobalt blue of the castle, making the blue brighter and linking his range of colours throughout the painting. You can see the ground most clearly in the bottom left-hand corner.

HOW DID TURNER CREATE DEPTH IN THIS PAINTING?

Although the colour is applied in thin washes so as not to create solid forms, it is still employed in the usual way to create the effect of pictorial space. The figure closest to us, the deer or cow, is in a brownish red. This is the warmest colour in the arrangement and therefore the animal will appear closest to us on the picture

Task

Analysing the composition

Although this painting appears abstract, if you make a sketch of the composition and block in the essential elements, you will see that the fundamental arrangement of the composition is traditional.

plane. The blue, as the coldest colour, is used for the pictorial element that is furthest away.

WHAT TIME OF DAY IS IT?

The reflection of the sun in the river brings the composition together and makes the whole painting feel like it is bathed in cool sunlight. Notice that the effect of thin yellow on white is to make the sun appear as cold as it would at sunrise; this is not the blazing red/orange heat of midday.

COMPOSITION

In *Norham Castle* there is a central figure, either a deer or a cow. Cows standing in water were a familiar device in landscape painting. Turner had already used them as a focus in several of his works. The castle is arranged behind this animal to lead the eye into pictorial space and is balanced by the sun above. The sun draws our attention to the role of light in this painting, both as a central part of the composition and as a subject for analysis in itself.

CONTEXT
TURNER, GOETHE AND COLOUR

Turner read a great deal about light, optics and colour theory, in particular the colour theories of the German poet and philosopher Goethe. Turner's copy of Goethe's *Colour Theory* is full of his notes and thoughts. Goethe rejected the scientific approach to colour of scientists like Newton, instead putting forward a system based on opposing polarities of colour. German artists and philosophers were keen on polarities of colour right into the twentieth century. Goethe placed what he called positive colours (particularly yellow) on one side against negative colours (especially blues) on the other. These opposites were compared to states of mind: positive = happiness, negative = anxiety. Turner drew Goethe's table of the opposing ends of the spectrum in his own sketchbook:

Positive	Negative
Yellow	Blue
Action	Negation
Light	Shadow
Brightness	Darkness
Force	Weakness
Warmth	Coldness
Proximity	Distance
Repulsion	Attraction
Affinity with acids	Affinity with alkalis

However, unlike Goethe, Turner felt that darkness should be more than the absence of light, that shade and the colours in shadows and the darker areas of a painting could be as expressive as full light (see Impressionist ideas about colour in shadows on page 143).

FOLLOW UP

Turner made two paintings to illustrate his ideas about colour: *Shade and Darkness — the Evening of the Deluge*, 1843, and *Light and Colour (Goethe's Theory) the Morning after the Deluge — Moses writing the book of Genesis*, 1843. These two images contrast the emotive qualities of colour. *Shade and Darkness* shows the disobedient, weak, negative humans about to be swept away by the flood in a series of dark blues. *After the Deluge* is a golden yellow spiral with Moses (a strong, positive biblical figure) in a bright warm light. You could make two contrasting approaches to the theme based on your own list of colours, emotions and suitable characters. Remember, as always, that these tasks need not be carried out in paint; most media or methods can be used for in-depth visual analysis.

Goethe's system is theoretical. Unlike complementary colours on the traditional colour wheel, where blue is usually opposed to orange, blue in Goethe's system is directly opposed to yellow. Oddly, Goethe also believed that red could be made by mixing yellow and blue — of course it can't, as Turner pointed out.

CONTEXT
TURNER, LEONARDO, AERIAL PERSPECTIVE AND SFUMATO

The overall golden glow of Turner's painting and the lack of distinct figures makes possible an immediate comparison with other methods of landscape painting, in particular Leonardo's techniques (see page 137).

Try comparing *Norham Castle,* with its lack of central narrative, to a painting that uses landscape as a background to the central figures, such as Leonardo's *Virgin of the Rocks*, 1508. Notice that Leonardo shows depth through aerial perspective and sfumato (the representation of the atmosphere as hazy and blue when seen from a long distance). How does this compare to a landscape that is hazy from foreground to background?

'FINISH'

In this context, the term 'finish' means the quality of a completed art work. We are now used to art that has an unfinished quality, a sketchiness, which is often seen as providing a truer insight into the artist's experience than a fully 'worked up' image. This was not the case in Turner's time, although he did a great deal to change opinions. It is probable that he made this painting for himself rather

than for public exhibition; it does not have the high quality of 'finish' expected in this period.

FOLLOW UP: SKETCH VERSUS HISTORY PAINTING

To understand the role of 'finish' in the presentation of art, it might be worth making a brief comparison of this late Turner sketch and an earlier, more aggressive and 'finished' work of his, such as *Hannibal and his Army Crossing the Alps*, 1812, which is in Tate Britain.

Ask yourself the following questions when comparing the two works:

1 What is the difference in composition?

2 What is the difference in use of colour?

3 How is the sun treated in each work?

4 What do these contrasts tell you about Turner's intentions in the two paintings?

Hannibal is considerably bigger (1,460 mm by 2,375 mm) than *Norham Castle* (910 mm by 1,220 mm). Any large art is intended to be a grand public statement, and *Hannibal* is no exception; it is a history painting (see page 6). *Norham Castle* is a more personal painting about a scene Turner knew well — it was where he had started to become a successful landscape painter some 50 years before.

TURNER *Hannibal and his Army Crossing the Alps*, 1812

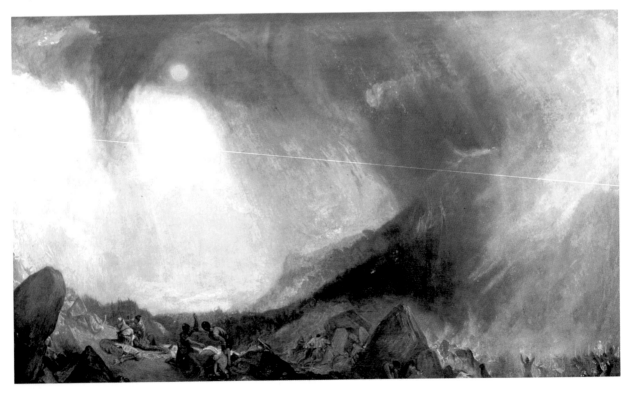

CONTEXT

SOCIAL/CULTURAL: ROMANTICISM

Turner lived in a period closely associated with Romanticism. The Romantic movement was responsible for the great interest in landscape, especially ruins, and the lonely, wild areas that had previously been ignored. Romanticism included the visual arts and literature, such as the Lakeland poets William Wordsworth and Samuel Taylor Coleridge. As a result of Romantic writing, many artists visited wild areas like Norham Castle and the Lake District to reproduce in paint what they had read about in words, and images of landscape were always in demand.

Romanticism stresses the personal experience of the artist. *Norham Castle* preserves the view in the early morning as the mist distorts the artist's vision. Romantic images are often dramatic: look at Turner's *Snow Storm — Steam Boat off a Harbour's Mouth making Signals in Shallow Water, and going by the Lead. The author was in*

What the examiner says: 'finish' and final pieces

Your own art can range across the types of 'finish' available, but it must be presented well and have the quality of 'finish' appropriate to the journey of ideas you have presented in your sketchbook. For example, something inspired by Abstract Expressionism should no doubt keep its gestural origins, whereas a photographic study of dawn light in the Scottish Borders should be printed to show each careful gradation from deep black to pure white.

this Storm on the night the Ariel left Harwich, 1842. The length and detail of this title tells us that the artist is trying to demonstrate his true experience. Turner famously said: 'I did not paint it to be understood but I wished to show what such a scene was like; I got the sailors to lash me to the mast to observe it; I was lashed for hours but I felt bound to record it if I did.'

FOLLOW UP: IDENTITY

In his later life, Turner made a secret identity for himself: Admiral Puggy Booth, a retired admiral. This was partly so that he could paint in peace and partly so that he could live with his lover in Margate. It is not unknown for artists to invent different characters for themselves. What sort of identity could you invent so as to assume the character of one who might create a Romantic landscape? The clothes you wear often affect how you make art. What sort of costume would inspire new imagery?

WHERE TO GO NEXT...

COLOUR, PALETTES AND OBSERVATION

It is useful to analyse the ranges of colour other artists have used. Take two other artists recording colour, Delacroix and Degas. Delacroix, the great nineteenth-century colourist, would spend weeks creating a palette (range of colours) for each painting, carefully working out the tonal relationship between the colours. Delacroix put paint samples on to pieces of canvas, writing on the samples where each tone was to go on the final piece. He used the terms reflection, shadow, half tone and highlight. Other artists collected his numbered painted strips; Degas himself bought a large selection after Delacroix' death.

Step 1: Look at Degas' strongly red painting *Combing the Hair*, 1896, and compare it to Delacroix' *The Women of Algiers*, 1834.

Step 2: Look at the palette of each artist and the colour combinations they use.

Romanticism: a brief definition

Romanticism was a movement of the arts that started in the eighteenth century and became extremely influential in the early nineteenth century. The concept of the artist as a lonely, misunderstood genius arose out of Romantic ideals:

- **Romanticism celebrated:** personal, creative experience; the mysterious.
- **Romanticism rejected:** scientific rationalism; conforming to traditional methods; authoritarianism.

The emotions created by a sense of place are central to Romanticism. Is there any writing that would inspire you in the same way? You may respond to a different type of landscape: the urban wilderness/jungle, the suburban desert or the industrial wasteland. Can you use Turner's thin washes to build up a non-topographical but powerful sense of place?

DELACROIX *Women of Algiers in their Apartment, 1834*

Step 3: Use those palettes in suitable colour-based studies of your own. Make sure that your sketchbook records their role in your art.

Delacroix kept hundreds of types of coloured papers to pin on his paintings as a way of judging ranges of tones. He also collected combinations of colours in textiles and ceramics. Why not make collections of examples of colours and colour combinations yourself?

THE EXPERIENCE OF COLOUR

Our experience of colour has changed over the last century. The invention of new and cheap pigments from the mid nineteenth century onwards radically changed art forever. The invention of highly

coloured plastics and vivid colours in the later twentieth century changed the way we view the world. Should this experience be reflected in your art about colour?

Step 1: Find the palette of colours available to an art student in the early nineteenth century and the limited range of colours around at that time.

Step 2: Find the palette of available colours you can work with now and that you will see when you look around you. Contemporary colours are chemically made, usually reflective, intense and often unnatural. Compare these two chronologically based colour ranges.

Step 3: How does this knowledge affect the art you make? What visual experiences could you find to reflect the passage of time? The logical step is to travel to Norham, find the same spot at the same time of day and use your two palettes to show how the view has developed. The castle is in Norham village, six miles southwest of Berwick-upon-Tweed. It is unlikely that you will have this opportunity, so find other sites: shopping centres, hospitals, grand entrances to public buildings, a park past its best, a street of shops, a car park...

TECHNIQUES: WATERCOLOUR

Which medium and techniques best recreate the experience of landscape? Turner's early works were in watercolour, a different medium to oil paint. Watercolour works in reverse from light to dark; there is no white paint. You lay transparent washes down so that the white paper still shows and gives the medium its luminosity. Oil paint works from dark to light: the earth shades and darker colours go first, the highlights are the last touch. In *Norham Castle*, Turner adapts watercolour technique into oil paint, as Cézanne would do 50 years later. If you have access to oils and watercolours, you can transpose the paint processes yourself. Acrylics do a passable imitation of both methods. Notice how thin washes create atmosphere, almost making air solid, and how blocks of colour create form and structure. Annotate your sketches carefully to bring out these qualities.

COLOUR PRACTICE

The artist Walter Sickert was taught colour practice by James Whistler. Whistler took Sickert to the River Thames and made him look at the view and then turn his back on it before making a careful colour study of what he had seen. This is extremely good practice.

Step 1: Look at a view with as much care as you can.

Step 2: Turn around, open your sketchbook and, with a suitable palette, make a chart of the colours you have seen.

Step 3: You can play this game with images. Look at the reproduction of an image and then try to make a chart of the palette of colours you have seen.

PURE COLOUR?

Colour can be divorced from description, but in art does pure colour exist? Look at Kandinsky and the role of edges in colour relationships. You could also investigate Rothko, or that other US Abstract Expressionist useful for this sort of analysis, Hans Hoffman.

SECTION SUMMARY

This section has:

- looked in some detail at the colour systems underlying both Seurat's divisionism and Turner's beliefs in the symbolic characteristics of colour
- demonstrated how useful both of the above formats are when tackling such large subjects as a big view and the changing light within it
- examined how Seurat's representation of figures as 'timeless moderns' allowed him to show modern Paris, and suggested how you might continue this theme yourself
- looked at how, underneath the apparently abstract quality of Turner's painting, the artist used a traditional composition
- made suggestions as to how, in view of the importance of Romanticism in Turner's context, you might make connections between a sense of place and writings about it to prompt your own art

4.2 'THE CITY VIEW'

INTRODUCTION

Section features

Works:
- Piet Mondrian
 Broadway Boogie Woogie, 1942–43
- Anselm Kiefer *Lilith*, 1987–89

Genre: landscape

Formal elements: colour and pattern

Unit element: second drawings

This section considers two apparently disparate images, one by that crucial abstract painter, Piet Mondrian, and the other a huge multimedia work by the contemporary German artist Anselm Kiefer. Despite their different appearances, these pieces are both cityscapes, of a sort, which you can use in an investigation of abstraction and the role of colour and pattern in your own art.

YOUR WORK IN THIS UNIT

At this point in the unit, the stage we call 'second drawings', you will have made your initial researches and some first sketches. Second drawings are where you start making some intensive drawings inspired by the theme 'Land'. The further study of Mondrian could lead you on to exploring abstraction, or analysing Kiefer could involve the role of myth in your studies of 'Land'.

THEMATIC OVERVIEW

Both the featured works are cityscapes, although they present different views of the experience of cities. You can see that in the composition of each work and their contrasting materials. Why two images about the same subject look so different? Mondrian was a Utopian, believing the arts could lead to a better life, and that belief underlay the careful organisation of his paintings. Looking at Kiefer's vast image, you realise that opposing beliefs inform his art. He saw the city not as Utopia, but dystopia. Both artists spring directly out of their own social and cultural context. Mondrian's Utopianism shows itself

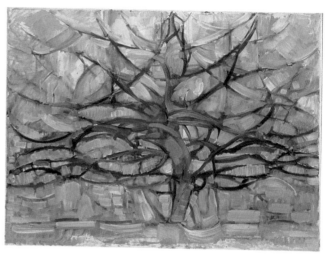

PIET MONDRIAN *The Grey Tree, 1911*, oil on canvas, 79.7 × 109.1 cm.
© 2006 Mondrian/Holtzman Trust c/o HCR International, Warrenton, VA, USA

Utopia, dystopia and artists

A Utopia is a perfect society, a dystopia is the opposite. Many artists and writers have described perfect, or imperfect, worlds. Utopias tend to rely on rationalism and an organised view of the world. Some dystopias depend on over-organisation, as seen in Orwell's *1984*, whereas others like Kiefer's exist in chaos. If you are looking for a positive view of the arts, the German artist Joseph Beuys (Anselm Kiefer's teacher) is well worth searching out, especially if you want an excuse to paint yourself in goldleaf and honey and talk to dead rabbits.

in his harmonic combination of opposites, the balance of horizontals, verticals and primary colours. Kiefer's grey/pink colours and photograph-based composition presents a multilayered image of decay as we fall into its chaotic depth; it is a deeply pessimistic image.

FOLLOW UP

Most of humanity now lives in cities, a fact reflected in the architect Will Alsop's proposal for cities to cover the area from Manchester to Liverpool. The effect of the modern city is a large subject for the arts. It spurred the beginning of 'modern art' and has been the subject for music from early rock and roll through to grime and beyond. Analyse how artists have used colour and pattern to present the urban state. You could begin to build images that present your view of the contemporary city.

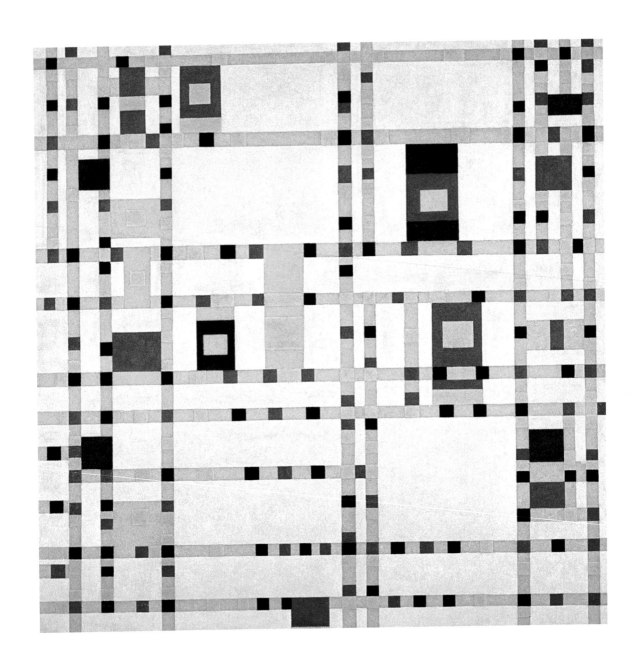

PIET MONDRIAN, *Broadway Boogie Woogie,*
1942–43, oil on canvas, 127 × 127 cm.
© 2006 Mondrian/Holtzman Trust
c/o HCR International, Warrenton, VA, USA

Piet Mondrian

Broadway Boogie Woogie, 1942–43

THEMATIC OVERVIEW

At first sight, this looks like a simple painting — a regular pattern of flat colours. Further investigation will tell you that there is much more going on. A great depth of ideas and visual investigation support this painting.

TECHNIQUES

The key to understanding Mondrian's classic work is to realise that his paint is flat. It does not try to represent depth and has no texture of its own. It has no layers or reference to any living form. It refers us to higher things.

Task

Understanding a landscape that does not describe depth

Although *Broadway Boogie Woogie, 1942–43* moved on from Mondrian's earlier compositions (see below), in that it did not feature black lines, it is still an arrangement of flat painted planes of colour, in a restricted palette, on a white background.

Step 1: To examine Mondrian's flatness, try placing this landscape painting (for that is what this is) next to a well-known landscape, such as Constable's *Hay Wain*.

Step 2: Look at the way each artist makes use of the same materials. Those carefully painted lines and blocks of colour that characterise Mondrian's classic works were painted by hand using the traditional artist's medium, oil on canvas. Take a section of Constable's painting and notice that his oil paint is thick and modulated. It is blended in thick strokes, whereas Mondrian uses planes of one colour only.

Step 3: Place two sections of each work in your sketchbook, with a range of colours and annotations that demonstrate your knowledge of the behaviour of colour and tone on a flat surface. Pay attention to pattern: how colour is arranged will affect interpretation. Texture is vital. Try using coloured cloth of different weaves, papers of different densities and so on.

COMPOSITION
DEVELOPING ABSTRACTION IN MONDRIAN'S ART

Broadway Boogie Woogie, 1942–43 was Mondrian's last completed painting. As with all artists' work, if you wish to understand one work, it helps to set the composition in the context of the artist's overall output (known as an artist's oeuvre).

The key point in Mondrian's development was the powerful influence of Cubism in about 1911. Look at his oeuvre. His careful drawings and paintings of trees, church

spires and the sea show a classic move toward abstraction. You might well have been shown this process before but, if not, the paintings to look out for are:

- *Apple Tree in Blue: Tempera, 1908–09*
- *The Grey Tree, 1911* (see page 157)
- *The Tree A, 1913*
- *Tableau I, with Red, Black, Blue and Yellow, 1921*

If you put these paintings in this chronological order, you can see Mondrian's gradual move toward total abstraction. This process led up to what is called iconic Mondrian, paintings that are purely horizontal and vertical and use white, black, grey and the primary colours.

FOLLOW UP

It is worth following Mondrian's process yourself to show your understanding of the art you are analysing. While doing this, ask yourself how these iconic paintings can be called Utopian. How can they represent a search for a better world?

What is boogie-woogie?

Boogie-woogie is a type of jazz, one that Mondrian became keen on after he moved to New York and started to frequent jazz clubs. He must have been an incongruous sight: a middle-aged Dutchman in a dark suit, dancing by himself, apparently not very well. Yet that love of rhythm turns up in his painting.

Boogie-woogie is syncopated, which means it has the jerky rhythm of a disturbed pattern, the same rhythm that characterises *Broadway Boogie Woogie, 1942–43*. You could experiment with displacing squares in a grid to analyse this idea. Expand the process to include gradations of colour in which one tone stands out.

UTOPIAN?

Mondrian was a member of De Stijl, a group of early twentieth-century Dutch artists. De Stijl was important between the two world wars, not just in visual art, but also in architecture and design.

KEY POINTS

- Mondrian believed that by stripping away all the non-essential, material aspects of life, it was possible to get to the pure spiritual world beneath.
- He saw art reduced to horizontals, verticals, the primary colours and black and white as a metaphor for the invisible laws that lie behind what we normally see in nature.
- This was the arrangement of contrary forces, or opposites, to create a new harmony or 'style', as these artists called it; hence, the group was named 'the Style' or, in Dutch, De Stijl.

De Stijl was a search for a universal language that everyone could share. Remember that this art was being made after the traumas of the First World War.

GEOMETRIC, SYMMETRICAL OR BALANCED?

De Stijl's easily identifiable visual language could be called geometric. Be careful, however, because geometric could mean symmetrical, and De Stijl is not symmetrical. Symmetry refers to a classical arrangement of form. A Greek temple, for example, is perfectly symmetrical about a centre axis. De Stijl artists preferred the terms harmonious or balanced, their art and architecture consisting of forms arranged to create balance not symmetry. What is the difference?

At first sight, *Broadway* looks like a straightforward grid, but study it carefully. In a true grid, the horizontals and verticals would have to be continuous, from top to bottom and from side to side of the canvas. Try following the verticals of what appears to be seven dominant upright elements; only five are continuous. The same applies to the horizontals. Close examination of *Broadway Boogie Woogie, 1942–43*

What the artist says: the colours of the city

'A street is not made up of tonal values, but is something that bombards us with sizzling rows of windows and humming beads of light dancing amid vehicles of all kinds, a thousand undulating globes, the shreds and fragments of individuals, the roaring tumult of amorphous masses of colour.'

From Ludwig Meidner, *Instructions for painting pictures of the Metropolis*, 1912

reveals that it is not a view or a straightforward plan of the city. Mondrian has turned the famously grid-like structure of New York into visual elements composed by balance rather than symmetry.

FOLLOW UP: BROADWAY

Broadway is the name of the only street that is not part of the New York grid. It runs diagonally right to left across the upper west side of Manhattan. What would this picture look like with a diagonal strip running across it? Try rearranging these balanced elements to find out.

Mondrian moved to New York in 1940; *Broadway Boogie Woogie, 1942–43*, painted between 1942 and 1943, is one of his last works. Does it represent a return in some way to painting what he actually saw, a response to a new world? His last works are more colourful, although they are still diagrams of hidden harmonies. Unlike his previous paintings, there are no black lines, or 'scaffolding', holding colours in

place. These have been replaced by small squares and rectangles of colour with smaller squares and rectangles between them.

Without the 'scaffolding' of black lines, Mondrian uses other methods to hold the painting's composition together. Look at the role of the small grey blocks. Are they as regular as they first appear? Where and how do they change in size?

CONTEXT
OTHER ARTISTS

Unlike the Cubism that influenced him and gave rise to so many other imitations, Mondrian's iconic images were complete in themselves and few artists attempted to make art that looked at all similar. But if you look at different types of design from the 1930s to the 1950s you will see his influence everywhere. On what objects would you print an imitation Mondrian design?

FOLLOW UP

The De Stijl group's activities were not just restricted to painting — they also designed house interiors. Only one complete building still remains — the Rietveld-Schröder House, built in Utrecht in 1924. It is well worth searching out.

Try looking further at Theo van Doesburg's work. His design for the wall of a cinema/dance hall in 1927 showed a range of flat rectangular shapes attached to the ceiling and the wall, laid on a diagonal axis. If you could design something similar yourself, what colours would you use to help the pattern?

BRIDGET RILEY
Nataraja, 1993

Task
Comparisons

To appreciate the role of Mondrian's beliefs in his compositions, try comparing a Mondrian to a Bridget Riley.

Step 1: Look at Riley's *Nataraja*, 1993. It is entirely abstract and purely about colour relationships arranged in symmetrical patterns. There is no other intention, such as the harmonious arrangement that Mondrian was searching for.

Step 2: Analyse the interrelationships of the elements of Mondrian's painting. How are they related to the size and edges of the canvas? How does this compare to the 'all-over' nature of the Riley?

Step 3: Like all Mondrian's paintings, *Broadway* is surprisingly small (127 cm by 127 cm). His works always look more homemade than you would expect and consequently slightly sad and vulnerable, and yet they have more character as objects than one would imagine from the reproductions. *Nataraja* is much bigger. What effect does this have on the viewer?

Step 4: Notice that *Nataraja* has a traditional landscape format, whereas *Broadway* is square. What is the result of these different arrangements?

Step 5: What would happen if you changed the scale and format of these works? What if they were skew to the edge or overlapped or didn't seem to fit? Would *Broadway* still be the well-mannered representation of this vibrant and famously rude city it appears to be?

WHERE TO GO NEXT...

CITIES AND MAPS

Broadway contains some reference to a map of a city. A map is another type of visual language, a way of encoding the visual experience of city life.

Step 1: Find large-scale maps of a city that interests you or perhaps download aerial photographs.

Step 2: Simplify the map or photo to create a working image that stresses the visual elements you think are the most important.

Step 3: On its own, this simplified image is probably not enough to create a convincing work. Try combining your 'sketch' for a composition with other views of the city, in particular using a personal range of colours that you feel sum up the urban experience.

TEXTURE AND PATTERN

Mondrian's paintings are deliberately texture-less and reduced to their bare essentials. How would his work look if you started to introduce texture? Try rethinking Mondrian's work by repainting it with the characteristic brush strokes of van Gogh. He was, after all, one of the artists that Mondrian studied in his early career.

WHITE AND LIGHT

Think about the role of the white areas of Mondrian's paintings, bearing in mind that white in art can be more than a background.

Step 1: You could choose an urban view to analyse.

Step 2: Work with a range of whites and different textures of paint to analyse the role of light within the scene, reducing the view to a series of receding blocks of simplified form.

Step 3: How do these simplified blocks catch the light and enhance or detract from each other?

Step 4: Compare your studies to those of Mondrian's paintings which were directly influenced by Cubism, e.g. *The Grey Tree, 1911.*

Step 5: Mondrian said, 'Let us now live in full daylight, so that we can create, let us paint the idea of the bright full day.' Will reintroducing aerial perspective techniques into your studies help in painting light? Look at the edges of the simplified blocks you have made. Will sharp or soft-edged planes create the illusion of depth?

What the examiner says

Mondrian's art exerts a strong influence. His iconic paintings have a characteristic visual language that many students find too forceful and their work ends in pastiche. You will need to ensure that your own art leaves behind sharp-edged blocks of colour arranged horizontally and vertically and held in place by black lines. Think about the intentions behind the visual language.

POUSSIN *A Dance to the Music of Time,* 1638

Task
Art, music and rhythm

It would be a good idea to make some visual analyses of rhythm and interval.

Step 1: There are many art works representing music. Matisse's painting *The Dance*, 1910, Poussin's *A Dance to the Music of Time*, 1638, or Jim Lambie's more contemporary arrangements of coloured tape on a floor are good places to start. Notice how the gaps between the elements, the figures or the strips of tape set up a pattern or visual rhythm. Annotated drawings of examples would help start the process of visual research into this aspect of the theme.

Step 2: In music, the gap between notes (intervals) matters as much as the noise the notes make; so does the composing of groups of forms in art. If the figures in an image are close together, this suggests some sort of rapid movement or tempo, while a large gap between figures suggests slower movement of forms. Look at a photograph of a crowd. Can you guess the event that drew these people together and their feelings about it from the spaces between them? Does this analysis still apply to arrangements of forms in more abstract works?

Step 3: Another place to see rhythm and interval is on the façade (front) of buildings, particularly those with columns. The distance between columns (called intercolumniation) is important and, like moving figures, different intercolumniations suggest different feelings and characters. Try comparing Bramante's Tempietto, 1502, a small circular temple in Rome where the columns are three diameters apart, with the English architect Hawksmoor's circular Mausoleum at Castle Howard in Yorkshire, 1729, where the columns are only one and a half diameters apart. The tempo of the Tempietto suggests something slow and thoughtful, the Mausoleum is like a quick march. Annotated drawings of examples of these solid rhythms would be helpful.

Step 4: Take examples of the forms you have analysed above and redraw, scan or photocopy them on to large sheets of paper. Compose them as abstract forms arranged under different tempos. How would you arrange them on a page to recreate the rhythm of New York, Berlin or London in 1940, or Leeds, Manchester or London in the early twenty-first century? Think of other arrangements inspired by various forms of music.

DEVELOPING ABSTRACTION

Once you have completed the iconic move to abstraction in your sketchbook, in the way described above, you could take the process further.

Step 1: Bearing in mind that *Broadway Boogie Woogie, 1942–43* was Mondrian's last completed painting, you could make the assumption that his art would have continued developing had he lived. In what way would that development have continued?

Step 2: Can you, as a result of your analysis of his work, make a series of subsequent images that combine a deconstructed grid or balance of images with a return to a simplified description of nature?

Step 3: After Mondrian many artists explored full abstraction. Search out Barnett Newman (e.g. *Adam*, 1951–52), Ellsworth Kelly, Agnes Martin and Clyfford Still.

Anselm Kiefer

Lilith, 1987–89

THEMATIC OVERVIEW

Detail

Anselm Kiefer was a post-Second World War German artist. He made this painting after a trip to São Paulo in Brazil. *Lilith*, 1987–89, is a huge painting that, like most of Kiefer's art, uses layers of allegory to explore his own country's difficult past. Kiefer has, for example, used burning and ash, which in this context has many resonances. They can make you think of burial rituals, and also act as a reminder of the killing of millions in the Holocaust.

Who was Lilith?

Lilith is a figure from Hebrew myth. She was apparently Adam's first wife but was so evil that she became the queen of demons and the devil. She symbolises the lure of the city, tangling young men in her red hair — hence the copper wire. Although the wire in the painting is oxidised, some of the bright copper still shows through.

TECHNIQUES
MIXED MEDIA

Kiefer uses 'mixed media', meaning a range of non-fine art materials. Apart from the extremely heavy paint (impasto), which has a clay- or mud-like quality, the mixed media in this work includes tangled copper wire, dust, sand and earth. The wire sits off the surface, looking a bit like strands of hair on a bald man's head and casting its own shadow; it seems separate from the rest of the work. The wire refers both to the collapse of communications and the red hair of the title character. We read the wire differently to the illusionistic paint, which points us toward reading the painting in different ways.

COMPOSITION
IMPASTO

Lilith is a thick impasto cityscape, showing skyscrapers from above. The viewer seems to be falling into an unordered mass of tall leaning buildings. On one level, this is an image about the chaos of contemporary urban life, the collapsing systems of the modern city and what that will inevitably lead to. On another level, it makes us reflect on what has happened in the past.

IMPASTO AND GRAVITY

Notice that the paint appears thicker at the foot of the painting. This technique brings gravity into the work. It creates an appearance of weight at the painting's bottom, which together with the heavy sludgy paint makes *Lilith* appear even less uplifting (literally). As we have seen before, arranging forms is an important technique. The combination of weight, colour and texture and the half-obscured pattern of the buildings makes a pessimistic view of *Lilith* predictable.

Task

A view of the city

São Paulo, the subject of this painting, is a huge city that has grown enormously. Some parts of the city were planned by the Modernist architect Oscar Niemeyer; other parts have grown out of control. Compare Kiefer's method of making art and subsequent meaning with the Modernist Utopianism depicted by Mondrian in *Broadway Boogie Woogie, 1942–43*, the other work featured in this section (see page 158).

Step 1: Could you remake Kiefer's painting to radically change his underlying pessimism about cities and a world in chaos?

Step 2: What area of the colour spectrum would you use?

Step 3: What thickness, if any, of impasto would you apply?

Step 4: What patterns would the buildings make?

Task

'Mixed media' materials

Which materials would fit your urban landscapes? They need not be 'art' materials, anymore than Kiefer's materials were. It would be relevant to think of the symbolic references that materials make. The whiteness of fine plaster points to public monuments, war memorials perhaps. Applied gold leaf will suggest riches, and gold itself, through its connection with Byzantine paintings, often means spirituality. Rusted metal implies decay, as does dirty cloth; white plastic might point to an invented future; ashes can mean a bad past.

IMAGES OF CITIES

Try finding other images of cities, such as those from earlier Dutch paintings. Carel Fabritius's *View of Delft*, 1652, is a detailed panoramic painting in which the view is curved, similar to the distorting effect obtained with a wide-angled lens. *View of Delft* was probably made for a perspective box. You could make a viewing device like this to investigate topographical accuracy in your work. Or you might compare Dutch exactness with the idealisation of Canaletto's Venetian views in *The Upper Reaches of the Grand Canal with San Simeone Piccolo*, c.1738.

Ask yourself the following questions:

- How do these artists use colour and pattern in different approaches to the city?
- How do these artists represent depth? Notice the diminishing verticals showing the scale of buildings towards the horizon.
- How do these essentially positive views of cities compare to that in *Lilith*?

If you were to make visual studies of a city, which palette and characteristic methods of composition would you use and why?

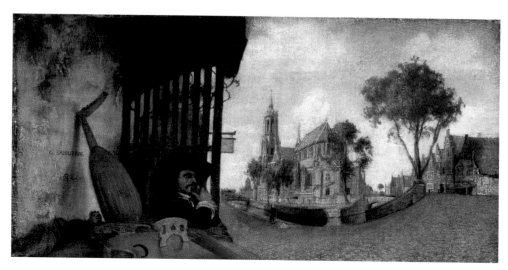

CAREL FABRITIUS *View of Delft,* 1652

CONTEXT
OTHER ARTISTS: THE ROLE OF SCALE

Lilith looks apocalyptic, an end-of-the-world image. There is a long tradition of such images, for example Martin's *The Great Days of His Wrath*, 1853. What are the characteristics of such works? Scale is clearly important. The techniques for using scale have always been a key part of landscape art. If a work of art is large, then you, as

the viewer, are not only diminished (literally, made smaller) by the work but you are also enveloped by it: you become part of it. This sense of actually being 'in the work' was also vital to the US Abstract Expressionists of the 1940s and 1950s, especially Jackson Pollock. His *Summertime: No. 9A*, 1948, is so large (85 cm by 555 cm) that, when you stand close to it, it is impossible to see the edges of the work. However, Pollock's and Kiefer's pictorial spaces are quite different.

In *Summertime: No. 9A*, pictorial space is shallow, the tangle of marks on the surface preventing the viewer from falling into the illusion of depth, as occurs in *Lilith*. The effect of Pollock's gestures laid on top of each other is to draw the viewer towards the work, making us look at how it was made and the detail of stroke and drip. In Pollock's painting, everything happens inside the picture frame.

In *Lilith*, pictorial space represents depth. Kiefer's image is like a vast poster. You have to stand well back in order to see what's going on and to piece the image together. This is an artist telling us about the outside world, making us think about what happens outside the picture frame.

What can you do with this knowledge?

- You need to decide what sort of art you want to make on the subject of land.
- Will it be a grand public statement like Kiefer's? Man's destruction of the environment, for example, could be the basis for a powerful image, directing us to the visible results of our actions.
- Alternatively, you may want to follow Pollock and create a work about the methods used to make art, inspired by the experience of a landscape. A 'gestural' work would not be an exact description, rather it would focus on shapes, textures, colours and ways of moving your body as a means of recreating that landscape experience.

Task

Analysis of viewpoint

Lilith is a work given extra poignancy after 9/11 (although it was made years earlier). It might be worth considering how our reading of images is affected by specific events.

Step 1: Reflect on how we might react to any cityscape after the collapse of the Twin Towers. Do we see these images of cities as further worrying prophesies? Do pictures of cities refer us back to that terrible event?

Step 2: If so, how does their presentation add to those reactions? Is it the combination of semi-documentary presentation and black and white that achieves this effect?

Step 3: The colours in *Lilith* are almost monochrome, but nothing else about it is objective. *Lilith* has little of the documentary approach. The viewer is pitched, literally, into the middle of the argument. The viewer's position in relation to the scene represented is always crucial in landscape art. Imagine if this image of São Paulo had been shown from pavement level. Would it have had the same impact?

Step 4: In your own art, therefore, think carefully about where you situate the viewpoint.

CONTEXT
SOCIAL/CULTURAL

THE GERMAN PAST AND *LILITH*

Where artists come from and when and where they produce their work is often a significant part of the meaning of an art work. This is certainly the case here. Although *Lilith* came from an image taken in Brazil, it is impossible to separate it from the postwar German context.

NEO-EXPRESSIONISM

Many German artists of the 1960s and 1970s — Baselitz, Beuys, Immendorf, Penck and Polke — shared similar approaches, although their art looked different. These artists were part of the mid-1970s return to figuration, a movement often called Neo-expressionism. What characterises their art is the move away from abstraction towards using or representing objects and views of the world. Most of these artists drew on mythologies, either creating their own like Joseph Beuys or working with myths of national identity in the manner of Kiefer. These artists were trying to understand their own past as Germans and their own future as artists. The underlying question in much of their work is: what is the relevance of art, abstract or otherwise, in the new Germany?

WHERE TO GO NEXT...

IMAGES OF DESTROYED CITIES

The context of postwar Germany could lead the viewer to make associations between *Lilith* and images of cities destroyed through war, such as the impact of the Blitz on cities such as London or Coventry (see Piper on pages 177–183).

Step 1: Compare the national myth of the Blitz in the UK to the cultural resonance of the British bombing of Dresden, Germany, on 14 February 1945, when between 60,000 and 250,000 civilians were killed. That one night in Dresden has become a powerful image that many postwar German artists have acknowledged as an influence. Try reading the early novels of the German writer Günter Grass about this event.

Step 2: Now compare that past horror with the pictures of destroyed buildings and terrified citizens that we see constantly, mainly on the television news. How do these images affect our beliefs in the survival of the city?

Step 3: What are the dominant characteristics of the visual languages used by these pictures? Are they light or dark? Do bright, cheerful colours feature?

Step 4: Try comparing these images and visual languages with some contemporary representations of extraordinary cities. A good example might be Tokyo, a city that appears constantly to reinvent itself through advertising and an optimistic celebration of modernity.

BOOKS AND LINEAR DEVELOPMENT

Kiefer, like many artists, makes books of images. A book is a useful format to explore, with its implied development of ideas as you turn the pages. Some of Kiefer's books are made from lead, a material with mythical associations but also one that is poisonous, expensive and heavy. Try looking instead at Kiefer's book called *Over Former Cities Grass will Grow…Isaiah*, 1996, in which a repeated image of a city is gradually obliterated with sand. Once the image is entirely covered, flowers (first white, then red) appear; red flowers in this instance remind us of the poppies of Flanders fields. This example of the sequential development of an image is one you might want to follow yourself.

What the critic says: art as political tool

Figurative art has often been used as a political tool. Both the German and the Italian fascist governments commissioned realist images of workers and leaders for propaganda, as did Stalin during the 1920s and 1930s in the USSR. After the Second World War, US artists and many Europeans made a specific connection between fascism and realism, insisting that abstraction equalled freedom and capitalism. This return to figurative art in Germany is indicative of more than just a different sort of painting; it is art that doesn't seek to excuse its national past but tries to sort out what to do about it. Search out Jörg Immendorf's *Café Deutschland* series for powerful figurative images about the artist's place in the world.

IMPASTO IN ART

Impasto is a key tool. Showing some analysis of it in your sketchbook would be helpful.

Step 1: You could show the effect of thick paint in art from van Gogh to Auerbach. Artists are well aware of how thick and thin paint creates different visual experiences.

Step 2: Think about how you can change the representation of a landscape through varying levels of impasto, from Turner-like watercolours such as *Norham Castle* (see page 148) through to the full impasto in *Lilith*.

Step 3: You could expand your investigations beyond thickly applied paint to looking at how sculptors use texture. Look at the delicate layers of riven slate in work by Richard Long, or the smooth forms in Goldsworthy's ice sculptures.

WHERE TO GO NEXT...

MYTH, ILLUSTRATION AND PARADISE

This painting concerns the representation of myth from past (*Lilith*) and present (the city). Although it is important to stress that *Lilith* is not a straightforward representation of a story, illustration has a long and honourable history. There are many myths that you might use to start your own work.

ANSELM KIEFER *Lilith*
(detail)

- Although expressed in different ways, many cultures have some sort of early Eden or paradise from which their ancestors were expelled. This could be a myth for you to draw on in your work.
- The Judaeo–Christian version of this is probably the most familiar, but the key element to consider is the difference between paradise and the land outside.
- How will your studies of impasto help you here?
- Will the non-paradise element of the myth be best represented in the sort of techniques that you have been looking at in *Lilith*? How should Eden be shown?

MYTH, ILLUSTRATION AND HAIR

Lilith features references to red hair. There are many myths and tales about hair, such as those of Rapunzel and Samson. Kiefer has made other works using the hair motif: *Your Golden Hair Margarete*, 1981, is one of a series referring to landscape. This work takes its title from a poem by Paul Celan called 'Death Fugue', written in a concentration camp in 1945:

> A man lives in the house he plays with the serpents he writes
>
> He writes when dusk falls to Germany your golden hair Margarete
>
> Your ashen hair Shulamith we dig a grave in the breezes there one lies
> unconfined

This painting shows a brown ploughed field disappearing into the distance and a cluster of red-roofed buildings. A hoop of yellow straw arching across the foreground is echoed by black strokes of paint smudged with grey. Above the straw, the title of the painting is handwritten in black paint.

The key here is probably the contrast between the golden (therefore, in this context, Aryan) hair of the woman and the ashen hair of Shulamith. A German reader would also think of golden-haired German heroines of the past, such as Lorelei. Shulamith was the princess in Song of Songs in the Old Testament. She is a Jewish version of beauty and could symbolise the Jewish people themselves. Kiefer represents that clash of cultures through a strong visual language, the bright yellow straw and the thick black paint strokes streaked with grey.

You could take such powerful histories as a subject yourself, always remembering that your work should be predominantly visual. You are making interpretations parallel to the past rather than just as an illustration of it. Like Kiefer, you have to find a new series of images rather than repeat the old.

What the artists say

This statement is written on a painting called *Can one change anything with these?*, made by the artist Jörg Immendorf in 1972:

'This is a simple brush for 70 pfennigs. This is normal house paint. This is a canvas stretched on a wooden frame. It is where the artist's ideas take shape.'

The US artist Barbara Kruger gives another viewpoint:

'Making art is about objectifying your experience of the world, transforming the flow of moments into something visual or textual, or musical. Art creates a kind of commentary.'

What the examiner says

When considering the national myths that lie behind work like Kiefer's and applying them to this country and your art, it would be tempting to make use of the obvious symbols. Try to avoid merely re-presenting the Union Jack or the Flag of St George. Notice that at no point do artists like Kiefer depend on the well-worn symbols of others. It is their careful examination of the mythic qualities of materials and how these relate to cultural history and personal experience that makes their art so powerful and interesting.

SECTION SUMMARY

This section has:

- covered two entirely different cityscapes, each composition demonstrating the different underlying beliefs about cities held by its creator
- discussed the process of developing abstraction and the ways that you could use that process in your own work
- analysed the importance of pattern and disrupted pattern in representing cities, demonstrating how the combination of art, music, rhythm and interval could be useful for you
- discussed the role of scale in landscape imagery
- covered the role of impasto and mixed media, both important tools in art
- analysed how myth and past narratives can help in illustration and produce art that represents the modern world
- analysed the reintroduction of figuration in art, referring to the connection between Neo-expressionism in Germany in the second half of the twentieth century, myth and realism

4.3 'THE WORLD VIEW'

INTRODUCTION

In this final section, we look at two works that appear to be different in process, format and visual content. As you might expect, however, they share key themes; they are art works about threatened identity and well-known landscapes that have changed.

YOUR WORK IN THIS UNIT

This section assumes that at this point in the unit system you are working towards 'the resolution of your ideas', to make a 'final piece'.

Remember that critical and contextual studies do more than start a unit. Your understanding of the work of others should flow throughout your sketchbooks, not least in this final phase.

Just because one work studied is a painting and one a photograph, there is nothing to prevent you from working in any media you choose. Always try to work in a medium that will challenge you, but be certain that you are confident in your chosen materials.

THEMATIC OVERVIEW

Both featured artists in this section are involved in the process of recording, their intentions from the outset being to record change.

One of these works contains black and white photography. While we are accustomed to paintings containing the opinions of the artist, photography is often thought of as a documentary medium. 'The camera does not lie,' we used to be told. This statement is clearly untrue and yet there is an apparent sense of truthfulness in a black and white image. Why is this?

The other image we are considering is a landscape. What truths can a full-coloured landscape painting contain?

FOLLOW UP

The effects of recording a scene with different methods are discussed throughout this section. To start thinking about this process, try choosing a suitable view and comparing the results of different ways of recording it: drawing, photography and video perhaps.

Section features

Works:
- John Piper *St Mary le Port, Bristol*, 1940
- Shirin Neshat *Untitled, (Women of Allah)* series, 1994

Genre: landscape

Formal elements: colour and pattern

Unit element: final piece

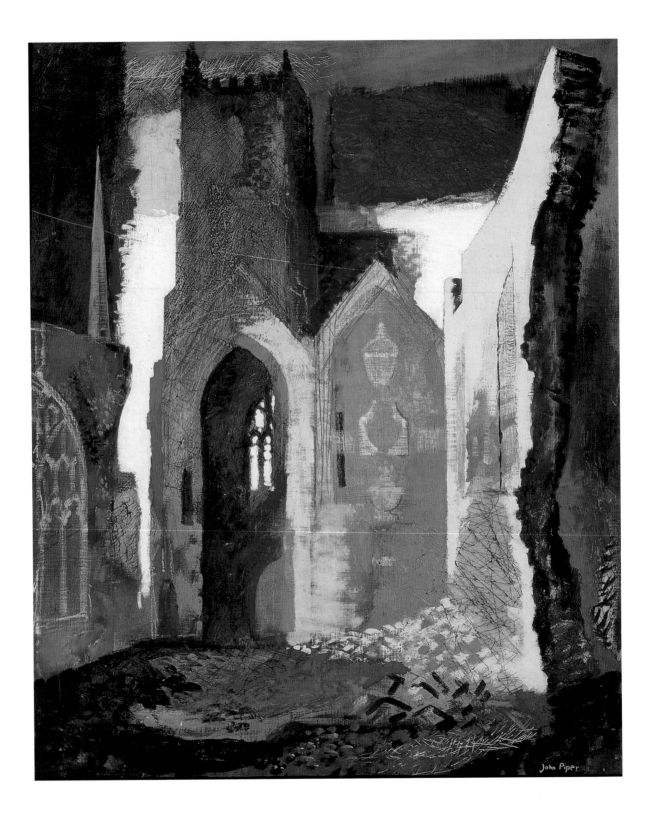

John Piper

St Mary le Port, Bristol, 1940

THEMATIC OVERVIEW

This is a painting of a bombed church in Bristol, made a day after the attack. The view is from the ruined nave (the central area of a church) near the altar, looking back towards the spire at the west end. It is an oil painting, worked up from a small gouache and watercolour sketch. Piper made sketches in front of the subject to serve as a basis for larger works made in the studio, a sensible system for landscapes, especially in bad weather.

Detail

TECHNIQUES
COLLAGE

One of Piper's earlier techniques, which had a visual effect on this work, is collage. Piper had a slightly different approach to the Cubists, who started using collage in 1912. Cubist collage uses paper and images that have already had a life elsewhere. That life, in the case of newspaper headlines, for example, becomes part of the meaning of the new work. By contrast, Piper, after making sketches of the view, tore coloured and textured papers into shapes suggested by his drawings. He often rubbed ink and pencil over those shaped papers before sticking them on his sketches. Modified collage is a technique that you might try.

You can see the effect of that process in this painting. Look at the arrangements of blocks of colour. The blue to the right of the church spire, for example, is an isolated rectangular shape. This is a section where, in a traditional landscape painting, you would expect to see an area (rather than this defined block) of blue acting as sky and creating the necessary illusion of pictorial depth. Aspects of that earlier method are still evident here. Notice the area of red at the front of the composition which makes this section of the landscape appear closest to the viewer.

MARK MAKING

There are references to several types of mark making in this painting. These range from short strokes with a brush on the bottom right, describing the broken edge of the church wall, to fine strokes of the brush used for the window in the cream wall to the left of that broken edge. There are also the rounded, almost random, thin strokes that look like doodles and that fill in the space below the cream wall, as well as evident pencil marks. Experimenting with all the means you can find to describe a scene would be a useful start to any landscape work.

St Mary le Port brings many sorts of art-making processes to the viewer's attention, drawing in particular. Piper seems to want us to be aware of each stage that the image has been through. This is a useful technique to remember, given that your work is to be examined. Making clear how you got to your final piece could be helpful.

COMPOSITION

The emphasis of this composition is vertical, echoing the spire as a key feature of the bombed church. The dominant forms make a repeated vertical pattern, corresponding to tall, thin, torn paper shapes. The pattern reminds us of broken pillars of buildings, with the shapes kept in place by horizontal blocks of blue, grey and white in the sky.

SYMBOLIC COLOUR IN LANDSCAPE

Look at the patch of red on the left of the painting and how it is outlined by bright white and reflected in another patch of red in front of the spire. Does red have symbolic associations, other than its association with the image of blood and the fires still burning in the destroyed church? It is important to think of the function of this image: it was an official composition for the War Artists Advisory Committee. The blocks of blue and white could have some sort of heraldic associations. In other words, these particular colours, and their arrangement as flat colours next to one another, may represent the flags or badges of countries or regiments.

Task
Symbolic colours
Can you use colour so that it has a descriptive and a symbolic function at the same time? Using paint in actual as well as symbolic layers is a useful process to pursue. There are two questions to ask yourself: what are the associations that particular grouping of colours has for you? What are the suitable forms, objects or scenes that you can use to bring out that extra layer of meaning?

CONTEXT
OTHER ARTISTS

Piper said: 'The nearest I can get to describing what I try to do in painting is to say that I want to make a pictorial parallel for what I see, complete in itself yet derived from nature.' This description fits the work of many landscape artists, such as that of the Cornish artist Peter Lanyon. Lanyon's tall thin painting, *Porthleven*, 1951, shows a fishing village with a harbour at the bottom of a steep hill. On the hilltop is a

clock tower. Lanyon was a keen motorcyclist, and he travelled across Cornwall at some speed. One reading of *Porthleven* points out the shape of a motorbike petrol tank and motorbike side mirrors at the bottom of the painting, and perhaps also the artist's sketchbook.

Ask yourself the following questions about making art derived from nature:

1 Should your landscape art include your experience of the elements and your method of travelling across the land?
2 What method of travel will you be using to get to your view and how will you record it?

BUILDINGS

Piper was interested in architecture. This painting depends on our knowledge of buildings: we know what a church looks like, therefore we understand its destruction. Understanding how artists represent buildings helps in analysing *St Mary le Port*. Consider three other artists and their works:

1 Turner the landscape artist, who started off as an architectural draughtsman.
2 Look again at *Lilith*, Kiefer's image of ruined buildings (see above).
3 Rachel Whiteread's famous concrete cast of the interior of a terraced house in East London, *House*, 1993, displayed the outside of the interior space of ordinary rooms.

What are the processes that artists use to make the solid form of a building? Observe how these artists use light and dark to create edges of form.

FOLLOW UP

Berchem backlit his views so that the light appeared to come from the horizon, a technique also used by the famous painter of classical Italian scenes, Claude Lorrain, seen in *Seaport with the Embarkation of the Queen of Sheba*, 1648. Where are the light sources in Piper's painting? Do the blocks of white act as light? Can you compare this light to your own representations of light in landscape?

Task

Ruins

Piper had painted ruins before the Blitz and became well known for painting them after the war. Ruined buildings have a long tradition in art. Does *St Mary le Port* fit into that tradition?

1 From the fourteenth century Italians had 'ruin rooms' decorated with murals of decayed classical buildings, reminding the visitor of an important past.
2 From the fifteenth century religious paintings in the Netherlands often included ruins, such as the three wise men visiting Jesus in an ancient shed.
3 Later ruins lost religious significance and represented the passage of time, often symbolising a nation's heroic past and present.
4 The Grand Tour involved studying ruins, recreating them for those at home. Nicolaes Berchem's *Peasants with Four Oxen and a Goat at a Ford by a Ruined Aqueduct*, 1655–60, describes an Italian scene. It shows the longing for the warm classical south, as cows stand around a tall Roman ruin artfully draped with ivy.
5 The largely British Picturesque movement of the late eighteenth and early nineteenth centuries celebrated the irregular shapes and textures of ruins; these were often set in idealised landscapes that looked like paintings, hence the movement's name. The Picturesque inspired huge landscape-gardening projects, as well as writing and painting.
6 Painted ruins create melancholy. Why does Piper's ruin have none of that gentle, melancholic longing for a mythic past?
7 What techniques has Piper used?
8 Compare them with Berchem's and other ruins to make your point.

CONTEXT
SOCIAL/CULTURAL

St Mary le Port was made at the height of the Blitz in 1941. An official war artist, Piper followed the German bombers from London to Coventry and Bristol to record the destruction they caused. Although the effects of war are obvious here, there are none of the images of man's inhumanity to man that might be expected. The sort of horrors that we are now used to from the television news are not evident. Have we become more brutalised since 1941, or is Piper's method more effective?

CHAPMAN BROTHERS
Hell, 1998–2000

PICASSO'S APPROACH TO THE SAME TOPIC

Picasso's *Guernica* is a huge painting made in reaction to the German bombing of a Spanish town on market day; it was the first use of military planes against civilians (see page 86). (You might try comparing *Guernica* to *St Mary le Port*.) As Picasso said, 'the arts are all the same; you can write a picture in words, just as you can paint sensations in a poem.' He wrote a long prose poem on the same theme as *Guernica*, 'The Dream and Lie of Franco', which was partly inspired by the etchings of the earlier Spanish artist Francisco de Goya:

> '...the banners which fry in the pan writhe in the black of the ink-sauce shed in drops of blood which shoot him — the street rises in clouds tied by its feet to the sea of wax which rots its entrails and the veil which covers it sings and dances wild with pain...'

Can you paint sensations in a poem?

GOYA'S *THE DISASTERS OF WAR*

The horrors of war theme demands reference to Goya's famous set of 80 etchings called *The Disasters of War*. Goya's prints were produced in reaction to guerrilla

warfare by the Spanish against French troops in Spain from 1807 to 1813, during the Napoleonic Wars.

The Disasters of War record Goya's eyewitness experiences of brutal violence on both sides, and are possibly the most shocking art images ever made. *This is Worse* shows a naked, armless man, impaled from neck to bottom on a tree. In *Great Deeds Against the Dead* the parts of three men are tied to a tree: a head is stuck on one stick and a pair of arms hangs from another. All of these mutilated bodies are naked, and cannot be identified by the viewer. This is anything but triumphant or victorious art.

TWO WORKS INSPIRED BY GOYA

Representations of the horrors of war in art are often linked with Goya, whose work has in turn inspired two contemporary artists. The Chapman brothers (discussed in chapter 3) have made two art works reacting to Goya's *Disasters of War* series:

1 Their version of *Great Deeds Against the Dead*, 1994, copied the composition of mutilated bodies hung from a tree. The brothers' three-dimensional remake contains what looks like doctored naked shop dummies. The blandness of the figures projects the original, horrifying image into our own image-saturated age. We are becoming immune to the power of images; indeed, shocking images are used to sell products and the Chapmans would point out that art is a branch of commerce.

2 The second art work is *Insult to Injury* (2003), the Chapman brothers' reworking, or, as they call it, 'rectification' of Goya's prints (others might call it mutilation). The brothers bought a genuine 1937 edition of the prints and drew their own additions on them — clowns, puppies' heads — and added colour.

The Chapmans say that their work is not a protest against war as such, but that it is more about the inadequacy of art as a protest against war. If, as they say, art can't stop wars, what is the function of the art we have analysed?

WHERE TO GO NEXT...

RUINS WITHOUT RUINED BUILDINGS

You may not have access to any ruins, but if you can find out what characterises such subjects, then you can use those features in your own work.

Step 1: Start by thinking about the difference between a complete object and the same object ruined. Take, for example, some crockery and compare the shapes before and after you have broken them.

Step 2: Next, try considering some of the other effects of ruination: weathering, rounding of edges, discolouration etc.

Step 3: Look at some of the examples mentioned above when beginning to arrange the composition of your 'ruins'.

Step 4: It will help your visual analyses if you decide from the beginning whether you are interested in the Romantic ruin or the effects of humans at war.

Step 5: Try looking also at some of Piper's later drawings and paintings of buildings, for example his images of Wales and Sheffield, or his larger paintings of Venice. Does his particular use of colour and texture seem a suitable one for you?

ABSTRACTION OR FIGURATION?

When faced with difficult subject matter, is it best to make art that others can immediately recognise? This is a question many artists have asked themselves and one that might be worth pursuing in your own sketchbook.

Piper was a fully abstract artist by the late 1930s, as seen in *Forms on Dark Blue*, 1936, but he returned to recognisable landscape paintings before war started

What the artist said in 1937

'There is one striking similarity in the surrealist and abstract painters' attitudes to the object: both have an absolute horror of it in its proper context. The one thing neither of them would dream of painting is a tree in field. For the tree standing in a field has practically no meaning at the moment for a painter. It is an ideal not a reality.'

From John Piper, *Lost, a Valuable Object*, 1937

What the artist said in 1938

'The thing for painters to do is be prepared not for war but for work. Not Air Raid Precautions; reconstruction precautions. If by a fluke there should be no war, painters indulging in abstraction and surrealism will not be ready.'

From John Piper, *Abstraction on the Beach*, 1938

in 1939. Why? Piper felt that the rise of fascism and the threat to freedom meant that abstract art was no longer the art of the future. He felt the need for an art of reconstruction, an art form all could agree on. Others would disagree. What is your position on this question?

FIGURE DRAWING AND CIVILIANS UNDER FIRE: MOOR AND ARDIZZONE

Like Piper's destroyed church, Henry Moore's shelter drawings remind us of the effect of war on civilians. Moore's shelterers are not individuals; they are a collective group, suffering together, elemental static people with no will of their own.

Step 1: How can you represent the attitudes of civilians in difficult situations?

Step 2: Will you concentrate on the individual and the personal response that stands for us all? Or should you avoid the individual and instead represent the whole of suffering society?

Step 3: What could be the role of colour? Compare Moore's work with other images of civilians during war. The English artist Edward Ardizzone also made drawings of civilians; his individuals are more cheerful than Moore's, waiting to go back to their usual lives. Ardizzone's war diary is currently on line at the Imperial War Museum and worth seeing: www.iwm.org.uk

Step 4: Contrast Ardizzone's drawings with Moore's. Look at line and how the pattern of lines, the speed at which the lines are drawn and their weight and texture tells us about character and how these figures are coping. Make your own drawings of figures, using these qualities of line.

Step 5: Think back to Goya's prints. Etching allows the artist to make direct lines with an intense expressive power that suits this subject. If you have access to a printing press, experiment with full etching techniques or dry point to reproduce your figure drawings. Even without a press, you can use pen and ink to analyse this theme.

What the examiner says

Inspired by the Chapman brothers, you might, for example, want to remake Piper's *St Mary le Port* in bubble gum to show how little some people value the comforting role of religion. Take care with such methods. Similar contemporary work depends on time, money, professional presentation and the sharp originality of the idea. It is easier to make a poor pastiche (and subsequently achieve poor marks) than a truly cutting-edge work asking the right questions. Ask yourself the question: have I really transformed the original and shown my own abilities, or have I just copied it?

The best way to do art

A young artist in art school used to worship the paintings of Cézanne. He looked at and studied all the books he could find on Cézanne and copied all of the reproductions of Cézanne's work he found in books.

He visited a museum and for the first time he saw a real Cézanne painting. He hated it. It was nothing like the Cézannes he had studied in the books. From that time on, he made all of his paintings the sizes of the paintings reproduced in books and he painted them in black and white. He also printed captions and explanations on the paintings as in the books. Often he just used words.

And one day he realised that very few people went to art galleries and museums but many people looked at books and magazines as he did and they got them through the mail.

Moral: It's difficult to put a painting in a mailbox.

John Baldessari, 'Ingres and other parables' in *Six Years*... ed. Lucy Lippard, 1997

Shirin Neshat

Untitled (Women of Allah) series, 1994

THEMATIC OVERVIEW

Shirin Neshat's work examines Islamic culture. This black and white photograph is one of her *Women of Allah* series, which she started in 1993. These photographs show Neshat's face or parts of her body and, while the images don't necessarily tell a story, they do ask questions.

In this particular photograph, she analyses the role of women within Islamic culture and how it connects, or not, with the West. Neshat grew up in Iran and studied in California. She returned to Iran in 1990, by which time the country had altered entirely to become an Islamic republic. Most importantly for Neshat, as a woman and artist, the public appearance and role of women had changed completely.

What the critic says: shade, hue and copying

Sometimes black and white are not described as colours (hues), but as shades. Such distinctions matter less than the effects that may be achieved through careful manipulation of these pure shades in the darkroom. Photography removes the full range of tones and simplifies visual information. This simplification is a major reason why your art teacher tells you not to copy from photographs. Choosing and representing visually significant areas of an object or scene is the key to observational drawing and you must show that you are capable of such a process.

In the new republic, women have to wear the traditional chador — a black dress that only shows the face, hands and feet.

TECHNIQUES
SOME QUALITIES OF MONOCHROME

The fact that this photograph is not in colour is significant. By making it seem like an old type of photograph, the artist is pointing to the meaning of the work.

- Black and white photography associates this image with the past. Can we infer, then, that women are also associated with similar qualities (e.g. tradition or dignity)?
- This monochrome presentation is an elegant image, with none of the grainy rawness that a black and white image can possess.
- Black and white can give images objectivity, a semi-scientific truthfulness. Is full-colour imagery associated in our minds with artificiality? Have we seen too many glossy-coloured adverts that we no longer trust?

FOLLOW UP

The following is a quick experiment to use later in your own work.

Step 1: Make images of groups of people, in monochrome and exaggerated full colour.

Step 2: Choose some would-be interviewees and pretend to them that your groups are politicians.

Step 3: Who would your interviewees vote for? Do the colour values have any effect on their answer?

Recording tools

The camera can make art in its own right, and it can develop art to be made by other means.

Digital cameras

The digital camera can act as a quick recording tool in the evaluation process (see 'Key terms' in chapter 7). It is an easy way to get visual information into a computer to work with; Adobe Photoshop Elements is relatively simple software to use. You can perhaps take photographs of objects to manipulate as images and add layers, for example. The results can be a spur for returning to other sorts of art making. Remember to keep each digitally altered stage in your sketchbook, fully annotated to show the development of your ideas.

Pinhole cameras

Pinhole cameras are a straightforward tool to make and use. The British artist Steven Pippin converts unlikely objects and places into temporary pinhole cameras. He used his local Laundromat washing machines, for example, to take, develop and rinse his prints to make a bank of images of figures in motion.

COMPOSITION

Women of Allah is a cropped image. It focuses on a woman's decorated hand touching her mouth. This gesture could mean thought, or silence. The face is not veiled, so according to Islamic law we are inside, or in a non-public place.

LAYERS

This image is layered, its stark tones helping to make the layers distinct. How do they work?

1 The first layer is sharp-edged text, made clear by the thin linear pattern running around the edge of the palm and fingers. This line makes it look as though Neshat is wearing a glove.

2 The next consists of short fingernails and some creased skin around the knuckles; the hand is visible under the text.

3 The third consists of the lips and face.

4 The deep black of the chador makes up the final layer.

As well as visible layers, this composition evokes intellectual and emotional layers. The text, for example, comments on other layers. The image suggests silence but 'the text suggests a voice,' Neshat explains. That 'voice' questions what might seem to be a traditional, even sensual image. Neshat called it 'a voice to question the stereotypically negative and victimising qualities associated with Islamic women.'

FOLLOW UP

The ability to select and order an image is a crucial skill, and one that requires practice. Would this image still be powerful if we saw all the face, or the entire figure? Try taking several well-known images and cropping or extending them to analyse this further.

Putting layers in your art can be a fruitful exercise, and the use of one part of the image to comment on another is well worth exploring.

TEXT AND FIGURATIVE IMAGERY

All of the photographs in the *Women of Allah* series feature text. The writing is in Farsi, which most Western audiences will not understand. The photographs themselves cannot be shown in Iran. Most viewers will therefore understand these photographs as abstract imagery, largely as pattern. The texts are by female Iranian writers, on subjects like sexuality, making them even more strongly forbidden in Islamic society. The striking black and white creates a strong, symbolic and different image to the Western pictures we are used to.

CONTEXT
OTHER ARTISTS

The law of the Koran prohibits representational art in important places such as mosques and in illuminated texts. As a result, Islamic imagery has developed differently to Western art. The majority of the designs in the *Women of Allah* series came from book illuminations based on calligraphy. These letters were treated as a pattern and scaled up or down to fit what was needed.

SYMBOLIC FORMS: THE CIRCLE

Notice the circle on the back of the hand. Geometry is important in Islamic art and has always been part of Arabic culture. Geometrical forms often have symbolic significance and the circle is important in most cultures, not least Islam. The circle and its centre are the beginning of all Islamic patterns, as the circle is the symbol of eternity, a figure without start or finish. Look back to page 118 and the circle in Hindu art.

SYMBOLIC FORMS: THE HAND

The hand is an important Islamic symbol, representing the five fundamental rules of conduct of Islam, the pillars of religion: faith, prayer, pilgrimage, fasting and charity. Each finger has a character attached to it: the thumb is the prophet and the four fingers are his companions, the Lady Fatima, her husband Ali, and Hasan and Husain her sons. The fourth finger also symbolises spiritual and moral goodness.

FOLLOW UP

The hand is equally well known in Western art and usually associated with Christianity, for example the hand of God almost touching Adam's on the ceiling of the Sistine Chapel in Rome.

Step 1: Try comparing the two belief systems.

Step 2: What are characteristic Western gestures? In Christian art, hands bless by extending the first two fingers of the right hand and the thumb. In Caravaggio's *Supper at Emmaus*, 1601, for example, Christ's right hand is extended in blessing.

What the artist says: return to Iran

Neshat said: 'When I went back everything seemed changed. There seemed to be very little colour. Everyone was black or white. All the women wearing the black chadors. It was immediately shocking. There's the stereotype about the women — they're all victims and submissive — and they're not. Slowly I subvert that image by showing in the most subtle and candid way how strong these women are.'

Step 3: Remember the cultural difference in early Western art between right (hand of power) and left (hand of submission and deceit). Try symbolic associations of colour, red being a stronger colour than, for example, yellow, and therefore possibly appropriate for the right hand.

Step 4: Vary drawing styles according to sentiment, for example using strong thick lines versus thin washes drawn with a brush.

Step 5: Can you combine Western naturalistic form with Islamic geometry, perhaps by representing a decorated hand against a geometric surface?

CONTEXT
SOCIAL/CULTURAL: BEAUTY

The photographs in this series are beautiful. Neshat said, 'Beauty has always been a major aspect of my work, partially because it is inherent in the nature of the Islamic

CARAVAGGIO *Supper at Emmaus*, 1601

tradition, it is an essential aspect of Islamic spirituality...beauty is a fundamental vehicle of mediation with God.' How is this beauty achieved?

1 Through the manipulation of tone, the sharp contrast between tones bringing out the clarity of lettering as a pattern against white skin.

2 To prove that observation, imagine the photograph in shades of grisaille. Does it have the same impact?

3 Combining this tone with the delicate hand and the clearly female lips makes a strong image of a woman and, in this context, one that has layers of meaning.

4 In not showing a Muslim woman as submissive, Neshat makes this image, and by association all Islamic women, powerful. This is an important political statement in this context.

What the artist says: how Western society restricted art

Why are there so few landscape paintings by women? One explanation was given by the painter Marie Bashkirtseff, who lived in Paris in the 1870s: 'What I long for is the freedom of going about alone, of coming and going, of sitting in the seats in the Tuileries, and especially in the Luxembourg, of stopping and looking in the artistic shops, of entering churches and museums, of walking about the old streets at night, that's what I long for, and that's the freedom without which one cannot become a real artist. Do you imagine I get much good from what I see, chaperoned as I am, and when, in order to go to the Louvre, I must wait for my carriage, my lady companion and family...This is one of the principle reasons why there are no women artists.'

NESHAT: FILMS

Neshat has made films that further explore the role of women, such as *The Shadow Under the Web*, a four-part projection, in which a woman in a chador is running in public and private places. In Islamic society, public places are largely male and private ones are female. Women running is not Islamic behaviour and could be an expression of Western freedom, but who is she running from, or to? What sort of freedom are we looking for?

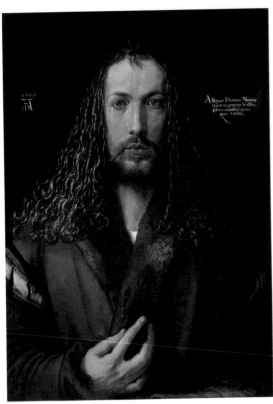

DÜRER *Self Portrait at the Age of Twenty-Eight,* 1500

WHERE TO GO NEXT...

SELF-PORTRAITURE

To an extent, this photograph is a self-portrait, but it is a portrait of the artist as archetype rather than an investigation of her as an individual. Many artists have shown themselves in different guises, clothes and characters, for example:

1 Dürer painted himself to look like Christ to emphasise the god-given gifts of the artist in *Self Portrait at the Age of Twenty-Eight*, 1500.

2 Cindy Sherman dresses as characters from recognisable art situations, or as stock television or film characters, seen in *Untitled Film Still #3*, 1977, which, like the Neshat image, is a black and white photograph. It shows Sherman as a stereotypical frightened woman in a 1950s' horror pose in a kitchen.

There are many more such images. If you were to represent yourself, what styles, poses and identities would you adopt? How would those identities affect the art that you chose to represent them?

ORIENTALISM

There is a tradition of representing the East in Western art, which is known as Orientalism. Orientalism is the practice of projecting Western fantasies on to images of the East, and women in particular.

Step 1: Examine Delacroix' *Women of Algiers in their Apartment*, 1834 (see page 154), which shows exotically dressed women in a harem. As in Neshat's photograph, we see women's private space, but there the similarities end. Delacroix' women are below the eye line of the viewer so that they appear submissive. Surrounding them are objects suggesting the east: hookahs and brightly patterned carpets.

Step 2: Why not isolate the characteristically luxurious colours and marks that Delacroix uses with the taut precision of Neshat?

Step 3: You could reimagine the scene from the *Women of Algiers in their Apartment* as it might be remade today.

Step 4: Alternatively, contrast the small fragment of white-on-green calligraphy in the Delacroix work with Neshat's precise Farsi text.

Step 5: If the subject of how the West approaches the East interests you, look also for the writings of Edward Said.

TEXT AND CALLIGRAPHY

Compare the written text in this photograph to calligraphy used by other artists.

Step 1: Find work by Mark Tobey, who was also influenced by Islamic calligraphy, in particular his white writing works such as *Universal Field*, 1949. His work shows those influences, and you could develop your own personal handwriting/mark making in similar ways.

Step 2: Try simplifying your own writing so that it becomes a series of meaningful shapes or objects.

Step 3: Make layer upon layer of these letter forms so that there is no distinction between object and ground.

HAND TOOLS

Hand tools demand characteristic gestures and can be a route to art of your own. If the hand is a tool for communication, texting is a new function for it. This activity has a characteristic hand position, usually involving the thumb.

Step 1: What is the texting position? How can you visually analyse it?

Step 2: What are the positions the thumb moves into? Does the emotional message of the text affect the movement of the thumb?

Step 3: Try turning the movements of the thumb into marks on paper. Rub graphite (e.g. from a pencil) on your thumb and make texting movements on paper (not on your phone).

Step 4: Repeat this process for texts with personal meaning. You are constructing a new visual language that could stimulate pattern-based images.

Step 5: Vary the colours and textures of the thumb gestures according to the strength of the emotions you are communicating. Refer to German Expressionism to help with knowledge of colour and emotional power, or back to Turner's thoughts about colour on pages 150–51.

Step 6: Once you have a sufficient number of images, make larger versions in a suitable medium or inscribe these new visual forms back on to the body. Make sure that any material you work with will come off afterwards.

What the examiner says

One tempting route to follow after looking at Neshat's image would be that of text written on the body. There is a long tradition of embedding images and text on the human body through tattooing. However, it would be difficult and painful to have your final piece tattooed on your body. There is an urban myth that someone had the entire Sistine chapel ceiling tattooed on his back, but this is not something to be recommended.

If you decide to research tattoos as part of your contextual studies, there are problems to avoid, similar to those encountered in comic art. The major difficulties students face are these:

- The dominant forms of tattooing are so strong and restricted that the opportunities for genuinely original personal visual research (i.e. the all-important observation phase of any unit) are few.
- It is difficult to expand the contextual studies beyond a few examples of skin art. This is a problem since you must be seen to have analysed the wider complexities of visual culture.
- When outcomes are assessed, final pieces often stand accused of plagiarism and insufficient personal response. In other words, the final piece looks as though it has been merely copied from another tattoo. A personal visual language has not been found.
- The nature of the topic makes it easy to miss key assessment criteria, and grades often suffer.

SECTION SUMMARY

This section has:

- considered two apparently different images, both emerging from complex and difficult contexts and both seeking to assess the nature of rapid and violent change
- examined Piper's role as a war artist and his ability to produce images quickly in difficult circumstances
- analysed Piper's interest in architecture and how other artists have represented buildings
- expanded this theme to consider the role of ruins in art, from early Dutch paintings through to the Picturesque
- analysed the ways in which the horrors of war have been represented by artists in the past, in particular Goya, and the ways in which contemporary artists have used Goya's work
- looked at the qualities and uses of monochrome

- carefully analysed the role of layers in Neshat's photographic image.
- identified the role of the circle as a geometric symbol and the abstract nature of Islamic art
- investigated the uses of text and calligraphy in the art of others and how you might use it in your own art
- developed the idea of the hand as a symbolic image to use in your own art
- looked at how Neshat uses notions of beauty to analyse the role of women in Islamic society
- considered a variety of ways in which a photographic image might be developed into work of your own in a different medium, emphasising the fact that your work would miss assessment criteria should you merely copy from photographs

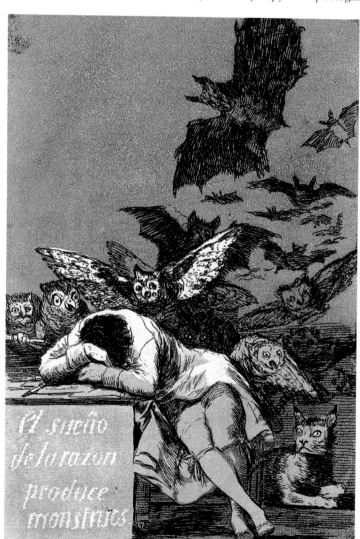

GOYA *The Sleep of Reason Produces Monsters*, 1799

CHAPTER SUMMARY

This chapter has:

- looked at the landscape Genre, from the depiction of a landscape through to images that analyse an entire culture
- looked at the two formal elements of colour and pattern
- analysed the semi-scientific use of colour by the divisionist artist Seurat and the complex colour systems underlying the apparently free use of colour in Turner's work
- looked at Mondrian's Utopian reduction of colour to the three primaries and to black, white and grey in his attempt to reveal the underlying natural structure
- analysed Kiefer's technique of applying colour in thick impasto and mixed media to the surface of a landscape, and the symbolic associations of his colours
- looked at what might be considered a more traditional landscape in the form of Piper's painting of a bombed church, revealing that even here his use of colour has underlying references
- considered the use of monochrome and its associations and the relationship of images to their social/cultural context

COURSEWORK WATCH

The final piece that you make as a result of careful visual research, critical and contextual study and development of your ideas is of course the completion of a major piece of art. It is vital, therefore, that you allow yourself enough time in which to finish it.

All too often students set themselves a task, to draw out and fill in an image, for example, and then believe that their final piece is complete. It is not; in fact, they have only just started. That final piece should involve the exploration of the new visual language that you have spent all those pages of your sketchbook developing. Once you have carried out the first basic task you have set yourself, then you must look carefully at your work to see what else it requires. There will be lots more to do on your final piece, so make sure that you leave yourself enough time.

COVER: DRAPERY

'EXTERNALLY SET ASSIGNMENT: HOW TO APPROACH EXAMS'

THIS CHAPTER FOCUSES ON...

- all the formal elements: line, tone, colour, form, pattern, texture

THIS CHAPTER INTRODUCES THE FOLLOWING TECHNIQUES...

- the treatment of light and shade on folds
- the use of the formal languages of the subject, e.g. the formal elements
- the use of other descriptions of visual vocabulary (rhythm, harmony or dissonance) to develop and resolve your ideas

BY THE END OF THIS CHAPTER YOU WILL BE ABLE TO...

- approach your externally set assignment with confidence
- construct a meaningful set of steps towards making a final piece
- work to a successful conclusion in the preparatory period before you take the exam
- ensure that the examination day(s) will be equally successful

Key words for this chapter

armature

contrapposto

scumble

synoptic

INTRODUCTION

No matter which exam board you use, one of the units submitted for final assessment at each level must be an externally set examination. Its basic format, explained below, is roughly the same as for the other units.

This chapter has a hypothetical theme and introduces you to three works of art to help you develop your own art. You may also use the theme as a unit of coursework.

EXAM PREPARATION

Each exam board has different preparatory study times or allows different study times to be set by your art teacher. Timed test hours spent making final pieces may also vary. The general methods, however, are the same, as are the assessment criteria.

Check with your teachers the exact amount of time available, and plan carefully. For planning frames and further guidance, see 'How to plan your time for an exam' on page 234. You have worked thematically throughout this book, and should continue to do so for this externally set unit.

What does 'synoptic' mean?

Work for both AS and A2 externally set assignments should be synoptic — that is, it must take account of the work you have made in previous coursework units. You should consider the following approaches:

1 When considering the theme, look back through past work, registering any relevant ideas in your exam unit sketchbook.
2 You can always return to the work of artists you have studied before, partly to reinforce your approach but also to discover new things.
3 When you start your first visual researches, go back to earlier successes. Show how they can help in this new work; a quick digital photograph or a photocopy pasted on to a page with annotations is all you need.
4 When you reach resolved ideas for your exam final piece, document previous final pieces. Show continuing themes that may have contributed to the solutions you have reached in this unit.

Refer also to page 278.

WORKING FOR THE EXAM
WHAT TO DO FIRST

Depending on the exam board, you may be given a single-word theme or a series of starting points. The first steps, however, are always the same.

1 Read the paper carefully.
2 Find the examples you have been offered.
3 Work outwards from an initial starting point or points.
4 Bear in mind that you are not answering a question and that a starting point is not a mathematical formula with only one answer.
5 What you make should build on your previous successes.
6 Document your thoughts and the journey of your ideas.

THE CONTEXTUAL APPROACH

As with previous thematic work, start with critical studies (see also 'How to approach a theme' on page 243).

1 Make a quick chronological survey, finding the earliest examples of the theme that you can. Put half a dozen examples together from then until now.
2 What links these images visually?
3 What links these images contextually?
4 What are the common uses of materials or techniques in the art you have chosen?
5 Put copies of these images on to a large sheet of paper and annotate them.
6 Either let that work lead you to more images to work with or, synoptically, contrast your current art studies with images from earlier units.
7 Combine the most useful examples and make annotated art studies of greater depth.

What the examiner says: observation work

A substantial part of your marks will come from visual research. Can you make relevant and competent imagery from primary sources, from something three dimensional directly in front of you? Do not restrict yourself by choosing approaches that have no route into visual research. Do not, for example, decide to make a life-sized painting of Bengal tigers if you have no access to the real thing (see page 224 for more details). Remember that exams are where you show off your abilities. If you can't draw ellipses, make sure you practise before you decide to set up a still life of teacups. If you still have problems, don't choose teacups to start with (see 'How to draw an ellipse' on pages 237–38).

FOLLOW UP: STORY BOARDS AND DEVELOPING IDEAS

When carrying out your exam preparatory studies, remember to keep pointing out the ways in which your research tackles the theme. Story boards are a good way of describing the movement of people and ideas from one position to another. Search out the story boards of well-known film directors; Ridley Scott, for example, makes carefully drawn images for the key scenes of his movies. Imagine the development of your own ideas as a series of story boards.

COURSEWORK WATCH

When working on the externally set assignment, you must concentrate solely on this unit. You will not have time for past coursework. Be organised and finish your other projects before you are presented with your exam paper. Do not restrict your success by completing old work at the same time.

5.1 COVER (DRAPERY)

THIS CHAPTER ANALYSES THESE WORKS:

- Joshua Reynolds *Three Ladies Adorning a Term of Hymen*, 1773
- Leonardo da Vinci *Study of Drapery*, 1480
- Christo *Wrapped Reichstag*, 1971–95

THEMATIC OVERVIEW: COVER

In order to demonstrate how to do well in an externally set assignment, this chapter takes a hypothetical starting point or theme: cover. It begins with critical studies, analysing how other artists have treated similar themes. In your art studies, be sure to analyse images in depth since these will be a substantial part of the supporting studies for the externally examined unit. If you follow the same unit format

What the critic says: who was Reynolds?

Joshua Reynolds was the most successful portrait painter of eighteenth-century London. He was also the first president of the Royal Academy of Arts, a national group of artists set up to raise the status of art. Reynolds had been to Italy in 1749 (he apparently went deaf copying a Raphael in the freezing Vatican). The links between Reynolds' painting, classical art and the Renaissance help in understanding his painting *Three Ladies Adorning a Term of Hymen*, 1773.

established throughout this textbook (i.e. first drawings, second drawings, final piece), you should cover all of the assessment criteria.

Cover, like most starting points or themes, is a vague term. A starting point is intended to provide many routes for your art. Here, we have taken the term 'cover' to mean covering oneself in cloth (i.e. clothing) and the art term, drapery. Drapery in this sense means cloth transformed into art. We are born into cloth, we die in cloth and represent ourselves through cloth during our lives. Drapery has been a standard sub-subject since art began.

CLOTH IN ART: DRAPERY

Draped cloth as art probably started with the classical period, for example the Elgin Marbles — or the Parthenon sculptures — from the fifth century BC. This classical beginning has meant that loosely draped clothes and flowing folds have become associated in the West with the classical past and therefore with higher thought and concepts such as idealism, civilisation and democracy.

JOSHUA REYNOLDS
*Three Ladies Adorning
a Term of Hymen*, 1773
(detail)

FOLLOW UP: GRAND MANNER

Three Ladies Adorning a Term of Hymen is a Grand Manner painting, also known as a history painting. The aim of the Grand Manner style, promoted by the Royal Academy, was to create art that did more than copy nature. Artists created elevated subjects based on classical myth and biblical stories. Figures made expressive gestures and wore classical clothing. Grand Manner figures emote in a vague mythical past, directing the viewer to universal truths.

Task
Drapery and the Grand Manner
Take gauzy muslin and make two sets of studies. In one, concentrate on the surface and exact forms of the cloth; in the other, make generalised visual statements about muslin blowing in breezes with light filtering through it. Which set best represents the qualities of this material? Why, and in what context?

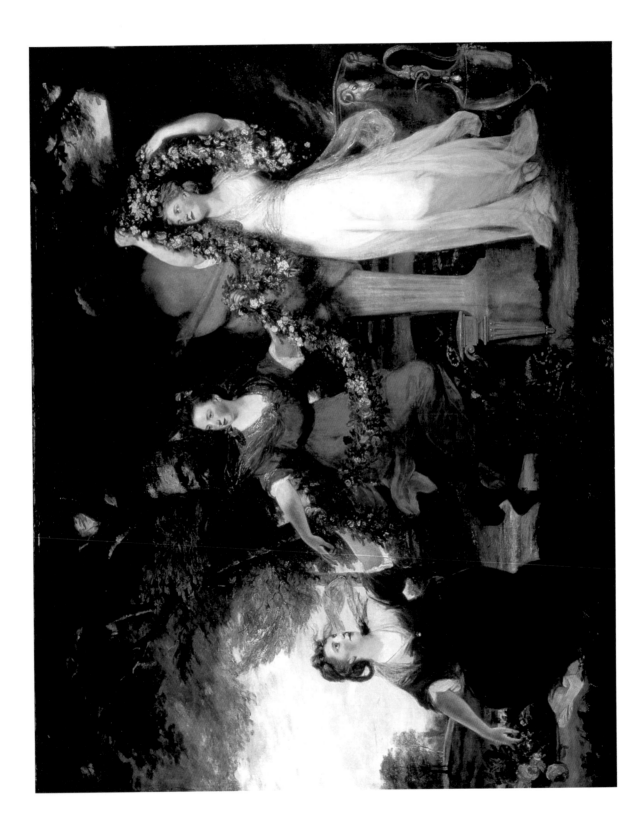

Joshua Reynolds

Three Ladies Adorning a Term of Hymen, 1773

At the 'first drawings' point in your exam preparatory studies, you are just starting to get to grips with the theme of Cover. The first steps are to refine that vague term to a focus on drapery. The next step is to analyse what other artists have done with a similar approach to the theme. Remember to document each step of the way; it is easy to lose marks by not making your ideas explicit.

THEMATIC OVERVIEW

In the exam preparation period, your time is limited. To reflect this, we have chosen one work of art to help your first analysis of the theme of Cover. It is a painting of three women in floating clothing, set on the edge of a wood. The artist, Joshua Reynolds, has filled the scene with clues to explain the image; the women's drapery is one of the largest clues, in every sense.

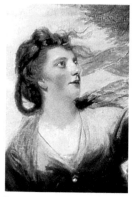

Detail

TECHNIQUES

Reynolds' painting changed after his trip to Italy. Before he went, he worked in block colour. Subsequently, he put down a layer of under paint, either a dark tone, like a blue black, or a white. The whites were then built up with thicker priming. Over this basic layer, Reynolds added glazes of almost transparent oil paint. He built up layers with long brushes, creating the play of light on flesh, cloth and trees. Rather than describing precise shapes and bodies through individual details, these layers of glazes elevated painted objects towards the ideal.

Three Ladies is an idealised representation of the imperfect people who came to Reynolds' studio. The substantial, slightly red-faced Montgomery sisters (British aristocrats) take poses from well-known paintings. They wear semi-classical dress and stand before a classical statue, but you cannot define their real shapes beneath the flowing cloth. You can see this idealisation in the setting of believable trees and hills, although none are individual trees and hills and the space behind the women is unclear.

COMPOSITION

This statue of Hymen is a 'term' (or 'herm', after the Greek God Hermes). A term was a Greek figure sculpture, usually bearded, that tapered toward the base; the shape of terms referred to fertility gods (like the lingam of Shiva — see page 119).

Section features

Works:
- Joshua Reynolds *Three Ladies Adorning a Term of Hymen,* 1773

Genre: all

Formal elements: all

Unit element:
first drawings

Hymen was the Greek (later Roman) god of marriage, and is always shown carrying a long torch. The woman in the centre, Elizabeth Montgomery, was due to marry. Her sister, standing closest to Hymen, was already married (she has passed the god whereas the others are moving toward him), and the sister furthest away wed a year later. This painting represents the passage of time or, at least, the social stages of womanhood, an interesting subject you could investigate yourself.

FOLLOW UP

The three figures are linked by the rope of flowers. This garland echoes the drapery, both the woman's clothes and the red cloth behind Hymen. The women's clothing is not properly classical — they are not wearing togas. But it is deliberately similar to classical dress, to conjure up associations with an important era for the viewers and patrons of this painting. Can you treat the clothes of people around you to bring out meanings associated with important contexts?

CONTEXT
WHO INFLUENCED WHOM?

Reynolds saw many paintings on his tour of Italy (see the task below). Try comparing the art that Reynolds saw with his own paintings.

Task
Reynolds and his sources
Step 1: Look at Raphael's *Transfiguration*, 1517–20, a painting full of exciting gestures, which are echoed by the heavy folds of cloth around the wild figures.
Step 2: Or, study Titian's *Assumption of the Virgin*, 1516–18, which has yet more gesturing figures. The central men are wrapped in red; above them, the Virgin Mary holds her hands to heaven. She too is swathed in red. Her dark blue cloak droops around her in a similar manner to Reynolds' garland.
Step 3: Rubens and Poussin are possible sources for Reynolds' figures. Their work has the important themes and expressive gestures of Grand Manner paintings. You could pose figures with these gestures yourself. If you cannot find figures to draw from, you could at least drape yourself in cloth in similar positions. Note the fall of the drapery and the weight of folds on your limbs. Can you record those sensations and to what extent the gestures are morally uplifting?
Step 4: Try two Poussin paintings. In *A Bacchanalian Revel before a Term*, 1632, the pose of the woman in blue with outstretched arms on the left recalls the Montgomerys; it is a similar subject. If these themes are interesting to you, a straightforward comparison of the two paintings would be a suitable task in itself.
Step 5: In Poussin's *The Adoration of the Golden Calf*, 1634, each figure is frozen in excitement and there is more dancing. In the background, the prophet Moses descends from the mountain carrying with him the Ten Commandments to stop their wicked ways.

HOW TO MAKE USE OF THESE COMPARISONS

Your topic is covering and drapery. The paintings suggested in the task use cloth to make moral statements. Is it possible to use drapery in the same sense now? You could just put cloth and/or figures into these positions/poses and build them up into your own art, but there is more to it than that. Ask yourself the following questions. What sort of cloth fits your interpretations? What sort of gestures would be suitable? Which medium should you employ and which range of textures, colours and patterns?

You may, for example, have heard the phrase 'draping yourself in the flag'. It is a metaphor, but one that you could turn into a physical reality.

POUSSIN *Dance to the Music of Time*, 1773 (detail)

THREE WOMEN

Any image containing three female figures prompts associations with The Three Graces. They were the personification of grace and beauty, a familiar classical composition. The connection between the Three Graces and Reynolds' painting was made at the time (see page 204 for further details).

What the art critic says:

The cloth swings around the dancers in the Poussin paintings as though it was weighted at the hem. No real cloth flows like this, but such techniques emphasise the swirling, uncontrolled nature of the dancers' movements. This technique has often been used in clothing. In the larger Prada shops, the display method for skirts includes putting them on a turning central shaft so that they swish in the same manner.

PERSONIFICATION

Personifying virtue is common in art, the artist's task being to compose convincing human beings with attributes that identify emotions and narratives. A good example is Rubens' *Peace and War (Minerva protects Pax from Mars)*, 1629–30, in which Minerva (also known as Athena), the goddess of war, learning and wisdom, holds back Mars, the god of destructive war. In the foreground, Peace is a mother feeding her plump child. Bacchus the god of wine and fertility offers food to more children. The rich velvets and satins fold around the figures, emphasising warm comfort and wealth. This painting was given to Charles I in an attempt to make peace between Spain and England, the personification of the main characters making the meaning clear. Here are some questions to ask yourself:

1 Could you use this method today?

2 What would the contemporary virtues be?

3 What composition would bring these qualities to the attention of the viewer?

CONTEXT
SOCIAL/CULTURAL

Emphasising the importance of the sitter is one function of portraiture. You can still see this process in the heavily stylised imagery used in today's urban music. What props, background and (crucially, in this context) clothing fit in a contemporary portrait? Do classical associations have the same meanings now? What are the attributes in a contemporary Grand Manner image?

Step 1: Your task is to portray a powerful contemporary player who wants to hide his or her face.

Step 2: Use drapery to establish the status of the sitter.

Step 3: Find lots of rich cloth and a figure, mannequin or figure-shaped armature.

Step 4: Arrange the figure in a sitting position. Remember the role of the pyramid in composition. The basic form should be a huge, wide-based pyramid.

What the critic says: who were the Three Graces?

The Three Graces were the three young women who looked after Venus. In classical compositions, two of the figures face one way and the third turns away through 180 degrees. Arranging figures to show different aspects is a helpful composition. Reynolds does not quite follow that classical tradition, and the figures do not face the viewer as you might expect in a portrait. What interested Reynolds was the Renaissance characteristics of the Graces: beauty, love and chastity.

Step 5: Light the form with the folds deep in shadow, the highlights strong and the background completely dark.

Step 6: The power and heavy stability of the shape will be emphasised by the richness of colour and texture. To bring out the status of the sitter, you must view it from below, so that the head is invisible and its great bulk towers above you.

WHERE TO GO NEXT...

PORTRAITURE

Reynolds said: 'he who in his practice of portrait painting wishes to dignify his subject will not paint her in modern dress, the familiarity of which alone is sufficient to destroy all dignity.' The choice of clothing in *Three Ladies* is intended to emphasise the high social and cultural position of the three sisters.

Step 1: If the visual aspects of clothing can be interpreted, they could be the basis of some exciting visual analysis. What, for example, are the classical associations of draped cloth as opposed to tight trousers or baggy jeans?

Step 2: Continue this approach by making drawings of appropriately formal folds of cloth or clothing.

Step 3: Contrast this visual research with the rumples in disordered cloth or clothing.

Step 4: Lead on to a series of analyses of different colours and textures, their contexts and meanings. Relief printing and etching would suit this approach.

LORENZO GHIBERTI *Story of Jacob and Esau*, 1425–52

CONTRAPPOSTO, A DEVELOPING POSE

Look at the figure in white on the right of the painting, the married Montgomery. She is posed with one knee bent and the other straight, putting the weight of her body on one leg. This pose is called contrapposto. It makes the figure appear in motion, twisting slightly against itself. Contrapposto was first used in classical Greek sculpture to show naturalistic movement in the static, single, male nude sculpture. Contrapposto was rediscovered in the Renaissance, and became one of the defining features for representing figures. Earlier classical figures had been nude. These later works used the disturbed folds of drapery to reveal movement and create form, as in this Montgomery knee. The use of contrapposto was a crucial artistic method for centuries.

Step 1: Try comparing Reynolds' Montgomery sisters with pre-Renaissance art, such as the Gothic figures from the west front of Chartres Cathedral, 1145, who have recognisable heads but long straight gowns with stylised folds that do not reveal the forms beneath.

Step 2: The later bronze figures on Ghiberti's gates of Paradise in Florence, 1430–37, develop contrapposto, for example the story of Jacob and Esau, where women turn their gently swaying figures. Ghiberti made movement through drapery: the underlying forms show through the cloth as it turns with the figure.

Step 3: Once you have acquired this knowledge (in much the same way as Reynolds did on his Italian trip), you could demonstrate your own understanding by posing figures in the varying chronological forms of contrapposto.

Step 4: Make drawings of each type, as a sort of library of drapery techniques.

Step 5: Consult your library to decide which of the posed figures or drapery swirls suits your interpretation of the theme.

Step 6: Stage your figures or drapery as a tableau. Light will be particularly important. This approach could lend itself to exploitation with textiles, especially built textiles.

COLOUR

The drapery in Reynolds' painting is in a series of pale shades. An important role for drapery in early Renaissance paintings, apart from representing timeless classical covering, is to hold colour. Colour in these earlier works acted symbolically, in a similar way to the attributes of each figure, to tell the viewer who was who in a painting. The Virgin Mary, for example, always wears blue; red is worn by brides in Japanese and Chinese weddings; green is a key Islamic colour — Muhammad's cloak, for example, was green.

WOMEN AND CLOTH

Try looking at other representations of women in which the cloth they are draped in has significance, e.g. Degas' *Two Laundresses*, 1884. This painting shows two women in baggy, nondescript clothing, although one has a strongly orange scarf. They are working — ironing more cloth in what looks like tiresome drudgery.

Task
Comparisons
Compare the heavy, thick cloth in Degas' painting, which is created by dragging dry oil paint over rough canvas, with Reynolds' aristocratic, lightweight, swirling fine silks. How has the representation of cloth displayed the class of people portrayed in the past? What are the methods you might use in the future to analyse visually social and economic differences?

SECTION SUMMARY

This section has:

- introduced you to the basic format for an externally set assignment
- stressed the importance of following the established unit format
- introduced you to a hypothetical theme, or starting point, to demonstrate how to tackle an externally set assignment.
- analysed a Grand Manner painting to examine different treatments of drapery and to find ways of making your own art as a result
- introduced you to gesture and personification as ways that artists in the past have introduced meaning into their art, and suggested contemporary routes for you to follow
- stressed the importance of working from direct observation to create understanding of the forms around you and to make your own art more convincing

Task
Colour and clothing
It would be interesting to pursue colour associations with cloth further, particularly the connection between clothing colour and cultural meaning. Does switching around the obvious associations still make exciting imagery? You need to be careful not to cause offence, but would the message still be the same if, for example, the Virgin Mary was dressed in a yellow floral print rather than sombre ultramarine? Or think of the colours associated with certain football teams — reds and blues. Would pink and turquoise mean the same thing?

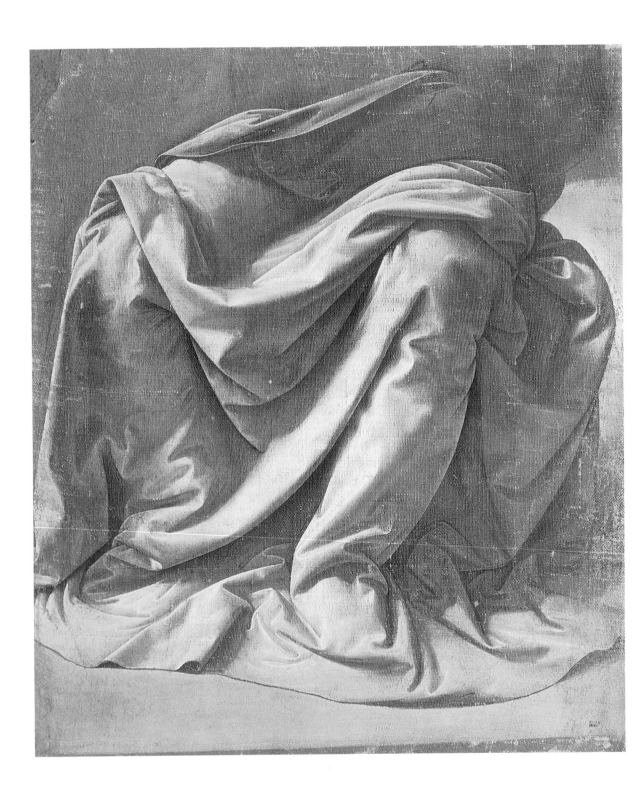

Leonardo da Vinci

Study of Drapery, 1480

YOUR WORK IN THIS SECTION

In this section of the externally set assignment, you are making second drawings. By now you should have made your first drawings based around the theme of Cover. You have analysed the Reynolds paintings to kick-start your contextual ideas. Now you are gathering your thoughts and planning for the journey to your destination: the final piece made during the exam period. How can what you have discovered about drapery so far be turned into art? What other observation-based work should you be doing? What other art should you be looking at?

Section features

Works:
- Leonardo da Vinci *Study of Drapery*, 1480

Genre: all

Formal elements: all

Unit element: second drawings

Detail

THEMATIC OVERVIEW

Through investigating this study by Leonardo da Vinci, we show how you can use a drawing by another artist to develop your own art. Drapery, as a subject for art, is intended to be timeless, whereas clothes date quickly. Ways of painting drapery have not changed much over the centuries, so this image is a useful guide to the processes and ideas that dominate this topic.

TECHNIQUES

When he was an apprentice, Leonardo da Vinci, like many before and after him, would soak muslin in clay water and drape it over a clay model, so that the folds didn't move. He would then draw the result. These drawings were usually exercises in studying the light and shade often used in later paintings.

Task

Drawing folds

Leonardo's technique is simple to update. Muslin, sometimes called butter muslin, is a fine netting-type material and can work well, but any cloth will do, such as sheets, old clothes and calico. It is the absorbency of the material that affects the drapery you get at the end.

Step 1: Put together an 'armature', a structure to drape the cloth over. Chicken wire, some cardboard boxes or even a couple of old chairs will be adequate.

Step 2: In a bucket, mix up some plaster of Paris or pottery plaster or even quick-drying builders' plaster (the fine topcoat finishing plaster is best). Clay water (water that has a solution of clay mixed into it) is really too dusty and fragile to use in an ordinary art room.

Step 3: Add some thick white emulsion paint. This slows down the drying time so that you can work with the cloth, but you will still need to work quickly. You can also add a good dollop of polyvinyl acetate (PVA) glue if you have some to hand.

Step 4: This is messy work, so first cover the floor with plastic.

Step 5: Soak the cloth in the mix.

Step 6: Take the cloth out of the bucket and drape it over your armature, making deep folds that move in a definite direction.

Step 7: When the cloth is dry, you should be able to take it off the armature and place it where you want. Alternatively, you can leave it on the armature.

Step 8: Light your arrangement strongly with a single source. Make your first visual researches, perhaps in watered down washes of black ink.

Step 9: Try using the traditional academic system when drawing on large sheets of paper. Work with a light brown ground to act as the midtones, a darker brown/black to act as the shadows and finish off with a dry scumbled white to act as the highlight. Or you could use red chalk, black chalk, pen and ink with wash on a range of tinted grounds, all highlighted with white. These are all traditional media for tonal drawings.

Step 10: Remember that you can also use this stiffened cloth as part of a relief art work itself. Staple the cloth to a board and paint and draw images of cloth over the board and the stapled cloth/sculpture to make a relief image of drapery.

Step 11: Some time after this drawing, Leonardo wrote that, rather than working from one static set of folds, artists should experiment with different cloths and textures. Again this is something you could try. Compare the folds in thick leather with those in fine cotton perhaps. What colours, textures of paints and mark-making tools work best with each material?

Step 12: It is worth pointing out that Leonardo made this drawn study on cloth, fine linen in fact, rather than paper. Partly this was because of the cost of paper, but largely it was so that he could use brush and ink (Bistre is the name of the ink-like pigment he used here) in a similar manner to the later painting. You could try different cloths to work on. It seems appropriate to analyse cloth by working on cloth.

Step 13: Your studies could lead on to final pieces in any media. Three- and two-dimensional work and textiles have already been mentioned. Delicately lit, your set up could be the site for photographic studies. Dramatically lit, you could make images to use for strong prints around the behaviour of figures at night. Both types of lighting could be the maquettes for a stage set.

COMPOSITION

Leonardo's drawing is a worked-up study. It appears to have moved beyond the first sketches or thoughts of an artist rapidly jotting down a thought. Leonardo's notebooks are full of examples of those sort of 'first drawings' and are worth searching out.

This drawing might look like a still-life analysis of cloth for its own sake. However, Leonardo stressed that drapery was only important if it closely reflected and illustrated the body underneath. In the Renaissance world, drapery was unimportant unless it was attached to a figure. What is the shape of the body we can see here?

Task
Visual analysis
How do you know there are two legs bent at the knee under here? **Step 1**: Look carefully at the role of the white areas and how they lie next to softer gradations of grey tone or sharper edges of deep shadow. **Step 2**: Take a viewfinder, select a horizontal cross section of the work and make a version of it. Remember the point of such an exercise is not to copy the work but to make an in-depth visual analysis that will lead to work of your own. **Step 3**: You will find that you are looking at two draped vertical forms at slight angles from the vertical, the right-hand form leaning slightly more than the left. Between the two skew uprights are a series of huge folds, probably the most visually interesting area of the piece. **Step 4**: Notice the effect of the heavier group of folds across the knees. Such a top-heavy composition creates a feeling of falling; placing the largest forms at the top automatically makes the viewer aware of gravity. Leonardo makes us feel the weight of the fabric as it topples in a series of swaying movements towards the floor. **Step 5**: Experiment with arrangement of forms, either in three dimensions in a series of sculptural experiments (the sculptor Anthony Caro might help you here), or through representations of cloth in similar arrangements. Experiment with top-heavy forms to recreate the pull of gravity.

FOLLOW UP: SCALE

Leonardo's drawing contains little in the way of carefully constructed detail; there are no small descriptive marks to hold the eye. One result of such a technique is to remove any sense of scale. Were you to put small figures at the base of these two vertical forms, it might look like a picture of the Grand Canyon, or an overhanging glacier with the snow about to engulf tiny mountain climbers below. How do other artists introduce scale in their work?

Make a series of analyses of other works from the point of view of an ant or a giant. Use these extreme viewpoints to rework your own drawings of drapery.

CONTEXT
OTHER ARTISTS/WHO INFLUENCED WHOM?

As an apprentice in the 1460s, Leonardo made drapery studies for his master Verrocchio. Verrocchio apparently gave up painting when he saw his student's painting of an angel. Many of Leonardo's early studies became standard models for other artists to copy. There is a surprising similarity between this study and the drapery of the Madonna in Ghirlandaio's *Madonna and Child with Saints Justus, Zenobius and the Archangels Michael and Raphael*, 1484. Look at the sharp fold on the left balanced by the heavy folds across the knees and the long thin fold running from the right knee to the ground.

DOMENICO GHIRLANDAIO
Madonna and Child with Saints Justus, Zenobius and the Archangels Michael and Raphael, 1484

FOLLOW UP: COMPARING SWAYING FOLDS AND FORMS 1

You could compare Leonardo's draperies or other traditional examples with art made in the twentieth century or later, such as Picasso's *Les Demoiselles d'Avignon*, 1907, or Paula Rego's *The Dance*, 1989. Ask yourself the following questions. How do the techniques of these later artists compare to Leonardo? How do their techniques help or advance the narrative? Which techniques are most appropriate for your treatment of this theme? Why?

What the critic says: intellectual art?

It is from Leonardo that we can trace the emphasis on the intellectual side to art. You could say that without Leonardo, Duchamp could not have lugged a gents' toilet into an art competition, nor Hirst displayed a shark. Although an astonishing technician and a man fascinated by new techniques, Leonardo's interest lay in solving problems mentally rather than in mechanical completion, hence his many unfinished works. Through his work and behaviour, artists began to be thought of as creative intellectuals rather than mere craftsmen. Once it was established that art had a conceptual base and that it involved thought, artists were free to concentrate on the mental approach at the expense of traditional skill, and so to toilets and sharks.

What the critic says: a *Da Vinci Code* reference

Leonardo's life is fascinating to read about. The recent publication of the thriller *The Da Vinci Code* has kept the name alive. The book as a whole is fiction but it does swing between fact and fantasy. The writer Dan Brown makes some intriguing claims for da Vinci, especially that he was a grand master of a secret group called the Priory de Sion. In fact, the Priory de Sion, on which the whole of *The Da Vinci Code* depends, was invented by a man called Pierre Plantard, partly to give himself a spurious family background. He registered the society with the French government as a social club in the 1950s, although it had only one member — him. Brown says at the start of the book that the Priory was founded in 1090 and that you can find related documents in Paris's Bilbliothèque Nationale. It wasn't, and you can't.

PAULA REGO
The Dance, 1989

FOLLOW UP: COMPARING SWAYING FOLDS AND FORMS 2

The semi-symmetrical swaying in Leonardo's drawing of the folds of cloth between the knees recalls a painting by the English artist Terry Frost, *Black and White Movement*, 1952. Frost was remembering the movement of boats in the harbour at St Ives. Curved black forms move rhythmically across a board that is taller than it is wide, making us aware of gravity as the curving shapes work down the surface. Making such unlikely associations is a natural part of looking at art. It is one you should practice constantly, keeping a record in your sketchbook. From such unlikely combinations, all kinds of exciting work can occur.

CONTEXT
SOCIAL/CULTURAL

Leonardo started his working life in Florence, a key city in the Italian Renaissance and one that was at the height of its power. This was the period in which the status of the artist changed radically, from that of a craftsman, placed in the same low guild (trade union) as apothecaries, to one of greater social importance; Leonardo supposedly died in the arms of the king of France. From the Renaissance onwards, therefore, we can start to talk about the artist's personal involvement in the work. From this date, the artist began to put his own ideas into his art, his beliefs therefore becoming a clue to the meaning of a work.

FOLLOW UP: THE CODE

Dan Brown's characters make unsupportable claims for Leonardo's paintings, especially the *Mona Lisa* and *The Last Supper*. Why not search out his claims and compare them to what you think of Leonardo's paintings? Or, find the work of another artist, and rethink and rework it so as to re-present it to an audience in a new reading.

WHERE TO GO NEXT...

FIGURE AND CLOTH 1

By incorporating life drawing into the drapery study, you can analyse the role of clothing and the 'empty shell' as a form of portraiture.

Step 1: Contrast the nude and draped figure. Drawings made earlier could be used, or make tonal drawings of the nude figure in strong contrapposto poses.

Step 2: Drape a figure in different cloths. Experiment with printed materials. Pattern shows changes of shape well.

Step 3: Using tone, discover the underlying form of the body in the cloths. Experiment with different highlights, according to the strain the body puts on the

covering cloth. Likewise, the depth, darkness and number of folds depend on the pressure the limbs exert on the cloth.

FIGURE AND CLOTH 2

Step 1: With this knowledge of draped figures, extend your approach to think about empty and filled clothes. Do clothes recently removed still keep the sense, either real or imagined, of the wearer?

Step 2: Can you show a real or imagined presence through your treatment of cloth? What about through colour? Experiment with flesh tones in the highlights. Could warm colours in the folds suggest human warmth?

Step 3: Try careful drawing, or rapid mark making, so that the folds of the discarded clothes still appear to hold the structure of the human form, perhaps the rise of the shoulder or the bump of the knee.

Step 4: This approach would suit life-sized monoprints. A Formica-topped table will take colour and would be a suitable surface on which to work. Ink up the Formica surface. Try imprinting cloth texture on to the wet ink. Wipe away areas with wet rags to make highlights. Large rolls of paper are suitable but expensive; lining wallpaper works well and is cheaper. Do not forget to dampen the paper in advance to make it flexible.

> **What the critic says:**
>
> Leonardo stressed the importance of the body underneath drapery. Drapery can be like another skin, with the folds reflecting the underlying skeleton and giving the cloth some structure. Did you know that the central point where a fold starts is called the eye of the fold?

FIGURE AND CLOTH 3

Step 1: Old clothes, especially from an unknown source (e.g. from a charity shop), have many possible past lives built into them. Old clothes have strange, sometimes unpleasant, smells. Old cloth produces characteristic noises when the fabric is rubbed together.

Step 2: Who has worn these garments? How should these clothes be arranged, draped or posed?

Step 3: Can you construct visual characters for these clothes? Can you reconstruct an identity, create a history and flesh it out by referring to images and portraits from the history of art?

Step 4: Which range of colours will bring back that past life? Spend time on the behaviour of colour in the shaded area of a fold. The ability to modulate colour confidently is frequently seen as a test of a candidate's subject knowledge.

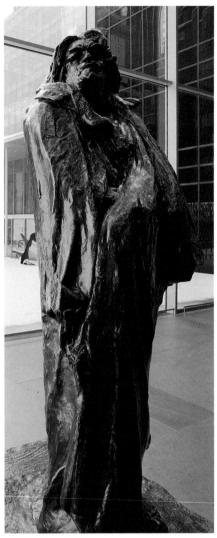

RODIN *Balzac*, 1898

WHERE TO GO NEXT...

THE CHADOR

Work for your externally examined unit should be synoptic. If you have looked at Shirin Neshat, consider the chador, the all-enveloping garment worn by Muslim women, or look back and see if Neshat has anything to offer you (see pages 185–93). Ask yourself the following questions. Does this concealing clothing offer a sense of protection for the wearer? What are the effects on women of wearing the chador? How does looking from inside a chador affect the perception of the wearer when analysing Western clothing?

RODIN

Rodin's *Balzac* is an astonishing sculptural study of the clothed figure. Cast from bronze and over three metres high, this huge monument to the great French writer caused controversy from the start. The figure is swathed in an enormous dressing gown. With little textural detail, the cloth reads as vast weighty planes of form. *Balzac* is a powerful, semi-figurative sculpture. As one of its patrons said: 'The stoutness, the stunted figure and the ugly profile of the inspired writer could on no account be observable and reproducible realities...The only thing that can possibly interest us is the representation of his mind by way of the general design of his attitude.' In other words, because the writer was ugly, it doesn't mean that his statue should be.

What the examiner says: colour modulation

The ability to modulate colour, also known as blending colour, is an important skill. It is frequently seen as a test of a candidate's understanding and subject knowledge. It would be useful in your careful analyses of fabric to demonstrate that you can modulate colour, for example across a fold. You will find this easiest by working with three tones (highlight, midtone and a shadow) and by lighting the subject with a strong raking light to bring out the highlights and shadows.

SECTION SUMMARY

This section has:

- analysed a worked-up study of cloth in order to develop visual and analytic skills
- researched the Leonardo study to develop three-dimensional forms, either as an end in themselves or as the site for further visual research
- looked at the role of the figure underneath the cloth, both real and imagined, as a source for your own art
- considered the importance of scale and viewpoint in your own and others' art
- considered Leonardo's contribution to the history of art, notably the importance of the intellect
- presented a range of approaches to making your own art, inspired by this study

What the artist says: how to paint drapery in colour

The traditional painting techniques for drapery have not changed much, so why not look at one of the earliest descriptions of the method, written by the fifteenth-century Renaissance artist Cennino Cennini:

'the Way to paint a drapery in Fresco... if you wish to paint drapery any colour you please, you should first draw it carefully with your verdaccio [a sort of thinned brown colour]; and do not have your drawing show too much, but moderately. Then, whether you want a white drapery or a red one, or yellow or green, or whatever you want, get three little dishes. Take one of them, and put into it whatever colour you choose, we will say red...make one of the other two colours light, putting a great deal of lime white into it. Now take some of the first dish, and some of this light and make an intermediate colour; and you will have three of them. Now take some of the first one, that is the dark one; and with a rather large brush and fairly pointed bristle brush go over the folds of your figure in the darkest areas; and do not go past the middle of the thickness of your figure. Then take the intermediate colour; lay it in from one dark strip to the next one and work them in together, and blend your folds into the accents of the darks. Then, just using these intermediate colours, shape up the dark parts where the relief of the figure is to come, but always following out the shape of the nude....Then in another dish take still another colour lighter than the lightest of these three; and shape up the tops of the folds and put on lights.'

Cennino Cennini, *The Craftsman's Handbook (Il Libro dell'Arte)*, 1437, translated by Daniel V. Thompson Junior, 1933

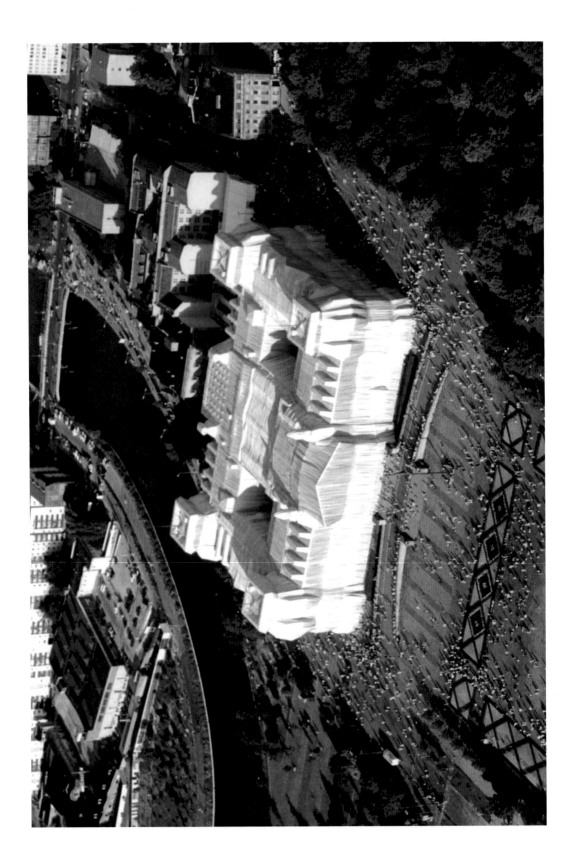

Christo

Wrapped Reichstag, 1971–95

YOUR WORK IN THIS SECTION

You have now reached the stage where you have to prepare and make your final piece. It is crucial that you are well prepared for what you are going to make and that your preparatory studies are complete. The vast, three-dimensional work featured in this section goes way beyond the straightforward images of cloth investigated so far.

THEMATIC OVERVIEW

Christo is the name of a man-and-wife team. Christo wraps things up and has become known for wrapping buildings and great chunks of geography. Its work is studied here because it does more than turn a building into an art work; it draws attention to the context of the building, summing up how complex the use of drapery can be.

TECHNIQUES

Christo's project drapes material over the building, tying it down with rope. On this scale, aesthetic arrangement of folds is impossible. The project demands years of planning, heavy machinery and huge gangs of workmen. It is the visual impact of the cloth, what Christo calls the 'irrationality of the work', and the underlying ideas that make the team's projects successful.

FOLLOW UP

To research the public element of this work, compare *Wrapped Reichstag* with domestic drapery.

Step 1: Choose three different types of domestic cloth, for example the small cloth used for wiping spectacles/sunglasses, a shirt and a folded sheet.

Step 2: Start by analysing the qualities of these three materials. How do they crease, reflect the light or absorb liquid? Try close-up observation drawings first.

Step 3: Vary the medium to suit the material. Use fine pencils for the shirt, soft pencils and washes of pale colour for the sheets and thin washes of Indian ink and pen drawings for the cleaning cloth.

Step 4: Move from close observation to human movements and scales relevant to each material. On larger paper, start making the characteristic gestures associated with each fabric with the medium you have chosen.

Step 5: You now know about these fabrics in a domestic context. Public monuments involve a huge change in scale. Choose a public monument that has some resonance, such as Nelson's column. Make a quick, small model; the cardboard inside a paper towel roll will do. Position, drape and record this little object with each of the cloths in a domestic setting. Ideally, record the results through drawing or a combination of drawing and photography.

Step 6: Contrast this with images of the public monument draped with each cloth. Use media close to the function of the column and its usual context, for example blue and gold from Nelson's uniform and epaulettes, the blue in sponged paint, the gold highlights in thick impasto. Use a range of sources for the public images: newspapers, postcards, the internet etc.

Step 7: Compare your studies with Christo's projected ideas and actual photographs of the wrapped building.

COMPOSITION

What the art historian says: what is the Reichstag?

The Reichstag is the rebuilt German parliament building, symbolising the reunified Germany. The original Reichstag was burned by the Nazis in 1933 and bombed by the Soviets in 1945. Given Germany's past, it is the most public and political structure in the country. Christo points out that the Reichstag is in collective ownership, belonging to every German.

Wrapping the Reichstag took a million square feet of silver, aluminium-treated, polypropylene fabric, kept in place for fifteen days by 15,000 metres of blue rope. Christo's curtain walls include *The Running Fence*, 1976, which runs through northern California, and *The Valley Curtain*, 1972, 142,000 acres of orange nylon run across Rifle Gap in Colorado (see also page 223 for thoughts on the Berlin Wall).

Christo sees its work as belonging to the drapery tradition in art, which stretches back to classical Greece. As part of your study, you might make a comparison between an example of Greek drapery (e.g. figures from the Elgin Marbles) and an area of the *Wrapped Reichstag*.

Christo also stresses the qualities of impermanence that it sees in its work:
1 The buildings, objects or landscapes are not draped for long — two weeks in this case.
2 Fabric by its very nature changes shape constantly, and the light that falls on it changes all the time.

FOLLOW UP

It is relevant when looking at this sort of wrapping to think about other forms of packaging, such as that of commercial products.

Step 1: Take something like a Mars Bar. Look at the relationship between the slightly loose black wrapper and the chocolate bar. How does the wrapper entice the buyer?

Step 2: Observe the way in which the black, red and gold catches the light. Marketing and technical directors will have spent a great deal of time creating the exact reflections and wrinkling qualities of this wrapper. What are they? How would the effect of this commercial product be changed if you varied these qualities?

Step 3: Expand this analysis to other relevant products. Build up your knowledge by enclosing the analysed product in one of those slightly transparent plastic bags from a supermarket.

Step 4: What does this final plastic outer wrapping tell us about the contents? Look at the shapes you can see pushing through the bag. How do the shapes vary according to the enclosed product?

Step 5: In what direction do you want to take your ideas towards a final piece? Would you be thinking about a sculptural treatment, perhaps of a work that viewers could unpack themselves? Think of the wrapping for presents in this context as well.

What the artist says

'Throughout the history of art, the use of fabric has been a fascination for artists. From the most ancient times to the present, fabric — forming folds, pleats and draperies — has played a significant part in paintings, frescos, reliefs and sculptures made of wood, stone or bronze. The use of fabric on the Reichstag follows that classical tradition.'

Christo, 1995

Step 6: You could attempt a large painting that considers the different qualities of light reflected from these products, using pattern and texture to analyse each commercial product visually.

Step 7: You could attempt a large print, using several different printing techniques to take advantage of the different weaves and qualities of fabric, paper and other wrappings that you have been examining.

CONTEXT
OTHER ARTISTS

How can a project of this size be financially viable? Christo makes its money from selling smaller works related to the larger wrapped projects: drawings, pieces of fabric as souvenirs, prints etc. There is a certain visual language to these images shared with the work of the artist Claes Oldenburg, who made giant versions of consumer objects, for example *Soft Dormeyer Mixer*, 1965. He lived in the Chelsea Hotel, New York, next to Christo in the 1960s.

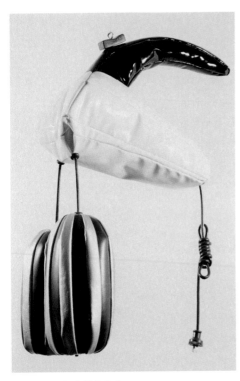

CLAES OLDENBURG *Soft Dormeyer Mixer*, 1965

What do Christo's smaller two-dimensional images look like? They depend on annotated photographs and careful, engineering-like drawings of objects that look as though they are substantially scaled up from the original. Cut-out images from catalogues and other sources are pasted on to the drawing to illustrate ideas, and artistic writing is scrawled across areas of white page. Try searching out these drawings and make your own 'formal' collage to present your projects and ideas.

FOLLOW UP

Wrapping a building yourself would only be a copy of Christo's art, but consider the team's reference to cloth in art.

Step 1: Take, for example, a caryatid from the Erechtheum, 415 BC. A caryatid is a carved figure acting as a column. The folds of cloth on the figure echo the fluting in an actual column.

Step 2: Compare these semi-structural folds with different white cloth, e.g. Singer Sargent's *Carnation, Lily, Lily, Rose*, 1885, which shows two young girls in white at dusk. The folds of cloth are gently painted, delicate yellows and pinks catching the light from the lanterns in the girls' hands.

Step 3: Look at the evident brush strokes of Berthe Morisot when she paints the fashionable dresses of young women, e.g. *A Summer's Day*, 1879, and her zigzag marks describing the light feel of silk and satin.

Step 4: Use these three methods to describe the fall of material over a suitable building. Would Greek columnar, vertical folds suit a school gym, or would the opposite tell us more about your attitude to such a structure? Try the same approach with other buildings. Select ones that suit the techniques used in the three works above. Alternatively, select art that you can find for yourself.

Remember: Christo's wrappings make the viewers more aware of the social, cultural and political structures present in the society in which the wrapped object exists. Will the way in which your object is draped reveal those structures?

CONTEXT
OTHER ARTISTS

It is important to remember that Christo's wrapping of the Reichstag involves not just the covering but also the negotiations beforehand and its removal afterwards. The building re-revealed will restore its innocence as if reborn from a cocoon. The draping and unveiling is not dissimilar to the way in which the unveiling of a

new public statue emphasises the process of showing and displaying. The other notable German architectural structure of this period was the Berlin Wall. Like the unwrapping, the removal of the wall mattered as much as its putting up.

WHERE TO GO NEXT...

BUILDINGS AND LANDSCAPES

Wrapping a building draws attention to its form and context. You could of course make straightforward landscape images that stress key architectural features. Scale, colour and composition will draw the eye to a building. Try thinking of the surrounding landscape as ripples of cloth.

What the artist says

Christo emphasises the temporary nature of its work. It is how it makes us rethink the wrapped object that is permanent: 'For a period of two weeks, the richness of the silvery fabric, shaped by the blue ropes, created a sumptuous flow of vertical folds highlighting the features and proportions of the imposing structure, revealing the essence of the Reichstag.'

CLOTHING AND OBJECTS, BEDS AND BEYOND 1

Twentieth-century art increasingly moved away from painting on stretched cloth (canvas) to including real cloth itself as part, if not all, of the art work. Robert Rauschenberg's *Bed* of 1955, for example, includes an entire bed — sheets, quilt and all — with paint splashed on top of it. The bed is hung on the wall, so we know we are meant to read this as art, yet at the same time be aware that it is an object from the real world.

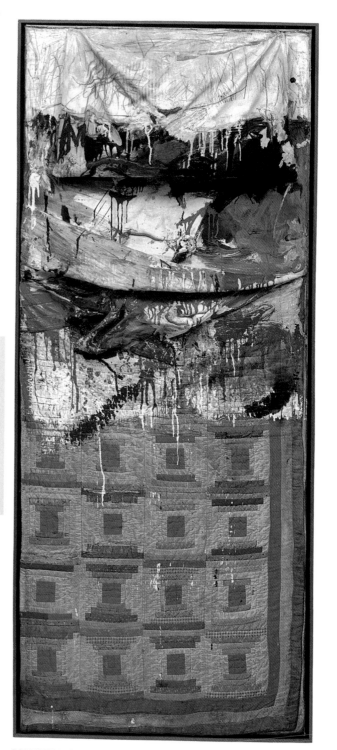

ROBERT RAUSCHENBERG *Bed*, 1955

CLOTH AND OBJECTS, BEDS AND BEYOND 2

Step 1: Move your analysis along further by looking at Tracey Emin, who took the process of bringing objects into the gallery to a logical endpoint by presenting her own bed in the gallery.

Step 2: More relevant to this approach to drapery are some of Emin's other works, for example her blankets, *Something I've always been afraid of*, 2002. These feature letters cut from cloth and sewn on to blankets. There are often misspellings, clashes of patterns, slight differences of materials and textures. The texts stay within the diary persona that Emin has adopted for herself, so the words they spell are often shocking. Her blankets are appealing as objects and interesting in the way that they use cloth as a method to tell stories, ask questions and demand thought from the viewer.

Task

Tracey Emin: objects and drapery

This is a route you could look at yourself. Try thinking of objects: how they combine with drapery and how you can use them, and not their representation, in your art. In other words, think about combining installation and paint in making new draped sculptures.

Step 1: You are unlikely to be able to drag your own bed into the art room and drench it with paint. In art terms, *Bed* is a cloth-covered armature; its domestic context links the work to self-portraiture. Instead of your own bed, there are other objects you might use. How would you, for instance, combine paint and a set of plastic cups, spoons, food boxes and paper napkins? A remade fast-food outlet with cloth demonstrating the movement of figures through the outlet would be one possible route to explore.

Step 2: Or, put knives, forks and food on a tablecloth, a more genteel form of dining perhaps. Drape your dining arrangement with carefully folded semi-transparent cloth, the folds making crisp shapes around the objects. Light the subject with soft white lights. This would be a good subject for etchings, large tonal drawings leading to more sculptures, or substantial table-top ceramic sculptures exploring positive and negative space.

What the examiner says: flexibility and the formal elements

Art students often fail to reach their true grade because they are inflexible and stick to ideas that don't allow them to show their abilities. If your observation work covers all the formal elements, then you should build in flexibility from the start. Think back to the Bengal tigers example given at the start of this chapter. We suggested that copying a photo of a tiger was a bad idea, in that making a mind's eye view of a tiger is usually unsuccessful. We suggested that you research the visual qualities of the animal and the role of:

- line
- tone
- colour
- form
- pattern
- texture

All animals move in a characteristic manner. How do tigers move? Could you show their movement by making line drawings focusing on the behaviour of a close selection of stripes?

The animal's colouring involves a particular range of colours. What is that range and how does it fit together? Where else can you find examples of this range of colours?

A tiger skin has a particular texture. What is it? What are the colours as it catches the light? Can you find an example of something similar to the subject for a series of close studies?

Continue working through the elements. There are always ways to find subjects for close observation. Work with a bit of flexibility.

WHERE TO GO NEXT...

QUILTING

Emin's work refers to quilting. Quilting was taken up by US artists, notably women. Many radical women felt that oil painting, particularly after Abstract Expressionism, had become a wholly male technique. The lone man in his studio fighting inner demons by violently throwing paint on to a vast surface was not the only way to make art; women were looking for ways of making art together. The US artist Judy Chicago has set up an international quilting bee in which individual women and women's groups make small quilts on the theme of women and their successes. These quilts are then shown together as part of a larger communal art work.

Traditional quilting is increasingly accepted as an art form, for example, the Gees Bend quilts made in a rural community in Alabama. The works that they make have a distinctive geometric style, visually similar to high Modernist paintings.

What the examiner says: plan carefully

Textile work generally, and sewing in particular, is certainly worth considering as a means of building up a final piece for the exam. The element you need to consider is planning; the time it takes to make meaningful textile-based work can often be longer than the time allowed.

IMPRINTS

There is a long tradition that powerful characters, for example the gods, leave an imprint of themselves on their garments. This clothing becomes more than a record of the god's existence; it becomes worthy of worship itself, a holy relic. The Turin Shroud is a good example, although the veracity of this object has been often doubted. The belief is that the shroud, which has the image of a man upon it, is the winding sheet that wrapped Christ after his crucifixion. Whether this is true or not, this process is one that is worth

Task
Quilts and beyond
Studying and using traditional forms, patterns and methods can be a productive route into art of your own. **Step 1**: Try the work of Michelle Walker, a quilt maker in the UK who is concerned with ecological issues and who often uses non-traditional materials in her art to make those concerns known. **Step 2**: Look for Barnett Newman, who used Navaho rugs as one form of inspiration. Even if it would take too long to make a full quilt for the timed test itself, this is still an art form worth using. Try looking at imagery in carpets throughout Asia, or rug work in Britain, or use them to consider purely formal elements in an image. This could lead to other textiles, or a combination of print and textile, or some large-scale photography that compares close-up photographs of carpets with larger landscapes.

investigating as a method of making art. Imprint a figure on to cloth and think about what methods of making and presentation could turn ordinary cloth into an image with considerable power.

SECTION SUMMARY

This section has:

- considered the role of context, in the *Wrapped Reichstag* in particular and in art work in general
- explored a range of uses for drapery in art of your own, stressing the importance of initial research no matter which final medium you choose to use during the timed test
- considered the whole life of a work of art, attributing equal importance to the removal of the wrapping from the Reichstag, for example
- developed the theme of wrapping to consider the role of drapery in the art made by women in deliberate opposition to traditional male techniques

What the examiner says: evaluation

Try to leave enough time at the end of your timed test to evaluate the work you have made. See 'Evaluation and how to do it' in chapter 6 for further information. It is crucial that you make connections between the art you make and the art you have looked at. How have the ideas, techniques and compositions helped you? After making this piece of art, what would you like to do next, and which art will you be inspired to investigate?

CHAPTER SUMMARY

This chapter has:

- shown you how to tackle an exam theme, 'cover', using critical and contextual study to turn the theme to your advantage
- pointed out the synoptic content of the exam unit — that fact that you should involve reference to your previous art
- shown you how to turn thematic analysis into meaningful observation work, and how to be flexible and to ensure that your visual analysis covers all the formal elements
- made sure that you follow the same unit structure you have used throughout this book, thereby ensuring that you cover all assessment objectives
- shown you how you might interpret and make use of traditional representations of drapery, from those associated with Grand Manner or history paintings to careful studies of cloth through to conceptual reinterpretations

EXAM WATCH: PREPARATION

Always remember that exams in art, as in any subject, are where you show off. While it might be tempting to go into the actual timed test to investigate new skills, this is a temptation to avoid. Try to make sure that you know the behaviour of any new materials you will be using. Investigate new techniques in your supporting studies before the day(s) when you have to use them under exam conditions. Don't decide you want to use arc welding or screen printing in your timed test if you have never done it before. It is extremely unlikely that an unknown technique will go well and get the sort of marks all your hard work deserves. See 'How to do well in an art exam' on page 233 for further details.

C H A P T E R S I X

HOW TO...

INTRODUCTION

This chapter takes you through some of the processes and formats you will need for success at this level. It is designed as a reference chapter to be used for specific needs.

THIS CHAPTER CONTAINS THE FOLLOWING TOPICS...

- How to annotate a work
- Colour: a checklist of some specialist terms
- Drawing: some types of mark making and how to use them
- How to write a cover sheet
- How to do well in an art exam
- How to plan your time for an exam
- How to display your work for external examination
- How to evaluate your work, why it's important and how to do it
- How to draw an ellipse
- How to find art to use in your critical studies/art studies
- How to use a sketchbook
- How to approach a theme
- How to show the 'turning edge'
- How to write about art

HOW TO ANNOTATE A WORK

Annotation is a key skill. It's a way of showing your knowledge, what you have learned so far and what you intend to discover in the future. Crucially, annotation is a way you can show all of this visually.

- Make a reasonable sketch of the work. A photocopy or similar will do, but a drawing will make you look harder and you can demonstrate some ability of your own. Do not spend too long on this part of the process; making a brilliant copy of a copy is not a worthwhile use of your valuable time. The role of the sketch is

to direct your own looking and that of the person marking your work. The artist looks by drawing and that is what is happening here.

■ The sketch need not involve the whole painting as long as the basic formal elements are covered, nor should it take you longer than a couple of short lessons to complete. The sketch is not an end in itself.

■ Place relevant information around the sketch, pointing out areas of importance by using suitable arrows, changes in scale, selection of key areas etc. Both Dorling Kindersley's *Annotated Art* and *Your Brain on the Page* from Tate Britain contain useful models.

The annotation around the painting should include reference to:
■ the theme you are analysing
■ the actual use of marks by the artist and a careful examination of the processes and the materials used; try making versions of the marks or brush strokes or provide evidence of the making of the work, e.g. chisel or casting marks etc.
■ the palette of the artist and an explanation of how the range of colour helps to create the work's impact; remember that, even with work that is monochrome or in pure white plaster, the artist is bound to have considered the fall of light upon the work and the shadows as part of the palette
■ the composition of the work, relating it back to your analysis of the theme
■ the context in which the work was made:

 * **artistic** Refer back to the artist's debt to the art of others and forward to his influence on others. Use comparison and contrast; annotated photocopies are a quick method.

 * **cultural** What was happening in the cultural world at the time? What questions were artists/writers/musicians/dancers asking themselves? What were some of the key cultural themes of the period? For example, in response to British Social Realism of the 1950s — a period overshadowed by fear of the atomic bomb — artists showed interest in black and white films, new forms of writing and so on; look at the intense vision of early Lucian Freud works.

 * **social/political** What was happening in the wider world at the time? Did those events have any effect on the sort of work that artists were making? Does our perception of those events then have any effect on us as we look at the works now?

This is an art study, not an artist study. Include little in the way of biography unless the parts mentioned are relevant. Does it help with the investigation of the role of still life, for example, to know that Cézanne's father was a banker? If it does, you will need to explain why. Merely copying chunks of biography and other people's opinions only shows that you are good at copying. In your annotated art study, you must be able to show an examiner that you are looking for a purpose. Always ask yourself the basic question: what is the relevance of this work to my own art?

COLOUR
A CHECKLIST OF SOME SPECIALIST TERMS

There are specialist terms that will help you to understand and describe the colours that you see and want to work with. You will find in-depth descriptions of their meanings under 'Key terms', but the following is a useful checklist:

- additive colour
- divisionism
- light
- optical colour
- saturation
- subtractive colour
- complementary colours
- hue
- local colour
- palette
- secondary colours

DRAWING
SOME TYPES OF MARK MAKING AND HOW TO USE THEM

Drawing is the making of marks on paper in response to something you have seen, are seeing or are imagining. It is the crucial process by which artists analyse what, and how, they perceive. There are many forms of mark making that you might consider. You need not restrict yourself to drawing with an unsharpened 2B pencil. The medium you use should suit the theme you are analysing and the subject you are drawing. Spend some time thinking about the surface on which you are drawing. Different absorbencies of paper will affect the end result, as will different colours of paper. Each of the mark-making tools below demands that you hold it in a different way; that grasp will affect the sort of marks that you make and the effects you create in response to your subject.

BRUSH

Claude Lorrain's *Woodland Glade*, a seventeenth-century landscape in monochrome (just one colour), shows the full range of brush techniques. By using a brush to draw, you can make a wide range of marks and achieve much more than a wash to fill in an area. The tip of the brush makes a fine, curling descriptive line, whereas the whole weight and full spread of the bristles can fill in a large area with the deepest density of colour. Indian ink is one of the media traditionally used. It will thin down with water to a pale grey which, once dry, can be overlaid again and again to produce some very fine washes.

CHARCOAL

Juan Gris' *Still Life with Pitcher*, 1910, is a pre-Cubist drawing by the third member of the Cubist movement, and one that fully exploits the properties of charcoal. From the dark shadow of a jug on the right of the drawing, bowls and plates jut into view,

each turn of the crockery being shown by curving highlights, made either by the white of the paper or by white chalk or gouache laid over the top. These white areas lie against grey directional strokes of charcoal, varying in density according to values of tone, i.e. the brightness of light or density of shadow. The great virtue of charcoal is the speed with which you can work and the large areas you can cover quickly. The downside is that it doesn't keep well. Charcoal usually comes in two basic forms. Compressed charcoal is powdered charcoal, pressed into round sticks bound with glue or made into pencils. It allows you to make some deep blacks and strong textural studies. Willow charcoal essentially consists of burnt sticks, in varying thicknesses. The thickest is known as scene painters' charcoal and allows you to cover an area or make long thick lines. Charcoal is worth using for curving lines and soft areas. Remember that you can use an eraser to work back into the darker tones to make highlights.

In the past, artists used chalks, black and red in particular. Dry or chalk pastels or Conté crayons are probably the closest you will get to these old media; modern classroom chalks are of an entirely different consistency.

PEN

Van Gogh's *Postman Joseph Roulin*, 1888, is a good example of the use of this medium. Van Gogh cut his own reed pens (see page 25 for a description of how to follow this process yourself). Drawing pens designed for use with ink (Indian ink tends to give the deepest black and the strongest line) can be easier to use as you can vary the nib and thus the quality of the line with ease. These sorts of pens are sometimes known as dip pens, from the process used to get the ink on to the nib. If you look at any of van Gogh's drawings, you can see the virtue of the medium. In *Postman Joseph Roulin*, thick lines form the heavy postman's coat, giving a curving weight to the bottom third of the work. Above the beard are slightly thinner lines without a clear pattern; finer crosshatching shows the structure of the face. Behind the postman, the flat plane of the wall is made clear by blocks of horizontal/ vertical crosshatching.

PENCIL

William Blake's *The Soul Hovering over the Body Reluctantly Parting with Life*, 1805, is a careful pencil drawing in which the artist applies the greatest detail to the dying figure at the bottom of the drawing. The smaller marks on the figure's chest make that area darker and draw our eye to the heart, presumably the source of the soul. Above the dying man is a floating female figure, delicately drawn in fine lines to make her appear lighter, ready to accept the heavy, darker soul.

Pencil is the standard medium for student drawing, although it need not be. Try varying the softness of the pencil according to the quality of light on the subject.

Remember that you can vary the way you hold the drawing tool to suit the subject. Drawing with the whole shoulder and a soft pencil frees the arm to make wide swinging movements and arcing marks on the page, whereas drawing with a sharp, hard pencil and tiny movements of the fingers creates dark, short lines suited to describing great detail.

HOW TO WRITE A COVER SHEET

A cover sheet is a one-page document you might put into the front of your sketchbook. It sets out your art, creating the frame through which the viewer can understand and assess it. It is something to make after you have finished the unit, to direct an examiner through what you have made.

- It is important that any viewer of the sketchbook understands exactly what brief you have set yourself and that they find this out on the first page.
- It is up to you how you lay the cover sheet out, but think about it visually. Does the look of this first page reflect the subject and theme of the unit?
- It also helps a great deal if you can number the pages and provide some vague chapter headings to direct the viewer through the book.
- First, however, mark your name, the unit, the date and the level you are studying.

Here are some questions to ask yourself about the unit as a whole and some aspects of it.

THE UNIT

1 What are you doing? Specify what tasks you have set yourself, the official unit title and the brief you are actually working to. Insert a relevant quote from a key artist here.

2 Why are you making this work? Don't list preferences. Instead treat this in terms of problem-solving. Include references to past work of yours.

3 How have you made the work? What methods and materials have you used and what is their relevance to questions 1 and 2 above?

ART STUDY

4 What are you studying — individuals or movements? Which themes/processes/ techniques are you comparing? Which key artists and images? What are the relevant historical and social contexts?

5 Why and in what way do the subjects of your art study relate to answers about the unit (especially question 2)?

6 How will your work benefit? Will any viewer know that you have studied these artists in depth? What means of study are you using? What art have you been to see?

ASSESSMENT

7 What are the key areas of your work that you want assessment to focus on? Where in the sketchbook are these key areas? Remember that you need to make the actual progression of your ideas clear. Don't expect someone to wade through sketchbook pages of densely written pencil to find a single line, hidden under layers of ink, glue and glitter.

8 Why do these key works of yours fit the problems you were trying to solve in question 2?

9 How well has your art study gone? Use evaluation and target setting (see the section on evaluation below). Analyse the outcomes, rather than giving minute-by-minute explanations.

You don't have to answer all of these questions. They are just a guide to help you think about what to put in the front of your sketchbook.

HOW TO DO WELL IN AN ART EXAM

1 Don't expect to be able to prepare and present all your development work for AS/A2 in the five minutes before you hand it in. Make sure that all course-work is finished and ready and that it makes sense before you start your exam unit.

2 Can an examiner understand why he/she is looking at what you have presented? Is the brief clear? Have you made a cover sheet (see 'How to write a cover sheet', above) or something similar at the start of this exam unit?

3 Start with the critical studies. Remember that 'all art starts with art' and critical studies are not a bolt-on at the end. 'Oh, I've finished my art work, sir. All I've got to do is choose an artist,' are the words of a failing candidate.

4 As one of the exam boards says in its instructions: 'Preparatory studies for the exam are obligatory and candidates must ensure that they have submitted suffi-cient evidence for an accurate assessment to be made. The onus of providing evidence lies with the candidate.' Make sure that every page of your sketchbook is thought about, with drawings edited etc. You are supposed to be presenting yourself in the best light you can. If the whole project depends on an unnoticed scrappy idea, are you going to get good marks? Get credit for your ideas by making them noticed. Don't lose marks by putting a rushed, half-finished drawing in a half-empty sketchbook. Plan enough time to finish the drawing. Those weeks in the run up to the timed test period are vital. At least 80% of your marks can come from these preparatory studies. Make sure that there are art studies, obser-vation drawings and substantial evidence of development of your ideas, and that the development relates to the art that you have studied.

5 Presentation matters. Make sure a clear visual theme runs throughout the exam preparatory studies. You are a visual person and you should make that clear in the presentation of your work. Remember that an examiner is following the trail of your journey through the development of your assignment.

6 Exam units are synoptic (see 'Key terms'); that is, you must include references to the work you have made in previous units, showing how what you have discovered before is helping you in this unit.

7 Plan your exam time carefully. The time given for both AS and A2 exams is short. Remember that a smaller final piece demands stronger preparatory studies. Exams are where you show off your strengths; do not try a technique or material you have never used before. Avoid, for example, experimenting with three-colour screen printing the day before the exam if you have never picked up a squeegee before.

8 Try to leave enough time at the end of the timed test itself to make an evaluation of what you have done. Ask yourself some fundamental questions. Is the work what I intended it to be? If not, why not? It might, for example, be much more effective than you planned. The evaluation is certainly not a time to put yourself down. Don't forget that the exam is supposed to be synoptic, in other words a summing up of the work you've done before. Is that clear in your exam sketchbook? Don't forget to refer to the art you have studied and, ideally, refer to the art you want to look at next as a result of what you have just made.

HOW TO PLAN YOUR TIME FOR AN EXAM

In this programme, you have to show what you're going to do and when, or how you're going to do it and when.

- Decide what sort of work to make or decide which discipline you are going to work within (e.g. painting/drawing, sculpture, printing, photography, textiles).
- Identify a starting point likely to lead to a successful outcome.
- Outline the route you are thinking of taking to arrive at the examination piece:
 * Assessment Objective 1 (AO1): record observations, experiences, ideas, information and insights in visual and other forms, appropriate to intentions. **First drawings**
 * Assessment Objective 2 (AO2): analyse and evaluate critically sources such as images, objects, artefacts and texts, showing understanding of purposes, meanings and contexts. **Art studies**
 * Assessment Objective 3 (AO3): develop ideas through sustained investigations and exploration, selecting and using materials, processes and resources, identifying and interpreting relationships and analysing methods and outcomes. **Second drawings/planning and development**

* Assessment Objective 4 (AO4): present a personal coherent and informed response, realising intentions and articulating and explaining connections with the work of others. **Final piece**

Note: Check in your examination instructions how long the lead-up period to your exam is. The length of time varies between exam boards and between AS and A2; it might be set by your art teacher. Check how many weeks you have got and plan carefully.

When	What I intend to do and how I intend to do it	Which Assessment Objective will be covered?
Week 1		AO1
		AO2
		AO3
		AO4
Week 2		AO1
		AO2
		AO3
		AO4

HOW TO DISPLAY YOUR WORK FOR EXTERNAL ASSESSMENT

Methods of displaying your work for external assessment will vary greatly from institution to institution, depending on space and time available, but there are certain pointers that can help the process.

1 The essential point to remember is that it must look as if you care about your work, that you want your art to look good and that you believe in your work. This does not mean that each sheet should look pristine and beautifully clean. Some examiners like work to look as if it has been 'loved', as they call it — as though you have consulted it a great deal, actually worked from your sketchbook as you have made your final piece and as if your sketchbook has been your constant companion for the past year.

2 Now that work is numerically sampled students are no longer required to put on an 'exhibition' of their entire output. You are simply required to display each unit clearly and separately. You could, though, think about how you might make a feeling of visual identity about the display of your art, so that it is recognisably your personal response. You could employ some sort of colour coding perhaps to declare your identity.

3 You do not have to mount up loose sheets of work that are not in sketchbooks, but creating some sense of unity about the way in which sheets are displayed can aid the way in which your display is viewed. You could organise odd drawings together on to larger sized sheets of the same size and clip them together so they form a book of your progress.

4 Make sure that the connection is clear between each sheet of preparatory studies, the relevant sketchbook page and your final piece. What is the relationship between studies and final outcomes? A photograph of your final work as part of the cover sheet (see above) might help.

5 Lastly, there will be a range of exam labels that have to be put on the front of your work, detailing your candidate number etc. It makes everyone's life a great deal easier if you put your name and unit number on the back of each piece of work and on sketchbooks. Check those unit numbers carefully with your teacher. The order in which they were taught to you will not always be the order in which they are examined.

HOW TO EVALUATE YOUR WORK, WHY IT'S IMPORTANT AND HOW TO DO IT

To evaluate well, you have to ask yourself what evaluation is for. Some answers are given below.

1 An evaluation is supposed to show what you have discovered, what you have made as a result of those discoveries and what you are going on to make next.

2 Notice that evaluation is not assessment. Do not write, 'I think I did this very well', nor for that matter, 'I think I could have done this better'. Evaluation is not the place to put yourself down and nor is it appropriate to boast.

3 If evaluation is a grouping together of your thoughts at the end of a unit, then obviously it makes sense to mention what those thoughts were.

4 Go back through the unit and find the two or three key issues that you discovered and that mattered when you made the final piece. If you were studying land-scape, for example, it could have been the realisation that Matisse's methods for reducing a complex view to a simpler two-dimensional decorative surface would

apply to your own art. Perhaps you discovered that your collage of sweet wrappers could be turned into a large textile, or that Rachel Whiteread's casting methods where just what you needed to make a large sculpture about how we use space to exclude others.

5 Whatever those discoveries were, they are the points to highlight in your evaluation. These highlights need not be long; a sentence or two and some diagrams or visual references will be enough.

6 It is essential in evaluation at AS and A2 that you refer to, and make connections between, your work and the work of other artists that you have studied.

HOW TO DRAW AN ELLIPSE

When you are drawing mugs, glasses or bottles, you will have to work out how to represent a circle in depth. The circular form of the object will have to appear as if it is going away from you, into the illusory depth of the paper. This tilting of a circle in space is called an ellipse. It is noticeable when this hasn't been done correctly, and there are a series of principles to follow that prevent inconsistency in your drawings.

- If you are drawing a label on a bottle or a can, one of the glaring mistakes students make is to forget that the lettering and the top and bottom of the label will also curve; they will be roughly parallel to the curve of the top and bottom of the object. It's a simple point but one that is often missed.

- There are various different ways to go about drawing an ellipse but they all depend on two basic methods — 'crating' and linear perspective.

- Crating an object means putting an imaginary box around it, a skill many students are taught in design technology lessons. Start by drawing a square, then draw diagonal lines to join each corner so that they cross at the centre. Draw centre lines to bisect the middle of each side of the square, thereby dividing it into eight equal triangular sections. Now draw a circle inside the square, making the centre of the circle the point at which all the lines of the square meet. The outside of the circle should just touch the square at the points where the four centre lines bisect it. The next step is to put that circle into the illusory depth of the paper or, as you might say, 'into perspective'.

- Remember the fundamental rule of linear perspective: all lines that are not parallel to the picture plane (those that are on the horizontal or vertical axis) will meet at infinity. These lines are called orthogonals. First, you need to establish the horizon line and from that the vanishing point at infinity where the orthogonal lines of your crated square will meet. Think carefully about your viewpoint. How high above the object do you want to appear to be? The wider the angle

between the converging orthogonal lines, then the higher the object will seem to be in relation to your own eye level. The narrower the angle between the orthogonals, then the further below your eye line the object will seem to be — you will appear to be looking down on it.

- Redraw your square, tilting it toward the horizon so that if the lines making two opposing sides were to continue, they would meet at your vanishing point. Put in the diagonals and crossing lines. The vertical centre line will go up the page to the vanishing point. Now redraw the circle so that it just touches the four crossing lines where they bisect the edge of the square. You will probably need a few goes at this to make sure that the circle is smooth and full. It is important to avoid your circle, in perspective, looking like a lemon or a squashed square with round ends. Turn the paper round and look at it from different directions to check. You have now drawn an ellipse.
- To turn this single ellipse into the top or bottom of an actual object, you will need to make your 'crate' enclose the whole of your cup, bottle, glass or whatever it is you are drawing. Again, you are working with a single-viewpoint linear perspective. First, draw the front plane of the box parallel to the picture plane. Establish your horizon line and vanishing point, so that the centre line of the box will go vertically to the vanishing point. Draw the orthogonals from each corner of the front plane to the vanishing point. Make the top back end of your box by drawing a line parallel and behind the top of the front plane, crossing the converging orthogonals as they go to the horizon. Drop a right-angled line from each end of the back of the box vertically down to the orthogonal below. Join up these two new lines to make the lower back end of the box.
- Draw your ellipse in the square in perspective formed at the top and bottom of the box. You will probably need to smooth out the circle as you did before and, clearly, you will need to rub out the sections that you cannot see in real life. This will give you a basic cylinder 'in perspective' that you can image as you need to.

This is the basic method for a single viewpoint drawing of an ellipse. You can experiment with varying the position of the crate in space and your eye line in relation to it, and you could move on to drawing cylinders on their side, for example. Once you get the hang of the single viewpoint, you can move on to two-point perspective, which changes the relationship of the object to the picture plane. Remember that drawing ellipses is not a mathematical formula and it will demand a fair bit of interpreting to get the ellipses to look right. The role of light is also important when researching the behaviour of objects in space. Experiment not only with tone in monochrome, using pencil or charcoal — try also playing with the properties of colour to bring out key three-dimensional features.

HOW TO FIND ART TO USE IN YOUR CRITICAL STUDIES/ART STUDIES

Apart from the images reproduced in this book, there are many other works mentioned. Details of these can be found in appendix 2, but there will be searches of your own that you may want to make and various routes you can take. As always, the best way to research art properly is to stand in front of it (see chapter 7 for further details on how to do this).

THEME

Start with a theme, either one you have been given or one you have chosen. Ask yourself what it is that you are interested in. It is common for students to think that by copying out the entire course of an artist's career, they have sorted out the critical and contextual section of their art course. They are wrong.

If you want to make an image of a waterfall or an aeroplane flying through a storm, it is unlikely that you will find an artist who has made his life's work tackling waterfalls, aeroplanes flying through storms or wherever your own life's work has led you to.

What matters to you, and what you should be looking for, is how other artists have represented similar subjects, used materials, reacted to art themselves or arranged forms in ways that make you think about what you are doing. You might not be drawing old French servants yourself, for example, but the way that Cézanne treats the figures in his *Card Players* (see page 34) could help you organise how to rearrange the form of that horse's leg you have been stuck on for weeks. Distorting the length of the leg, removing perceptual constancy, as Cézanne did with the card player's arm, might be the way to make the form seem more real. Notice that not once have you had to say that the name of Cézanne's wife was Hortense, because it is not relevant to your horse's leg, however much you might read about her in books and on the internet.

INTERNET

One of the most common routes to finding images is the internet. It is an astonishing resource for imagery, but precisely because there is so much out there, you have to be careful. The computer will suck up your precious time like no other tool (see pages 303–10 for a list of useful websites).

During internet searches you must remember that what matters is what you do with the results of the searching. It is easy to sit in front of the computer for an hour or so and flick through websites and think you have achieved something.

What matters is the art you make because of the research. Just finding a few images to print and stick scrapbook-style into your sketchbook, without annotation or evidence of thought, does not further your own art. For internet searches, the important point remains the same: before you go near a keyboard, decide exactly what you are after.

The text on most sites is exclusively biographical, which is not much help. What you need is:

1 Art that tackles the same themes or subjects as your own. It might use similar methods, processes or forms of composition.
2 Art that you like, are excited and intrigued by and that you want to find out more about. That is the best sort of art to analyse.
3 Studies that analyse art, not artists. You are analysing their work, not where they went to school and what they had for breakfast. You will have to do most of the analysis yourself. The internet is where you go to get the images to use for research. It won't tell you what to do with them.

Remember:

- Do not cut and paste great chunks of biography. Most examiners are familiar with the major sites and what they say. Copying from the internet in this way is not only illegal, it will get you no marks at all and may even get you disqualified. If you find something useful, you can of course turn it into a quote by explaining where it came from, who wrote it, how it fits your theme and the art you want to make. Cutting and pasting without acknowledging the source will only serve to make anyone marking your work suspicious about where the words you *have* written came from.
- Each museum has its own gallery website (see Bibliography). Some, like the Tate or the National Gallery, let you search the whole collection and, subject to copyright, all the works can be seen. Others, like the Louvre, only let you see a small selection, but often have simulated versions of each room that you can digitally 'walk' through. There is a substantial list of websites in the bibliography.
- Google is a good search engine (a straight Google search tends to be better than a search using Google Images) and more general engines appear all the time, using different techniques to rank sites. The different engines are roughly the same for users in that you just need to type the name of the artist and the work you are looking for and a list of sites will appear. There is also an increasing number of specialist art search engines. Artchive and Artcyclopedia are useful, and there are many others, ranging from a site that includes lists of images of every single character mentioned in the Bible to sites that specialise in Victorian artists.

LIBRARIES/ART MAGAZINES/BOOKS

Art books are prohibitively expensive, so the best place to locate them is in libraries. Get into the habit of looking in the bibliography section of books that you have already found useful, since it can refer you to other texts that can help. Few books will have a title that directly refers to the theme you are following, so you will have to get used to working harder in your searches. Look through the contents list, the index and the list of illustrations to find what you need.

Most schools and colleges have collections of books in their art departments, always a good place to look when researching a theme. Their collections will have been chosen specifically for the sort of work that you are doing. The problem, usually, is that everyone else on your course also wants the same book. There are other places you can try instead. Many institutions have larger libraries, often with substantial art sections that aren't used much. Don't forget that there will also be a reference section in a library, and often that is where the bigger, more expensive art books are kept. Try your local library too. Librarians can be helpful if you explain what you are looking for, and may guide you to a particular book that you might not know. Librarians can also order books for you if they don't have it on the shelves, but don't get paint on any book you borrow. Also, don't forget to take books back, otherwise this useful route will be closed to you.

There is a range of art magazines that are worth looking at, although their relevance varies according to how recently the magazine has been remodelled. Most of the bookshops at the major museums and galleries stock them. Have a look through for useful articles each time you go to an exhibition, or you might be able to persuade a library to stock one or two titles. Art magazines are certainly helpful when it comes to previewing or reviewing current exhibitions, and interviews with artists can be full of insight. There is a list of suitable magazines in the bibliography. The Tate magazine is probably the most useful, and it is more than likely that the head of your art department will take this as it comes free with Tate membership. Ask to see any issues which tackle themes that might help.

DOCUMENTING A SEARCH

If you have been through a great deal of work to find information and images that have really helped you, then it makes sense to get some credit for all that work. You should always keep a bibliography: a list of the books, websites, magazines etc. that you have consulted during each unit of work. Make sure that you write down each title as you look at it — it is often difficult to remember book names. Keep the bibliography in the back of the sketchbook for each unit. It will direct the examiner to the level of research you have been doing.

HOW TO USE A SKETCHBOOK

The traditional name for the bundle of notes, drawings and thoughts made by an artist is 'the sketchbook'. It tends to refer to a particular object or book. The term 'work journal' or 'supporting studies' is the name currently given by some exam boards to *all* the work that you do in preparing to make a final piece. The 'work journal', or 'supporting studies', will therefore include your sketchbook(s), which is probably where most of your art will live, as well as larger drawings, practice pieces, and identification of things you have seen and things you have done. In this book, however, we tend to use the term 'sketchbook' as it is the most familiar. We mean it to cover all the work that you do in preparation for a final piece.

All this work will need to be displayed so that it makes sense and tells the story of the development of your ideas, as well as allowing you to show off your all your abilities. Refer to the following other topics in this chapter:

- How to annotate a work
- How to write a cover sheet
- Evaluation: how to evaluate your work, why it's important and how to do it
- How to find art to use in your critical studies/art studies
- How to approach a theme
- How to write about art

The sketchbook must include:

1 evidence of research and analysis/recording ideas and observations
2 exploration of media
3 development of ideas
4 visual and/or written evaluation about your conclusions

Examiners will be looking in your sketchbook for evidence of:

- your ability to apply your understanding of the theme to the informed composition of your own images
- some sense that problems you have encountered have been solved and that a conclusion has been reached
- explicit development of ideas, which means that you must constantly review your work, annotating and revising your journals each time you open them
- the all-important notion of 'review and refine', which might be made more apparent if you can get into the habit of dating your sketchbooks in different colours each time you revisit a page
- the relevance of your chosen artists and the knowledge you have drawn from their comparison, which must be stated on every page
- the relevance of all this work to the theme, which should also be stated at every opportunity

The sketchbook is more than just a single object and a great deal more than a scrapbook. It refers to a process, a way of working and showing the development of your ideas. It should include art studies, visual research, evaluations, planning and the development of your art. Think carefully about the way you present your sketchbooks.

1 Do they reflect the art and design that you make and have studied?

2 Are they readable? Not many examiners will wade through pages of barely legible, minute script in silver pen on white paper.

3 Are they presented to reflect the theme and the art you have studied? If, for instance, you have studied someone like Mondrian and the abstract work of de Stijl, is your sketchbook laid out appropriately with bold sharp edged areas of primary colour? Are there large white spaces and clean text and have you considered using the specially designed de Stijl font, for example?

4 Can anyone looking at the sketchbooks see evidence of you developing ideas as to how to display them?

5 Can they see your journey?

6 Is there evidence of 'review and refine'?

Review is the key word here. Go back through the work for each unit and comment on it yourself. Date these comments by writing them in a new way to show what you have learned since you started; this method displays progression.

HOW TO APPROACH A THEME

Most of the work you make at AS and A2 will be thematic — art made in response to a concept, brief or idea. Ideas are the starting point for most art and design and they are essential for the creative process. Remember that a theme is not a question or the solution to a formula. A question requires a specific answer whereas the thematic approach should stimulate your personal response and route to an outcome. The key to approaching a theme is to start looking at what others have done. Remember that you will not find an exact match with your own work but you will find similarities (see 'How to find art to use in your critical studies/art studies' above). The key to examination success is to keep referring to the theme throughout your sketchbook and especially in the evaluation at the end (see the section on evaluation above).

You might not know what it is about a work that is relevant at first. To begin with, it should be enough that you find a piece of art interesting, exciting or even infuriating, and want to find out more about it. You can always come back to the immediate relevance of an exciting work later. Be wary of art that is just visually seductive, that looks attractive but actually has little depth. The work of artists like Dali and Warhol tends to fall into this category.

Here is a quick checklist for you to bear in mind at the start of a unit:

- Compare and contrast the approaches of other artists to the theme or variants on it. Try to look at more than one work by more than one artist. Link different types of art through their treatment of the theme.
- Explore the ways that artists have used different media to analyse this or similar concepts.
- Develop those discoveries into visual research of your own, taking the composition, the subject, the media or the processes used as a guide (first drawings).
- Refer your first visual researches back to the theme and those first art studies you made. Use this as a point at which to widen your critical approaches to art, making new connections between forms of art that might be considered opposites. Start making some substantial visual researches of suitable subjects that you have selected for yourself (second drawings).

In other words, how have you worked from the original theme toward one or more well-considered conclusion? Can an examiner follow your train of thought? None of us necessarily work in a clear sequential manner, but when presenting your final piece it helps if you can display the journey you have taken so that it makes sense.

HOW TO SHOW THE 'TURNING EDGE'

The majority of objects that you will be called on to analyse visually and to make drawings of will have a rounded form. Think of that stand-by of all still-life work, the apple. Hold out an apple and you will see the rounded surfaces turning away from you. The temptation when drawing such an object is to simply make a single oval line on the page and fill it in with tone. Resist this temptation. Using a line in such a way fundamentally misunderstands the visual properties of line. A line around a tonally described form makes an edge that stops the eye, whereas what you need to show is a surface that has no end. The ability to show that surface, what is referred to as the 'the turning edge', is often looked for by examiners when analysing students' work.

If you want to make a drawing showing your mastery of the turning edge, the simplest way is to use tone. The way light is reflected from a surface and the shadows that are made as a result tell us a great deal about the three-dimensional properties of an object. The apple held in your hand, for example, will have a highlight, the lightest part of your drawing; the darkest part with the heaviest use of tone (made with your softest pencil) would probably describe the area where the curving surface of the apple meets your hand, usually the part with the most shadow. Aim for a broad range of tones in your drawing. The way in which tone is used conveys

a great deal of information about shape and the sides of a form. A gradual tonal change from light to dark implies a gentle curve and indirect light, whereas clear changes of tone mean sharper edges and direct light. Take, for example, Caravaggio's *Supper at Emmaus*, 1601 (see page 189). Observe the pear on the right in the basket of fruit. It shows a gentle curve running from the bright highlight of the bottom of the fruit as the form turns into the dark shadow of the basket. The white cloth of Christ behind it varies from sharp creases to gentle folds.

Colour is of course the other way to show shape. As you know, the warmer end of the spectrum (reds/oranges) appears to come through the picture plane towards you while the cooler end of the spectrum (blues/darker greens) seems to recede behind the picture plane. The highlight on your apple could therefore be a strong red changing, as a result of a gradual move through the spectrum, to a range of cool blues where the apple meets the hand.

HOW TO WRITE ABOUT ART

Writing about art is as old as art itself, and most of the text you will find tends to centre on the following:

- how the art was made
- critical opinions about the subjects chosen
- complaints about new-fangled modern art (you can even find complaints about 'modern art' in the first century BC)
- far-fetched stories about artists' characters, from Michelangelo's poor personal hygiene through to Tracey Emin's drinking

All of this list is relevant to you, except, of course, biography. Avoid copying out large sections of an artist's biography; it is rarely relevant to your analysis of a theme and will alert an examiner to your lack of focus. As this book has demonstrated, there are occasions when short sections of biography can be relevant, but select them carefully.

THE LANGUAGE USED

All the exam boards for AS/A2 Art and Design examine in English, so any writing that you submit must be written in English, as must the majority of your sketchbook. The language you use must reflect the high level at which you are being examined. Art is a complex subject, and when you use the specialist vocabulary of the discipline, you must do so accurately and spell it correctly. If you find writing difficult, it is best to approach it in short, gentle but regular doses. Try a few hours a week, rather than attempting to get it all done the night before the work is due in.

There are certain areas that need to be tackled in any of your writing on art, at any length:

- context
- close visual analysis
- personal response
- relationship to your own work
- evidence that the writing has been organised and is coherently put together, that it makes sense and that it is relevant to the art you are studying

CONTEXT

What is crucial is an understanding of the period or era an artist was working in, and how that era contributed to their art.

The context of an art work can be broken down into chronological and cultural context, although often the two categories are intertwined. When (the chronological context) and where, why and what others thought about it (the cultural context) obviously affects the final appearance of an art work. Equally important are the ideas and art works that came before. For a more advanced approach to writing, it is a good idea to set the art work in a cultural continuum, stating what happened before and what happened as a result. It can be a useful trick to imagine what direction art might have taken if the work you are studying had never existed. You don't need to write about the entire history of pre- and post-First World War art when studying Harold Gilman, for example (see page 21). However, some understanding of how the world was changing, and the effects of the new and challenging art that had been coming to England from Paris since the 1850s, is essential to analysing the colours Gilman uses. You could follow up that research with some further work on the development of colour in art after the First World War, looking at German Expressionism for example. You could then make a series of studies of interiors, varying the palette according to a time line and geographical placing that you select yourself.

CLOSE VISUAL (OR FORMAL) ANALYSIS

This will probably be where your studies, if not the presented writing, actually start. It is the annotated work you have been doing with your art studies, the close examination of composition, colour, methods, materials and intentions of the artist(s). These notes could be presented as they are, and the studies submitted as part of the sketchbook. Or, you could take key phrases and ideas and write them up as a longer, more flowing text. This choice will depend partly on which exam board you are working with. Talk to your teachers about what the exam board wants.

As well as analysing the role of the formal elements in the art work(s), visual analysis should directly relate to the fundamental question you are asking yourself and the themes you are studying (see 'How to approach a theme', page 243).

PERSONAL RESPONSE

As you go to look at an art work, you should keep a record of what you see and what you feel when you stand in front of it (see chapter 7, 'Visiting museums and galleries'). Your personal study must contain supported and justified opinion; it cannot be a long gush about what a genius the artist was without gathering some evidence to prove the case.

To make the personal study work well, it is essential that you start with some sort of brief. Set out the themes you are interested in and then set this interest in the context of your own work. What art have you made in the past that has led you to investigate these forms of art now? Make sure that each investigation and statement you make is based on careful analysis of one, or ideally more, actual pieces of art. This way you can avoid generalising vaguely about huge subjects and eras. By continuously referring to art, you can make sure that each opinion is supported and justified and that you are always returning to the theme and brief you set yourself at the start of the study.

RELATIONSHIP TO YOUR OWN WORK

It's always important that you make art as a result of your critical studies, and equally crucial that you relate that art back to the work you have made in the past. Perhaps the easiest way to gain credit for this is to make quick snaps of your work (digital or otherwise) and then make simple visual comparisons with the art studied. Alternatively, use a series of small icon-like images of the developmental steps your ideas have gone through, or some sort of flow diagram showing what you have seen and what you have done.

You could compare and contrast your work with other art you have studied by a series of formal analyses. It is useful, for example, to describe how the works you made before led to the present study and to combine that with subsequent, short analyses of future directions and other art to look at. To this, add larger separate sheets showing investigations of new forms of drawing, mark making and maquettes inspired by the new discoveries you have made. Remember that all units are marked entirely separately, so make sure that there is enough work for each one.

COHERENT ORGANISATION

In these days of literacy hours, spelling and grammar checks, you should be able to produce a reasonable text. The fundamental rules of literacy, which after all govern most of the rest of the curriculum, apply also to writing in art, so those skills you have learned elsewhere can be applied here. Students tend to think of each subject as hermetically sealed, but it need not be.

SOME TIPS

- Most students appear to work best by writing in small doses, a paragraph or two at a time. Experiment to see which approach works best for you. Try showing short drafts to other teachers as well. You might be able to submit the drafts as evidence for key skills work, and get the staff skilled in those areas to help you.

- Do not leave the writing until the last minute. A way of avoiding this is to set yourself a programme of due dates and to make sure deadline targets are specific, such as '50 words by next week'.

- Try to find examples of past work on this (or any other unit) to look at, not as something to copy, but so that you have equivalent work on which to bounce your ideas and to prove to yourself that others have gone through the same process in the past and succeeded.

- To avoid plagiarism and pure transcription, you must acknowledge your sources and make sure that quotes are written down as such. Every time you read a book, an article or visit a website, write down the title in your sketchbook and the number of the page you were looking at. You will need to submit a bibliography at the end of your personal study, and it is also a good idea to do so at the end of each unit (see 'How to find art to use in your critical studies/art studies', page 239). Such a list will also help you to find something you were reading again.

VISITING MUSEUMS AND GALLERIES

THIS CHAPTER FOCUSES ON...

- structuring a visit, including what to do before visiting an exhibition, what to do in the gallery and how to use the gallery visit in your own work
- all of the formal elements

BY THE END OF THIS CHAPTER YOU WILL BE ABLE TO...

- use museum and gallery visits in a way that substantially adds to the evidence you will present of your critical and contextual understanding
- plan your visit and make the most of your time
- know what to do in the museum/gallery
- use that research in your own art

INTRODUCTION

Standing in front of real art is a different experience to looking at photographs of art in books, postcards or backlit images on a computer. The scale and texture of real art is a crucial part of its meaning. Imagine if an examiner could only see a 10 cm by 20 cm version of your own art. Would you think that he or she had got the whole picture and had understood the full subtlety and complexity of your art and all the hours you had put into it?

Artists design their work carefully to be shown in galleries, a space that is often described as a white cube. How does the gallery experience change the meaning of an art work?

First-hand research is a vital part of AS and A2 Art and Design and you must be able to demonstrate that research in your sketchbook. This chapter takes you through the steps necessary to make those visits meaningful.

Section features

Works:
- the exhibition 'Faces in the Crowd: picturing modern life from Manet to today', in reference to those works you expect to see on your visit and other art relevant to the theme you are studying

Genre: all

Formal elements: all

Unit element: before, during and after visit

Key words for this chapter

content
objectivity
scale
structure
subjectivity

PRE-VISIT RESEARCH

Works of art shown in galleries and museums can be described in two general categories:

- **historic collections** These provide an overview of work accumulated over a period of time. They may include private collections, which have been given to the museum or gallery and over which the museum has had no control or influence. Historic collections may have an underlying 'theme' (e.g. the work of the Pre-Raphaelites) or they may be random collections of work.
- **exhibitions with specific titles** These set out to explore a particular idea, thesis or chronological period, such as 'Objects of Desire' (an exploration of the use of still life) or 'The Importance of Blue' (an exploration of the use of the colour blue in art). For these exhibitions, the curator selects particular works and places them in a particular order so that the exhibition will illustrate the theme.

STRUCTURING A VISIT

Museum and gallery visits are a rich resource for your own development. However, being confronted by rooms of works you have never seen before can be bewildering and sometimes overwhelming. In order to gain maximum benefit, you should plan in advance for any visit you may be contemplating and, before you start planning, establish the theme you are investigating (see 'How to approach a theme' on page 243).

As already mentioned, a good route to success in AS/A2 Art and Design is to follow a thematic analysis. In order to make your museum and gallery visits equally successful, you must find out the relevance of your own theme to the artists you are studying, or at least to those artists you can find to see and subsequently use in your own art.

This chapter concentrates on how you can use exhibitions to benefit your own work. It focuses on one particular exhibition as an example, but the methods discussed can be applied to any visit you might make to a museum or gallery. The chapter is structured around the following three stages involved in any visit, and the work each stage entails:

WHAT TO DO BEFORE THE VISIT

- Research the collection or the exhibition — the internet is useful for this — and make preliminary decisions about the focus your visit will take.
- Research definition of terms.
- Identify links between artists in the exhibition and artists you are studying.
- Identify and refine your focus.

WHAT TO LOOK FOR IN THE MUSEUM/GALLERY

- What is the exhibition title?
- What is the exhibition about?
- What are the key elements?
- How do these elements relate to the development of my own practice?

HOW TO USE THE MUSEUM/GALLERY VISIT IN YOUR OWN WORK

- Determine the relevance of what you have seen to your own work.
- Use what you have discovered in your own art and contextual reference.

OVERVIEW

To help you understand the best way to use a gallery or museum visit, we have taken a particular exhibition as an example. 'Faces in the Crowd: picturing modern life from Manet to today' was shown at the Whitechapel Art Gallery in London in 2005 and was curated by Iowna Blazwick and Carolyn Christov-Bakargiev (the catalogue is available). Based on the theme of life in the city and including a wide range of media and approaches, the exhibition provides many different examples of routes you might take when visiting other exhibitions. It does not matter if you have not seen this show. What is relevant is that you use this example to structure your own visits and, even more importantly, that you use studying art at first hand as an aid to your own work.

WHAT TO DO BEFORE THE VISIT

RESEARCH THE COLLECTION

The access you have to art will vary according to geography, finances, the structures of the course you are taking and the school or college in which you are studying. As explained earlier, there are two possible sources of art to view. You will be looking for established institutions that have a historic collection, such as the National Gallery in London; the City Museums in Birmingham, Leeds and Manchester; Edinburgh's National Gallery of Scotland; the Burrell collection in Glasgow and so on. Entry is usually free to these major collections. You will also be looking for specific exhibitions that closely suit your own area of study. The best place to find out details about exhibitions is in the arts sections of national newspapers for major shows, and in specific art magazines (see Bibliography) for smaller galleries. Try reading reviews to give you a flavour of the sort of show you want to see and the art that they contain. There is nothing wrong with photocopying reviews and pasting them into your sketchbook, but only do this if you intend to annotate the review before the visit, explaining the relevance of what you are

reading. Ideally, after the visit you can return to the review and note down your own thoughts. It will be interesting to compare your viewpoint with that of the initial reviewer.

The internet has become the usual reference point for most students (see 'How to find art to use in your critical studies/art studies' in chapter 6, page 239). Many galleries and museums have increasingly sophisticated websites, with the majority of their available images on show (see Bibliography for further details). From these websites, you can often find the exact placing of the works you wish to see and, importantly, whether they will be on show when you visit. If you search around these websites, you will often find helpful information about the art you are interested in. Try the teachers' packs or school areas. It is in the nature of the internet that information is never discarded and you will be surprised what you can find on past exhibitions that might be relevant.

If you are interested in a specific work but don't know where to find it, check first in the illustrations list at the back of the book in which you first saw it. This should tell you where the art is on show. Or, try some of the art search engines (Artchive or Artcyclopedia are currently the best, but inevitably this will change), which should tell you where to look.

RESEARCH DEFINITION OF TERMS

You may find it helpful to research and define some relevant terms prior to your visit. It is best to take examples of these terms from works other than those within the exhibition, in particular those that have contextual relevance for you. These key terms can, in turn, raise questions which might be useful to discuss with your teacher as a way of helping you find ways to approach the works in the exhibition. Below are five key terms — which will be common to all art works you are likely to encounter — with associated questions for you to consider.

- **objectivity** An objective work of art is one that appears to depict its subject in a totally truthful manner, without interpretation from the artist. Are photographs more objective than paintings?
- **subjectivity** A subjective work of art is one in which the artist's interpretation becomes more important than the factual rendition of the object. Manet wrote: 'The truth is art should be the transcription of life…you must translate what you feel.' Do you agree?
- **composition** Composition relates to structure, armature or organisation of space and form. There are ways in which the artist directs the viewer's gaze. Which particular means does the artist you are looking at use to create a specific focus?
- **scale** Reproductions of works of art in books or on a screen give little indication of scale. This means that when standing in front of an actual work, you often

have to adjust your understanding of the work. What makes a work of art 'monumental'? Is it more than just scale?

- **content** Some works of art are described as 'having content'. Is content more than 'narrative'?

IDENTIFY LINKS BETWEEN ARTISTS IN THE EXHIBITION AND ARTISTS YOU ARE STUDYING

You will often find that the artists you are studying do not have work on show anywhere that you can get to, but don't let that worry you. What is equally likely is that there will be many connections between the work you know and art that you can find to look at. All art is rooted in art that came before it and in art that was made at the same time ('contemporaneous', as it is known). Can you find art contemporaneous to that which you know already? Or, can you find art to match any of the key elements, such as style, methods and materials, content, composition, mood? Lastly, think of how these key elements relate to your own art. How do the artists you will be able to see use these qualities?

IDENTIFY AND REFINE YOUR FOCUS

The focus of your visit should be on how the art you want to see relates to your theme. In common with the difficulty of finding particular artists, you could also have difficulty finding an exhibition that exactly matches your theme. This is where the key elements come in. Ask yourself how your investigation of the relevance of these key elements to the art you can visit relates to your own interpretation of the theme you are analysing. If nothing else, you should find an exhibition that you will enjoy, or art to see that you actually like. If you can interact with the art while you are there, you are bound to find work that will relate to your theme.

WHAT TO LOOK FOR IN THE MUSEUM/GALLERY

When you arrive in the gallery, you will probably be faced with what seems like an undifferentiated mass of art work. Don't lose heart. You will have already done your research and identified certain key works and ways of working. It will probably be useful to make a swift tour of the exhibition to locate those works and to note other appropriate art that would benefit from closer study. Start making notes in your sketchbook. This initial walk-through will also allow you to absorb the overall flavour of the exhibition.

Now refer to your key terms and works, and begin to structure a more careful observation of works you have located. Be selective, rather than trying to look at every work in depth. Think about the relevance to your art, the theme you are studying, the sort of art you have looked at in the past and, if at all possible, make more than one visit.

Annotation and visual notes should be an essential part of your visit. Do not wait until after the exhibition to make these notes, when you will have forgotten what you have seen and what you thought about it. Draw and make notes in front of the exhibits.

For the purposes of this chapter, we will use the example exhibition to help you understand how to identify areas of focus. The following list of headings in question/answer format will help you to structure your thoughts. Put this brief list into your sketchbook before the visit, as a reminder.

WHAT IS THE EXHIBITION TITLE?

'Faces in the Crowd: picturing modern life from Manet to today'

WHAT IS THE EXHIBITION ABOUT?

It is an exhibition depicting contemporary life and the many ways there are of recording that life.

WHAT ARE THE KEY ELEMENTS?

- picturing urban space
- the street
- spaces of public leisure and entertainment
- isolation
- community

HOW DO THESE ELEMENTS RELATE TO THE DEVELOPMENT OF MY OWN PRACTICE IN TERMS OF:

- style?
- methods and materials?
- content?
- composition?
- mood?

HOW TO USE THE MUSEUM/GALLERY VISIT IN YOUR OWN WORK

What follows is an analysis of the exhibition using the headings listed above.

STYLE

Style in this context means the personal visual characteristics of an artist's work and implies more than an artist pouring out his personality on to the canvas. Style is the individual combination of formal elements that make up an artist's work, a

characteristic combination that recurs throughout the artist's working life. Think of a technique such as 'blurred form', in which the edges and three-dimensional shape of a form are not clearly visible. Many artists use this method. In this exhibition, it is handled in different ways. For example, in Carlo Carra's *Leaving the Theatre*, 1909, the figures and their shadows are depicted in a blurred manner against the snow, losing their individuality and creating a sense of movement (simultaneity). The dynamics of the diagonals symbolise the forward march of progress. At the same time, the figures have a ghostly appearance signifying a vanishing era. Carra was one of the first Futurist painters, as shown in the dynamic line of his brush stroke, which creates an image of energy and movement. Francis Bacon's *Untitled (Crouching Nude)*, 1950, blurs the human form to create the impression of torment. In Gerhard Richter's *Eight Student Nurses*, 1966, the photographic portraits are blurred, rendering the images indistinct, as a way of representing a moment captured and instantly lost in time. The artist is interested in the gap between what we see and how it is represented, the significance of subjectivity and identity. Each one of the women in the work has met a particular and untimely death, and yet remains anonymous in these passport-type images.

CARLO CARRA
Leaving the Theatre,
1909

Relating it to your own art

- You may be working with ways of showing movement, or moments in time that require a fluidity of handling. Richter's technique of dragging a dry paintbrush over the canvases while they are still wet, thus blurring the image, reduces the individuality of each image by evening out their distinctive features. You could compare the blurred form with the sharply defined form to show how one form differs from the other.

- This is an exhibition about the city and the effects of urban living. Life in the city is full of surprises and the half-glimpsed stories of others. The blurred form might be a suitable way of demonstrating these metropolitan qualities.

Relating it to your critical and contextual reference

- This might be *Futurism and the Futurist Manifesto* (1910); the London Group of Painters (Bacon, Freud, Auerbach, Andrews); the integration of photography and painting.

- The Impressionist artists — Monet in particular — were interested in the light upon a form rather than the form itself. As a result, their work appears edgeless as the envelope of light wraps around the whole scene, making shapes seem blurred.

METHODS AND MATERIALS

The process an artist uses to make his or her work and the materials that he or she uses in that process will significantly influence the result and the meanings that the viewer reads into it.

George Segal makes body casts from gauze bandages soaked in plaster of Paris (mod-roc), freezing his life-size models into everyday poses that the viewer might encounter on the street, as seen in *The Dry Cleaning Store*, 1964. Gillian Wearing's 25-minute video *Dancing in Peckham*, 1994, shows a young woman in the middle of a shopping mall, dancing happily, ignoring everyone around her. She is not a street performer, nor is she noticeably unhappy or separate from the rest of the crowds around her. Video is an increasingly familiar method for making art and you will find examples of it in most exhibitions of contemporary art. Andy Warhol uses monotone screen-printed repeat images to reflect everyday events within urban culture, e.g. *Orange Car Crash (Orange Disaster), (5 Deaths, 11 Times in Orange)*, 1963.

Relating it to your own art

- You may be working with the figure or using industrial materials. Look at how Segal makes human-scale figures with appreciably human characteristics, but with materials that have none of the colour or surface qualities that viewers would associate with being human.

ANDY WARHOL *Orange Car Crash
(Orange Disaster), (5 Deaths,
11 Times in Orange)*, 1963

■ You may be seeking appropriate ways to document the everyday, the ordinary and overlooked parts of the world around you, all subjects of still life since the Genre began. The methods of collecting objects to help in that analysis can become part of the work itself. Rauschenberg talked about having a house rule for finding material to make his combine art; he would walk for one block and collect anything he could find.

■ You may be looking for ways of working with images derived from popular culture. Since the Cubists, lettering, advertisements and newspapers have been a legitimate subject for, and material to use in, art. What are the common publicity materials that dominate the life of the city that you have observed? How can these images be a part of your art?

Relating it to your critical and contextual reference

■ Compare and contrast the work of Segal with that of Anthony Gormley. How does each artist use the figure? What difference does including the context to the figure make to your understanding of the art?

- Pop art in the USA and Europe developed along slightly different lines. US Pop artists did not celebrate European culture in the same way that European Pop artists adored US culture and examples of US consumerism. Try finding examples of how artists in each geographical area treated advertisements and images of luxury goods, then update the methods Pop artists used on both sides of the Atlantic to consider how Lichtenstein's Ben Day dots, or Richard Hamilton's collages, might be treated today. See pages 107–09 for more information on dots.
- John Heartfield used photomontage to make radical political comments, combining photographs and words to attack the Nazis at home and in their relationship to international politics. This combination of image and text can be a sophisticated medium, provided you have a clear target to aim at.

CONTENT

The terms content and subject are often used interchangeably, although their meanings do in fact differ. Subject involves some analysis of what the art is about; it combines content and the wider world to bring about some understanding of the broader meaning of the work. Content is more of a list of what the work contains. A piece of art with little in it will have a different effect on the viewer to something crammed with detail. To return to Francis Bacon's *Untitled (Crouching Nude)*, 1950, the figure is alone, the centre of an anonymous space, a container, laying bare the individual's sense of isolation and anxiety. The African photographer Seydou Keita, in his work *Untitled*, 1959, depicts his subjects in isolation, using studio props as an important element in the creation of the self-image and aspirant modernity of the sitters, and as a link back to the community. Also shown at this exhibition is Chris Ofili's work *The Adoration of Captain Shit and the Legend of the Black Stars*, 1998. His combination of layers of swirling colour, thick dots of colour outlined by white lines and collaged pictures of eyes cut from magazines make up a large figure, surrounded by lumps of actual elephant dung. This painting, full of content again, concerns contemporary identity (see pages 104–14 for further detail on Ofili).

Relating it to your own art

- You may be working with ideas concerned with isolation and/or community. The relationship of the single-represented figure to the content of the rest of the work is an area worth exploring.
- How we relate as individuals or communities to the built environment (architecture) that surrounds us and continually influences our behaviour is a rich subject for analysis. Think of the effect the proportion of an art room, even just the height of the ceiling or the colour of the room, can have on the way you approach your art. Contrast this with group behaviour in the larger urban environment, such as in a supermarket, shopping mall or driving around a city one-way system.

■ Some of the work mentioned above could be the basis for your own analysis of ideas about body image, either your own or those put upon your own gender, culture or religion. Or, you could relate the works to how you have perceived others coping with received ideas about indigenous cultures.

Relating it to your critical and contextual reference

■ The London Group of Painters (Bacon, Freud, Auerbach, Andrews) are again relevant. Their presentation of the figure owes a great deal to existential theory. Try reading some Jean-Paul Sartre and contemplating your aloneness in an uncaring universe to get the idea.

■ Jeremy Deller's films about communities are watchable (not always the case with video art). His *Battle of Orgreave*, 2001, is a re-enactment of one of the more violent clashes between the police and striking miners during the 1984 miners' strike. The film brings up issues about the past that are still raw today. A great deal of art has taken stories from the past as subjects. How the content of those subjects is presented — as accurately as possible in Deller's case — tells us a great deal about the intention of the artist.

SEYDOU KEITA *Untitled*, 1959

■ Nan Goldin's series of photographs document her complex and sometimes upsetting New York social life. Her work usually features her friends and their emotional interaction. Personal, national, cultural and sexual identity and difference come up in these images of transvestites, drag queens and interestingly dressed young people, the sort of world sung about by Lou Reed. Yet the underlying themes of her work remain the difficulties of relationships, and the usual problems that all of us, of any age or identity, face.

COMPOSITION

Analysing how the content of a work is arranged (i.e. the structure the artist chooses to represent the forms he or she works with) is vital in any approach to a work of art. In David Bomberg's painting *Ghetto Theatre*, 1920 (see page 260), the tightly cropped image draws our attention to the spectators, whose angular, clear-cut forms are enhanced by the diagonal structure of the architecture. Combinations of composition and colour can tell the viewer more about the situation of the figures represented and

their world than any long essay ever could. In other words, images matter. In Gilbert and George's coloured photoworks, the multiple photographs that make up their art are always arranged in a black-lined grid. This compositional formality gives their art a serious aspect, often undermined by its content. Jack Yeats' painting of a successful boxer, *The Small Ring*, 1930, positions the viewer behind a fair-haired man. Ranged in front of him are great banks of spectators, looking not unlike fighters themselves. On closer study, the fallen figure of the other boxer, on the floor of the ring becomes apparent. The composition stresses the results of success, not necessarily what led up to it.

DAVID BOMBERG *Ghetto Theatre*, 1920

Relating it to your own art

- The symbolic arrangement of basic architectural forms has a long history. Renaissance theorists, for example, believed that the combination of the square (representing the earth) and the circle (symbolising the spiritual world) was a sacred composition. You can see this in Leonardo's famous drawing of the Vitruvian man. The architect Andrea Palladio, in his *Villa Rotunda*, 1552, extended

this theme, making the circle the circular hall in the centre of the building. The circle, in plan, extends into space to become the central circular hall, a drum or rotunda that can be seen above the roofline. Surrounding this circular form are rectangular rooms that make the square of the external walls of the building.

■ The arrangement of installations can be a three-dimensional method for working with ideas, the structure of the installation reflecting the content of the work. Elin Wikström's *Rebecka Is Waiting for Anna, Anna Is Waiting for Cecilia, Cecilia Is Waiting for Marie...*, 1994, is a work based on everyday behaviour. Women go to a particular spot, where they wait for 5 minutes until joined by another woman, who then waits for the next and so on. In 1994, in the first version, 52 women took part. This organised form of waiting is designed to reflect the traditional ways that the lives of women have been structured, or composed.

■ You may be working with ideas concerned with ways of depicting particular communities or ways in which people are affected by how their community is treated. Look at the work of George Grosz, such as *Café*, 1915. Like many other German Expressionist painters, Grosz distorts and twists the forms into swirling shapes, reflecting not only the drunkenness and wildness of the period but also the underlying insecurity.

Relating it to your critical and contextual reference

■ The structure within Christian Boltanski's work *The Dead Swiss*, 1990, is 'actual'. The work is an installation, comprising a low-lit, enclosed space containing a collection of uniform photographs displayed as a grid. The grid creates a sense of order in contrast to the unease of the darkened room. Notice also the importance of the small lights placed in front of each work. Although not bright, the pool of low-watt intensity has some difficult associations that add to the unsettling and thought-provoking arrangement of this work.

■ Manet's painting *Masked Ball at the Opera*, 1873, shows a long line of men wearing dark suits and white shirts, the blackness of their clothing transforming them into an undifferentiated mass that stretches horizontally across the centre of the painting. What contributes to the sense of claustrophobia created by this composition is that the tops of their shiny top hats are almost all at the same height. Pushed to the front of this wall of black are figures in lighter clothes, women presumably trying to earn a living by selling themselves. The combination of urban life and sex is one that recurs throughout this exhibition.

■ Léger's art always reduces the human figure to mechanical forms, tubes and spheres, for example *Three Friends*, 1920, in which the figures appear trapped within upright dark lines. The machine aesthetic in which humankind's progressive relationship with machines is celebrated is an aspect of early twentieth-century art that could bear some careful analysis.

MOOD

As an element, this is easy to identify but not easy to define. It can take many different forms, such as in Alex Katz's painting *Thursday Night #2*, 1974, where mood is created through an implied narrative of power and conspiracy. In Max Beckman's painting *The Artist's Café*, 1944, the mood of isolation of the individual figures is created by the dense black outlines, sealing each of the figures within their own space. Brassai, in his collection *Paris by Night*, 1932, uses chiaroscuro to create a mood reflecting the strange balance between reality and dream in smoky Paris restaurants and streets at night.

Relating it to your own art

- Mood is largely created through manipulation of the formal elements. Try experimenting with each of them in turn. Contrast darker colours, for example, with bright cheerful colours and highlights to bring out the difference in mood created by colour.
- You may be working with light and the ways in which tone creates mood, for example dark overpowering areas in your paintings, photographs or textiles, or brooding shapes that cast deep shadows in three-dimensional work.
- Telling a story through an image or images can create a series of moods. The ideas surrounding narrative are powerful and worth investigating.

Relating it to your critical and contextual reference

- The paintings of Walter Sickert, who was much influenced by his teacher Degas, use heavy impasto, loose highlights and a wide range of dark tones in images that are often taken from photographs or based on photographic qualities of light and composition. *Gaité Rochechouart*, 1906, for example, shows the stalls and balcony of a music hall as seen from the stage. Sickert was interested in finding out how to represent ordinary activities, the sort of life ignored by art, and many of his paintings aim to create moods unusual in art. Try looking at a work of his titled *Ennui* (French for 'boredom'), *c*. 1914.
- Expressionist artists took the notion of mood in art and heightened it until there was nowhere else for them to go. Their paintings are like long, drawn-out, loud screams. Edvard Munch's painting of the same subject is a well-known illustration of that idea, so well known in fact that it is probably worth avoiding unless you can find something novel to say about it. There are many other paintings of his that you could look at, such as *The Day After*, 1849–95, which shows a young woman unconscious on a bed, her hair flowing behind her onto the floor. On a table, at her feet, are bottles and glasses. The whole painting is in a dreary range of browns and off-whites, creating a grim mood.

- Documentary photography has its own visual language to create mood, especially that in black and white or, rather, the full range of tones in between and including deep black and pure white. Weegee's photographs from the 1930s and 1940s use high contrast between the tones to record the excitement and the serious danger of New York nightlife. His *Murder on the Roof, August 14*, 1941, shows a dead figure in the foreground lying below a low wall. Two men are next to the body, the white straw hat of the standing man shines out against the grey walls and dirty sky. Behind them, a row of people are watching with little interest. See page 73 for more on monochrome.

CHAPTER SUMMARY

This chapter has:

- shown you how to work thematically
- explained how museums and galleries are divided into two basic types: historic collections and specific exhibitions, often within the same building
- described how to research your visit beforehand, including working outwards from the key elements and not worrying if you can't find anything that precisely corresponds to that theme
- explained why it is important to use the internet carefully and to look through other sources for information as well
- emphasised the importance of continually making links between art to be studied and your own work
- shown you how to plan your visit carefully, seeking out art work that is relevant to the theme you are studying
- explained, by taking a specific exhibition as an example, how using key terms can help you to categorise the work you see
- focused on the following key terms: style, methods and materials, content, composition and mood
- emphasised the importance of using annotation and making visual notes during your visit

RELATING WORK SEEN TO WORK MADE

There is little value in simply copying a style, but there is much to be gained from analysing an artist's approach. Similarly, you may wish to investigate any one of the issues raised in this chapter rather than merely copying style or presentation.

Ask yourself the following questions:

- Why has this been done?
- How has this been done?
- What has been achieved as a result?

By now, you will have discovered the value and importance of preliminary research and of making annotated and visual notes in front of the work. Museum and gallery visits are invaluable ways to enrich your own studio practice and to broaden and deepen your contextual reference. The methods of research, of identifying and recording the relationship of verbal and visual languages, are skills you will have begun to acquire in this chapter. Looking is a skilled process and requires a trained eye. The keenness of your eye and the understanding you will bring to your recording will improve the more you practice.

APPENDIX ONE

KEY TERMS

Each subject area has its own specialist language and art is no exception. It has a large number of subject-specific terms with precise meanings. Your task as a student is to seek out these specialist terms, to use them as accurately as possible and to spell them correctly. The more you get used to these key terms, the easier it becomes to explain your artistic ideas, to understand the ideas of others and to show off your extensive vocabulary, both to examiners in your sketchbook and to others around you.

abstract Technically, work that has no reference to anything outside the picture frame — in other words, a work that is not an illusion of anything else.

The term may be used vaguely. Indeed, people sometimes use it without thinking to describe any form of art that they don't understand. Cubism is sometimes described as abstract because viewers can't comprehend what it is about. One example is Picasso's *The Accordionist*, 1911. Both Picasso and Braque, however, started working from a studio portrait or still life to get to the final image; because parts of that visual analysis are still to be seen in *The Accordionist* (i.e. it still refers to work outside the picture frame), the painting cannot be described as abstract.

The intention of abstract art is to refer only to itself, to the process of making and the arrangement of forms within it and to previous abstract art that came before it. A more useful term, perhaps, is non-figurative, with its related terms, figurative and semi-figurative. Figurative means clearly referring to forms in the world (not just figures); semi-figurative refers to works in which some of the figuration is still visible (e.g. the Cubist example given above); and non-figurative means entirely abstract. Abstract art used to be called autonomous (which means self-governing or being independent), having no reference to anything outside its own frame.

Try searching out the first purely abstract painting in the Western art tradition. (Remember the considerable difference between Western and Eastern art. The Koran, for example, forbids representational art in important places.) The Russian Suprematist Kasimir Malevich's *Suprematist Square*, 1914–15, a plain black square placed onto a slightly larger, white canvas square, would qualify. This painting

meets the definition of abstract because it appears to refer to nothing but itself; the shape of the square does not come from nature or organic forms, but standard geometric shapes.

additive mixing A method of arranging rather than mixing colours. Additive mixing aims to keep colours bright by placing different hues next to each other so that they 'mix' in the eye rather than on the palette. Isaac Newton showed that when white light (i.e. ordinary daylight) passes through a prism, it breaks down into the full colour spectrum. In other words, white light contains all the colours of the rainbow: red, orange, yellow, yellow–green, blue–green, blue, violet. When you recombine all the rays, the colour returns to white. The usual system of mixing colour pigment with normal opaque paint, known as full body colour, is the method that most of us is familiar with, e.g. yellow plus blue equals green.

Additive mixing with light is mostly used in printing, colour photography and lighting. It is not the same as mixing pigments. In the additive system, the three primaries are magenta, cyan blue and medium yellow. Bearing in mind that, in light, all the primaries added together make white, this method has two basic applications in painting:

1 You can mimic the process of additive mixing by using layers of transparent glazes on white paper. Mix and apply thin layers of acrylic paint, waiting for each layer to dry before applying the next. Make sure that you can always see through to the paper underneath. Transparent glazes used like this can behave slightly like additive colours, in that each layer of glaze can be seen at the same time, and they reflect less white light than opaque paint. If you can see all the colours at once, then you are starting to recombine the colours of the spectrum and the resulting colours will be much brighter than if you had used the usual subtractive mixing system. The other method, best suited to working on a large scale, is to mix water-based coloured inks with a PVA-type glue and then scrape thin layers on to the paper. Again, each layer must be dry before you put on the next one. The combined colours should be lighter and more stimulating to the eye than if they had been mixed on the palette.

2 Divisionist artists used the additive process by adding small points of pure primaries to create additive mixtures from a distance. This technique can also be hinted at if you mix colours on canvas, paper or board. If you take care not to mix the colours too well, the additive mixing will result from bad blending. (See also divisionism on page 268.)

armature The structure or skeleton for a sculpture. The 'skin' of the sculpture, whether clay, plaster, chicken wire, papier-mâché or another material, is placed over the underlying armature to make up the whole work. You can use anything of a reasonable strength to make the armature since it won't be visible in the end product: old pipes, bent willows, sticks, carpet tubes etc. Try anything you can find.

It can be kept together with string, wire or even sellotape, as long as you are able to anchor it in some way so that it doesn't move around while you work on it.

attribute An object that is seen or associated with a person to help the viewer identify that person. It is usually Christian saints who are depicted with attributes. For example, St Mark is recognisable by the lion that always accompanies him, while St Catherine is associated with the wheel, the object on which she was martyred. It is possible that you will be making paintings of saints, but more likely that you will want to portray other figures, and attributes can be useful as a way of identifying them. Examples are Margaret Thatcher with her handbag, a teacher with a register and a teenager with a mobile phone.

This sense of the term is not to be confused with the process of working out who painted a particular work and 'attributing' it to the artist, proving that he or she has made it.

chiaroscuro A technique used in painting since the Renaissance, in which a strong, often dramatic, contrast of light and dark is used to create the illusion of form. Using tone in this way to make a shape appear darker at its edges and brightly lit at the centre (its highlight) is a straightforward method, but it suffers from one drawback that you will quickly discover in any form of visual research. Shadows, particularly those cast by strong sunlight, are not black. They contain the colours of the objects that cast them and the surfaces on which the shadows lie. Traditional chiaroscuro loses all that colour. Try comparing paintings by Cézanne and Caravaggio to see how these artists approach shadow, and then make your own studies based on your discoveries. Chiaroscuro is still the basic method to use when drawing with pencil, charcoal or other monochromatic techniques, but it will need adapting to show how you observe colour in highlight and shadow.

complementary colours Those colours directly opposite each other on the traditional colour wheel — red/green, blue/orange, yellow/violet — which produce white if mixed additively and black if mixed subtractively. If, rather than mixing complementary colours, you put them next to each other, the effects of the two colours would be intensified. The opposite of complementary colours are analogous colours, those that lie next to each other on the colour wheel, such as red/orange. Do not confuse compliment with an 'i' (a nice word or phrase about somebody) with complement with an 'e', which means adding up to a whole.

cropping A term that comes from photography, meaning cutting the edges of an image to focus on a particular section. Cropping also refers to the accidental cutting in half of a figure or tree that often occurs in snapshot photographs. As a particular form of composition, cropping was taken up by the Impressionists to suggest modernity; Degas especially used the look of cropping in his work. You might think

about this yourself when posing figures and objects. Do they always need to be placed in the centre? Would aggressive cropping help present your ideas better?

Dada A hugely influential art movement that used irony and cynicism as new materials for making art. Dada started during the First World War, when artists began to rebel against traditional art values by making the first 'anti-art' works. Dadaists used deliberate nonsense and new ways of making art, such as photomontage, sound poems, performance and shock. Artists such as Hans Arp, Marcel Duchamp, Max Ernst, Francis Picabia, Man Ray and Kurt Schwitters blamed the rational, scientific and technological approach of society for the mass slaughter of the First World War. They felt that, after something so senseless, the only way forward was art that made no obvious sense and therefore attacked tradition; in other words, art that was absurd. Many of the Dada artists became involved in the later Surrealist movement, which also celebrated the irrational.

Dada (especially Marcel Duchamp and his ready-mades) influenced the entire direction of twentieth-century art. It was no coincidence that the cover of the catalogue for the 'Sensation' exhibition of 1996, at the Royal Academy in London, which brought the Young British Artists (YBAs) to fame, featured an iron similar to Man Ray's art work of an iron studded with nails (*Gift*, 1921). Dadaists' use of accident and chance, for instance automatic writing, were later used both by the Surrealists and by Abstract Expressionists.

discipline All of the different processes of making art require specific skills and a wide knowledge of the properties of individual materials. These differences have resulted in distinct approaches to making art called disciplines or endorsements. There is a series of disciplines/endorsements that you can take at AS and A2, usually only one at a time. Or, you may take a broad-based (unendorsed) course that includes two or more disciplines. Currently, the different processes of making art include fine art, graphic design, three-dimensional design, textiles, photography and critical and contextual studies.

divisionism A method of dividing colour using the properties of light. The technique was first developed in Paris in the late nineteenth century by the Neo-impressionists Georges Seurat (see *Sunday Afternoon at La Grande Jatte* on page 140) and, to a lesser extent, Paul Signac. Usually colours are mixed on the palette to get the right shade — red and blue to get purple, and so on — then the mixed colour is painted onto the canvas. In divisionism, small patches of pure primary colour are placed so close to each other on the canvas that they appear, to the eye, to mix together to make secondary colours. Therefore, a dot of yellow next to a blue will look from a distance like the green of grass, for example. This is sometimes called optical mixing. The Neo-impressionists took their ideas partly from the scientific theories of colour and light of the US scientist Ogden Rood. They

were also influenced by Michel-Eugène Chevreul's laws of simultaneous contrasts, which had shown that placing colours next to each other makes them seem more brilliant and creates the shimmering effect of light. Chevreul was trying to get brighter effects in textiles, something you could look at yourself.

Although most artists found Neo-impressionist painting too dull a process, the idea of dividing colour and the search for intense vibrancy by using pure colours lived on. Consider how the work of van Gogh was affected after he had seen Signac's paintings. Seurat's investigations made possible the removal of colour from its function as a describing element, and allowed artists after him to use colour as an abstract medium. 'Colour expresses something in itself,' as van Gogh said.

endorsement see **discipline**

en plein air (French for 'in the open air') The practice of painting outside — not just a quick sketch, but the creation of a whole painting from start to finish in front of the subject. Clearly, the subject will be a landscape of some sort. The practice is closely associated with the Impressionism and Post-impressionism of the second half of the nineteenth century and the start of the twentieth century. Once tin tubes had been invented in 1841 to carry paint around (previously artists had used things like pigs' bladders to carry oil paint, which split easily), then artists could begin to work outside. Even so their paintings where still small because they had to be carried to the site, and the thicker paint made to go in these new tubes also held the marks of the brushes or palette knives. Try working outside on a complete work yourself. Apart from only working with what you have remembered to take with you, you will also be affected more by light and climate than if you had just popped out for a quick sketch. Try to include the effects of those stimuli in your art.

figurative see **abstract**

Grand Manner A style of painting that ignored detail to show the broad sweep of the brush, creating ideal or idealised human beings; also known as history painting. Grand Manner paintings told important moral tales, usually taken from the Bible or classical mythology, and sometimes from historical events or literary themes. The essential aim of the style was to make art that appeared better than ordinary nature and the everyday world, art that made the viewer think noble thoughts about beauty, truth, courage and nationhood. The little details of, for instance, landscape or portraiture were left out in favour of figures wearing classical drapery or ideal nudes, with stressed muscles and lots of dramatic gestures. The key artists are probably Raphael, Poussin, Rubens and Reynolds, but there are many others; it is the style of the majority of paintings in the National Gallery.

History painting was thought to be the highest form of art in painting and Grand Manner paintings were always the largest images on display. This tendency

continued into the twentieth century, when the US Abstract Expressionists declared the importance of their art by making it larger in scale than any previous abstract work. History painting was followed in the Genre hierarchy by portraiture, landscape, still life and lastly 'genre scenes'.

grisaille (from the French for 'grey') A technique of painting in shades of grey, as opposed to monochrome, which means painting in any one colour. In the past, grisaille was often made for an engraver to copy from. You can sometimes find images from the late nineteenth century and, occasionally, from the twentieth century where artists have used the grisaille technique to make their work look like black and white photographs. Nowadays, the use of this restricted palette can be useful when investigating the range and function of tone in an image, primarily because the eye won't be distracted by colour.

hue The dominant wavelength of light that corresponds to a named colour, such as the part that produces the redness of red. Hue is what we really mean by colour, although another important constituent is saturation — how much of the colour is present.

impasto A method of applying thick paint with a palette knife, spatula or brush, in which the strokes made to get the paint on to the surface remain visible. Impasto can create a three-dimensional effect in itself, since the paint will often stick above the picture surface and catch the light.

Impasto became well known through the Impressionists' use of thick paint to describe the effects of light. Before them, the Realist Gustave Courbet was known for using thick paint, put on with a palette knife, to bring a sense of truth or real life to his images. Impasto effects are often thought to achieve this. Try experimenting with texture (an important formal element) to test this idea.

It is easy to make heavy impasto with oil paint, simply by not using any medium to thin the paint. Acrylics will need either a specialist gel or modelling paste mixed in with them; try something cheaper and quicker, like sand, wallpaper paste or PVA. Watercolour, which is based on washes, doesn't work well as thick paint. Gouache paint (a heavy body medium, full of saturated colour and quite expensive) is thick, but its uniform nature means that the thickness of the surface is sometimes difficult to see. You can achieve heavy impasto with wax, a method know as encaustic and first used by the Ancient Greeks. If you can gain access to a machine for melting wax (e.g. one used for batik), you can dissolve any pigment in wax and then apply it, while the wax is still molten, to a board or canvas (a textured surface is best). Be careful — hot wax hurts — and the process can make an awful mess of a wax boiler, which tends to upset textile artists.

installation Art that is made for a particular gallery or space, also sometimes called a site-specific art work, although the latter is a term with wider connotations. An

installation has to be seen as whole, in the sense that the entire arrangement matters, not just the discrete hanging of a few particular art works on a white wall. The viewer is surrounded and immersed in the art work.

Installation started as an art form in the 1970s, but had its roots in the 1960s and earlier forms of Modernism. The Surrealist exhibitions from 1925 onward, for example, were always more installations than ordinary exhibitions. If you want to find some extraordinary forms of installation, look for the work of Ed Kienholz, such as *Barney's Beanery*, 1965. One of Damien Hirst's earliest works was an installation, *In and Out of Love*, 1991, which featured cocoons, live butterflies and plants for them to feed on.

light Waves of energy that travel at different wavelengths and intensities and are interpreted by the retina of the eye as different colours. What we see is what is reflected to us, not what the coloured surface absorbs. This basic definition assumes an opaque ground. If a painted colour becomes more translucent (see-through), the colour underneath becomes more important. Try experimenting with different coloured grounds. For example, artists have used a green ground as the underpainting for flesh colours. Try it yourself.

local colour The actual or 'true' colour of an object, or area, seen under plain daylight before its colour is affected by reflected light, overshadowing, distance from the eye, etc.

lost wax method The most common method of casting metal sculpture, involving making a wax version that looks exactly as you want the final version to appear. This wax model is then completely covered in a heavy material, usually clay, to act as a mould, and a small hole made in the bottom. The mould is heated so that the wax melts and runs out of the hole, leaving a 'negative' version. Molten metal, usually bronze, is poured into the mould and, when it cools, the mould is cracked open to reveal the metal version of the wax original. There are much more sophisticated versions that allow the final metal sculpture to be hollow rather than solid, but the basic principle is always the same: the original wax version is 'lost'.

Some design and technology departments have the facilities to use a form of expanded polystyrene as the 'wax' model. Once the carved polystyrene is covered in clay, hot metal can be poured into the mould and the polystyrene melts away in a similar method to the original lost wax technique.

Minimalism A form of abstract art in which art works are reduced to simple, basic shapes, mostly three dimensional, such as cubes, rectangles and spheres; it is summed up by the phrase 'less is more'. As an art form, it only really makes sense in a gallery and museum context. The Minimalist artist Ad Reinhardt called his purely black drawings 'art as art and as nothing else'. Donald Judd's sculptures are also characteristic, although he disliked using the term. Important characteristics of

Minimalism are its repetition of geometrical structures, its industrial look and the well-made appearance of its art works, which. involves removing all traces of the artist's hand.

Minimalist art does not contain any of the traditional devices you might expect, so there is no attempt at illusion or pictorial space. Neither is there any use of symbols, metaphor or story-telling devices; 'what you see is what you see', as the Minimalist artist Robert Morris said. Minimalism bears some relationship to earlier forms of abstract art, such as de Stijl and Constructivism.

modelling The process of creating shape; the term is used to describe work in both two and three dimensions. A painter, for example, is said to model form, making it look solid by describing the action of light on a shape and the highlights and shadows cast. This modelling shows the surface of an object as it turns towards (highlight) or away from (shadow) the viewer. The brighter the highlight, the closer the surface appears to be; the darker the shadow, the further away it appears to be. Painters also manipulate the properties of colour to create shape. Warm colours appear to push out in front of the picture plane and come towards you, while cooler colours seem to recede into pictorial space. For a simple version of colour modelling, you can paint the front of an object in red tones and the back in a range of blues, although obviously you can include a greater subtlety of colours than this crude explanation suggests.

Sculptors model form in soft materials, usually clay. Modelling is an additive process, one piece of clay being added to another to make the form. It is the opposite of carving, which is a subtractive process, the sculptor cutting away the material to reveal the form. Modelling tends to create smooth, rounded, compact forms, whereas carved forms can be sharper and more distinct.

narrative Describes any art that narrates or tells a story. In the past, narration was one of art's primary functions. This is less true today, although even purely abstract art contains the crucial story of its own making. Art is an ideal medium for telling any form of story. Unlike a still photograph, for example, an image can contain many layers of meaning or simultaneous time schemes. More than one narrative strand can also be included. Similarly, an action, its effect and the resolution of the problem may all be contained within one frame. In Pontormo's *Joseph with Jacob in Egypt*, 1515, Joseph is shown presenting his father to the Pharaoh (on the left), on a chariot listening to the pleas of the poor (on the right), walking up a staircase with Jacob (above) and lastly with his dying father (upper right). Each image of Joseph is a key but separate part of his narrative, yet they together make up a unified painting.

Neo-impressionism see **divisionism**

non figurative see **abstract**

optical colour Colour affected by atmospheric conditions, aerial perspective etc.

palette A flat surface on which to hold paint; also the range of colours associated with a particular artist or work.

The palette, as an object, allows the artist to mix paint and carry it to the painting so that it doesn't fall from the brush as he or she walks from table to canvas. Traditionally, an artist's palette was an oval-shaped thin piece of wood with a hole for the thumb that allowed the larger part of the oval to be balanced along the arm. Palettes often had small dipping pots clipped to them so that a medium for mixing the paint could be kept close at hand as well. Palettes are rare objects these days. Most students make do with an old plate for acrylic paint. White plates work well and can be easily washed or covered with cling film if you want to keep the paint wet for a day or so.

The palette, as an idea, refers to the range of colours that an artist might use, either in a particular work or more often throughout his or her life. Many painters are characterised by a specific range of colours. Delacroix, for example, had a strong range of reds and high-coloured flesh tones that he always used. Many artists actually collected the strips of canvas on which Delacroix worked out palettes for particular paintings, hoping to be able to use that selection of colours themselves. Take a few artists that you like and make a colour analysis of each artist's work in an attempt to establish the palette used. Now try using the individual palettes in work of your own that tackles similar themes. Which works best?

pastiche An attempt to imitate and reproduce an artist's style, usually with dishonest intentions, in a new image. It is crucial that you avoid this accusation being levelled at you when you are carrying out critical and contextual studies of other artists. Making a drawing from another artist's work can be useful, however. You want to be able to show that you have looked at the work carefully, and making a drawing is one of the best forms of visual analysis. Do this task well, but don't spend forever doing it. The point is to investigate, not to copy. Equally, make sure that the work you create as a result shows clearly that you have learned from your research but have also moved on. Studying van Gogh's *Sunflowers* and then making an impasto-ed painting of large bright yellow flowers in an ochre jug with your name in blue lettering on it would be an indefensible pastiche. Instead, you could take van Gogh's principles and compare different ways of 'bringing the sun' into the studio by looking at the saturation of colour in different surfaces. You don't even need to use yellow. Or, notice that the original bunch of sunflowers contains flowers at every stage of their life cycle. You could put together a selection of objects that symbolises life from 'cradle to grave'.

picture plane The flat surface — board, canvas, or paper — on which two-dimensional art is made. In Illusionistic paintings, artists try to create a sense of

depth or 'pictorial space', the illusion that behind the flat surface of the painting, the picture plane, is actual depth. In this context, the picture plane is often referred to as a fourth wall, the other three walls representing the illusionist depth of pictorial space. The Renaissance artist, architect and writer Alberti's description of the workings of perspective in 1425 called the picture plane 'a window between the viewer and the view shown in the painting'. Traditional Illusionism depends on a combination of linear perspective, scale and the properties of colour to achieve the illusion of depth. These are not the only techniques available; abstract methods will work as well. For example, you can create pictorial space with colour, red appearing to push in front of the picture plane and blue receding behind it.

Pop art An art movement inspired by popular culture and consumerism that started in Britain and the USA at roughly the same time, lasting from the late 1950s to the end of the 1960s; it was called Neo-Dada too. Dada also used everyday things in art. Look, for example, at Duchamp's ready-mades, real objects made into art by being placed in galleries, then find the similarities with the early, or pre-Pop, work of Jasper Johns and Robert Rauschenberg.

Pop in both countries was a deliberate reaction against the fine-art approach to making art, especially that of the Abstract Expressionists, and a celebration of all things modern, particularly if they were from the USA. Like the Cubists before them, Pop artists used the images of consumerist society, mostly advertising, for example Warhol's famous Campbell's soup cans. Unlike the Cubists, who took new subjects but used traditional techniques to represent them, Pop art adopted both the visual characteristics and the mechanics of the modern world. For example, in Lichtenstein's comic-book painting *Whaam*, 1963, he painted the Ben Day dots used in basic printing processes onto huge canvases, turning cheap-looking images into high art.

Lichtenstein's comic images were taken from war or love comics, the 1960s being associated with the Cold War and also a time of sexual freedom. The USA had already fought in Korea and was about to become disastrously involved in Vietnam. Jasper Johns made many drawings and paintings of the US flag, such as *Three Flags*, 1958, which is in the Whitney Museum, New York. Although these images do not obviously comment on their subject, they make a commentary of sorts on issues of the period. Which contemporary images and issues would you approach in this manner?

Post-impressionism A term used to describe the work of four leading French artists of the late nineteenth century who reacted against Impressionism and Neo-impressionism.

Impressionist paintings were supposed to represent exactly what could be seen, emphasising the fall of light on objects, people and landscapes rather than the objects themselves. Impressionists used the term 'optical truth' to describe this process, which meant that they did not try to interpret the subject, just represent it.

Their search for optical truth denied the symbolic nature of art and the possibility that the painting could, for example, be a personal and emotional response. Impressionists had attempted to capture the envelope of light around an object or in the general atmosphere. This technique, while revolutionary, made creating solid pictorial form difficult (see page 9 for a definition of this crucial formal element). Post-impressionism, which ran from about 1880 to 1905, began the move away from this process. There was no organised group of Post-impressionists but four key artists (Cézanne, Gauguin, Seurat and van Gogh) reacted against Impressionism, trying to make art that included a powerful representation of form. Cézanne said that he wanted to 'make of Impressionism something solid and enduring, like that of the museums'. Van Gogh and Gauguin searched for an art that could have a symbolic as well as optical content, thereby forming the link between Impressionism and Expressionism.

These four artists were the major inspiration for most early twentieth-century art movements. Between them, they were largely responsible for what is sometimes called 'modern art'. Cézanne's work on pictorial form was crucial for Picasso and Braque and, subsequently, Cubism (the early versions of which could well be called 'Cézannism'). Gauguin's investigations of Symbolism in Brittany and primitivism in Tahiti, and van Gogh's use of power and colour, led to Fauvism and Expressionism and the recognition that personal emotion could be a suitable subject for art. Seurat's semi-scientific investigations of colour made the removal of colour from its functional, purely descriptive role possible and allowed artists to use it in an abstract manner.

raking Strong light that comes from a distinct, low angle. The effect of raking light is to cast strong shadows and bright highlights. It is a useful way of lighting objects if you wish to analyse form more closely.

repoussoir A traditional form of composing landscapes, in which an object set in the foreground of a painting frames the mid ground and background to create a sense of pictorial depth. This system need not apply only to landscapes; it can also be used in abstract work such as Willem de Kooning's *Door to the River*, 1960 (see page 147). In this work, the yellow strokes on the left and at the top act as framing devices, leading the eye into the composition. In other words, moving from a bright foreground to a darker background creates depth, the usual method of constructing a landscape. You could try reversing this order.

Romanticism An eighteenth- and nineteenth-century movement that included all the arts. In essence, this was a movement about the individual and how that individual experienced the world. You can see this essence of Romanticism in Caspar David Friedrich's *The Wanderer above the Mists*, 1817–18, in which a single, lonely figure stands on the top of a mountain staring down into a misty valley.

Romanticism started in Germany and expressed 'the voice from within' of the artist, resulting in lots of atmospheric landscapes similar to the example given above, as well as paintings of ruins showing the passing of time and the beauty it created.

The Romantic movement in painting and literature created a great interest in landscape, especially in ruins and other wild areas that had previously been ignored; the first mountain climbers were Romantics. In France, Romanticism produced a more public, less personal art, such as Eugene Delacroix' *Liberty leading the People*, 1830, which shows an actual incident: the Parisian riots that led to the Revolution. It might help your understanding of the visual characteristics of Romanticism to look at its opposite, Neo-classicism, as seen in David's *Oath of the Horatii*, 1784, a painting full of reference to the classical past. Delacroix used swirling colours, thick paint and soft shadows to show workers in contemporary and suitably dirty clothing, whereas the figures in David's painting are in classical dress and striking heroic poses, but are sharply lit with harsh shadows on an empty stage. Delacroix' bright palette and his refusal to use black to create tone was particularly important for the later Impressionists and Post-impressionists. Cézanne, for example, started as a Delacroix copyist.

saturation The purity or intensity of a hue (or colour). The more saturated the colour, the more intense it will look. It might help you to understand the term if you think of water soaking into a white cloth. A fully soaked cloth is saturated when it can take no more water. Now imagine if that water was a pure red colour; the wetter the cloth, the deeper the colour would be, i.e. the more intense the saturation of the pure hue would be.

scumble A painting technique in which one layer of paint is put over another in such a way that both layers can be seen at once. A scumbled layer is not a wash, i.e. a thin transparent layer. Scumbling involves putting opaque (non see-through) or semi-opaque paint over a layer of paint that is already dry. The top layer needs to be put on irregularly so that the bottom one shows through. Turner used scumbling a lot to suggest the qualities of skies, e.g. the clouds over the sunset in 'The Fighting Temeraire'. It is a key technique for painting texture, as well as a method for gently altering a colour or making a flat colour look more interesting.

secondary colours The three colours that are made by mixing the primary colours — yellow and blue to make green, red and yellow to make orange, and red and blue to make purple.

sgraffito In art history terms, any method for scratching through one layer (often gold) to reveal a different coloured ground underneath. In recent painting, the term tends to be used to describe the process of scratching lines through paint to show the white of the primed canvas underneath. The French artist Jean Dubuffet used

this technique in the painting *Monsieur Plume with Creases in his Trousers (Portrait of Henri Michaux)*, 1947, in which the artist scratched the line portrait into a thick brown surface of oil paint. If you have ever worked with scraperboard, where you scrape through a layer of black to reach a white surface underneath, then you were using the sgraffito technique.

The name graffiti does indeed derive from this term and was first used to describe the scratching of names into stone and brickwork. It has now expanded to include spray-painted artwork, tags etc.

squaring off/up A technique for copying from an image, usually to make a much larger version, although the system is often used to copy a drawing across to a painting. The first step is to put a grid over your existing image. You can actually draw on it or use an overlaid acetate sheet, making a grid of equal squares to cover the image. Draw the grid on your new surface, scaling up the size of the squares as appropriate — you need to have the same number of squares in the same proportion as in the original. The grid gives you guidelines to copy from and, by marking off where key features cross the axes of each square, you can make an accurate copy.

stipple A painting technique that involves making up a paint surface with small dabs of a brush or sponge. The effects vary according to the size and type of the brush or other tool you are using. You can build up many layers of stipple to create dense areas of fine texture with gently varying colour over a small area (or a larger one, if your patience will stand it).

subtractive mixing The usual process of colour mixing, in which each new pigment added makes the mixture darker, so that in theory, after many mixes, the result will be black. This process is known as subtractive mixing because each successive colour that is added absorbs (takes away or subtracts) more waves from white light (ordinary daylight). The effect of this mixture of many colours is to make the final colour appear duller or muddier.

There are various ways of keeping the brightness of colours. You can, at some expense, buy a few pigments that are bright secondary colours, either naturally or chemically made, e.g. emerald green (viridian), which is a bright pure tone because it is a single pigment. The divisionist artists Seurat and Signac used optical or additive mixing (see page 266), painting with small dots of colour so that they mixed in the eye not on the palette. Try the same system yourself.

On a more practical level, make sure that the water you use as a medium for mixing acrylic paints is always clean, otherwise you are just mixing in small amounts of other colours and thereby creating a minor form of subtractive mixing. Likewise, when using linseed oil and refined turpentine as a medium for oil paint, keep the mixture as clear as possible.

Surrealism Largely a literary art form, but one that had an enormous effect on the visual arts. Surrealist art of every sort tried to remove the usual conscious controls over thought, employing many different techniques to find new poetic images and ideas. One such technique was automatic writing, in which the artist would fall into a semi-hypnotic trance and write down whatever came into his or her mind, or hand, without thinking. It is a technique you might try yourself, although it is surprisingly difficult to do without the brain taking over. Automatic writing was an important technique for later Abstract Expressionists; as well as from Jackson Pollock, look at the work of Mark Tobey.

Remember the date and the place Surrealism started: after the First World War and largely in Paris. Early Surrealists and Dadaists saw the madness of the world's first mechanised war as the result of reason. Therefore, they deliberately looked to the illogical as an alternative to the hopelessness created by humankind's conscious thought.

The psychoanalyst Sigmund Freud had earlier explained the importance of the subconscious to the waking mind, and many saw the subconscious as one of the last areas left to explore. The key Surrealist intention was to discover and release the creative power of the imagination and the subconscious. They tried to capture the irrational and the uncontrollable, unconscious mind, which they called 'the marvellous'; such a state was normally only arrived at through dreams. The route to the marvellous was to upset the conscious mind. An important and useful method the Surrealists developed was the unlikely contrast of unrelated objects: 'Bringing widely separate realities together and drawing a spark from their contact,' as the founder and writer André Breton called it. Or, as Comte de Lautreamont wrote, 'as beautiful as the chance encounter of an umbrella and a sewing machine on a dissecting table' (like all true Surrealist images, both exciting and disturbing at once). What objects can you find and in what circumstances can you put them together so that you can access the marvellous?

Later Surrealists, from about 1929, became more interested in the dreams themselves and tried to represent them, producing detailed dream paintings of unlikely objects in curious settings. Dali and Magritte are the obvious representatives here. When looking at paintings by these two infamous Surrealists, be careful that you are not seduced by the glamour and illusionist skill of their imagery. Just copying a melting clock, turning a rock into a skull or changing a boot into a foot would be a poor response. You need to move beyond copying and produce art of your own, not a pastiche (see above) of the superficially attractive.

Surrealists also used objects. The Surrealist object was often a real thing that had been treated in some way to open up the unconscious mind, such as Meret Oppenheim's *Breakfast in Fur*, 1936, which shows a cup and saucer covered in fur. Surrealism and Dada were closely linked, as were the Surrealist object and the ready-made. Apart from influencing many later filmmakers, Surrealism also

produced its own films. The most famous was probably Luis Buñuel's and Salvador Dali's *Le Chien Andalou* of 1929, which has the truly upsetting scene of a razor blade being dragged across a woman's eyeball, superimposed on a cloudy sky. Surrealist images have been an endless reference point for art, film and, especially, advertising since the movement began.

synoptic Providing a brief survey or summary. Work for both AS and A2 exams is supposed to be synoptic. In the exam board sense, this means ensuring that your preparatory studies for each exam unit take account of the work you have made during previous coursework units.

Look back through past work and register any relevant ideas in your sketchbook. You could perhaps take photographs of a past piece and annotate them (see 'How to annotate your work', page 54) to show how your approach to an exam theme is built on earlier discoveries you have made. Try to show any continuing themes of your own that may have contributed to the solutions you have reached so far. When you start to make your first visual researches, go back again to your earlier successes and show how they can help in this new work.

If there is a key section in a past sketchbook that is relevant to your current studies, try photocopying the right pages. Reduce them slightly to fit on the new pages and point out which unit they have come from and why they are still useful. You cannot get marks for the same work twice so it is important that you make it clear that the work is synoptic, part of the build-up to where you are now but not for assessment in this particular unit. You can always return to artists you have used before, partly to reinforce your approach but also to find out new things about them.

tonking A useful technique, mostly for oil paint, in which absorbent paper is used to soak up thick or wet paint, either with the aim of removing some of the wet layer to reveal parts of other layers, or in order to give the top layer an interesting texture. Newspaper works quite well, as does kitchen towel or light tissue paper. Tonking is not a term that is used now. Nonetheless, it remains a viable technique.

vanitas A style of still-life painting popular in the seventeenth century, particularly in Holland. Vanitas from this period are characterised by having a roughly similar content and message, for example Harmen Steenwyck's *Still Life: an Allegory of the Vanities of Human Life*, 1640. In contemplating a vanitas image, the viewer is meant to reflect on the inevitability of death and the pointlessness of worldly ambitions, especially accumulating riches, knowledge or power. The term vanitas comes from the Bible: 'vanity of vanities, all is vanity…as he came forth of his mother's womb naked, shall he return to go'. Vanitas paintings were made during a period in which people where deeply concerned about the afterlife. They accepted that their time on earth might be hard, believing that, for the good and God-fearing person, paradise would make it all worthwhile. Conversely, if you did not look after your

soul, you would end up in purgatory or hell. You could collect all the riches of the world but, unless your soul was pure, you would end up in hell, where all your past possessions could not help you.

These beliefs explain the contents of a vanitas work. The skull is the most obvious, being what is called a memento mori, a reminder of death and its inevitability. Around the skull, expensive objects are usually arranged to reinforce the visual sermon. There may also be musical instruments to make the connection between love (music is the food of love) and death, and always something to emphasize the passing of time, either a chronometer, an hour glass, an extinguished lamp, a candle or a bubble — an object so easily burst.

These paintings are paradoxical in that they depend upon the viewer enjoying beautiful objects in a fine, expensive painting, while at the same time warning the viewer against collecting too many expensive, beautiful objects. Despite the collapse of obvious Christian themes in contemporary society, the vanitas composition can still be a relevant one to explore. You will often find critics describing this theme in art made recently. Why not try it yourself?

APPENDIX TWO

ART WORKS REFERRED TO IN THIS BOOK

This appendix contains a list of art works referred to in the text. It is organised by artist and gives you more information about individual pieces so that you can get a greater sense of their size and the materials used. Ideally, however, you should go to see the works themselves. Art is made to be seen; scale and texture are vital ingredients in the experience of seeing art, and these are lost in reproduction. See chapter 7, 'Visiting museums and galleries', for further details on this essential part of your art education.

Bacon, Francis

Triptych May–June, 1973, oil on canvas, each panel 198 × 148 cm, private collection (page 76)

Untitled (Crouching Nude), 1950, oil on canvas, 196 × 135 cm, Faggionato Fine Arts, London (pages 255, 258)

Baldovinetti, Alesso

Portrait of Lady in Yellow, 1465, egg tempera and oil on panel, 63 × 41 cm, National Gallery, London (page 111)

Beckman, Max

The Artist's Café, 1944, oil on canvas, 60 × 90 cm, Richard Nagy, London (page 262)

Berchem, Nicolaes

Peasants with Four Oxen and a Goat at a Ford by a Ruined Aqueduct, 1655–60, oil on panel, 47 × 39 cm, National Gallery, London (page 179)

Bernini, Gian Lorenzo

The Ecstasy of St Theresa, 1645–52, marble, 350 cm high, Santa Maria della Vittoria, Rome (page *125*)

Blake, William

The Soul Hovering over the Body Reluctantly Parting with Life, 1805, pencil on paper, 27 × 46 cm, Tate Britain, London (page 231)

Boltanski, Christian

The Dead Swiss, 1990, 200 black and white photographs behind glass, lamps, cable, site-specific size, Tate Modern, London (page 261)

Bomberg, David

Ghetto Theatre, 1920, oil on canvas, 75 × 62 cm, The London Jewish Museum of Art, London (pages 259, *260*)

Bourgeois, Louise

Cell (Eyes and Mirrors), in progress, 1989–93, marble, mirrors, steel, glass, 236 × 211 × 219 cm, Tate Modern, London (pages *40*, 41, 44, 47, 48, 52)

Untitled, 2000, fabric, stainless steel, private collection, 193 × 30 × 30 cm (page 48)

Brassai

Paris by Night, 1932, gelatin-silver print, 40 × 30 cm, Musée d'Art Moderne de la Ville de Paris, Paris (page 262)

Burri, Alberto

Wheat, 1956, oil paint on burlap on canvas, 150 × 250 cm, Kunstsammlung Nordrhein-Westfalen, Dusseldorf (page 83)

Canaletto, (Giovanni) Antonio

The Upper Reaches of the Grand Canal with San Simeone Piccolo, 1738, oil on canvas, 1,250 × 2,050 cm, National Gallery, London (page 169)

Caravaggio, Michelangelo Merisi da

Supper at Emmaus, 1601, oil and tempera on canvas, 141 × 196 cm, National Gallery, London (pages 64, 188, *189*, 245)

Carra, Carlo

Leaving the Theatre, 1909, oil on canvas, 69 × 91 cm, Estorick Collection, London (page *255*)

Cézanne, Paul

Still Life with Green Melon, 1902–06, watercolour and pencil on paper, 32 × 48 cm, private collection (page 100)

Still Life with Plaster Cupid, 1895, oil on paper on board, 71 × 57 cm, Courtauld Institute of Art Gallery, London (page *99*)

The Card Players, 1893–96, oil on canvas, 60 × 73 cm, Courtauld Institute of Art Gallery, London (pages 19, *30*, 31, 35, 43, 239)

Woman with a Coffee Pot, 1895, oil on canvas, 131 × 97 cm, Musée d'Orsay, Paris (pages 23, 28)

Chapman, Jake and Dinos (Chapman brothers)

Chapman Family Collection, 2002, 33 hand-carved wood figures, paint and mixed media; CFC76311561, 2002, wood and paint, 92 × 58 × 49 cm, CFC78396086, 2002, wood and paint, 46 × 99 × 37 cm, CFC79309302, 2002, wood and paint, 36.5 × 13.5 × 9 cm; Saatchi Collection, London (pages 79, *126*, *127*, 128, 130, 132)

Great Deeds against the Dead, 1994, mixed media with plinth, 277 × 244 × 152 cm, Saatchi Collection, London (page 181)

Hell, 1998–2000, fibreglass, 9 parts of plastic and mixed media, 244 × 122 × 122 cm (8 parts), 122 × 122 × 122 cm (1 part), Saatchi Collection, London (page *180*)

Insult to Injury, 2003, portfolio of 80 etchings reworked and 'improved', ink, pencil and crayon on paper, 37 × 47 cm, Jay Jopling Gallery, London (pages 128, 181)

Chardin, Jean-Baptiste–Siméon

The House of Cards, 1737, oil on canvas, 80 × 65 cm, Musée du Louvre, Paris (page 34)

Young Draughtsman Sharpening his Pencil, 1737, oil on canvas, 80 × 65 cm, Musée du Louvre, Paris (page *34*)

Christo

Wrapped Reichstag, 1971–95, 1 million square feet of aluminium-treated polypropylene fabric, 15,000 metres of rope (the actual wrapping stayed in place for 15 days, but the project took four years to prepare) (pages 198, *218*, 219, 220, 226)

Constable, John

The Hay Wain, 1821, oil on canvas, 130 × 185 cm, National Gallery, London (pages 7, 66, 159)

Cotan, Juan Sanchez

Quince, Cabbage, Melon and Cucumber, 1600, oil on canvas, 69 × 85 cm, San Diego Museum of Art, USA (page 7)

Courbet, Gustave

The Stonebreakers, 1849–50, oil on canvas, 190 × 300 cm, formerly Gemäldegalerie, Dresden (destroyed) (pages 15, 89)

Cragg, Tony

Britain Seen from the North, 1981, plastic and mixed media, 440 × 800 × 10 cm, Tate Britain, London (pages 56, *57*)

David, Jacques-Louis

Death of Marat, 1793, oil on canvas, 165 × 128 cm, Musée Royaux des Beaux Arts Belgique, Brussels (pages 79, 87, *90*, 91, 92, 93)

The Oath of the Horatii, 1784, oil on canvas, 330 × 425 cm, Musée du Louvre, Paris (page 6)

Da Vinci, Leonardo see **Leonardo da Vinci**

Degas, Edgar
Combing the Hair, 1896, oil on canvas, 114 × 147 cm, National Gallery, London (page 154)
Two Laundresses, 1884, oil on canvas, 73 × 79 cm, Musée d'Orsay, Paris (page 207)

De Kooning, Willem
Door to the River, 1960, oil on canvas, 203 × 117 cm, Whitney Museum of American Art, New York (pages 7, 146, *147*, 275)

Delacroix, Eugène
Liberty leading the People, 1830, oil on canvas, 260 × 325 cm, Musée du Louvre, Paris (page 276)
The Death of Sardanapulus, 1827, oil on canvas, 392 × 496 cm, Musée du Louvre, Paris (page 10)
The Women of Algiers in their Apartment, 1834, oil on canvas, 180 × 229 cm, Musée du Louvre, Paris (pages *154*, 190, 191)

de la Tour, Georges
Saint Joseph the Carpenter, 1640, oil on canvas, 137 × 102 cm, Musée du Louvre, Paris (page 64)

Delaunay, Robert
Eiffel Tower (Tour Eiffel), 1911, oil on canvas, 202 × 138.4 cm, Solomon R. Guggenheim Museum, New York, gift, Solomon R. Guggenheim, 1937 (pages 66, *67*)
The Red Tower, 1912, oil on canvas, 160 × 128 cm, Art Institute of Chicago, Chicago (page 66)

Della Francesca, Piero see **Piero della Francesca**

Deller, Jeremy
The Battle of Orgreave, 2001, project including film, 63 min, commissioned by Artangel, London (page 259)

Dine, Jim
Four German Brushes, 1973, suite of four etchings, 76 × 56 cm, Museum of Modern Art, Fort Worth, Texas (page 89)

di Paolo, Giovanni see **Giovanni di Paolo**.

Dubuffet, Jean

Monsieur Plume with Creases in His Trousers (Portrait of Henri Michaux), 1947, oil and grit on canvas, 130 × 96 cm, Tate Modern, London (page 277)

Duchamp, Marcel

Bicycle Wheel, 1913, metal wheel, painted wooden stool, 128 × 64 × 42 cm, original lost, copy 1951, Museum of Modern Art, New York (page 54)

Fountain, 1917/64, porcelain, 36 × 48 × 61 cm, The Israel Museum, Jerusalem, Israel, Vera and Arturo Schwartz Collection of Dada and Surrealist Art (pages **53**, 54)

Dürer, Albrecht

Self Portrait at the Age of Twenty-Eight, 1500, oil on panel, 67 × 49 cm, Alte Pinakothek, Munich (pages 87, **190**)

Emin, Tracey

Bed, 1998, mattress, linens, pillows, objects, 79 × 211 × 234 cm, Saatchi Collection, London (pages 48, 224)

Something I've always been afraid of, 2002, appliquéd blanket, 263 × 174 cm, Saatchi Collection, London (pages 48, 224)

Eyck, Jan van see **van Eyck, Jan**

Fabritius, Carel

View of Delft, 1652, oil on canvas, 16 × 32 cm, National Gallery, London (page **169**)

Frost, Terry

Black and White Movement, 1952, oil on board, 70 × 40 cm, Tate St Ives, Cornwall (page 214)

Gainsborough, Thomas

Mr and Mrs Robert Andrews, 1748–49, oil on canvas, 70 × 119 cm, National Gallery, London (page 53)

Gauguin, Paul

Christ in the Garden of Olives, 1889, oil on canvas, 73 × 92 cm, Norton Museum of Art, West Palm Beach, Florida (page 24)

Vision After the Sermon (Jacob and the Angel), 1888, oil on canvas, 75 × 93 cm, National Gallery of Scotland (page **11**)

Ghiberti, Lorenzo

The Story of Jacob and Esau: God's prophecy to Rebecca, the birth of Jacob and Esau: Esau sells his Birthright and Isaac blessing Jacob, 1425–52, panel from the Gates of Paradise, gilt bronze, 79 × 79 cm, Baptistery of Florence Cathedral (pages *205*, 206)

Ghirlandaio, Domenico

Madonna and Child with Saints Justus, Zenobius and the Archangels Michael and Raphael, 1484, tempera on panel, 190 × 200 cm, Uffizi Gallery, Florence (page *212*)

Gilbert and George

Death Hope Life Fear, 1984, four hand-coloured photographs, 422 × 250 cm, 422 × 652 cm, 422 × 250 cm, 422 × 652 cm, Tate Modern, London (page 7)

Gilman, Harold

Mrs Mounter at the Breakfast Table, 1917, oil on canvas, 61 × 41 cm, Tate Britain, London (pages 19, *20*, 21, 22, 23, 24, 25, 26, 27, 28, 31)

Giotto di Bondone

Massacre of the Innocents, 1304, fresco, 200 × 185 cm, Scrovegni Chapel, Padua (page 81)

The Lamentation of Christ, 1305, fresco, 200 × 185 cm, Scrovegni Chapel, Padua (pages *36*, 37)

Giovanni di Paolo

St John the Baptist Retiring to the Desert, 1454, oil on panel, 31 × 39 cm, National Gallery, London (page 137)

Gogh, Vincent van see **van Gogh, Vincent**

Goya, Francisco

Dona Isabel de Porcel, 1805, oil on canvas, 82 × 55 cm, National Gallery, London (page 24)

The Disasters of War, 1863, plate 37, *This is Worse*, etching and aquatint, 15 × 22 cm, British Museum, London (pages 180, 181)

The Disasters of War, 1863, plate 39, *Great Deeds against the Dead*, etching and aquatint, 17 × 22 cm, British Museum, London (pages 180, 181)

The Sleep of Reason Produces Monsters, 1799, etching and aquatint, 21 × 15 cm, Origin PD Caprichos Pl. 43, British Museum, London (page *193*)

Gris, Juan

Still Life with Pitcher, 1910, charcoal on paper with small touches of gouache and white chalk, 48 × 31 cm, Douglas Cooper Collection (owned by Churchglade Ltd) (page 230)

Grosz, George

Café, 1915, oil and charcoal on canvas, 61 × 40 cm, Smithsonian Institute, Washington (page 261)

Guston, Philip

Drawing for Conspirators, 1930, graphite, ink, coloured pencil and crayon on paper, 57 × 37 cm, Whitney Museum of American Art, New York (page 85)

Martial Memory, 1941, oil on canvas, 102 × 82 cm, Saint Louis Art Museum, Saint Louis (page 85)

Painting, Smoking, Eating, 1973, oil on canvas, 197 × 263 cm, Stedelijk Museum, Amsterdam (pages 79, **84**, 85, 86, 101)

Reproduced by permission of the Stedelijk Museum, Amsterdam

The Bell, 1952, oil on canvas, 117 × 102 cm, private collection (page 85)

Hamilton, Richard

Just What is it That Makes Today's Homes So Different, So Appealing?, 1956, collage, 26 × 25 cm, Kunsthall, Tübingen, Prof. Dr. Georg Zundel Collection (page 112)

Hirst, Damien

Argininosuccinic Acid, 1995, gloss household paint on canvas, 335 × 457 cm, Saatchi Collection, London (page 108)

Hogarth, William

The Painter and his Pug, 1745, oil on canvas, 90 × 70 cm, Tate Britain, London (page 8)

Holbein, Hans

George Gisze, A German Merchant in London, 1532, oil on wood, 96 × 86 cm, Gemäldegalerie, Staatliche Museum, Berlin (page 24)

Howson, Peter

Serb and Muslim, 1994, oil on canvas, 215 × 153 cm, Aberdeen Art Gallery (page 93)

Immendorf, Jörg

Cafe Deutschland (one of a series), 1978, acrylic on canvas, 282 × 330 cm, Neue Galerie-Ludwig, Aachen (page 172)

Can one change anything with these?, 1972, acrylic on canvas, 50 × 80 cm, Galerie Werner, New York (page 174)

Ingres, Jean-Auguste-Dominique
Sir John Hay and his Sister, 1816, pencil on paper, 29 × 22 cm, British Museum, London (page *16*)

John, Gwen
Dorelia in a Black Dress, 1903–04, oil on canvas, 73 × 49 cm, Tate Britain, London (page 22)
Nude Girl, 1909, oil on canvas, 45 × 28 cm, Tate Britain, London (page *111*)

Johns, Jasper
Painted Bronze, 1960, painted bronze, two casts, 14 × 20 × 12 cm, Museum Ludwig, Cologne (pages 7, *50*, 51, 53, 54, 55, 56, 57, 58)

Painted Bronze, Savarin, 1960, painted bronze, 34 × 20 cm, artist's collection (page 89)
Three Flags, 1958, encaustic on canvas, 77 × 116 cm, Whitney Museum of American Art, New York (page 274)

Judd, Donald
Untitled, 1986, 30 units of Douglas fir plywood and plexyglass, each unit 100 × 100 × 50 cm, collection of Judd Foundation (page 101)
Untitled, Stack, 1969, 10 units of copper, each unit 23 × 102 × 79 cm, Solomon R. Guggenheim Museum, New York (page 101)
Untitled, Stack, 1980, steel, 10 units of aluminium and Perspex, each unit 23 × 102 × 79 cm, Tate Modern, London (pages 79, 95, *96*, 97, 100, 132)

Kahlo, Frieda
The Broken Column, 1944, oil on board, 39 × 31 cm, Fundación Dolores Olmedo, Mexico City (page 22)

Katz, Alex
Thursday Night #2, 1974, oil on canvas, 183 × 366 cm, Timothy Taylor Gallery, London (page 262)

Keita, Seydou
Untitled, 1959, gelatin-silver print, 60 × 50 cm, C. A. C., the Pigozzi Collection, Geneva (pages 258, *259*)

Kiefer, Anselm

Lilith, 1987–89, oil, emulsion, copper and mixed media on canvas, 3,800 × 5,600 cm, Tate Modern, London (pages *166*, 167, 168, 169, 170, 171, 172, 173, 179)

Over Former Cities Grass will Grow…Isaiah, 1996, photo collage, sand, ash, acrylic paint on handmade paper, 59 × 45 × 4 cm, Norton Museum of Art, Palm Beach, Florida (page 172)

Your Golden Hair Margarete, 1981, oil, emulsion, straw on canvas, 130 × 170 cm, Collection Sanders, Amsterdam (page 173)

Kienholz, Ed

Barney's Beanery, 1965, mixed media, 200 × 190 × 700 cm, Stedelijk Museum, Amsterdam (page 271)

Kooning, Willem de see **De Kooning, Willem**

Lanyon, Peter

Porthleven, 1951, oil on board, 96 × 48 cm, Tate St Ives, Cornwall (pages 178, 179)

Léger, Fernand

Contrasts of Form, 1913, oil on canvas, 100 × 81 cm, Centre Georges Pompidou, Paris (page 44)

Three Friends, 1920, oil on canvas, 92 × 73 cm, Stedlijk Museum, Amsterdam (page 261)

Leonardo da Vinci

Mona Lisa, 1503–6, oil on panel, 77 × 53 cm, Musée du Louvre, Paris (pages 110, 214)

Study of Drapery, 1480, oil on canvas, 26 × 23 cm, Musée du Louvre, Paris (pages 198, *208*, 209)

The Last Supper, 1495–98, fresco, oil and tempera on plaster, 460 × 860 cm, Santa Maria delle Grazie, Milan (page 214)

Virgin and Child with St Anne (painting), 1508–10, oil on panel, 168 × 130 cm, Musée Du Louvre, Paris (page *22*)

Virgin of the Rocks, 1508, oil on wood, 190 × 120 cm, National Gallery, London (pages 22, 61, 122, *136,* 137, 151)

Lichtenstein, Roy

Whaam, 1963, acrylic on canvas, 173 × 406 cm, Tate Modern, London (pages *107*, 108, 274)

Lissitzky, El

Beat the Whites with the Red Wedge, 1919, poster, 48 × 58 cm, Van Abbemuseum, Eindhoven (page **93**)

Long, Richard

Slate Circle, 1979, slate, circumference 660 cm, Tate Britain, London (page 7)

Lorrain, Claude

Seaport with the Embarkation of the Queen of Sheba, 1648, oil on canvas, 148 × 194 cm, National Gallery, London (pages 149, 179)

Woodland Glade, c. 1635, sepia wash over black chalk on paper, 21 × 33 cm, British Museum, London (page 230)

Lucas, Sarah

Two Fried Eggs and a Kebab, 1992, photograph, fried eggs × 2, kebab, table, 76 × 152 × 89 cm, Saatchi Collection, London (page 87)

Malevich, Kasimir

Suprematist Square, 1914–15, oil on canvas, 79 × 79 cm, Tretyakov Gallery, Moscow (page 265)

Manet, Edouard

A Bar at the Folies-Bergère, 1881, oil on canvas, 96 × 130 cm, Courtauld Institute Gallery, London (pages 44, 46, 53)

Déjeuner sur l'Herbe, 1863, oil on canvas, 208 × 264 cm, Musée d'Orsay, Paris (page 87)

Masked Ball at the Opera, 1873, oil on canvas, 59 × 73 cm, National Gallery of Art, Washington (page 261)

Martin, John

The Great Days of His Wrath, 1853, oil on canvas, 196 × 303 cm, Tate Britain, London (page 169)

Matisse, Henri

Luxe, Calme et Volupté, 1904, oil on canvas, 98 × 119 cm, Museé National d'Art Moderne, Centre Georges Pompidou, Paris (page 147)

The Dance, 1910, oil on canvas, 260 × 398 cm, Hermitage Museum, St Petersburg (page 165)

Woman in Back View 1–4, 1916–17, bronze, each 189 × 117 × 800 cm, Tate Modern, London (page 100)

Milroy, Lisa

Shoes, 1985, oil on canvas, 176 × 226 cm, Tate Britain, London (pages 75, **88**, 89)

Miró, Joan

Still Life with Old Shoe, 1937, oil on canvas, 82 × 117 cm, Museum of Modern Art, New York (pages 14, *15*)

Mondrian, Piet

Apple Tree in Blue: Tempera, 1908–09, 75.5 × 99.5 cm, Haags Gemeentemuseum, The Hague (page 160)

Broadway Boogie Woogie, 1942–43, oil on canvas, 127 × 127 cm, Museum of Modern Art, New York (pages *158*, 159, 160, 161, 165, 168)

Composition A, 1920, oil on canvas, 90 × 91 cm (page *102*)

Composition of Lines and Color III, 1937, oil on canvas, 80 × 77 cm, Haags Gemeentemuseum, The Hague (page 103)

Tableau I, with Red, Black, Blue and Yellow, 1921, 103 × 100 cm, Haags Gemeentemuseum, The Hague (page 160)

The Grey Tree, 1911, oil on canvas, 79.7 × 109.1 cm, Haags Gemeentemuseum, The Hague (pages *157*, 160, 164)

The Tree A, 1913, 100.2 × 67.2 cm, Tate Modern, London (page 160)

Monet, Claude

Grandes Decorations (part of the late water-lily series), 1923, oil on canvas, three panels, each 200 × 425 cm, Musée de l'Orangerie, Paris (page 85)

The Gare Saint-Lazare, 1877, oil on canvas, 75 × 100 cm, Musée d'Orsay, Paris (page 67)

Water Lilies, 1904, oil on canvas, 90 × 92 cm, Musée du Louvre, Paris (page 85)

Moore, Henry

Shelter Drawings, 1941, crayon with pen, ink and watercolour on paper, all 19 × 16 cm, British Museum, London (pages *3*, *39*, 41)

Morisot, Berthe

A Summer's Day, 1879, oil on canvas, 46 × 75 cm, National Gallery, London (page 222)

Munch, Edvard

The Day After, 1849–95, oil on canvas, 115 × 152 cm, National Museum of Art, Oslo (page 262)

Neshat, Shirin

Untitled (Women of Allah) series, 1994, gelatin-silver print, ink, 36 × 28 cm, Galerie Thomas Rehbein, Cologne (pages *184*, 185, 186, 187)

Newman, Barnett

Adam, 1951–52, oil on canvas, 243 × 203 cm, Tate Modern, London (pages 100, 165)

Ofili, Chris

No Woman, No Cry, 1998, acrylic paint, oil paint, polyester resin, paper collage, map pins, elephant dung on canvas, 244 × 183 cm, Tate Modern, London (pages 79, *104*, 105, 109, 110, 111)

Courtesy Chris Ofili — Afroco

The Adoration of Captain Shit and the Legend of the Black Stars, 1998, acrylic paint, oil paint, polyester resin, paper collage, map pins, elephant dung on canvas, 244 × 183 cm, Victoria Miro Gallery, London (page 258)

The Holy Virgin Mary, 1996, paper collage, oil paint, glitter, polyester resin, map pins, elephant dung on linen, 244 × 183 cm, Saatchi Collection, London (page 110)

Oldenburg, Claes

Soft Dormeyer Mixer, 1965, pencil on white paper, 77 × 56 cm, private collection (pages 221, *222*)

© Geoffrey Clements/CORBIS

Oppenheim, Meret

Breakfast in Fur, 1936, fur-covered cup, saucer and spoon, 11 × 9 × 7 cm, Museum of Modern Art, New York (pages 9, 278)

Palladio, Andrea

Villa Rotunda, 1552, brick and stone villa, Vicenza (page 260)

Paolo, Giovanni di see **di Paolo, Giovanni**

Paolozzi, Eduardo

Real Gold, 1950, collage, 36 × 50 cm, Tate Britain, London (page 112)

Picasso, Pablo

Les Demoiselles d'Avignon, 1907, oil on canvas, 240 × 234 cm, Museum of Modern Art, New York (pages *129*, 212)

Reproduced by permission of the Bridgeman Art Library. © Succession Picasso/DACS 2006

Glass and Bottle of Suze, 1912, pasted papers, gouache and charcoal, 65 × 50 cm, Washington University Gallery of Art, St Louis (page 77)

Guernica, 1937, oil on canvas, 349 × 777 cm, Museo del Prado, Madrid (pages 76, *86*, 180)

Reproduced by permission of the Bridgeman Art Library. © Succession Picasso/DACS 2006

Still Life with Chair Caning, 1912, oil paint, oilcloth and pasted paper on canvas edged with rope, 27 × 35 cm, Musée Picasso, Paris (page 106)

The Accordionist, 1911, oil on canvas, 130 × 90 cm, Solomon R. Guggenheim Museum, New York (pages 35, 265)

The Three Dancers, 1925, oil on canvas, 215 × 142 cm, Tate Modern, London (pages ***123***, 124)

Piero della Francesca

The Baptism of Christ, 1450s, tempera on panel, 124 × 123 cm, National Gallery, London (pages 62, ***63***)

Piper, John

Forms on Dark Blue, 1936, oil on canvas, 91 × 122 cm, private collection (page 182)
St Mary le Port, Bristol, 1940, oil on canvas, 76 × 64 cm, Tate Britain, London (pages ***176***, 177)

Pollaiuolo brothers

The Martyrdom of Saint Sebastian, 1475, oil on panel, 292 × 203 cm, National Gallery, London (page 102)

Pollock, Jackson

Blue Poles, Number 11, 1952, 1952, enamel and aluminium paint with glass on canvas, 210 × 487 cm, National Gallery of Australia, Canberra (page 76, 86)
Summertime: No. 9A, 1948, oil, enamel, house paint on canvas, 84 × 555 cm, Tate Modern, London (pages 75, 170)

Pontormo, Jacopo

Joseph with Jacob in Egypt, 1515, oil on panel, 97 × 110 cm, National Gallery, London (pages 68, 272)

Poussin, Nicolas

A Bacchanalian Revel before a Term, 1632, oil on canvas, 98 × 143 cm, National Gallery, London (page 202)
A Dance to the Music of Time, 1638, oil on canvas, 82 × 104 cm, Wallace Collection, London (pages ***164***, 165)

The Adoration of the Golden Calf, 1634, oil on canvas, 154 × 214 cm, National Gallery, London (page 202)

Quinn, Marc

Alison Lapper Pregnant, 2005, marble, 3.5 m high, temporary installation in Trafalgar Square, London (page 133)
Self, 1991, blood, stainless steel, perspex, refrigeration equipment, 208 × 63 × 63 cm, Saatchi Collection, London (pages 118, 119)

Raphael

Transfiguration, 1517–20, oil on panel, 410 cm × 279 cm, Musei Vaticani, Rome (page 202)

Rauschenberg, Robert

Bed, 1955, oil and pencil on pillow, quilt and sheet on wood supports, 191 × 80 × 20 cm, Museum of Modern Art, New York (page *223*)

Rego, Paula

The Dance, 1989, acrylic on paper laid on canvas, 84 × 108 cm, Tate Britain, London (pages 212, *213*)

Rembrandt van Rijn

A Woman Bathing, 1654, oil on canvas, National Gallery, London (page 145)
The Blinding of Samson, 1636, oil on canvas, 236 × 302 cm, Städelsches Kunstinstitut, Frankfurt (page 17)
The Three Crosses, 4th Version, 1653, etching, 38 × 45 cm, British Museum, London (page *17*)

Renoir, Pierre Auguste

Boating on the Seine, the Skiff, 1879–80, oil on canvas, 71 × 92 cm, National Gallery, London (page 142)
Dance at the Moulin de la Galette, 1876, oil on canvas, 131 × 175 cm, Musée d'Orsay, Paris (page 143)

Reynolds, Joshua

Three Ladies Adorning a Term of Hymen, 1773, oil on canvas, 234 × 291 cm, National Gallery, London (pages 198, 199, *200*, 201)

Richter, Gerhard

Eight Student Nurses, 1966, oil on canvas, 8 elements, 95 × 70 cm, private collection, Zurich (page 255)

Riley, Bridget

Nataraja, 1993, oil on canvas, 165 × 228 cm, Tate Britain, London (page *162*, 163)

Rodin, Auguste

Balzac, 1898 (cast in 1937), bronze, 302 × 170 × 160 cm, Boulevard Montparnasse, Paris (page *216*)

Rosenquist, James

F1-11, 1965, oil on canvas with aluminium, 305 × 2,621 cm, private collection (pages **70**, **71**, 72, 74, 75, 76, 77, 112)

Rubens, Peter Paul

Descent From the Cross, 1611–14, centre panel, oil on panel, 115 × 76 cm, Courtauld Institute Gallery, London (page 92)

Peace and War, (Minerva protects Pax from Mars), 1629–30, oil on canvas, 204 × 298 cm, National Gallery, London (page 203)

San Vitale

Emperor Justinian with his Retinue, sixth–seventh centuries AD, mosaic, left-hand side of the apse in San Vitale, Ravenna (page 124)

Sargent, John Singer

Carnation, Lily, Lily, Rose, 1885, oil on canvas, 174 × 154 cm, Tate Britain, London (page 222)

Saville, Jenny

Propped, 1992, oil on canvas, 214 × 183 cm, Saatchi Collection, London (page 49)

Segal, George

The Dry Cleaning Store, 1964, plaster, wood, metal, neon, paper/gesso, 213 × 213 × 244 cm, Moderna Museet, Stockholm (page 256)

Seurat, Georges

Bathers at Asnières, 1884, oil on canvas, 201 × 300 cm, National Gallery, London (page **144**)

Sunday Afternoon at La Grande Jatte, 1884, oil on canvas, 208 × 308 cm, Art Institute of Chicago (pages 139, **140**, 141, 144, 268)

Sherman, Cindy

Untitled Film Still #3, 1977, black-and-white photograph, 20 × 25 cm, the artist's collection (page 190)

Shonibare, Yinka

Mr and Mrs Andrews Without Their Heads, 1998, two life-size mannequins, Dutch wax printed cotton, dog, bench, gun, 165 × 570 × 254 cm, National Gallery, Ottawa, Canada (page 131)

Sickert, Walter

Gaité Rochechouart, 1906, oil on canvas, 50 × 61 cm, Ivor Braka, London (page 262)

Ennui, 1914, oil on canvas, 174 × 134 cm, Tate Britain, London (page 262)

Steen, Jan

The Effects of Intemperance, 1663, oil on board, 76 × 106 cm, National Gallery, London (page 7)

Steenwyck, Harmen

Still Life: an Allegory of the Vanities of Human Life, 1640, oil on panel, 39 × 51 cm, National Gallery, London (pages 21, 65, 279)

Titian

Bacchus and Ariadne, 1522–23, oil on canvas, 175 × 190 cm, National Gallery, London (page *55*)

The Assumption of the Virgin, 1516–18, oil on canvas, 690 × 360 cm, Santa Maria Gloriosa dei Frari, Venice (page 202)

Tobey, Mark

Universal Field, 1949, tempera and pastel on cardboard, 71 × 111 cm, Whitney Museum of American Art, New York (page 191)

Turner, Joseph Mallord William

Hannibal and his Army Crossing the Alps, 1812, oil on canvas, 146 × 237 cm, Tate Britain, London (page *152*)

Light and Colour (Goethe's Theory) the Morning after the Deluge — Moses writing the book of Genesis, 1843, oil on canvas, 79 × 79 cm, Tate Britain, London (page 151)

Shade and Darkness — the Evening of the Deluge, 1843, oil on canvas, 79 × 79 cm, Tate Britain, London (page 151)

Norham Castle, Sunrise, 1845–50, oil on canvas, 91 × 122 cm, Tate Britain, London (pages *148*, 149)

Snow Storm — Steam Boat off a Harbour's Mouth making Signals in Shallow Water, and going by the Lead. The author was in this Storm on the night the Ariel left Harwich, 1842, oil on canvas, 92 × 122 cm, Tate Britain, London (page 153)

Uccello, Paolo

Drawing of a Chalice, 1430, pen and ink on paper, 34 × 24 cm, Department of Prints and Drawings, Uffizi Gallery, Florence (page 101)

van Eyck, Jan

The Arnolfini Marriage, 1434, oil on oak panel, 89 × 60 cm, National Gallery, London (pages 44, *45*, 46, 48, 53, 102)

van Gogh, Vincent

A Pair of Boots, 1887, oil on canvas, 30 × 41 cm, Baltimore Museum of Art, Maryland (page 15)

La Berceuse (Madame Roulin), 1889, oil on canvas, 91 × 72 cm, Van Gogh Museum, Amsterdam (page 26)

Postman Joseph Roulin, 1888, pen and ink, 32 × 24 cm, J. Paul Getty Museum, Malibu, California (pages 8, 231)

Postman Roulin, seated in a Cane Chair, 1888, oil on canvas, 81 × 65 cm, Museum of Fine Arts, Boston (page *26*)

Vincent's Chair, 1888, oil on canvas, 92 × 73 cm, National Gallery, London (page 146)

Velásquez, Diego

Las Meninas, 1656, oil on canvas, 318 × 276 cm, Museo del Prado, Madrid (pages 44, 46)

Vermeer, Jan

A Young Woman standing at a Virginal, 1670, oil on canvas, 52 × 45 cm, National Gallery, London (pages *29*, 80)

The Kitchen Maid, 1656, oil on canvas, 46 × 41 cm, Rijksmuseum, Amsterdam (page 18)

Vinci, Leonardo da see **Leonardo da Vinci**

Vuillard, Edouard

Moira Sert and Felix Valloton, 1899, oil on wood, 68 × 51 cm, Musée d'Art Moderne, Paris (page 29)

Warhol, Andy

Campbell Soup Cans, 1962, acrylic paint on canvas, 32 canvases, each 51 × 41 cm, Museum of Modern Art, New York (page 274)

Orange Car Crash (Orange Disaster), (5 Deaths, 11 Times in Orange), 1963, silk screen print on acrylic on canvas, 209 × 219 cm, Fondazione Turino Musei, Turin (pages 256, *257*)

Wearing, Gillian

Dancing in Peckham, 1994, video, colour sound, 25 min, collection of Maureen Paley, Interim Art (page 256)

Weegee
Murder on the Roof, August 14, 1941, gelatin-silver print, 33 × 28 cm, International Center of Photography, New York (page 263)

Weems, Carrie Mae
From Here I Saw What Happened and I Cried (series), 1995–96, e.g. *You Became a Scientific Profile*, C Print with sandblasted text on glass, 42 × 31 cm, Museum of Modern Art, New York (page 46)

Whiteread, Rachel
Ghost, 1990, plaster on steel frame, 269 × 355 × 317 cm, Saatchi Collection, London (page 82)
House, 1993 (destroyed 1994), poured concrete, commissioned by Artangel, Grove Road, Bow, London (page 179)

Wikström, Elin
Rebecka is waiting for Anna, Anna is waiting for Cecilia, etc, 1994, activated situation, women waiting for each other for 15 minutes from 12 p.m. until 6 p.m., Moderna Museet, Stockholm (page 261)

Wright of Derby, Joseph
An Experiment on a Bird in the Air Pump, 1768, oil on canvas, 183 × 244 cm, National Gallery, London (pages *60*, 61, 65, 66, 68, 142)
The Corinthian Maid, 1782–85, oil on canvas, 106 × 131 cm, National Gallery of Art, Washington (page 66)

Yeats, Jack Butler
The Small Ring, 1930, oil on canvas, 61 × 91 cm, Crawford Municipal Gallery, Cork (page 260)

Unknown artist
Beaded crown, nineteenth century, Yoruba Nigeria, glass, textile, metal, cotton, 72 × 16 × 23 cm, Ethno 1904, 2–19–1, British Museum, London (page 109)

Caryatid from the Erechtheum, 415 BC, marble, 2,310 cm high, British Museum, London (page 222)

Ear Plugs, twentieth century, Zulu Natal, South Africa, wood, paint, vinyl asbestos, Perspex, metal, rubber, 7cm (max) × 4 cm (min), Ethno 1999, AF5. 1–7 British Museum, London (page 109)

Painting of Ardhanarishvara, Rajasthan, late eighteenth and early nineteenth century, pigment on paper, 30 × 20 cm, Charles Townley Collection, British Museum (page 121)

Parthenon sculptures (Elgin Marbles), fifth century BC, marble, 1,160 cm high, frieze slabs average 99 × 122 cm, pedimental sculptures average 116 cm high with varying widths, metopes average 116 × 116 cm, British Museum, London (page 198, 220)

Shiva Nataraja, southern India, Tamil Nadu, *c.* AD 1100, bronze, 90 × 50 cm, British Museum, London (pages 79, 115, ***116***, 117, 118)

Venus of Willendorf, 24,000–22,000 BC, oolitic limestone, 11 cm high, Willendorf Museum, Vienna (page 111)

APPENDIX THREE

BIBLIOGRAPHY

To make it easier to find the book or website you want, this bibliography is divided as follows:

See also 'How to find art to use in your critical studies/art studies', in chapter 6, page 239, in particular the section on how to use libraries.

GENERAL USE

Berger, J. (1987) *Ways of Seeing*, **Pelican**

Although written some time ago, this short book is still essential reading. It covers how we look at images, the types of meanings we extract from that looking and how that looking can be manipulated. As it says on the cover, 'Seeing comes before words'. The book also contains 'pictorial essays', carefully presented arrangements of images that put forward visual arguments, a useful example for your work on contextual studies.

Blazwick, I. & Wilson, S. (2000) *Tate Modern, the Handbook*, **Tate Publishing**

A useful rundown on most art movements since Impressionism, with excellent pictures. Definitely the book to read before any visit to Tate Modern.

Butler, A., Cleave, C. V. and Stirling, S. (eds) (1999) *The Art Book*, **Phaidon**

A concise version of a larger book, containing a good pocket-sized collection of images.

Chilvers, I. and Osbourne, H. (eds) (1997) *The Oxford Dictionary of Art*, **Oxford University Press**

The *AS/A2 Art and Design Essential Word Dictionary* does not contain biographies, and there might be times when you need greater detail. There are many art dictionaries around but this is probably one of the better ones, particularly in its coverage of the Modern movement. It also has a handy chronology at the back, with a list of key works starting at 530 BC and ending 1995. These works are linked to other events to give you some sort of idea of their context. Always look in the back of dictionaries and reference books, since they often contain lists which can be valuable.

Cumming, R. (1997) *Annotated Guide to Art*, **Dorling Kindersley**

Annotation is a key skill in examined art these days. There are many books that show an annotated approach to understanding art. This was one of the first. It is the best on the market and the easiest to understand.

Dorling Kindersley has published small books on individual artists that are equally useful. Sadly, most of these are now out of print but they are worth searching out where still available. Remember, though, that your aim is analysis not biography.

Fineberg, J. (2000) *Art Since 1940, Strategies of Being* **(2nd edition), Laurence King Publishing**

A useful guide to post-Second World War art movements, especially the US ones, although not an easy read.

Gombrich, E. H. (1999) *The Story of Art*, **Phaidon**

The standard progressive history of art and a book that every art teacher will have read, but nonetheless still useful. It contains good pictures as well, although Gombrich considers art after Impressionism that is a little hard to get excited about.

Gordon, D. (1988) *The National Gallery, London*, **National Gallery Publications**

This, or whichever guide to the National Gallery is current (see Langmuir below), can be useful when working on contextual studies. These types of guide are a great help when planning a trip to a gallery and deciding exactly which works to see. With luck your art department will have a copy of this and the Tate equivalent. Use them, and their websites, as often as you can.

Hagen, R. M. (2000–2004), *What Great Paintings Say*, **Taschen**

Taschen publishes an enormous number of reasonably priced books on every type of art. Those from its smaller series on individual artists are often good but, being cheap, they fall apart quickly.

Harrison, C., Wood, P. and Gaiger, J. (eds) (1998) *Art in Theory: An Anthology of Changing Ideas, 1850–1900,* **Blackwell Publishing**

One of a series of books that present key texts by artists and critics, probably most useful when you are working on your contextual studies. These books are huge, over a thousand pages each, so go to your library to find them.

Honour, H. and Fleming, J. (1999) *A World History of Art,* **Laurence King Publishing**

This vast, standard art history text is expensive but useful to consult if you can find a library with a reference copy. There are short sections about every art movement since the Neolithic, although some parts are vague.

Hughes, R. (1991) *Shock of the New,* **Thames and Hudson**

An excellent account of the history of Modernism, based on a 1980s' television series and highly readable. Try to find the original videos. They are easy to watch and feature some great art and stunningly dated hairstyles.

Langmuir, E. (2002) *The National Gallery Companion Guide,* **National Gallery Publications**

An excellent guide to works in the National Gallery, with helpful texts on each work. It is arranged room by room, which can make some works difficult to find, but try the index. The National Gallery bring out new editions frequently and so far they have always been good.

Movements in Modern Art **series, Tate Publishing**

This series covers various themes, from Realism through to Postmodernism and beyond, with many more titles planned. Although the books tend to be academic and sometimes quite difficult to read, it is worth giving them your full attention. The pictures of key works are always good.

Sturgis, A. (ed.) (2000) *Understanding Paintings,* **Mitchell Beazley**

A substantial book crammed full of good quality illustrations, with art organised according to themes and Genres. A wide span of art is covered and there is a good list of illustrations at the back so that you can find where the art is displayed. It is expensive so try to get your art department or library to buy it.

Toogood, C. and Roberts, M. (2004) *Your Brain on the Page,* **Tate Publishing**

The sub-heading for this pamphlet, 'a students' guide to using a sketchbook in the gallery', describes what this little book is for. It is full of ways of using annotation and is heartily recommended.

Tucker, W. (2002) *The Language of Sculpture,* **Thames and Hudson**

Although this book restricts itself to a few modernist sculptors (Rodin, Brancusi, Picasso, Gonzalez and Matisse), it has all the terminology and analysis you need to

understand most of the sculpture that you will come across, and is written in a style that is reasonably easy to understand.

Ward, O. (ed.) *The Artist's Yearbook*, **Thames and Hudson**

This book is updated every year and, as it says, contains 'all the information and advice you need to get ahead in the UK art world'. It has some handy short chapters. For example, it contains the phone numbers and websites of all UK colleges offering foundation courses, as well as lists of materials suppliers and all the UK museums. It is not worth buying yourself, but your art department would benefit from a copy, or else go to your local library. If you want to go to Barking or Yorkshire Coast College, buy an easel in Norwich or look at photographs in Belfast, then this is the book to consult.

METHODS AND MATERIALS

Anderson Feiner, E. (2001) *Colour, how to use colour in art and design*, **Laurence King Publishing**

There are many practical books on the market. This one is good on colour.

Cole, A. (1992) *Perspective*, **Dorling Kindersley in association with the National Gallery, London**

Sadly, this seems to be out of print at the time of writing, but it and all other related books by this publisher are worth searching out. Many bookshops still keep them, and they are common in second-hand bookshops. The perspective book, as you would expect from DK books, is properly illustrated to explain the mysteries of perspective. It shows well-known paintings from the National Gallery and, helpfully, has sections on later Modernist paintings and their use of space, from Cubism through to Pop art. There are also DK books on the techniques of painting and drawing, as well as on the properties of colour.

Mayer, R. (1991) *The Artist's Handbook of Materials and Techniques*, **Faber and Faber**

The standard guide to all artists' materials, mainly useful as a reference book since it is enormous and expensive. It contains more or less everything you would need to know, especially with regard to materials for two-dimensional surfaces. If you want to know how to make traditional egg tempera (separate yolk from white, grind pigment into paste and mix directly into the yolk), to obtain the colour gamboge (yellow), or to find out where the hair in Camel hair brushes comes from (squirrels' tails), then this is the book for you.

Smith R. (1991) *The Artist's Handbook*, **Dorling Kindersley**

Solely about painting, drawing and printmaking, this is an easier book to approach than the Mayer above. It is much better on basic techniques but is less authoritative on materials. It has colour illustrations, which are useful for the sections on colour.

WEBSITES

These change constantly. Due to copyright restrictions, most sites won't allow you to download or print images, especially those featuring art made after 1960. There are a couple of important things to remember when using the internet for your art studies:

- There is more to an art study, a major contextual study unit or a piece of analytical work than a cut-and-pasted image. Remember that you must analyse more than you describe and always relate what you see to your own work.
- Monitor how long you spend searching for a vital image or piece of information. It's easy to waste valuable hours searching for something that's in a book on the shelf beside you. As a general rule, look on the shelves first. It's a quicker, if less interesting, process.

MUSEUMS AND GALLERIES

All major museums have their own websites, some of which are excellent and feature virtual walkthroughs of their rooms, as well as proper information on and access to images. Most substantial galleries also display some sort of useful information once you get there. The following is by no means an exhaustive list, but it includes most museums and galleries with a searchable collection.

British Museum, London

www.thebritishmuseum.ac.uk/compass
The Compass search is useful for finding past cultural objects, for example, Shiva or Islamic patterns.

Courtauld Institute Gallery, London

www.courtauld.ac.uk/gallery
A private museum in central London that has a wide range of art from the medieval up to the late nineteenth century. It is particularly good on Impressionism and Post-impressionism. The site is well worth a visit, as is the museum, which currently allows students in for free.

Guggenheim Museum, New York

www.guggenheimcollection.org
You can search the museum's mostly Modernist collection on line.

Harvard University Museums, Cambridge, Massachusettes

www.artmuseums.harvard.edu
In common with other major US universities, Harvard has a large art collection and several museums, ranging from Islamic art through Bauhaus architecture to contemporary art. The part of the site to look for is the on-line collection at:
www.artmuseums.harvard.edu/collections/servlet/webpublisher

This gives access to about 85,000 works, providing information and sometimes images. It is worth investigating.

Hirshhorn Sculpture Gardens, Washington DC

http://hirshhorn.si.edu

This collection of outdoor sculpture is mainly twentieth century and contains most of the greats.

J. Paul Getty Museum, Los Angeles

www.getty.edu/art

The Getty collection is vast, covering all periods and types. There is a lot to look at and, like many US museums, it has a great deal of the 'decorative arts'.

Manchester Art Gallery, Manchester

www.manchestergalleries.org

A large searchable collection, although most of the actual images are unavailable on line.

Metropolitan Museum of Art, New York

www.metmuseum.org

The Met is close in style to our British Museum, with a wide chronological range and including objects as well as paintings and sculpture.

Musée du Louvre, Paris

www.louvre.fr

This is not an easy site to navigate, but it has a huge collection, ranging from the Greeks through to great artists of the nineteenth century.

Museum of Modern Art (MOMA), New York

www.moma.org

MOMA only has highlights of its collection online. Nonetheless, this is a major collection of Modernist art to consult.

National Gallery, London

www.nationalgallery.org.uk

An on-line collection that is extremely well put together and easy to research, with art ranging from the early Renaissance to the end of the nineteenth century. The gallery has some of the best examples of Western art in the world and one of the best websites.

National Portrait Gallery, London

www.npg.org.uk

A useful gallery for putting work and ideas in their historical context. It often has interesting exhibitions based around portraiture, and the website is helpful too.

Rijksmuseum, Amsterdam

www.rijksmuseum.nl

A museum that specialises in the northern Renaissance.

Royal Academy, London

www.royalacademy.org.uk

This is not an easy site to navigate, but useful when researching an upcoming exhibition.

Tate Galleries, London

www.tate.org.uk

Like the National Gallery, this has nearly all of its collection on line. Tate Britain houses British art from 1500 to 2004. Tate Modern has international Modernist and Contemporary art. The Tate also has a growing range of information and ideas tucked away in its Tate on line and Tate Learning sections.

24 Hour Museum

www.24hourmuseum.org.uk

The 'National Virtual Museum', featuring links to over 3,000 museums and galleries in the UK; useful for local museums and 'what's on' guides.

Walker Gallery, Liverpool

www.liverpoolmuseums.org.uk/walker

A site that has much of the Walker collection on line. The gallery has a large collection from 1350 through to now, and a great deal of sculpture. Highlights are available on line, with short and helpful texts.

White Cube, London

www.whitecube.com

The gallery for most of the key Brit art players, from Hirst to Quinn and beyond. It is a visually exciting site.

WOMEN'S ART

www.shephard.edu/englweb/artworks/menu.html

This gives a brief list of women artists through the ages with examples of their work.

www.wendy.com/women/artists.html

This site does much the same thing but tends to lead you to other sites and texts rather than images.

http://web.ukonline.co.uk/n.paradoxa/links.htm

This site links to a large list of women's art sites, indivdual women artists and resources.

National Museum of Women in the Arts

www.nmwa.org

This website has some works on line and useful lists of information and artists to look at. It is a 'virtual' museum and has, sadly, no physical location.

Guerrilla Girls

www.guerrillagirls.com

The Guerrilla Girls are a group of anonymous artists, writers and filmmakers who started making art propaganda in the 1980s. They use humour, gorilla masks, videos, posters, billboards and their website to highlight the continuing poor position of women in the art market, for example the under-representation of women in major museums.

USEFUL SEARCH SITES

Apart from the museum and gallery sites, other useful sites include various forms of portals or search engines dedicated to finding art images. Google Images is not always as helpful as some of these dedicated sites, which you should try first.

Artchive

www.artchive.com

An invaluable site which, along with Artcyclopedia, is usually the first place students go to find images. It is always helpful in finding art, and has theory, criticism and juxtapositions for thematic work which can be essential for internet research.

Artcyclopedia

www.artcyclopedia.com

Much like Artchive, this has huge lists of artists. You can search by name, movement or period. It provides a vital resource well worth using.

Art Guide

www.artguide.org

A list of museums, galleries and artists across the UK. This is a site to use when you know exactly what you want, rather than one for browsing in the hope of finding something interesting. It contains a huge list of UK museums, galleries and artists, and is full of links to local galleries. It does take a little while to find what you want, but largely because it is so comprehensive.

Art Lex

www.artlex.com

The Art Lex dictionary is a huge site and worth investigating. It is full of references to artists and themes, and is illustrated with many useful examples of art. It gives quotations by a small number of mainly twentieth-century artists and also bunches quotations under types of art.

Dare

www.dareonline.org

A digital art resource for education, this is a growing site, with links to others and resources of its own.

Education Guardian

www.educationunlimited.co.uk/netclass/schools/art

The *Guardian* website which, like those of many of the major newspapers and the BBC, has good reviews online, as well as a wide range of links to other sites of particular interest to art students.

Olga's Gallery

www.abcgallery.com

Although riddled with pop-ups, this site has a range of images from most art periods and can be helpful.

Web Gallery of Art

www.wga.hu

This web gallery is vast and will lead you to images of most of the artists from the past that you will need. The information given tends to be purely autobiographical, but it has all sorts of useful sections such as a complete listing in chronological order of Rembrandt's self-portraits.

Wikipedia

www.en.wikipedia.org

Wikipedia is an on-line encyclopedia that anyone can edit or contribute to. The content varies but can be excellent, and it is useful for other subjects too.

World Wide Arts Resources

www.wwar.com

A portal that has links to images and resources across the web, mostly contemporary.

ART HISTORY SITES

There are thousands of art history sites, mostly linked to US universities. Many are overly text based and difficult to understand, but some are useful. The following is a selection of the more helpful ones:

www.bubl.ac.uk

The BUBL catalogue of internet resources is more of an art history portal, but has links to all sort of useful sites on subjects ranging from ancient history through to tattoos.

www.art-design.umich.edu/mother

The mother of art history sites, although probably not as good as Witcombe (see below). It is full of lists and places to research but it does take a while to load.

www.artcyclopedia.com/history/index.html

A list of all art movements in a timeline and alphabetically. Part of the useful Artcyclopedia site.

http://witcombe.sbc.edu

A huge list of art history resources available on the web, with extensive lists of available images, texts and information. It can be extremely useful.

INDIVIDUAL ARTISTS

The following is a brief list of sites relating to individual artists mentioned in the text.

Francis Bacon

www.francis-bacon.cx

A useful site, with Bacon's paintings arranged by date and a great deal of other information too.

Chris Drury

www.chrisdrury.co.uk

Drury's examples of land art, especially his *Cloud Chambers,* are exciting and interesting structures and ways of thinking about light. Try also:

www.sheepfolds.org

This has pictures and maps of how to get to see his sheepfolds project in Cumbria.

Andy Goldsworthy

http://collection.britishcouncil.org/html/artist/artist.aspx?id=17920

www.sculpture.org.uk/image/504816331403

There are many sites on Goldsworthy. These two are reasonably useful and show many of his works.

Antony Gormley

www.antonygormley.com

Gormley's own site has some wonderful images of his work and some interesting texts. It features pictures of nearly all his work.

Richard Long

www.bbc.co.uk/bbcfour/audiointerviews/profilepages/longr1.shtml

The BBC has a huge range of resources on art and artists. This site, for example, is a series of short sound bites taken from an interview with the Land artist Richard Long.

Like many artists, long has his own official website with images and texts about his work:

www.richardlong.org

Giorgio Morandi

www.museomorandi.it

Morandi is the artist who made all those quietly toned still-life paintings, which are helpful to refer to when looking at light, close-toned colour or still life. This website for the museum of his work is full of suitable images and information.

Paula Rego

http://library.thinkquest.org/17016

A useful site that shows the background to Rego's work.

James Rosenquist

www.jimrosenquist-artist.com

Rosenquist's official site, but one that is difficult to open.

Robert Smithson

www.robertsmithson.com

The artist who made the Spiral Jetty, and many other exciting works too. This site has lots to see.

Vincent van Gogh

www.vangoghgallery.com

www.vangoghmuseum.com

Like many well-known artists, van Gogh has numerous sites dedicated to him. These two are among the best.

SITES OF GENERAL USE

Artists' signatures

www.artarchive.net/doku/artistsignatures

It is possible that you might need to know how Warhol or Cézanne signed their name. However, don't just copy it onto your work hoping to get a mark. On its own, such a copy means little. This is an alphabetically listed site from ABILDGAARD, Nicolai A. (1743–1809) through to ZORN, Anders (1860–1920).

Atlantis Materials

www.atlantisart.co.uk

One of the standard places that art students go to get their materials in east London. They will deliver, at a price. The shop is huge and, if you research the site and then visit the shop, you will find most of the things you will ever need and many you didn't know existed — if you don't mind queuing, that is.

Symbols.com

www.symbols.com/

A vast searchable list of signs and symbols. Some are art based, so this site can be useful. If, for example, you want to know about the signs used in Nordic religions

before Christianity (a cross within a circle, interestingly enough) or what a caduceus was (a staff or stick with two snakes wrapped around it), then this is the place to look.

BOOKS RELATING TO SPECIFIC CHAPTERS

Many of the books mentioned below are catalogues from past exhibitions. They are usually still available from the museum or gallery that held the show. If you can afford them, or can get your art department to buy them, exhibition catalogues are an invaluable source of information and large images to consult.

CHAPTER 1

Sandler, I. (2004) *A Sweeper-Up After Artists*, **Thames and Hudson**
Sandler was a friend of most of the Abstract Expressionists and other important later artists who lived in New York. This book is his memoir of living in this art centre in the second half of the twentieth century. It's full of all the stories, such as Pollock pulling the phone booth off the wall of the Cedar Tavern while Kline was still inside.

CHAPTER 2

Cachin, F. et al. (eds) (1996) *Cézanne*, **Philadelphia/Tate Publishing**
Smith, P. (1996) *Interpreting Cézanne*, **Tate Publishing**
Both these books accompanied a major Cézanne exhibition. The smaller book (*Interpreting Cézanne*) is considerably cheaper and has many illustrations and some helpful essays. The larger catalogue is full of images allowing you to understand the development of Cézanne's art.

Compton, S. (ed.) (1986) *British Art in the Twentieth Century*, **Royal Academy of Arts, London**
This is the catalogue of a large exhibition. It is still possible to find copies of it at the Royal Academy. It has a great number of full-page illustrations and good essays on significant periods in British art, including a short section on the Camden Town Group to which Harold Gilman belonged.

Foster, A. (2004) *Tate Women Artists*, **Tate Publishing**
It can be difficult to find the work of women artists in traditional art books. This is an overview of significant woman artists, ranging from Mary Beale (a successful seventeenth-century portrait painter) through to Andrea Zittel (who makes *Living Units*, which are single pieces of furniture supposed to satisfy all her needs). It includes a short section on Louise Bourgeois.

Gopnik, A. and Varnedoe, K. (1990) *High and Low: Popular Culture and Modern Art*, **Museum of Modern Art, New York**
This contains helpful references to Rosenquist and information on different approaches to the role of the object in twentieth-century art.

Grosenick, U. (ed.) (2003) *Women Artists in the 20th and 21st Century*, **Taschen**
Part of the Taschen Icons series, this is a small book with brief essays and pictures of each artist's work. A wide range of art is included.

Humphreys, R. (2001) *Tate Britain Companion to British Art*, **Tate Publishing**
A useful guide that puts artists like Harold Gilman and Joseph Wright of Derby in context.

Rewald, J. (1986) *Cézanne, A Biography*, **Simon and Schuster, London and New York**
A surprisingly readable and useful description of Cézanne's life and the standard source for information on Cézanne. Rewald's edition of Cézanne's letters is also worth looking at.

CHAPTER 3

Auping, M. (ed.) (2003) *Philip Guston, a Retrospective*, **Thames and Hudson/Royal Academy**
This substantial catalogue to a recent exhibition has good, large illustrations and detailed and thought-provoking essays. It is an essential book for studying Guston.

Blurton, T. R. (2001) *Hindu Art*, **The British Museum Press**
Apart from specific information on Shiva, this book should also help you begin to get to grips with the wide range of Indian art in general, and Hinduism and its representations in particular.

Button, V. (2003) *The Turner Prize: Twenty Years*, **Tate Publishing**
Full of images and short essays on all the Turner Prize contenders and winners, including the Chapman brothers and Chris Ofili.

Cennini, Cenino (1954) *The Craftsman's Handbook (Il Libro dell'Arte)*, **Dover Publications**
First written in the fifteenth century by a practising artist, this describes how to make art and how to run a studio in Renaissance Florence. If you want to 'paint trees and foliage in fresco and in secco' or need to know 'how to keep Minever tails from getting moth eaten' (and remember that 'no others are suitable, and these tails should be cooked and not raw: the furriers will tell you that'), then this is the book for you.

Dehijia, V. (1997) *Indian Art*, **Phaidon Press**
Indian art is a vast subject. This book contains excellent illustrations and has a reasonable range of information about images of Shiva.

Doniger, W. (translator) (2005) *Hindu Myths*, **Penguin Books**

This has a short section on Shiva. The book as whole gives a fine flavour of the complexity of Hinduism and its stories.

Michell, G. (2000) *Hindu Art and Architecture*, **Thames and Hudson**

This is reasonably illustrated and has many references to Shiva Nataraja, but the text is not as helpful to practising artists as some of the other books mentioned here.

Serota, N. (2004) *Donald Judd*, **Tate Publishing**

This is the catalogue from a recent major Judd retrospective. Apart from some interesting essays on his work, which should help with understanding where his art fits in, the images are of high quality and give the reader a clear sense of what he was trying to do.

For information on the US context with relation to Guston and Judd, see also Fineberg's *Art Since 1940: Strategies of Being* (details listed under chapter 4).

CHAPTER 4

Fraser Jenkins, D. (2000) *John Piper: the Forties*, **Philip Wilson Publishers/Imperial War Museum**

This has a range of Piper's work made during and after the Second World War and good essays on how his art developed from abstraction back to figurative images in order to show the effect of war on Britain.

Gage, J. (1997) *Colour and Culture, Practice and Meaning from Antiquity to Abstraction*, **Thames and Hudson**

This is a big, well-illustrated book on the history of colour, with all sorts of information and ideas that you might be able to use. It is probably more of a reference book than something to read straight through.

Leighton, J. and Thomson, R. (1997) *Seurat and the Bathers*, **National Gallery Publications**

Although this is a catalogue from an exhibition on Seurat's *Bathers at Asnières*, it has many references to *Sunday Afternoon at La Grande Jatte* and a great deal on the role of colour in his art.

Richter, I. (ed.) (1998) *The Notebooks of Leonardo da Vinci*, **Oxford University Press**

Leonardo's sketchbooks are still worth analysing, even 500 years after they were written. This book contains his written notes, but his drawings should be looked at too, especially if you want to draw natural forms like water.

Riley, B. (1997) *Mondrian, Nature to Abstraction*, **Tate Publishing**
A selection of, and writings on, Mondrian's key images, leading from his first drawing through to his classic purely abstract paintings.

See also:
Foster, A. (2004) *Tate Women Artists*, **Tate Publishing**
Grosenick, U. (ed.) (2003) *Women Artists in the 20th and 21st Century*, **Taschen**

CHAPTER 5

Graham-Dixon, A. (1996) *A History of British Art*, **BBC Publishing**
Another spin-off from a television series, this book is a bit thin on later British art, but puts artist like Reynolds and Gainsborough clearly in context.

Langmuir, E. (2002) *The National Gallery Companion Guide*, **National Gallery Company Limited**
This has good sections on Reynolds and Leonardo da Vinci.

Leonardo Drawings **(1980), Dover Publications**
The Dover art library contains a selection of reasonably cheap books of images. A good source of work to consult, this one has little text but a wide range of Leonardo's drawings.

Fineberg, J. (2000) *Art Since 1940: Strategies of Being*, **Laurence King Publishing**
This has information on the background to Christo's work.

ART MAGAZINES

These magazines often change their style, but they will have up-to-date ideas on current exhibitions and artists in fashion. Rather than subscribing to them, it is probably best to buy a copy when it seems relevant; they are often useful when you are working on a contextual study. The following is a list of current magazines that could be worth looking at.

- *Art Monthly*
- *Artists Newsletter*
- *Art Review*
- *Modern Painters*
- *Royal Academy*
- *Tate Magazine*

See also *The Artist's Yearbook*, which has a section on all available art magazines. It is listed in the general bibliography at the start of this appendix.

INDEX

WITHDRAWN